Lines of Thought

LINES OF THOUGHT

Branching Diagrams and the Medieval Mind

AYELET EVEN-EZRA

THE UNIVERSITY OF CHICAGO PRESS
Chicago and London

The University of Chicago Press, Chicago 60637
The University of Chicago Press, Ltd., London
© 2021 by The University of Chicago
All rights reserved. No part of this book may be used or reproduced in any manner whatsoever without written permission, except in the case of brief quotations in critical articles and reviews. For more information, contact the University of Chicago Press, 1427 E. 60th St., Chicago, IL 60637.
Published 2021
Printed in the United States of America

30 29 28 27 26 25 24 23 22 21 1 2 3 4 5

ISBN-13: 978-0-226-74308-0 (cloth)
ISBN-13: 978-0-226-74311-0 (e-book)
DOI: https://doi.org/10.7208/chicago/9780226743110.001.0001

This book was published with the support of the Israel Science Foundation.

Library of Congress Cataloging-in-Publication Data

Names: Even-Ezra, Ayelet, author.
Title: Lines of thought : branching diagrams and the medieval mind / Ayelet Even-Ezra.
Description: Chicago : University of Chicago Press, 2021. | Includes bibliographical references and index.
Identifiers: LCCN 2020045478 | ISBN 9780226743080 (cloth) | ISBN 9780226743110 (e-book)
Subjects: LCSH: Manuscripts, Medieval. | Signs and symbols | Paleography, Latin | Philosophy, Medieval.
Classification: LCC Z105.E94 2021 | DDC 091—dc23
LC record available at https://lccn.loc.gov/2020045478

♾ This paper meets the requirements of ANSI/NISO Z39.48–1992 (Permanence of Paper).

Contents

Introduction, 3

PART I

1 } The Form: Chronological, Linguistic, and Cognitive Perspectives, 15
1.1 FORM: A CHRONOLOGICAL PERSPECTIVE, 16
1.2 FORM: A LINGUISTIC PERSPECTIVE, 25
1.3 FORM: A COGNITIVE PERSPECTIVE, 36

2 } The Habit: On What, Where, Who, When, and How Often, 50
2.1 DIAGRAMMING AS A FORM OF MARGINAL ANNOTATION, 57
2.2 PARASITIC, EMBEDDED, AND TAPESTRY FORMS, 75
2.3 BEYOND THE CLASSROOM, 79
2.4 CONCLUSION, 81

PART II

3 } Structures of Concepts: Distinctions, 89
3.1 NATURAL PHILOSOPHY, METAPHYSICS, ETHICS, 91
3.2 BIBLICAL DISTINCTIONS, 99
3.3 CANON AND CIVIL LAW, 109
3.4 MEDICINE, 114
3.5 CONCLUSION, 118

4 } Structures of Language, 119
4.1 VERSE AND RHYME, 119
4.2 LETTER WRITING (ARS DICTAMINIS), 129
4.3 GRAMMAR, 135

5 } Structure of Texts, 145
5.1 ORIENTATION AND COMPOSITION: THEOLOGICAL QUESTIONS, 146
5.2 ANALYSIS: ARGUMENT, 156
5.3 ANALYSIS: BIBLICAL NARRATIVE, 170
5.4 WHAT HT DIAGRAMMING TELLS US ABOUT THE SCHOLASTIC PERCEPTION OF TEXTS: AUTHORS AS ARCHITECTS, TEXTS AS WISELY MADE CONSTRUCTIONS, 180

5.5 CODA: BACK TO THE FUTURE—PARALLELS TO THE *DIVISIO TEXTUS* IN TWENTIETH-CENTURY NARRATIVE ANALYSES, 182

APPENDIX: LATIN AND ENGLISH SURFACE TEXT OF THE BOOK OF JOB PARSED AND NUMBERED (TRANSLATION FOLLOWS THE *ENGLISH STANDARD VERSION*), 187

Epilogue, 193
Acknowledgments, 200
Notes, 203
Bibliography, 227
Index, 247

Lines of Thought

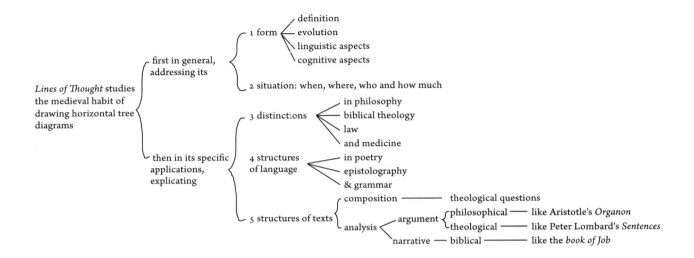

The plan of this work

Introduction

From sounds in the air to inscriptions on the printed page, the material structures of language both reflect, and then systematically transform, our thinking and reasoning about the world. ANDY CLARK, *SUPERSIZING THE MIND*, 59

From cave paintings to smartphones, human beings have been drawing or typing lines, letters, and figures, seeing their ideas, imaginings, thoughts, and dreams materialize outside their minds. They have done so not only to transmit them to others but also to converse with those others who are in fact themselves, reflecting upon their reflections. We use pieces of paper and computer screens to remember things we fear shall be forgotten, to perform complicated calculations we cannot complete in our heads alone, to organize the chaos that fills them, to ponder, and even simply to wander in our imaginations while doodling funny heads or endless chains of flowers. We conduct our lives surrounded by external devices that help us recall information, calculate, plan, design, make decisions, articulate ideas, and reflect once and again upon our inner thoughts and images. We think *with* objects.

Plato's *Phaedros* treats love, the soul, and other noble issues, but as Derrida so keenly observed, one of its deepest and most meaningful layers is that which relates to speech and to the written word that he characterizes as the *pharmakon*: both medicine and poison.[1] This layer reflects, as in an underwater mirror, the acute tension between Plato, the master of philosophical writing, and Socrates, the idealized artist of oral, dialogical philosophy. A meaningful element of this layer is the Egyptian myth Plato puts in Socrates's mouth:

It would take a long time to repeat all that Thamus said to Theuth in praise or blame of the various arts. But when they came to the letters, "This invention, O king," said Theuth, "will make the Egyptians wiser and will improve their memories; for it is a *pharmakon* both for the memory and for the wit." But Thamus replied: "O most ingenious Theuth, the inventor of an art is not always the best judge of the utility or inutility of his own inventions to the users of them. And in this instance, you who are the father of letters, from a paternal love of your own children, have been led to attribute to them a power the opposite of that which they really possess. For this invention of yours will create forgetfulness in the learners' souls, because they will not

use their memory. Their trust in writing, produced by external characters which are not part of themselves, will discourage the use of their own memory within them."[2]

External expression frees the mind from its burden; it extends the self and changes the way it interacts with information and its carriers; it changes the way we think and, at the same time, the way we conceive of ourselves.

Plato's musings about writing and the boundaries of the self remain very relevant in contemporary philosophy of mind, in cognitive studies of writing, diagramming, and externalization, and particularly in Extended Mind Theory and its descendants. Cognitive psychologists, who suggest alternative approaches to classical theory in close relationship to computer studies, attempt to understand the specific value of external cognition, while others who study mental imagery compare it with externalized visualizations, particularly diagrams, especially in human-computer relationships but also in other environments.[3] An influential experiment by Chambers and Reisberg demonstrated that subjects who memorized an ambiguous image (of the duck/rabbit kind) could report only one of the two interpretations. When they copied the image on a page, however, they immediately apprehended the alternative interpretation.[4] The distinction between nonexperts and experts proved significant in these studies. Thus, for instance, Anderson and Helstrup wondered whether external representation would improve performance in a known test of creativity, called the Finke Test. They gave half of the subjects the option to doodle on paper while forging creative combinations. They found that externalization did not improve results in terms of creativity but improved them with regard to other criteria.[5] Later experiments demonstrated that experienced sketchers significantly improved their creativity, combining and restructuring when given the option to sketch rather than acting solely with the aid of mental imagery. Davies, who studies programmers' cognitive behavior, has shown the advantages of externalizing ideas in diagrams and the importance of training and experience.[6] Architects, designers, and engineers do not plan in their heads and then represent their plans on paper: they use pencil and paper, or their equivalent, in the very act of *processing* the design, engaging in complex interactions with the technology they use, whether pencils or sophisticated computer programs.[7] "These cognitive artifacts, externalizations of thought, expand the mind. They enable thought, guide variations, allow play, discovery, and invention."[8] These insights are further researched in a variety of fields, from math education to hardware design and business studies.

Extended Mind Theory, first suggested by Clark and Chalmers in 1998, sharply articulated these intuitions and studies.[9] This provocative and engaging theory pointed out the crucial importance of looking at human cognition while giving due weight not only to processes that occur inside the skull but also to external means such as pencils and notebooks as part and

parcel of the cognitive system. No, the pencil does not think per se, but neither does a single neuron. Both take part in a bigger system performing the marvelous process of thinking. One of the most memorable parts of Clark and Chalmers's primary argument was putting side by side the imaginary persons Otto and Inga—he, searching his personal notes for the directions to a museum, and she, searching her memory—highlighting the great similarity between their activities. As Sutton has argued, the point is not in blurring any distinction between purely internal processes and those involving external devices, or between those able to make complex calculations in their minds and those who use paper, as if there are no real differences.[10] There certainly are. But the immense significance of Extended Mind Theory in particular, and theories of externalization in general, lies in the imperative to recognize that internal and external operations, though different in their advantages and disadvantages, under specific conditions turn into one dynamic system. And precisely these differences of availability, durability, and flexibility make the combined system intriguing.

This fundamental understanding is a gold mine for the feasibility of a history of cognition, a history interested not only in *what* people have thought but also in *how* they were thinking, including their habits of work and of organizing knowledge.[11] If human cognition not only expresses itself through external means but is also composed of them, then cognition has a history—because these means, their availability, and the habitual patterns of interaction with them are culturally conditioned and subject to historical change.[12] Reading and writing, drawing and using maps, diagrams, tables, graphs, and their like, are learned skills. They depend not only on innate inclinations but also on learned strategies and expertise. Different levels of expertise in a field such as programming and software design have been shown, for instance, to affect greatly the choice of strategies, particularly regarding the use of diagrams.[13] This dynamic between fixed capacities and the historical-sociological context in which certain cognitive skills are encouraged or neglected, and the expertise in cognitive strategies that evolves at a certain point in time, are the object of historians. Finally, the externalization of thinking processes such as analysis, classification, and grouping provides the very access into these processes in the first place.

The history of the emergence, evolution, and decay of practices involving materialities and external devices has recently been the subject of intense interest on the part of leading intellectual historians. Marginal annotation, footnoting, arranging excerpted passages, and other modes of organizing information turn out to be intriguing agents of change, both in relation to broader historical processes and in their own right.[14] In scholarship on the medieval period, experts in the traditional disciplines of paleography and codicology have engaged these interests anew, mapping changes in script, layout, and practices of annotation.[15] They have also opened windows to

INTRODUCTION

History of thought and scholarly habits may be affected by
- new tools
- new types of users of existent tools
- new availability of existent tools
- new patterns of interaction with existent tools
- new contexts of use and applications of different functions

the habits and practices of ordinary educated men and women, tracing everyday realities and microhistories of intellectual history, in search of the way scholars read and understood texts and objects. Historians of science and art have been devoting attention to practices of visualizing knowledge through diagrams, graphs, tables, and allegorical pictures, to understand the significance of visuality both in scientific thinking and in education and the importance of changes in the external representations and images in fields like mathematics and biology. In the process, they are joining the lively interest in infographics, diagrams, and visual studies in a wide variety of disciplines in the past two decades.[16] Scholars of medieval Europe are engaging enthusiastically in this field.[17]

The Western scholastic culture of the late twelfth to the fifteenth century nurtured among its members specific habits and practices of thinking, reading, and writing. Ideas of knowledge organization, which were developed in previous centuries, matured with the rise of cathedral schools and universities and with the rapid growth of student bodies, texts both original and translated, and institutions. These developments posed new demands, such as exams, textbooks, and fast, focused learning. They opened new options for systematic cultivation of collective, standardized practices and the efficient shaping of habits. The distinctive methodologies of analysis and expression that were crystallizing in these years in western European centers of learning make scholastic culture a perfect candidate for a study of forms and habits of organizing thought.

Indeed, the very revival of the term "*habitus*" in modern scholarship by Bourdieu has its origin in the study of medieval culture. It was "in his obscure translator's afterword to the work of another," Panofsky's *Gothic Architecture and Scholasticism*, "that Bourdieu develops for the first time what will become his central theoretical category for relating human subjects to the forces, histories, and structures that determined their forms of life and thought."[18] Yet while many aspects of the scholastic intellectual modes have been studied, the visualization practices prevailing at this significant phase in Western intellectual history have never been investigated. Panofsky argued that strong similarities obtain between the structures of Gothic architecture and those expressed in scholastic writing. The connection that accounted for this effect was "more concrete than mere parallelism," yet more general than individual influence of one thinker on another of the type historians of ideas and art usually identify. It was a certain *habitus*, learned through words in one realm and expressed in stone in the other. One of its clearest features was subdivision or "progressive divisibility," parts and distinctions all around.[19] Bourdieu's theory of *habitus* flourished and developed in other directions to a much more nuanced and multifaceted set of codes, actions, and dispositions from posture to musical taste.[20] Panofsky's thesis keeps stimulating scholars, despite the harsh critical response it has received over

the years. For many, its generalizations seem too sweeping, its analogies too vague or thin.[21] The visuality of the schoolmen themselves, however, was never seriously considered, unlike long-known examples of the early Middle Ages such as the Square of Opposition, Porphyry's Tree, Boethius's musical and mathematical diagrams, the division of the sciences, or twelfth-century splendid diagrams.[22]

The lacuna in understanding the visual habits of scholastic culture led scholars of later periods, like Ong in his classic *Ramus: Method and the Decay of Dialogue* (1958), to claim mistakenly that the Ramist diagrammatic mode of spatializing knowledge was an early modern invention associated with the print revolution. Ramus and his followers, he argued, spatialized logical notions as multilevel trees and expanded this method to other areas of knowledge as well. This was not the work of a single mind but became a veritable movement. The Ramist diagrammatic mode of thought, Ong argued, leaned on a scholastic logical quantification. But it was also the child of humanism and above all, following McLuhan's focus on the impact of technology, of the new medium of the printed page. As memorable and influential as his study was, some crucial aspects of his grand thesis were wrong: the diagrammatic, knowledge-spatializing mode he found in Ramus and his followers is not "Ramist" at all. It pertained neither to humanism nor to print but was scholastic from head to toe, not only in what he termed "quantification" but in its being a direct continuation of a rich medieval tradition of horizontal tree diagramming about which Ong and other scholars have been silent. As this book will show, writing in the form of horizontal tree diagrams in the margins or within the columns of parchment manuscripts became popular in the beginning of the thirteenth century and continued during the introduction of print in the fifteenth century and well beyond. These were not the products of a few singular minds like that of Raymond Lull. Thousands of such trees feature in manuscripts of all university disciplines, including systematic, biblical, and pastoral theologies, as well as law, philosophy, grammar, physics, and even poetry.

The present book does not address all kinds of medieval diagrams. It attempts to portray the very specific and strictly defined visualizing habit of drawing horizontal tree diagrams. It is a detailed example of studying historically a scholarly habit using multiple approaches: qualitative, quantitative, and cross-disciplinary. Historians constantly try to reconstruct dynamic processes by looking at static objects such as documents, chronicles, or coins, and historians of reading and writing are no exception to this rule: the habit must be reconstructed from the diagrams themselves. The vast majority of these diagrams are not particularly pretty or ingenious. The human protagonists of this book are almost all anonymous, hands writing and drawing on manuscripts which we cannot connect to known figures or stories.

In a somewhat poetic ironic sense, the authors-scribes become completely identified by the external devices that once interacted with their minds.

Individual manuscripts and specific text-image traditions of medieval diagrams have been the subject of fine studies. It is time now to step back and look at habits and phenomena of large communities, in a somewhat similar way to Moretti's "distant reading" (as opposed to close reading) of literature.[23] Thus, to give one familiar example, despite the thorough studies of the arts of memory in the ancient, medieval, and early modern periods, it remains unclear to what extent such techniques were practiced and whether they were deeply rooted. When Hugh of Saint-Victor recommends a memorizing technique, to what extent did he actually practice it? Once or twice? On a regular basis? For any type of information? How many scholars followed his suggestions? Did most educated medievals? Only a few? To try and answer such questions and acquire a broader, clearer picture of the habits of a community, or even a culture, one must begin with the fascinating qualitative examination of individual patterns of thought and practices in single manuscripts and authors but proceed to quantitative analyses and metrics of data from multiple authors and objects.[24] In the medieval fields of manuscript studies, projects like those of Derolez, Teeuwen, and Buringh have begun to apply such methods to better map changes in script, manuscript design, and practices of annotation; the subject of quantitative codicology has become increasingly popular.[25] A full investigation of this specific practice should therefore address questions about its essence and potential and, beyond that, specifics regarding the historical actualization of this potential: its distribution, intensity of use, contexts of use, the types of information it was applied to, the fields in which it was practiced, and the nuances and functions it assumed in each field.

An auditor of one of my talks on this topic said once that he was curious as to what story I was going to construct from these sources. I am not going to tell any story. This is a somewhat static portrait rather than a narrative, following diagrams that in themselves challenge linearity. I offer a brief account of the evolution of the form of these diagrams from their predecessors in the period before 1150 in section 1.1 and lightly trace their adventures and echoes in the centuries following 1500 in the conclusion. But for the intervening centuries, it is not a tale of major shifts or of emergence or decay. As I pursued my research, it gradually became apparent that the general form, nature, context, and principal subject matters of this technique existed already in 1250 and did not significantly change before 1500. Nuances such as changes in distribution, a gradual increase in the number of users, or the emergence of new themes, however, could not be detected. I hoped at the beginning of this study that the current state of data about manuscripts and paleography would allow me to detect historical changes in form and use, perhaps even identify geographical tendencies. Yet such

a task is clearly not feasible given the present state of insufficient data on a large enough number of manuscripts, such as statistics on distributions, survival rates, and other parameters, which are essential to construct such a narrative. The paleography of this period, as advanced as it is, is often unable to provide accurate enough estimations of date and origin of manuscripts, all the more so when it comes to occasional isolated marginal glosses of later hands, the state in which most of our diagrams are found. Often, therefore, I do not mention a specific script, date, or origin, and when I do, I rely on my own experience but also on secondary literature and catalogs, which might sometimes prove inaccurate. None, however, is so inaccurate as to present a thirteenth-century manuscript as a fifteenth-century one. In-depth analyses of individual manuscripts may yield better results, of course, but we are after the portrayal of a cultural phenomenon, broadly investigated, rather than diving into one manuscript or one tradition, and this approach, while it has obvious benefits, has its limits.

PART 1 of this book, consisting of two chapters, explores the habit of branched writing that produced horizontal tree diagrams in general.

CHAPTER 1 defines the basic form of such diagrams, then examines their form from three perspectives. The first, a chronological one, traces the evolution of such diagrams from early medieval forms up to the curly bracket or brace that survives on modern keyboards. Special treatment is given to distinguishing branched writing from other diagrams in the rich world of visualizing information in the Middle Ages and to a consideration of parallel phenomena in other contemporary or closely contemporary cultures. The second perspective investigates the principles guiding the form of these diagrams from a linguistic point of view. It considers in particular grouping and categorization, in thought and in natural speech, particularly through the phenomenon of coordination, then their written expression in regular linear writing that partially reflects linear speech, in free writing and lists and finally in horizontal tree diagramming. It shows the diagrams' deep relationship to the syntagmatic and paradigmatic axes of language, as well as the flexibility that the tree form allows for shifting the relational load from natural language markers into lines, while still retaining many of the natural language markers. From the third perspective, and building on these insights, the advantages of this form are examined from a cognitive approach, addressing the ways in which drawing and reading such diagrams encourage, reflect, and participate in processing written ideas, categorization, abstraction, manipulation, brevity, and memorization.

CHAPTER 2 situates the production of these diagrams in the contexts of medieval scholars, professional scribes, and students, asking where such horizontal tree diagrams were drawn, by whom, and in which contexts. Analyzing levels of execution and the balanced layout of columns versus margins, I reconstruct the specific position of this practice in both private and

public spheres and across social contexts of writing to demonstrate that the great majority of these diagrams appear as readers' responses to preexisting texts, in the form of marginal glosses—in informal, semiprivate contexts. Marginal annotation, the principal context for such drawing, is then studied at length. How widespread was this habit? How often did readers draw such diagrams when they were already prone to do so? Did readers replicate specific diagrams, or did they generate individual variations in creative ways? Did they differ in their choices as to which bits of information to convert this way and how? To achieve valid statistical results and draw a portrait of a social phenomenon, as opposed to scattered individual tendencies, I present the results of a survey of manuscripts of Aristotle's *Organon*, measuring diagrammatic annotations in different parameters. Results demonstrate that branched writing and production of horizontal tree diagrams were highly prevalent among annotators (75–96%), with significant variation in intensity of use and in content. Moreover, the nature of the text had little effect on the choice of whether to fill it with diagrams or not. These findings and those of later chapters carefully delineate the contours of a highly popular but personal habit, deeply internalized to enable freedom and creative use, uniform in appearance, yet (unlike the use of graphs in modern economics or symbols in algebra) not entirely and publicly institutionalized. While most of the horizontal tree diagrams were in the margins, I then look at three other codicological contexts: embedded and parasitic forms and, finally, pages featuring nothing but horizontal tree diagrams, whether unorganized or composing coherent sets in finely executed codices or works meant to please the eyes and minds of others and to serve as study aids.

PART II delves into the application of horizontal tree diagramming in a range of disciplines and subjects, presenting particular expressions and functions that reveal the intense scholastic fascination with concrete structures. Each chapter consists of a short introduction to the general visual tradition in its respective field, followed by several examples of horizontal tree diagramming, including fully translated diagrams taken from different manuscripts and contexts. As a collateral benefit, Part II may serve as an illustrated tour of scholastic thought.

CHAPTER 3 presents the most popular use of this technique: *distinctiones*. It discusses the intellectual tool of distinction and enumeration and follows its use and form through four general disciplines. It shows the versatility of the technique for sharpening philosophical concepts; for sophisticated analyses of metaphorical thought and intertextuality in theology, reflecting and continuing on the page neural nets of associative thought; for the articulation of procedures and cases in law in an algorithmic manner; and for organizing thinking on symptoms and causes in medicine.

CHAPTER 4 examines how such diagrams were applied to represent linguistic structures themselves. While diagrammatic *distinctiones* rely upon

linguistic features to represent conceptual divisions, I now turn to how they were applied as a technique to highlight structures of rhyming verses, addressing challenges of visualizing sound. I then proceed to examine horizontal tree diagrams that functioned as two-dimensional "machines" generating epistolary formulae in manuals of *ars dictaminis*: the medieval art of letter writing. The chapter ends with a discussion of the intriguing relative lack of application to highlight grammatical and morphological features.

CHAPTER 5 explores the intricate phenomenon of diagrams that represent the structure of texts. It addresses diagrams representing the structure of theological *quaestiones*, suggesting that such diagrams were used as orientation tools as well as outlines for editorial and compilation purposes. It moves then to diagrammatic *divisiones textus* that illustrate the distinctly hierarchical medieval analyses of authoritative texts. A close comparison of such visual analyses of texts, such as Aristotle's logical works and *Ethics* or Peter Lombard's *Sentences* in theology, reconstructs medieval perceptions of the structure of argumentation, while *divisiones* of biblical narratives, where the relation between single story lines and multilevel structures is perhaps most intense, generate sophisticated narratological analyses. The chapter also draws out the implications of diagramming for improved understanding of scholastic perceptions of textuality and authorship. I conclude with a coda pointing out surprising similarities between (*a*) medieval insights and their graphical expression and (*b*) modern approaches to text and narrative in literary criticism, cognitive studies, and computational linguistics.

THE EPILOGUE gathers the insights from this tour through scholastic culture into an integrated portrait of this cognitive habit in its diverse expressions, addressing the different functions explicated and discussed throughout the first and second parts. It ends with a look forward to the later developments of this technique in the early modern and modern periods.

Three tips for reading strategy:

1. Diagrams set themselves apart from the flow of the text. This attracts the attention of the eye and the mind but at the same time makes it extremely easy to skip over them, as I noticed readers of drafts have unconsciously done. Try to read them nevertheless. I made considerable effort to reconstruct the original designs (even when they were confused), as well as to preserve the semigrammaticality of the nodes (on which see section 1.2) while trying to be faithful to the Latin. Latin is, however, more flexible than English, and its translation frequently results in English that is a bit strange.
2. Almost all the manuscripts discussed here are available online for you to browse through freely: https://digi.vatlib.it/mss/, https://gallica.bnf.fr, http://www.internetculturale.it/, and other databases.

3. This book is about a practice, but practices cannot be truly understood if you do not practice them. I implore readers to try to annotate this very text diagrammatically. To help, I have added exemplary marginal diagrams, either summarizing in horizontal tree form notions from the text or analyzing its structure. I will be extremely happy if you send me your marginal diagrams!

An important note on literature and bibliography: The subject of diagrammatic thought in general, and of medieval diagrams in particular, has drawn immense scholarly attention over the years. In today's culture of information and databases, I find it unnecessary and impractical to cite extensively general literature on this topic and have chosen to cite only those works concretely relevant to my specific argument. Similarly, the horizontal tree phenomenon extends across multiple textual traditions and subjects. It would be as impractical to cite extensively literature about each of these fields, such as medieval canon law, medieval medicine, or epistolography. On each such subject I provide a few basic works on the authors and texts discussed for further reading but I do not presume even to begin to cover it, else the book would double its size and turn into a bibliographic guide to scholasticism.

PART I

¶ In this chapter the author first defines the form of the diagrams that are the subject of this book

then discusses its evolution from a historical perspective
its principles from a linguistic perspective
and its functions from a cognitive perspective

{ 1 }

The Form

Chronological, Linguistic, and Cognitive Perspectives

Medieval schoolmen did not use any specific term for diagrams like the diagrams populating this book. In fact, most of them did not refer to them at all. The English theologian Richard of Fishacre (1200–1248), who produced elaborate horizontal tree diagrams for his commentary on Peter Lombard's *Sentences*, described them as drawings "in the manner of a ramifying tree" (*in modum arboris ramificatae*).[1] Thomas Le Myésier (d. 1336) and Nicole Oresme (d. 1382) were satisfied with "*figura*/figure," the general medieval term for diagrams.[2] Modern scholarship has coined no specific term either. Some modern scholars refer to them as *distinctiones*. In its medieval sense, *distinctio* referred to textual units bigger than chapters or to the result of listing and distinguishing similar concepts or items from one another while simultaneously marking their commonalities, such as the multiple meanings of a single equivocal term or a collation of similar events or phenomena. Distinctions of this kind were frequently represented as horizontal trees, but they were also frequently articulated in a purely oral manner during lectures and sermons or written in regular script without any specific graphical expression. It therefore does not fit our needs. I shall call the specific graphical expression that is the focus of this book *horizontal tree* diagrams (HTs), while keeping in mind that real trees are not horizontal; that branches of ink trees, unlike their botanical referent, may merge again after splitting; and that there are pictorial tree diagrams that have no connection to our story at all, for reasons outlined below. I shall refer to the writing-drawing technique that results in the specific form of this diagram as *paradigmatic writing*.

The basic structural principles of HTs in my nomenclature are as follows. Read from left to right, they are made of verbal units, or *nodes*, connected by simple lines, which form their *branches*. The nodes themselves contain content of varying length, from parts of words to multiple phrases. *Terminal nodes* are those nodes to which no other node is linked on the right, marking the end of the specific trail that leads to them. When there is only one node on the left, it is called at times a *root*. Frequently, links between nodes obey the rules of natural language, including prepositions and declined nouns, so that following one *trail* from left to right results in a

complete or almost complete grammatical sentence. Nodes may, however, consist of only nouns in the nominative case. In the former instance, the preposition or verb at the end of the node to the left is the source of the branch's relational meaning. Prepositions may either end a node or open the next one. A node may be linked and *split* in relation to multiple nodes, all of which are usually ordered vertically as a list to its right. A group of similar nodes may also *converge*, connecting to a single node further to the right. At times, nodes may shoot out only one branch. Each further split or convergence forms a new *level*. Thus, in the diagram below (figure 1.1), A to H are nodes; the lines between them are branches; A splits to B, C, and D; C and D converge to H. *Trails* combined of, for example, A-B-E or A-D-H frequently result in grammatical or semigrammatical sentences. This diagram has a maximum of three *levels*.

1.1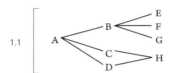

In some types of tree diagrams lines must have the same meaning along the way. But in the case of HTs, the simplest, principal meaning of the line is to describe the direction a reader must follow in order to continue reading the next semantic unit. The multiple examples we see in manuscripts show that writers were willing to curve the lines, elongate them, and lead them back and forth, but they always made clear where the eye should follow. This chapter will elaborate on these formal and graphic traits from three perspectives: chronological (tracing the evolution of the HT form), linguistic (analyzing its relation to similar oral and written expressions), and cognitive (examining its cognitive functions).

1.1 FORM: A CHRONOLOGICAL PERSPECTIVE

Schmitt has briefly suggested an evolution of diagrams from the primarily geometrical form (in antiquity and the early Middle Ages) to the pictorial image (culminating in the twelfth century) and back again to simplification toward the late twelfth century.[3] I would not presume to refute this large-scale narrative or to delineate an alternative but instead concentrate on the distinctive evolutionary thread that leads directly to HTs. Vertical branching diagrams were drawn in the West for centuries before 1200, and the synthetic history of these forms and practices up to the twelfth century is yet to be written. On the threshold of the eleventh century three types seem to have been the most current: (1) the "genealogical" type, with medallion-

like, circumscribed nodes connected by one or more lines; (2) a division splitting in the same way but without the circles; (3) and a form in which all nodes—the root as well as its branches—shoot horizontally from one straight vertical line (figure 1.2):

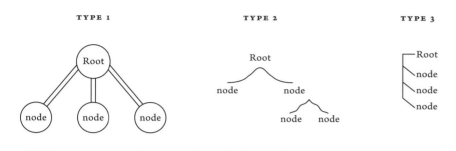

1.2 Three prototypes

Genealogical diagrams of type 1 may have contributed to the general preference for a diagrammatic mode of thought, but the most direct ancestors of HTs seem to be types 2 and 3, spotted in the margins of early medieval codices. While type 1 kept its form into the sixteenth and seventeenth centuries, the others evolved into or paved the way for the HT during the twelfth century. The few decades circa 1200 show that manuscripts began to feature lineation in various directions. Consider, for example, MS BL Harley 3255, which contains Richard Barre's *Compendium veteris and noui testamenti*, a theological-pastoral work composed around 1190. The codex in question is thought to have been copied very close to this date.[4] Many of its pages feature little *distinctiones* in the margins, listing the different spiritual meanings of certain objects (on which see section 3.2 below). The nature of the association between the nodes here can be understood only through the context, that is, the text in the central columns of the codex, and the lines may be verbally encoded as "spiritually signifies," or just "are." The burden of associating them one to another lies exclusively on the freely drawn line. Consider, for example, the one on *fume* (figure 1.3):

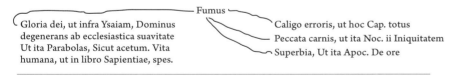

1.3 London, BL Harley 3255, fol. 10v, detail.

Clearly, the author means not only to connect *fume* to its four spiritual senses but to classify as well, putting the glory of God on the left and the

THE FORM

other three, negative senses—the cloud of error, the sins of the body, and arrogance—on the right, which results in a mixture of the vertical and the horizontal. A more fluid figure is the distinction of *osculum* (kiss) in folio 8r of the same manuscript. "Kiss" stands in the middle, two spiritual meanings float below to its left ("of peace and harmony," *pacis et concordantie*), another on the upper right ("of love," *dilectionis*), while two others appear on the right below (*carnale*; *simulationis*). Thus, verticality and horizontality play interchangeable roles in this manuscript, with a seeming preference for the vertical split, as in the following example seen in the distinction in folio 32r, showing that "horses" may allude to demons, apostles, or passions of the body (figure 1.4). The last is further divided into lust, pride or arrogance, impudence, etc. "Human happiness" is obscurely linked as well:

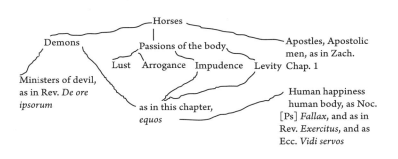

1.4 London, BL Harley 3255, fol. 32r, detail, translation.

While the manuscript contains many vertical and mixed forms, it also features what would become the classic horizontal form next to them. Other manuscripts executed in this historical phase, such as that of Nigel of Longchamps (alias Nigel Witeker, 1130–1200), display a similar variety and flexibility of forms.[5] Soon, however, the horizontal form defined above became overtly dominant.

From 1200 to 1500, the basic direction of the lines was horizontal, with straight or wavy lines stretching from node to node. At times, when the line begins, not from the root, but from "bullets" at the beginning of each item on the list, they link more easily with a straight vertical line to create a square form. The < and [forms dominate in thirteenth- and fourteenth-century manuscripts, with a range of stylistic variations. Many times, the same diagram features different styles of branch. When several lines split from one root or converge into one node, they receive an additional meaning: all the connected items belong to the same group. This use of the < or > form may appear on the *right* side of the group as well, framing it. It was occasionally only hinted at by framing lines leading only to the first and last nodes in the group.

CHAPTER { 1 }

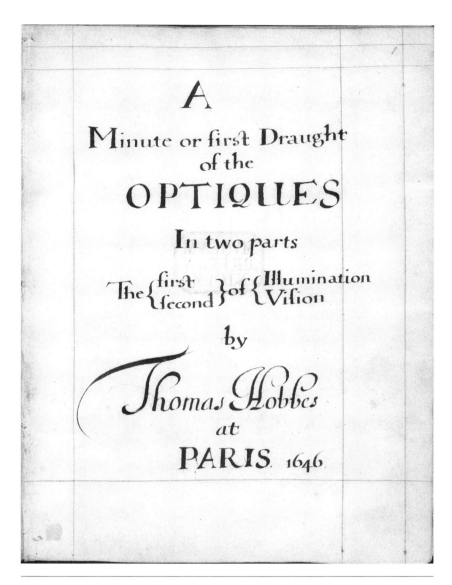

1.5 Thomas Hobbes, *A minute or first Draught of the Optiques In two parts, the first of Illumination, the second of Vision* (Paris, 1646), London, BL Harley 3360, fol. 1r

 As the central function of the lines is to connect nodes and show their groupings, often the lines took different shapes, according to the skill of the author and depending on whether spatial planning was done in advance or the diagram was composed on the fly. One technique that became common was to arch the line backward before it reached the first and the last nodes, in order to save space, which results in the curly bracket { } seen in figure 1.5. This form was dominant in fifteenth-century manuscripts, was transmitted to the print age, and still appears on our twenty-first-century keyboards.

THE FORM

*HTs Compared with Earlier and Contemporaneous
Medieval Diagrams and Tables*

According to the scholastic method, definition must engage, either implicitly or explicitly, with the distinction of a species from others of its genus. To refine our understanding of HTs as a visual form of writing that differs from other sorts of figures, a few words contrasting them with other medieval diagrams and other means of visualization are in order. The world of visualized information in the European Middle Ages, not to mention other cultures and periods, is vast, and scholarship on the subject is multiplying as you read these words. I do not presume to suggest any general typology or theory here, as such endeavors have already been undertaken by others, but want to clarify the definition of HTs within the infographic context of these centuries.[6]

First, we should distinguish drawn diagrams from mental images; for the latter, one is guided to imagine in one's mind using an "internal eye" but not necessarily to actually draw what one imagines. Second, we must distinguish diagrams that represent objects and relations that, in their real existence in the world, are *already* visual and spatial in some way from those employed to visualize conceptual matter. The first group includes geometrical, astronomical, anatomical, and mechanical diagrams and maps. Such diagrams differ from richly figurative and pictorial representations of the same objects mainly in their simplified schematic form, which is achieved by omission of visual details considered irrelevant for the specific purposes of their creators, and which thus aids selective attention to the relevant traits.[7]

Conceptual diagrams do not convert one spatial, visual object into another but translate conceptual and abstract relations such as "more important than . . . ," "includes . . . ," "divides into . . . ," or "derives from . . ." into visible signs. They may also translate the related objects themselves into visible two-dimensional entities, as in allegorical images, such as those employed in early modern art where logical terms may be represented as boats sailing on the river of logic.[8] Medieval manuscripts during the Middle Ages feature a dazzling variety of conceptual diagrams, some undoubtedly remnants of a Hellenistic, late antique book culture, while others are novel and innovative. Among those especially well known from early medieval times to the twelfth century are the diagrams that accompanied Boethius's and the Latin encyclopedists' works on arithmetic and music;[9] multiple figures of the division of the sciences from Boethius and Cassiodorus to Radulfus Ardens (one such figure was the subject of a famously intense debate during Gerbert of Aurillac's time);[10] Porphyry's Tree and the Square of Opposition in logic;[11] the Trees of Affinity and Consanguinity in the canonical legal tradition;[12] and the rich diagrams and the images bordering the diagrammatic

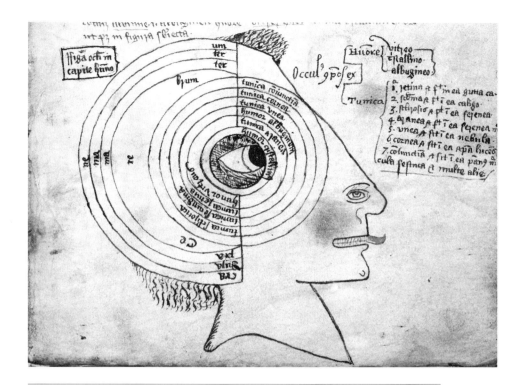

1.6 London, BL Sloane 981, fol. 68r, detail. Courtesy of the British Library Board.

in manuscripts such as Lambert of Saint-Omer's *Liber floridus* or Herrad of Hohenberg's *Hortus deliciarum*.

An illuminating example of interaction between the two forms of visualization—"real" and conceptual—is beautifully seen in London, BL Sloane 981, a medical miscellany from the late fourteenth or early fifteenth century (figure 1.6).[13] The eye diagram on the left and the HT on the right present almost the same information on the parts of the eye. Yet while the illustration on the left presents the place of the liquids and tunics in the spatial structure of the eye, the HT visualizes the mental classificatory structure of the components into humors and tunic layers.

Many medieval hierarchical or divisive diagrams representing conceptual grouping through relations, such as the division of knowledge or other themes, are constructed as a vertical genealogy of a multitude of medallions or bubble-like nodes that are connected to each other with either straight or curved lines (i.e., those named type 1 above). Other authors of conceptual diagrams chose to put the abstract relations over a prior figurative skeleton, such as a wheel, a leafy tree (generally vertical), a ladder, a seraph with six wings, or more complex pictorial/geometrical settings.[14] Others employed a special geometrical form to designate relations, such as the diagrams that

THE FORM

Joachim of Fiore designed to convey his ideas on the Trinity or those of Lothar de Segni.[15]

HTs differ from all of the above in their form, as well as in aspects of their context, production, distribution, and other features that shall be discussed in chapter 2; the next section of the current chapter will address their unique linguistic principles. The nodes of HTs are not as graphically isolated as the encircled nodes in "medallion" genealogical diagrams but encourage the reader to link them to one another and read them as part of a continuum. HTs are not modeled on any recognizable figurative or geometrical skeleton, nor do they contain any pictorial elements, either decorative or allegorical, vegetal or other.[16] They lack any evident affective effect common to pictographs, which employ images that evoke positive or negative associations.[17] If there is an additional figurative sketch such as a little human or animal face, it is attached to their left or right end, in exactly the same way such minicartoons are attached to purely verbal notes in the same manuscript. Indeed, they share many features with regular textual paragraphs, except the obvious one of horizontality. A paragraph mark (*pied-de-mouche*), *nota*, or a manicule (pointing hand) is often attached to their left. When branches are colored, they are either red or alternating red and blue, the same colors used for paragraph marks and titles throughout the manuscript. If the diagram extends beyond the width of the page, scribes often use a *signe-de-renvoie*, a reference mark, to lead the reader to its continuation in a different place on the same page or on the facing page: the HT is breakable. I have not seen the use of such a technique to indicate "to be continued" in any other medieval diagram. These tend to have a unitary, unbreakable, iconic nature, keeping the form. However, this technique is frequently found in purely textual notes.[18]

All these features place HTs in a peculiar intermediary realm between regular punctuation norms and diagrams, employing spatiality in a somewhat free, but still restrictive, manner to express conceptual relationships. They have thus become one specific and distinct tool within a toolbox of various graphical means possessed by medieval authors and scribes, who chose them for certain purposes and others for other purposes. The lavish "Wellcome Apocalypse" (London, Wellcome Library 49), a German miscellany from around 1420, displays this toolbox in all its peacock-tail variety, with a wealth of diagrams and illustrations of medical, scientific, theological, and moral topics. The scribes and illuminators employed vertical medallion diagrams of virtues and vices, tables, ladders, towers, trees, detailed anatomical illustrations, and, probably the humblest ones, a few HTs, examples of which are detailed in section 3.4.

I will reserve comparison with vertical lists for the next section. The final graphical organization tool available to the medieval scholar to which the HT may be compared is the table. Tables share with HTs the combination of horizontal and vertical trajectories that allow their creators and readers to

identify all items within the same column as paradigmatic. They differ in several points, however. Tabular cells are markedly isolated, therefore leading readers to distinguish and itemize, in contrast to the horizontal flow of HTs. Furthermore, a table is restricted to two principles in its several horizontal and vertical axes, generating a fixed grid of largely equal rectangular fields hosting equal-length text. The HT is far more flexible and can accommodate changes to the number and length of its nodes according to the matter in question: one branch can be extended to include several sentences and at its end may split into five short nodes; another branch originating from the same parent node may be short and then split several times; a third branch may not feature a single split. Each split or convergence begins graphically just where the last word ends, and each group of nodes or list of terms may obey a different paradigmatic principle.

The elliptical verbal economy of HTs emphasizes common ground among nodes by converging-reducing similar items into one. This significant difference relates to their very essence and function. In a table, one should, in principle, fill *all* cells, even if several cells contain identical elements. Such a complete table cannot, therefore, explicate any relative relational structuring. Another important function of tables is to enable the rapid location of an item answering to two conditions by crossing the horizontal and the vertical to find it, preferably without relating to any other cells in the same table. HTs do not allow this, precisely because of their flexible form.

Distinguishing things does not preclude their amalgamation and hybridization, in attempts to enjoy the benefits of all worlds. BL Harley 658, a thirteenth-century miscellany originating from the theological schools of the early thirteenth century, contains dazzling diagrams, few of which combine vertical medallion divisions with the HT form.[19] Figure 1.21 shows a combined use of pictorial images, text, and HTs (to be discussed later). Figure 1.7 transcribes an amalgamation of an HT and a table of the first noun declension in Latin.

The proximity of the HT form to other visual means, such as regular writing, lists, tables, and various other diagram forms, reveals its relation to larger historical developments in norms of writing and diagramming, patterns of thought, and the intersections between them. As Parkes noted, during the early medieval period writing was not understood merely as the record of speech. For Isidore of Seville, to give one example, the signs of language are not signs of sounds but "signal directly to the mind through the eye."[20] Spaces between words were gradually introduced during the early Middle Ages, a phenomenon which is associated with the growth of silent individual reading, disassociated from communal reading aloud in new intellectual and social settings.[21] Parkes has noted the parallel evolution of punctuation marks. Parkes and Rouse and Rouse have ingeniously shown the rapid development of new types of reference texts, associated

		nom.	Gen.	dat.	acc.	voc.	abl.	nom. pl.	gen.	dat.	acc.	voc.	abl.	
Hec est agnitio prime declinationis quod nominativus terminat in		a	e	e	am	a	a	e	arum	is	as	e	is	ut musa
		as	e	e	am	as	a vel e	———						ut Eneas
		es	e	e	am	a	a vel e	———						ut Anchises
		am	e	e	am	am	am	———						ut Adam

		nom.	gen.	dat.	acc.	voc	abl	nom. pl.	gen.	dat.	acc.	voc.	abl.	
Hec est agnitio secunde declinationis quod nominativus terminat in		er	i	o	um	er	o	i	orum	is	os	i	is	ut faver
		ir	i	o	um	ir	o	i	orum	is	os	i	is	ut vir
		ur	i	o	um	ur	o	i	orum	is	os	i	is	ut satur
		um	i	o	um	um	o	a	orum	is	a	a	is	ut templum
									nisi fit per cincopam ut duum pro duorum					
		us	i	o	um vel a	e	o	i	orum	is	os	i	is	ut dominus
									exceptis duobus neutrum, scilicet vulgus, pelagus quorum vocativus in us […]					
		eus	i	o	um	en	o	ut penteus	et in omnibus masculinis ut ditus agnus que [..] in us et propriis nominibus....					

1.7 Florence, BML Plut. 25 sin. 05, fol. 26r (28r in the later foliation), transcription.

page layouts, and sophisticated graphical tools designed to facilitate orientation and quick retrieval of specific information and to clarify relations between gloss and main text. In twelfth-century centers of learning, running titles, paragraph marks, indices, lists of contents, and other features invented centuries ago became standard.[22] These newly designed pages, codices, and their repertory of visual semiotics responded to the needs of a rapidly changing reading culture, at a time when knowledge became the aim of many, and patterns of transmission underwent deep changes. A parallel development may be traced in the history of diagrammatic expressions. Early medieval traditions of visualizing knowledge in tables and diagrams of all sorts multiplied and reached new heights, particularly in the field of theology, but in others as well. The twelfth century and the beginning of the thirteenth witnessed a flourishing of diagrams, including the genealogical, "medallion" type along with novel and creative employment of imaginative pictorial means, colors, and forms, which served multiple ends. The birth of paradigmatic writing, or HTs, is indebted to these developments, just as it is to its direct predecessors.

The gradual shift into horizontality distinguishes the scholastic Latin diagrams not only from their Latin predecessors but also from older and contemporary Greek tree corollaries, the *diaereses* (divisions into genera and species), which had populated hundreds of glosses to Aristotle since at least the tenth century.[23] Horizontality brings them closer, however, to Syriac *pulaga* and Arabic *tashjīr* diagrams, which split horizontally, except for their first split from the root (forcing the reader to tilt her head or turn the

book).[24] As in the Latin tradition, these graphic representations of division were applied not only to logic but to medicine and theological subtleties as well, producing *distinctiones* remarkably similar to the Western ones we shall meet in chapter 3.

The history of intercultural influence in manuscript culture and in diagramming habits in the Middle Ages—early and late alike—largely remains uncharted territory.[25] Long-established artistic parallels and circumstantial evidence may support a hypothesis of mutual influence.[26] In the specific case of the twelfth-century Aristotelian tradition, for instance, one may suggest a partial influence of the specific practice of drawing *diaereses* in the margins of logic manuscripts. In numerous works Ebbesen has demonstrated the steady, varied, and mutual interaction between Greek and Latin philosophical traditions.[27] It was this interaction that first brought the new logic to the Latin West, and not only in the form of the Aristotelian text itself but accompanied by a rich wardrobe of marginalia translated into Latin. Codices which could very well have been produced on the fringes of Latin culture, such as Florence, BML Plut. 72.3 of the twelfth century, are filled with dense glosses and multiple trees. It is quite plausible that someone like James of Venice or other westerners encountered some trees in Greek manuscripts.

If indeed the production of HTs in the West owed a debt to Byzantine arboreal visualizing habits, the mechanism of influence would become an intriguing nexus of a cross-cultural history of visualization because if so, then strangely, only *diaereses* inspired Latin scribes. Byzantine marginal scholia contain not only trees but also, and sometimes many more, syllogistic diagrams, in which syllogisms of different types are represented by three or more points connected by arches or straight lines, resulting in boatlike or triangular figures.[28] Yet despite their centuries-long popularity in Byzantine manuscripts, I have not found a single such syllogistic diagram in the dozens of medieval Latin *Organon* manuscripts I have surveyed. The Byzantine habit itself continued well into the early modern period in its ancient, vertical form.[29] We do find them in a later phase of the Greek-Latin interaction: they are used by early modern scribes known to be working with Greek manuscripts and in sixteenth-century prints of Greek-Latin bilingual editions which accurately reproduced all Greek paratextual elements.[30] As far as I know, this system was never adopted in the West. This issue, as well as the possible Arabic inspiration, remains a subject for further studies.

1.2 FORM: A LINGUISTIC PERSPECTIVE

To understand the essence of the type of diagram that is the central object of our inquiry, we should consider the ever-intriguing triangle of thought, speech, and script. "All models of speech production agree on the assump-

tion that during the course of generating an utterance, the speaker runs through three major stages: conceptualization, formulation, and articulation."[31] During this complex process of representing ideas in verbal phrases, speakers are forced to linearize the concepts or information they wish to express, as the physiological articulation of speech limits what can be pronounced at any single moment. As the continuum of sounds and pauses unfolds, speech becomes linear, like time. Obviously, this does not mean that all our thoughts or conceptual structures are linear—far from it. But if we want to convey them through words, we must weave them into one thread. This is what Levelt defined as "the speaker's linearization problem": since speaking does not enable "simultaneous expression of multiple propositions, a linear order has to be determined over any knowledge structure to be formulated."[32] During the stages of formulation and articulation, concepts and their verbal equivalents are selected and organized sequentially, filling certain slots according to their semantic relations and formal rules of syntax. The lexical concept bears syntactic features according to these slots. Since Ferdinand de Saussure, the resulting utterances of this process have generally been analyzed by linguists through two central axes, often called the paradigmatic axis and the syntagmatic axis, shown clearly in figure 1.8.

PARADIGMATIC AXIS					
The	dog	sat	in	the	car
A	man	lay	on	a	carpet
My	cat	slept	on	the	sofa

SYNTAGMATIC AXIS

1.8 Paradigmatic and syntagmatic axes

The syntagmatic axis stands for the relations between lexical units that occur together in a linear sequence and aligns with the horizontal line of standard Western writing systems. The paradigmatic axis, on the other hand, is according to one definition "an analytical dimension spatialized as a vertical plane representing a set of alternative signifiers which would be syntagmatically legitimate in a given structural context." Paradigms are defined in terms of their syntagmatic positions and the common nature of the items that can accommodate each of these positions. Hence, they are defined as "a set of linguistic or other units that can be substituted for each other in the same position within a sequence or structure."[33]

Substitution plays a critical role in maintaining the infinite potential of linguistic creativity. Take the simple phrase "I read a book." We can generate infinite sentences by replacing only the occupant in the "I" position with a proper name or an expression:

You read a book
Dave and Sean read a book
All the women in the coffee shop read a book

Similarly, "read" may be replaced by "write"; "book," by "journal" or "the note my girlfriend left me on the desk" or anything else from the virtual set of paradigmatic items. Knowing one sentence, you may now generate an infinite number of sentences. This principle allows us also to save words and energy with another ingenious trick: coordination. Let us suppose that "Dave" did not do one but multiple things today, and we wish to convey that in speech. We may generate this group of simple phrases:

Today Dave woke up
Today Dave brushed his teeth
Today Dave had lunch
Today Dave drank orange juice

But why repeat "Today" and "Dave," as these have not changed and convey no novel information? *Coordination*, one of the most basic and universal of all syntactic constructions, allows us to compact all this into: "Today Dave woke up, brushed his teeth, had lunch, and drank orange juice." Extending the relevant position in one core sentence enables it to include more than just one item of that virtual storehouse of suitable items imagined on the vertical axis, juxtaposed and combined by "and," "or," or another adjunct.

Prose sequencing of coordinative sentences with corresponding triads or couplets was a style favored by several High Medieval authors. It lends a certain musicality and rhythm to their texts and produces a meditative effect on the reader. See, for instance, this excerpt from the historical-prophetic *A Chronicle or History of the Seven Tribulations of the Order of Brothers Minor* by Angelo Clareno (OFM, 1247–1337), presenting a few lines from Christ's second speech to Francis (coordinated structures are marked here by italics):

For the goal of my whole promise and the consummation of my grace and glory is that you be configured and be assimilated to me *visibly, intellectually and effectively*. If you cling to me with *your whole heart, your whole soul, your whole mind and all your strength*, so that all your thinking may be *in me and about me* and all your words may be *from me, for me, and in front of me* . . .[34]

See also this excerpt from Bonaventure (which indeed received HT expression), here in Latin to keep the rhythm:

Ad stimulum autem conscientiae hoc modo debet homo exercere se ipsum, scilicet *ut primo ipsum exasperet, secundo exacuat, tertio dirigat.* Nam *exasperandus est recordatione peccati, exacuendus circumspectione sui, rectificandus consideratione boni.*

Many similar phrases can be found in *De triplici via* (*On the triple way*).

Coordination is a fascinating phenomenon that linguists studying syntax still struggle to understand. One major difficulty is that coordinate structures vary immensely from one another—so much so that one leading scholar has argued that "it has become clear that the degree of success of any theory of language structure largely depends on how successful it is in integrating coordination."[35] We shall not enter into these complexities. For our purposes, suffice it to note that this flexibility enabling one to include multiple items in one position has benefits, costs, and limits. As Goodall notes, the conjuncts are typically symmetrical in many ways: they often belong to like syntactic categories, and if nominal, each has the same case.[36] Coordinate structures can conjoin lexical and phrasal material of any kind and typically exhibit syntactic parallelism in the sense that each conjunct belongs to the same lexical or phrasal category. It saves time and avoids redundancy, thereby allowing one to focus on the significant and novel additional information; it may be, however, costly in terms of cognitive processing and lead to obscurity. Furthermore, in spoken language, the flexibility of this position is limited. Unlike the written list, which can host hundreds of items, too many items in too many positions will produce too heavy a load on speakers and listeners, writers and readers, threatening to tear the thread of the syntagmatic axis and leave them puzzled as to where the sentence began. There are extremely strict limits on the quantity of information one can and will squeeze into one utterance, or even into a regularly written sentence, without challenging listeners' and readers' comprehension and patience.

Most written, textual expressions of language faithfully imitate the linear feature of speech chains. They obey the logic of articulation in time with well-ordered sequences of written signs arranged in a continuous line. Though this line is broken into multiple lines because of the length and spatial constraints of the writing surface, it is meant to be read as one string.

However, the constraint of linearization is partly false. For unlike the narrow, letter-width scrolls in figure 1.21, writing surfaces are usually two dimensional. They therefore allow other means of play within this space, which interact with different stages on the continuum from ideas to linear speech. Visible features may substitute for vocal inflections. Instead of raising my voice, I may represent conceptual qualities such as "**important**" by using a bigger and bolder font or ALL CAPITALS. Cognitive habits of

spatial (rather than temporal) arrangement may now be combined with the writing of words. Kirsh has shown the sophisticated ways people use space as a resource for solving problems, from simplifying choice to playing with spatial dynamics in order to simplify internal computations, such as reordering Scrabble pieces to prompt better recall of candidate words.[37] One may therefore put different concept words on parchment or paper in different places, floating in space as they float in one's mind, without articulating concrete relations in a full, syntactic manner. One may signify unarticulated relations of one item to another with lines or arrows, without specifying the nature of this relation or its direction.

To signify that some concepts constitute a group, one may employ visual features such as arranging their written signs on the surface in a group or encircling them. One may arrange the group members vertically. One may assign a new line for each item or phrase, not because the column is not sufficiently wide or in order to produce an equivalent for a vocal feature such as a pause in breathing, but in order to convey the abstract, conceptual quality of these being separate items which nevertheless share something: a list. And thus, we may produce a list comprising dozens of Dave's activities:

DAVE'S ACTIVITIES TODAY:
Waking up
Brushing teeth
Having lunch
Drinking orange juice
[*and so on . . .*]

Back to speech for a moment, coordination can nest a list within the syntagmatic flow of language. In speech, "listing" or coordinate intonation helps hearers to understand lists and coordinate structures as such.[38] Entering into the orbit of written language, however, many features of speech, such as phrasing, volume, intonation, pace, and bodily gestures, are lost, sometimes with no obvious equivalents to fill their multiple functions. Different writing cultures aiming to record spoken language have addressed these losses to a certain extent. Western medieval scribes slowly developed graphic signs to compensate for some of these lost features of speech by using punctuation marks (e.g., question marks), rubrication, and paragraph marks, as well as other signs that convey structural information, such as the beginning of a new issue. But when examining the interface between spoken and written language, it seems that coordinate structures have no specific graphical expression, except perhaps in the case of the humble Oxford comma. The sentences we read remain entirely horizontal, faithfully following the linear constraint of time dictated by speech. But what if we merge the two forms together and nest a vertical list in a horizontal sentence?

The paradigmatic writing resulting in HTs—the hero that stands at the center of this book—does just that, nesting a vertical list in a horizontal sentence. The resulting figures visualize the horizontal (syntagmatic) axis and realize one or more of the vertical (paradigmatic) axes by combining the basic horizontal flow with a relevant vertical list or lists. To produce this effect, lines were introduced, which create the resemblance to a tree. And so, our example from above would look like the basic HT in figure 1.9.

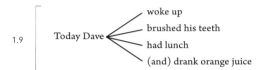

1.9

This diagram can be read either as one coordinate sentence (Today Dave woke up, brushed his teeth, had lunch, and drank orange juice) or as the equivalent of four simple sentences (Today Dave woke up. Today Dave brushed his teeth. . . .). When read separately, the fourth trail (Today Dave and drank orange juice), with the conjunction "and," would be a little strange. But conjunctions frequently appeared in medieval HTs, thus enabling both alternatives. It is easy to read simple diagrams with one split sequentially from left to right, then down the list. In more complex cases, the best way of reading is probably to return to your last point of divergence or convergence and then choose the next trail. By visually isolating the paradigm and the items it accommodates, the common part of these four sentences is reduced to one, and what differs remains so. All the similar phrases are represented as one archetypal sentence, a template, highlighting their grouping and common ground.

This game can become even more fun as it becomes more complex, exceeding the coordination possibilities that regular sequential speech and writing allow. One can enlarge *several* positions, load a greater number of items on one position, split multiple positions, and fuse again into different groups without a cost in processing or loss of clarity. Writing bears more than oral memory can. In regular speech and its written equivalent, both listeners and readers might need to return and reconstruct omitted elements (ellipses), retaining them in short-term memory even after many words have elapsed ("Hmmm . . . , when did she say that Dave did all this?"). But written in HT form, the missing element is not missing at all. It is still there to see, and it occupies its correct place for such a reading, without being buried somewhere four lines above. The full explication always remains accessible.

Every coordinate structure, whether one sentence or several that position multiple items in one paradigmatic position, can be converted into an

HT. For instance, consider these three representations of quotidian technical phrases marking the end of one book and the beginning of another:

1. Two full sentences:
 Here ends the first book of the Posterior Analytics. Here begins the second book of the Posterior Analytics.
2. One coordinate sentence, omitting in the second instance the implied "Here," "book," and "of the *Posterior Analytics*":
 Here ends the first book of the Posterior Analytics and begins the second.
3. HT diagram (figure 1.10):

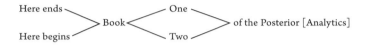

1.10 Uppsala, Bibl. Regal. Univ. C. 599, fol. 177v, translation

Paradigms are often clear, but since they rely upon the somewhat illusive flexibility of coordination and substitution, they can be quite flexible as well. Take, for example, a case of an HT in canon law dealing with the ordination of serfs to the priesthood. The root is "*servus ordinatus*" (a serf who was ordained), and it branches to the complementary "without his master's knowing," "with his master's knowing," "as presbyter," and "as deacon." The first two cases belong to the same paradigm, related to the awareness of his master; the other two belong to another—the specific ecclesiastical function. But they all branch from and complete the same root and thus are placed one below the other.[39]

While coordination constantly occurs in speech, some kinds of phrases seem to have lent themselves more easily to such a representation in scholastic culture than others. First, there are sentences in which the paradigm of a division or a list is explicated within the original sentence, or includes explicit enumeration, such as "Fruits divide into three kinds: sour, sweet, and juicy," or "this happens in two ways...." The split then signals distribution of the group into its members, a sort of relation that in spoken language is signaled by a meaningful pause, specific intonation, or both, and which today, as I have just done, is signified in writing by a colon, which was not known in the West in this period. The sentence "Desire is twofold: the one is a natural desire without cognition and the other is a voluntary desire which follows cognition," will be diagrammed as seen in figure 1.11.

Since such diagrams display different options to continue, end, or begin a sentence, they are particularly fit to represent information about diverse

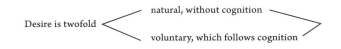

1.11 Paris, BnF Lat. 6459, fol. 2v, translation

possibilities or situations with coordinate structures like "either . . . or . . ." —all the more so when there are several such structures or subdivisions, such as

A divides into A1, A2, and A3, and A1 divides into B1 and B2. . . .

One may also represent multiple options recursively in a way that speech just cannot do, as in this unlikely sentence, which is almost impossible to comprehend:

Every A is either B which is either D which is either L or M or E or C which is either F or G.

To render this comprehensible in regular "speaking" writing, we would need to produce several sentences, repeat terms, and remember where we left off in order to return there in our mind: "Every A is either B or C. If it is *B*, it is either D or E. If it is *D*, it is either L or M. But if A is C, it is either F or G."

As this technique merges that which is common and highlights and distinguishes that which differs, the diagrams that result easily demonstrate hierarchy and classification, from the most general and common to the individual species, creating a classic tree of "every A is either . . ." or "and if this is the case, then. . . ." Such diagrams may function also as algorithms or procedural flowcharts, instructing what should be done in each case of combined conditions. As in the multiple "either/or" conjuncts, the larger the quantity of data, the more difficult it is for the spoken or written sequence to be properly processed. Diagramming becomes more advantageous, not only in the efficient presentation of the entirety of the data, but by facilitating navigation within the data and, more importantly, allowing the reader to ignore some parts in order to quickly retrieve the item required.

Brevity and reduction may lead to confusion and ambiguity. Can each item in one paradigmatic list be combined with each one in the other, or only with its own match?

1.12 Combinations

In figure 1.12, for instance, we have avoided having to write "loves" three times. But we pay with ambiguity. Is this scheme equivalent only to

"A1 loves B1";
"A2 loves B2"; and
"A3 loves B3"?

Or are we allowed to follow the lines freely to generate cross-combinations such as "A1 loves B2" as well?

Both options for reading such diagrams existed in the Middle Ages. Authors of diagrams in the field of letter writing, like the ones analyzed in section 4.2, used this graphical potential to present free combinations, expecting their users to generate sentences by whatever trail they chose, in a "mix-and-match" fashion. The HT in figure 1.13, for instance, can be read not only as "*Non ignorat vestra dominatio*" (Your Highness shall not ignore) but also as "*sicut bene scit tua discretio*" (As your discretion knows well).

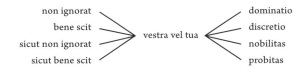

1.13 Paris, BnF Lat. 8653, fol. 4v, transcription

The ability to split and converge enables pointing at different classifications on the same diagram, a plasticity that a classical tree, which only splits and never converges, cannot offer. Thus, for instance, the diagram translated in figure 1.14 divides logical propositions in three different ways and allows a similar combinatory operation.

1.14 BAV Borgh. 133, fol. 15v, translation

This form, however, loses the "algorithmic" function. If one would like to determine for each resulting proposition whether and how it can be converted (switching A and B), this form would not do. One would need to make a tree that only splits, where each combination ends in a terminal node with a clear, specific answer (for exactly such a tree, see Saint-Omer,

THE FORM

BM 620, fol. 2v). In other cases, however, items should be matched with corresponding partners. In rhyming verse, for instance, which is treated in section 4.1, the eye must return after the convergence to the same height it started with in order to complete the phrase, as seen in figure 1.15.

1.15 Munich, Bayerische Staatsbibliothek clm 4660, fol. 77r, transcription

In spoken and linearly written coordinate structures, one may use "respectively" to clarify this sort of ambiguity, as in the sentence "Tamar and Ayala were *respectively* twenty-five and thirty years old." The visual equivalent for such a deployment of "respectively" in paradigmatic writing is to position such items at the same height, disposing the eye to read 1 with 1 and 2 with 2. Such "respect" is also nicely shown in diagrams that highlight corresponding lists within one phrase, such as the one in figure 1.16, reproducing an HT from a preachers' manual.

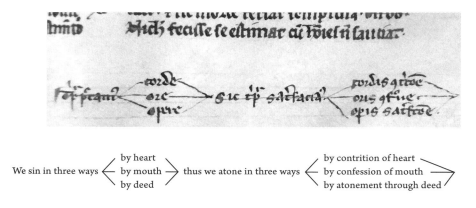

1.16 Oxford, Bodl. Laud. Misc. 511, fol. 24r, detail: items at the same height "respect" each other

Experimenting with paradigmatic writing with my students, I have noticed that the most difficult characteristics to adapt were horizontality and discursiveness, that is, use of prepositions and partially syntactical phrases. In fact, even toward the end of the course, a few students still submitted assignments designed as vertical trees with lines connecting nominal nodes instead of horizontal trees with nodes beginning with "in order that" and the like. These two difficulties are intertwined. As noted above, two-

dimensional writing surfaces allow us to relate concept words or phrases to one another in two basic manners: through syntax and/or through lines connecting undeclined content words. One may write that "A divides into three . . ." or draw three lines proceeding from A. One may write explicitly "and thus it makes C" or delegate the semantic load of result expressed in a phrase like "and thus it makes" to a simple line linking to C. HTs employ the two interchangeably and frequently combine elements of both. Since

1.17 (top) BAV Borgh. 133, fol. 17v, translation

1.18 (bottom) Assisi, BC 327, fol. 183r (identical with Florence, Plut. 11 sin. 3, fol. 197r), translation

the lines have no fixed, specific meaning, verbs and prepositions lend each line its specific meaning. Figures 1.17 and 1.18 exemplify this range. Both were drawn in the margins of Aristotle's *Prior Analytics* and represent the different combinations of premises in the first figure of syllogisms presented by Aristotle. I shall discuss the specific content in chapter 2. For the present, one should note that while both represent the same information, they differ in the degree of discursiveness, that is, in their proximity to either the conceptual or the fully articulated state of thinking. The more succinct one, for instance, is satisfied with "useful" or "useless" at the last node, while the other features "and then the combination is useful" or "and these are useful."

Whether the vertical or the horizontal branching has any cognitive advantage over the other, thus making one a more natural choice, or whether one is more codicologically fit than the other remains to be determined. Centuries of Western and Byzantine glossing prove that both served well the needs of scholars and scribes. Horizontality is not easier, more convenient, or better remembered. Verticality emphasizes the split, the separation of the main node from its branches. Horizontality emphasizes their continuity. It aligns better with the flow of the regular eye movement of reading. Finally, the horizontal is the only direction possible to demonstrate paradigms *within* words, as in the case of merging the common endings of rhyming verses, a practice seen already in late twelfth-century manuscripts (see section 4.1). It is also the most sensible way to exemplify the structure of language itself, that is, of phrases, as shown in the *ars dictaminis* diagrams (section 4.2). When we understand the diagram as a result of the paradigmatic technique, horizontality appears as the more natural choice: a normal text written horizontally, connected in the same reading direction to a vertical list of alternative paradigmatic items.

1.3 FORM: A COGNITIVE PERSPECTIVE

Diagrams in general have multiple cognitive functions, discussed at length by cognitive scholars, though most discussions concentrate on "real" diagrams, such as mechanical, rather than conceptual. What are the principal cognitive functions which the specific form of HT diagrams facilitates? We have seen above the offloading of the computational load of "reconceptualization" of natural language by identifying commonalities and coordinate structures, and therefore its potential for facilitating reading. The question of function will accompany us in the next chapters as well, when we follow the actual uses of readers and authors in different fields more closely. Here, let us present few of the basic potential functions of the form, regardless of specific historical and intellectual actualizations, but while listening to the scattered reflections of contemporaries.

Clarification through External Analysis

The basic functions of drawing and reading an HT stem directly from the specific properties described above. While linear speech works very well for communicating certain forms of information that are linear in nature, such as narration of what occurred on the previous day, it performs poorly when used to describe complex, nonlinear or multilinear objects and structures. Using space allows us a more direct approach to the conceptual realm in such cases where language obscures more than it elucidates.

What does it mean "to elucidate" and "to clarify"? The rich metaphor of seeing as understanding is as rooted in contemporary minds as it was in the Middle Ages. We "clarify," "illuminate," "shed light," and when we suddenly understand something, we "see" it. Building on this metaphor, clarity of sight is in fact the ability to distinguish items from each other. Blurred, pixelated pictures are obscure because the items of their content merge with each other. Anyone who wears glasses knows that everything is clearly seen when particulars are distinct. When we hear or read a string of words, in a certain manner we reverse engineer the process of its generation. We decipher by de-linearizing the continuum of signs into the not-necessarily-linear meaning it conveys, untying grammatical characteristics.

The most important term to borrow from cognitive discourse, in order to understand the advantage of paradigmatic writing, is "externalization," which connotes the transferring of information from the brain to something external. In the first place, externalization operates in a twofold manner: it takes on the load of short-term and long-term memory; and it encourages selective attention by separating information and specific operations from the chaos in our minds. The most common use of externalization is for storage of information. The page remembers, and we may forget, just as in Plato's Egyptian myth retold in the introduction. We may consult the page when we need to retrieve this or that item. Since memory is required for almost all cognitive processes, this facilitates advanced processes while interacting with the page, such as calculating a long series of big numbers. In reading, punctuation marks and other marks improve our ability to reconstruct the proper relations between concepts, as written language lacks the intonation and pacing that signal these relations in oral speech. The capitalization of nouns in German, for instance, speeds the process of reading comprehension, because it relieves the mind of the burden of identifying words as nouns, freeing it for other tasks.[40]

Paradigmatic writing similarly communicates coordinate structures, lists, and paradigms. Instead of separating the relevant parts and groups in one's mind while reading, analysis is done on visible, external entities, written signs on the page. Beyond freeing processing power, one may externalize through drawing an HT classic processing operations such as distinction,

separation, acknowledgment of similarity and difference, grouping, categorization, classification, correspondence of groups of items, and other forms of organization patterns. As with a child who puts all blue objects in a bucket, it is easier to divide conceptual items into groups and label these groups when we see clearly the items on the page outside ourselves rather than only mentally. And there is the bucket itself, of course: the lines connect the pieces together so that the unit of information presented this way is tied up and packed, singled out from the sea of words around it, and ready to travel elsewhere if needed.

Richard of Fishacre (d. 1248) was among the first Dominican friars to comment upon the *Sentences*. Most manuscripts of his commentary contain rich, highly ramified HTs of *divisiones textus*. Richard introduces the first tree, a *divisio* of the part he calls the *proemium*, with the words "We have drawn the division of this part so that each unit would present itself to the eyes more easily, in the manner of a ramified tree" (*Huius autem partis divisionem, ut oculis facilius occurrant singula, in modum ramosae arboris depingimus*).[41] Richard thus stresses this crucial point: processing information presented verbally must involve identifying units and recognizing the relations between them. We do it all the time mentally when we read chains of words, inserting spaces between them so that we don't need to separate them mentally as a reading operation. Paradigmatic writing externalizes the inner process of identifying paradigmatic units for the reader, just like peeling an apple and slicing it into manageable pieces instead of eating it as is. When drawing an HT the reader cuts and organizes the pieces for himself, or for the next reader or user of the text. The layout cuts and organizes the pieces for the reader's mind, allowing a faster and easier process. By doing this, it also conveys something of the structure that this conceptual network had prior to its linearization in language. The most significant function of such a visualization is, therefore, to separate relevant things spatially and dissect the indistinct thread of sentences, the bulk of ideas, into visible, separate units while at the same time stressing their relations.

The creation of an HT, therefore, not only the use of an existing one, yields benefits. This may account for a strange phenomenon in London, BL Egerton 633, a fantastically rich copy of the *Sentences* with numerous HTs, among them pairs of identical twins, facing each other. The twins in book 4, distinction 16, may be explained as an attempt at improvement: in one, the author forgot to insert a branch, added a dot in the place it should have been inserted and connected it to the missing branch. The diagram on the facing page is correct. But more puzzling are the HTs in folios 270v–271r. These diagrams of a division of the virtues are not draft and copy: they are identical ink twins, to the point of having the same *signe-de-renvoie*. So are those on folio 359v. The most plausible explanation for this is that the actual fashioning of the diagram was important for the second read-

er, just as some of us insist on recording our own notes on a lecture. There is no point in using a highlighted book. The *act* of highlighting the lines is what matters.

Grouping, Labeling, Classification, Abstraction

The basic form of the HT merges that which is common and separates what differs. It may divide a general subject into its species and individuals. But an HT may also be generated "backward"—that is, working from the terminal nodes to the root—by considering the common ground of several items in a list, labeling them, and thus sharpening to perfection the basic cognitive operation of classification. HTs work both ways, from the particular item to the general group and back. Labeling or tagging "creates a new realm of perceptible objects upon which to target basic capacities of statistical and associative learning." It enables second-order insights and the investigation of complex properties and relations.[42] The interesting cognitive process externalized here happens not so much in the list but rather in the gradual weaving of inner groupings of items in the inner nodes. Medieval scholars invested extraordinary intellectual energy in just such structures and groupings. The specific spatial arrangement of the split sentences in the HT controls and manipulates the passive readers' awareness of the common and the distinctive. For the active producer, spelling out the basis for grouping items promotes generalizations that, merely implicit, might have gone unrecognized. Lists give rise to categories, and as categories are articulated, they encourage adding new items. Separation greatly enhances the ability to move items around mentally, to play with their order, and to experiment with diverse constellations that generate labels for other groups, other categories, and subcategories. We shall see such regroupings and rearrangements in part II in different intellectual fields.

This double cognitive movement is seen even in the designs themselves: some betray a technique in which the nodes, as a list, are written first and then connected, and other designs clearly start from the root and proceed toward the terminal nodes. One or two classifications can easily be held in the mind alone and then executed on paper. But for a handsome, precisely organized diagram with several levels, one should count or estimate *beforehand* the maximum number of nodes and splits needed, set them out so that they divide well (usually, though not always, authors sought to align the root with the middle of the list of the next stage), and calculate the length of each node. Figure 1.19, Oxford, Balliol College 62, folio 193r, a tree classifying heresies, shows the difficulties of planning the space, as well as the resulting flexibility of the lines curving forward and backward, in order to squeeze it all in.

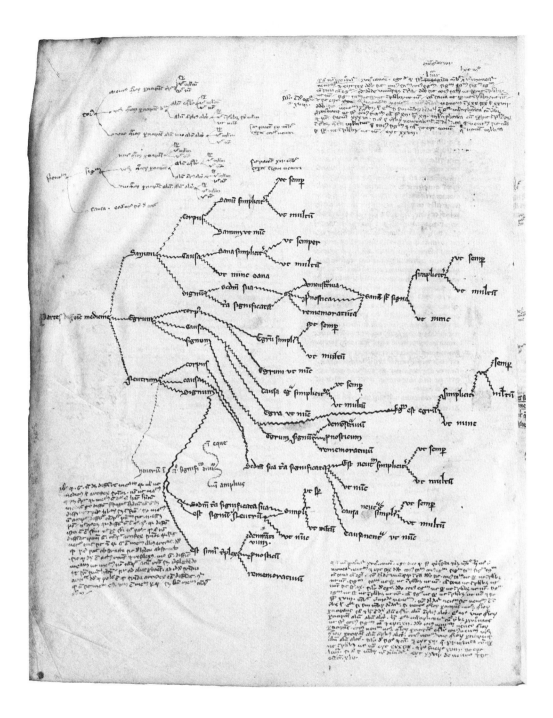

Figure 1.20 is another example of what happens when the scribe inaccurately estimates the space he needs to assign between items. It works well up to the third level. The first branch divides nicely, but the lower branches are forced to bend lower and lower. More than revealing flawed scribal technique, figure 1.20 demonstrates the power of externalization for complex

1.19 (facing) Oxford, Balliol College 62, fol. 193r. Courtesy of the Master and Fellows of Balliol College, Oxford.
1.20 (above) Paris, BnF Lat. 16174, fol. 116v

THE FORM

abstraction, hinting that structuring was enabled by, and at the same time reflected in, the technique. Clearly (and understandably!), the author did not have the entire structure in his head or his "mind's eye" prior to beginning his drawing. Rather, it emerged during the process of drawing.

Brevity and Concision

Richard de Mores (Ricardus Anglicus, 1161–1242) studied law in Bologna or Paris during the 1180s and taught at Bologna in the last decade of the twelfth century. From 1202 until his death in 1242, he served in different capacities as an expert in legal affairs. Inspired by fellow theologians and the Paris schools, he compiled a thread of *distinctiones* summarizing Gratian's *Decretum* by way of HTs (on which see section 3.3). Richard's aim, he discloses in his prologue, is to present the material briefly (*sub brevitate*) because of his colleagues' demands, combining the social and cognitive aspects of rapid learning. The diligent reader, he promises, will be able to locate fine distinctions therein, as well as succinctly summarized novel insights that are usually discussed by the doctors at great length (*sub nimia prolixitate*). In a most revealing anticipatory response to anyone who might blame him for the insufficiency of the work, he praises the way in which the genre helps one to eradicate superfluities, separate the wheat from the chaff, and include "the marrow of truth alone, whose friend is simplicity" (*sola veritatis medulla cuius est amica simplicitas contineret*).[43] Richard, who had already written several aid-books, credits the diagrammatic form with the triple benefits of brevity, simplicity, and ease of understanding.

The historical development of HT diagramming was in this respect the graphic expression of the urgent search for "working tools that would condense the essence of what they [i.e., schoolmen] should know in a given domain"[44] in the face of what they conceived of as a flood of information. This arc began with guides for selective, careful reading, such as Hugh of Saint-Victor's *Didascalicon*; proceeded with books-of-books and informed compilations, like *Sentences* of diverse kinds, Gratian's *Decretum*, and various florilegia; then continued with the making of abridged versions of these and other scholarly works. These made large bodies of knowledge smaller, at least in physical size. The HT form brought this desire for condensing the essence to the cognitive, prearticulated microlevel of selected units of ideas.

While HTs may contain long phrases in each node, they encourage brevity and help to maintain a concise, clear presentation. First and foremost, their basic linguistic-graphical mechanism reduces superfluous repetitions. Second, their ability (characteristic of diagrams in general) to load lines with relational meaning such as "divides into three" or "there are two kinds of" reduces verbosity. Finally, a feature I have noticed while training

myself in HT writing is that my prose became significantly clearer and more economical, because assigning a distinct branch to an item encouraged me to consider seriously whether the issue deserved such an operation at all. Whenever I wanted to employ several adjectives, nouns, or adverbs, for instance, and drew the resulting coordinate structure as an HT, I stopped and asked myself whether they are indeed so distinct from each other or whether perhaps one would suffice. To distinguish also means to sift out those pieces of matter that are not sufficiently distinguishable.

Simultaneity and Gradual Unfolding

Brevity eliminates verbal embellishments in order to concentrate content. Since units are reduced, more can be gathered together and thus be seen simultaneously. Decades after the two Richards, Thomas Le Myésier, Raymond Lull's avid student, whom we briefly met earlier, provided in his *Breviculum* (or *Electorium parvum*) a glimpse into his use of HTs and their desired effect and stressed this advantage. Explicit remarks from contemporary authors are exceedingly scant. People practiced paradigmatic writing but hardly spoke about it.[45] Yet Thomas attributed great importance to the visual aids he employed in his work, and he took care to explain in rare detail why he ordered them to be fashioned in the way he did. The main function I wish to discuss through his detailed explanations is that of simultaneity, but since this account is so rich, we shall also delve into some other aspects he discloses, such as his use of pictorial and HT means for different purposes, or functions such as aesthetic and intellectual pleasure.

On his first miniature picture, for instance, he reflects:

The reason I had the following picture made is double: my first intention was so that the origin of Raymond's art and his other arts and books would be known; the other is for pleasure, because looking at such [pictures] many times arouses the soul to do well and to do good things.[46]

The creation of the figures, he reveals on another miniature, was a matter of revelation. In a note in the upper margins of a miniature depicting Thomas sitting at the feet of Raymond, Thomas prays and thanks God, "who wanted to show me today the principles . . . and taught me to create from them two figures." This confessional mode is inseparable from Thomas's special interest in mental processes, an avid preoccupation that reveals itself in his narration of Raymond's experiences in the biographical section, as well as in multiple notes, discussions, and figures with which he treats the subject in the text and by which he hopes to train the reader's mind and intellect toward the Lullian art.

Thomas employs three types of figures: pictorial miniatures; a circular figure ("The first figure"); and dozens of complex HTs that constitute the body of the work. The miniatures, like the one in figure 1.21, tell a story. The texts in the scrolls represent live dialogues, while name labels designate the characters. But the small HTs in the miniatures represent a type of information that is not narrative or aural but essentially visual and structural. Miniature XI is exemplary in this regard. Thomas and Raymond converse. Their words are conveyed to us through scrolls and regular writing. At a certain point, however, Thomas says to Raymond: "Our contemporaries [*moderni*] are fond of brevity. I want to ease learning and the tiredness of the eyes, especially regarding the confusion of the significations of the alphabet of the demonstrative art." Raymond does not reply to Thomas's wish in words. Rather, he refers him to HTs that clarify the matter. These are depicted outside the frame of the conversation, signaling that they do not form part of the oral/aural dialogue but are genuinely visual: the technique-*ars* itself. That seems to be the case also in figure VII, where small HT diagrams appear on the flags of Raymond and his soldiers.

The first HT appearing in the *Breviculum* is located in a pictorial, allegorical miniature. On the left are nine philosophers, each representing a fundamental question (e.g., What? How? About what?). These are connected by converging lines to the verbs *sit* or *est* (is), then split again into a ladder whose different steps signify subjects like "God" or "angel." Except for the pictorial images of the philosophers and the ladder, it is a generative HT, representing all possible combinations, such as "What is God?" or "How is the angel?"—a machine for generating questions similar to the machines Lull invented but, being closer to the *ars dictaminis* diagrams in Thomas's times, closer to the habits of Thomas's readers. While he explains the pictorial, allegorical elements, he sees no need to explain the self-evident HTs.

The second employment of the paradigmatic technique occurs in the right ladder. Time and again, Thomas declares that his main object is facilitating the learning of Raymond's art for the readers. This technique, he confesses, is extremely difficult for people without proper preparation, being new, strange, and unlike any ancient method (*nova, extranea, ignota, mirabilis*). Particularly strange and difficult, Thomas notes, is that the same letters signify different things.[47] Indeed, medieval schoolmen were used to the employment of letters in geometry and even theology, but only as labels for specific lines, points, or excerpts. They were less familiar with the idea that the same letter could stand for several things depending on the context, a principle upon which Raymond's system is built. The HT demonstrates this principle in the most simple and familiar way Thomas knows. Each letter, the diagram shows, stands for two things, at least in this picture: either a certain attribute of God like goodness and greatness (upper nodes) or a logical relation such as difference and concordance (bottom nodes).

1.21 (facing) Karlesruhe, Badische Landesbibliothek, Cod. St. Peter Perg. 92, fol. 11v

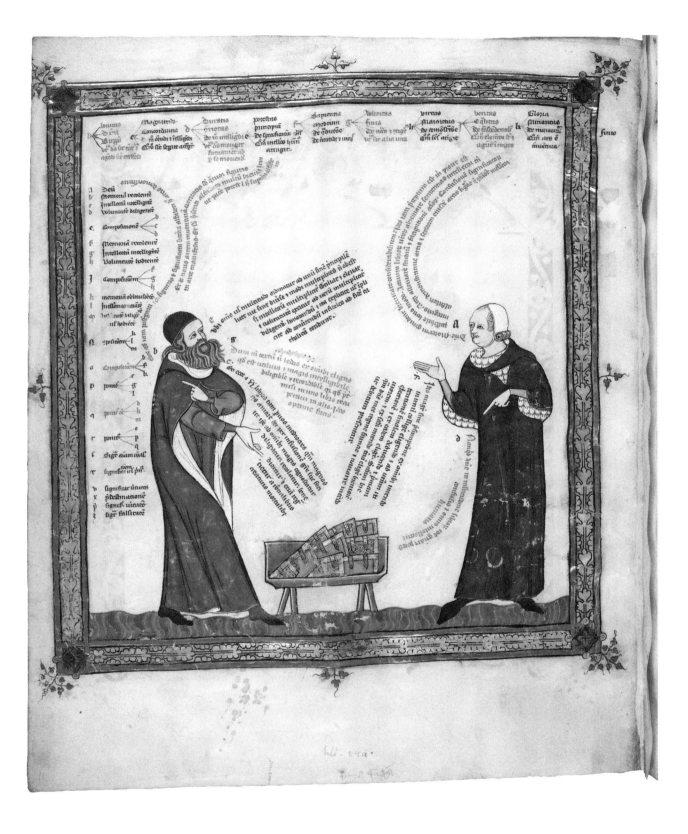

Thomas's primary tools for preparing the reader's intellect for the Lullian technique are the figures and the verbal explanations he appends to them. Figures are not real objects, Thomas continues. Although they are seen on the page, they are the equivalents of the forms in our imaginative faculty, those that exist even when the real object is absent. Their effect on the imagination is due to this similarity. This equivalence between external and internal images is remarkable in its clarity and significance. Furthermore, their unreality and "imageness" enable one to transcend the senses. The mind is able to look at a circular, two-dimensional figure and imagine the larger sphere of earth and firmaments, and thus to touch with the imagination those stars that man cannot truly touch: "although sight cannot penetrate the stellar sky, nevertheless by the power of imagination elevated above the senses it can reach high and above the stellar sky to an even bigger one."

While pictorial miniatures served the introductory, semiautobiographical section, as we move into the first preparatory section of the body of the book, abstraction takes the lead by way of a circular diagram followed by multiple HTs. Thomas describes the first circular golden figure thus:

This figure is . . . like a primary alphabet and a visible instrument. . . . For I have made this visible figure so that it will appear, so that the inception to the doctrine will be easier for those who do not know the other and profound sciences, and so that it will be the first one object of being.[48]

Like an alphabet, this visible instrument does not carry meaning but is intended to carry infinite yet implicit potential for all that is about to come. All diagrams after this first one are multilevel, well-fashioned HTs. Do they operate in the same way as the first, "alphabetical" one does? Thomas compares the two types. The second figure, which is the first of the HT kind, emerges from the first, explicating its implicit facets. The proceeding diagrams similarly open and unfold further explications.[49] To clarify what he means by this process of further explication, Thomas offers a telling cognitive similitude, familiar from medieval epistemological theory. Suppose we see something approaching us from afar. We recognize it as a substance. When it comes a little closer, we refine our assessment and see that it is an animal. When it comes even closer, we identify it as a human being, then recognize the face of the individual man Socrates. The power of this description lies in that it demonstrates an equivalence between the hierarchies we use in logic and perception. Socrates is a man, men belong to the category of animals, and animals to the category of substances. This hierarchy unfolds in reverse to our mind's perception. Thomas guides the reader as the eye approaches the second diagram: what was implied and confused in the first is now seen as apparent and clear ("*Sic enim appropinquante oculo ad hanc figuram apparet manifeste, quod in prima erat implicata, et quod in ea erat et quasi quoddam*

confusum"). The HTs are the means by which the first figure shows, directs, and leads its own parts, expanding to reveal the most interior parts of being and leading the intellect from the general to the particular.[50] Thus, while the first diagram helped Thomas put everything in a nutshell, Thomas realizes that the true nature of teaching the doctrine lies in explication, and he finds that the better way to do it is not discursive but by means of HTs that imitate this process of explicating in their ramifying form. The function of *solatium*—solace or even pleasure—is mentioned mainly regarding pictorial miniatures and rarely regarding the HTs.[51] All figures, however, aim to affect the soul, the memory, and the intellect.

"The reason I have had these visible figures," Thomas explains,

lies in that they are seen openly *at once*. Through seeing them, many things are called to the memory *at the same time and at one time*. The figure is caught in the imagination, then led to the memory and to the intellect and even further to the will. The soul that looks at the figure thus acquires knowledge and delights in it.[52]

Statim, simul, semel: that is, unlike any oral speech or writing that imitates oral speech. The simultaneity of vision is what tempts him. Clearly, Thomas realizes that no one can actually read simultaneously all there is in the figure. He knows that people are used to reading HTs from left to right and downward, an awareness he discloses in the only instance in which he instructs the reader to study a figure proceeding from the bottom up, in opposition to the normal process.[53] Nevertheless, the form that is created is one object and one meaningful unit that can be perceived as such, even if one needs time to read it through.[54] Finally, Thomas argues that the spacing of the figure's members is useful also because it enables one to check easily whether a certain statement is true or false. Modularity enables quick judgment, for if the statement at stake contradicts even one of the members, it is already proven false.[55] These two functions complete each other.

Memorization

"Through seeing figures many things are called to the memory at the same time and at one time." One slightly undesired effect of the long-standing interest in memory in medieval studies is that every visual means in pedagogical contexts is immediately suspect and judged as an essentially mnemonic device. Another is that few attempt to define and distinguish between the specific ways in which different visual layouts facilitate memorization. First, therefore, let us state the obvious: diagrams, graphs, and tables are not necessarily mnemonic. They populate modern journals of chemistry, economics, meteorology, and education, with no intention on the part of

authors or readers to commit the information they present to memory. They represent information by visually conveying conceptual features such as correspondence and opposition, whereas running script conveys visually only the flow of speech it stands for and leaves the brain to do all the analysis. All this may or may not have to do with the wish to commit the content to memory. In the medieval world as well, visual layouts had multiple functions that had nothing to do with memorization, such as providing demonstrative force and guiding meditations. And finally, as Carruthers pointed out once and again, memory in the medieval sense referred to much more than memorization performed to internalize information to the point one could retrieve it without consulting an external object. Notably, memory also meant the collective memory of the community: writing documents or stories for others to remember.

As noted above, explicit comments on the practice of HT diagramming are rare, but what we have lends little support to the mnemonic hypothesis. Richard of Fishacre insists on presenting his *divisiones* to readers' external eyes, saying nothing about a mental eye or about any desire to internalize these figures and their content. Richard de Mores sings the praises of brevity, simplicity, and truth. Thomas Le Myésier speaks of memory in its intermediary position between imagination and the intellect, memory taken here in its general sense of mental categorization and understanding. He desperately wants people to understand Lull's difficult ideas, but he says nothing of memorizing his figures in the strict sense, that is, being able to retrieve them from the mind alone without the aid of anything external.

Parallel cases of diagrams and mnemonic verses sharpen this impression. BAV Vat. Lat. 22, for instance, a beautiful, richly executed Bible, opens with a description of the structure of the biblical corpus, employing multiple HTs to represent the different groups into which the books of the Bible divide (fols. 2v–3r). After an HT showing the structure of the Pauline Epistles, the author suggests a method to remember their names and order through a verse composed of the first letters of each ("Nominum et ordinem autem epistolarum Pauli habere possumus per hunc versum: *Ro.Cor.Bis.Gal.*" etc.). Clearly, he or she did not think the diagram would serve a similar aim. The case of useful syllogisms presents a similar parallel in which it seems that the verse, the notorious "*Barbara Celarent*," is a much more efficient mnemonic than the set of HTs. At the same time, the diagrams are useless for any other purpose save that of clearly demonstrating the matter, which they perform beautifully. Finally, as the next chapters will demonstrate in detail, paradigmatic writing was employed in contexts with no relation to memorization, such as tax registrations and memorial plaques.

Having said that, HTs could definitely facilitate internalization of information and learning by heart if scholars wished them to, but even here we should consider how precisely. Visual features assist the recording of ideas in

memory in different ways, but not all fit this specific type of diagram. First, HTs do not presuppose a prior visual template, such as a six-winged seraph, a ladder, or a circle. Such templates are easily imprinted on our memory because of their recognizable and informative forms. Since we already know a seraph has six wings, for instance, we know immediately there will be three pairs of concepts and may even recall which item was on the upper set of wings and which on the right. Pictorial, allegorical, or geometrical forms (a square, a circle) stick in our memory as such.

HTs, however, do not have a recognizable, specific, familiar, and therefore memorable form, not even that of a real tree. As we shall see in the next chapter, many authors did not even care to compose them with a neat form. HTs are quite memorable when they are short, with a minimum of splits and convergences and with no more than a few nodes on each.[56] But in more complex ones, the number of nodes and splits, as well as the fluid form, makes it difficult to recall visually whether, say, the seventh branch was split into four or five leaves (I say "recall visually" because one can also remember that there are, for example, seven branches without referring to one's visual mental image).

Visuality facilitates memorization indirectly as well, and here perhaps lies the true strength of the HT. By externalizing and imitating processes of division, categorization, and classification on the page, visual organization improves understanding, and that which is better understood is better impressed on memory. As Carruthers has argued in detail on several occasions, and as cognitive scholars worldwide agree, memory is not only about storage but about a *well-arranged and retrievable* storage place that enables adaptive thought, predictions, abstraction, and so on. If a mnemonic was intended by the authors of these diagrams, therefore, what made them efficient in this regard was probably the singling out of this or that piece of information, the brevity, the hierarchization, the clarification of divisions and units, and the affinity of that structure to conceptual relations. Beyond any improvement of the process of internalizing information in the brain, however, such diagrams improved the organization of the material memory of the page.

The best conclusion regarding the technique's functions and purposes, however, is that there is no one-size-fits-all answer. From the moment a tool is born, different people use it for different ends, guided by its potential, their material context, the habits inculcated by their culture, and, above all, their specific needs. Authors used HTs to clarify matters for readers and to reflect upon their own writings. Readers used them to process, analyze, and summarize what they read. Preachers may have used them to memorize their sermons. Certain scribes employed them for aesthetic reasons. In the next chapters, we shall explore these diverse applications.

{ 2 }

The Habit

On What, Where, Who, When, and How Often

Le plus souvent, le seul indice de l'usage du livre est le livre lui-même. De là, les sévères limites imposées à toute histoire de la lecture. De là, aussi, son impérieuse séduction. ROGER CHARTIER, *PRATIQUES DE LA LECTURE*, 87

In which situations did medieval scribes draw horizontal tree diagrams (HTs)? The only sources we have at our disposal to answer this question are the material traces in the manuscripts in which they appear. Indeed, the only place we find HTs in the period between 1200 and 1500 is in parchment and paper codices. Wax tablets were in regular use throughout the Middle Ages and may well have been used for diagramming, but owing to their ephemeral nature, they did not survive. As diagrams thrive in open space, walls might have served as a natural canvas of sorts as well. A much earlier culture to the east presents intriguing testimony, recording a story of a hermit who drew *pulaga*, Syriac dividing diagrams, on the walls of his cell.[1] A few years

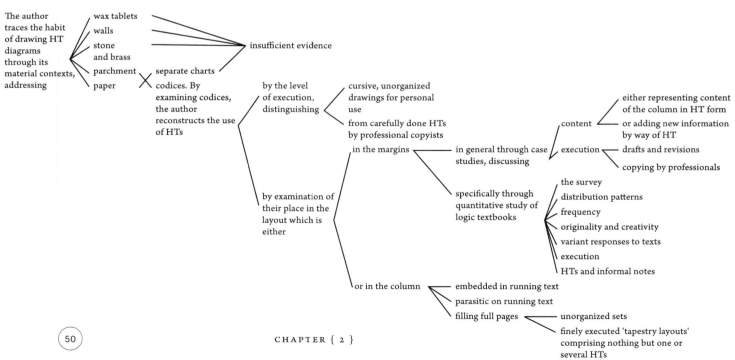

ago in Sweden, scholars identified a Square of Opposition diagram scraped on a side wall of a church dating to the scholastic period.[2] In his extensive survey of graffiti in English parish churches, Matthew Champion discovered inscriptions that feature musical notes, architectural drawings, and crude human heads or animals.[3] As the latter look very similar to the doodles of human heads and animals found on manuscript pages, it is plausible that one day we will find an HT on such walls as well, but in the meantime none has turned up.

Commemorative plaques from later periods show paradigmatic writing applied to marble and stone in nonscholarly contexts, when scripts, designs, and epitaphs migrated from pages to tombstones and vice versa.[4] Not a few plaques from the seventeenth and eighteenth centuries coordinate dates and ages—"anno" (in the year) splitting into "*Domini*" (of the Lord) or "*salutis*" (of salvation) and "*aetatis*" (of his age) (figure 2.1). Others write details relating to the death of a husband and wife paradigmatically (figure 2.2). A complex monument in memory of George Halifax (d. 1695) set in the Lady Chapel at Westminster Abbey bears this English inscription (figure 2.3):

2.1 (above) and 2.2 Epitaph of a memorial plaque, Oxford, All Souls College, translation

2.3 Westminster Abbey, Lady Chapel. Copyright Dean and Chapter of Westminster.

This application represents the trickling of a scholarly and administrative habit of writing and reading into the sphere of public memory and deserves its own study. Yet present documentation of medieval epigraphy does not include such inscriptions from the period 1200–1500 on tombs, incised slabs on walls, or monumental brasses.[5]

The archive is thus limited to parchment and paper, and even further to codices. Fine historiated initials of textbooks depict real or idealized medieval classrooms in miniature form. None of these, or any other contemporary description of the medieval classroom, suggests the existence of boardlike objects to display writing, or any other visual medium.[6] It is equally difficult to determine whether diagrams in logic, medicine, mathematics, or any other discipline were drawn on large sheets and hung on a classroom wall or in a study room on a regular basis, though here again, this may be a matter of material durability and storage conditions contributing to a catastrophically poor survival rate.[7] This absence of visual materials testifies that while books and notebooks were indispensable tools for university classroom methodology, the central form of *interaction* was oral and aural. Diagrams could have had at best a negligible place in formal group classroom teaching, because present evidence suggests that no handy, direct visual medium of transmission was employed.

But codices—first parchment, then paper—survive by the thousands and became increasingly cheap and accessible as the years went by.[8] They are private in nature, especially regarding graphics. Teachers might have drawn an HT in their books and read it aloud by converting it to speech, and students might have converted the oral presentation back into a diagram in the margins of their books or in their notes. But the actual drawing and reading in this case would have remained an intimate thing, either an entirely private matter or occurring during one-on-one teaching or in very small groups in a setting where scholars and students gathered around a page. Let us therefore humbly enter this intimate space between a man and his codex.[9] He sits with his own copy or the college's copy of a textbook open on the table, annotating hastily or carefully; or he may stare at the clean pages of his still-empty quire, waiting to be filled with thoughts incarnated in letters and lines.

The keys to reconstruct reading and diagramming behavior lie in the analyses of execution and layout. These include particularly the relations between columns and margins and codicological and paleographical traits, which I hope will not get too technical. A classic example of such a reconstruction is *Space between Words*. Paul Saenger closely follows the increasingly common practice of inserting a space between words in the early Middle Ages to trace the steady increase in privatization of the act of reading, which was closely associated with the increased use of visual elements and reading aids.[10] There is a very good reason to associate HTs with the intimacy of scholars with their books. The growing demand for and significant changes

in manuscript production, particularly commercial production and standardization, meant that more people could allow themselves to own copies and hold them in front of their eyes during class or in their private libraries. One could also consult intimately with one's own copy or a borrowed one before or after class, in the schoolmaster's room, or in the college's library.

In the pre-print age, distinctions between writing/copying for oneself and for others' use (the latter of which we may refer to as "publishing"), between informal and formal, cursive and bookhand writing, or between notebooks and books were often obscure. One's personal codex, into which one has been copying excerpts of texts that impressed and addressed a need, becomes in the next decade another's "book." Nevertheless, with the development of the professional book trade we are on safer ground at times, and we may very carefully use two features to help us navigate this alien culture: the level of execution, skill, and craft; and the page architecture of column(s) versus margins. As a rule of thumb, which, as most do, has its exceptions, the more orderly, neat, and beautiful the bookhand script and spatial planning are, the more likely the writing was intended for the eyes of others and produced by professional scribes in a scriptorium or a bookshop.

Unorganized personal notes and thinking-with-quill drafts were associated with ephemeral supports such as the wax tablet or the unbound notebook (*caedula*) and therefore remain mostly beyond the historian's reach. This situation, however, gradually changed precisely in the time frame we are analyzing here, allowing us to glimpse these intriguing cognitive contexts and the habits of scholarly society at large, and not only those of professional scribes. Consider, for instance, Paris, BnF Lat. 15652. In the years 1246–47, a student of theology in Paris took notes from all the classes he attended. As parchment was expensive, he covered all the free space available on the diverse-sized folios that constituted his messy notebooks with tiny, dense, cursive script. These miniscule notes in two volumes, as crowded and almost undecipherable as they are, constitute a genuine treasure trove for those wishing to understand the use of writing in these years, and they are the sole source for the teaching of several masters on the *Sentences* and the Bible.[11] In folios 13r–16v, he excerpted and summarized Augustine's *On the Trinity*, chapter by chapter. If you look closely at folio 13r, you will see that the columns of his summaries contain dozens of small HTs. Figure 2.4 shows a relatively larger one on another dense page.

Further into the manuscript, our student employs the technique occasionally: once to present a distinction made in a reply to a scholastic question (fol. 18vb; on distinctions, see section 3.1 below); on another occasion to represent the subdivisions of the theological question at stake (fol. 21ra; on scholastic questions' structure, see section 5.1); and on two other occa-

2.4 Paris, BnF Lat. 15652, fol. 105v, detail

sions when he reports or summarizes lectures upon Peter Lombard's *Sentences* from the mouth of the master Peter the Archbishop (fols. 32r, 37r).

On the other side of this imaginary scale of use and skill, consider the *divisio textus* diagrams in London, BL Add. 10961 in figure 2.5 (on *divisio textus*, see section 5.2). The hand here is identical to the one that produced the running text in the columns above. This scribe carefully ruled the margins for this purpose, planned space accurately, rubricated the first letter of each node and the underlining of the lemmata, and drew elegant, fine, red threads between the nodes. This is the work of a professional.

Level of execution, however, cannot stand alone as a criterion for assessment of personal versus public writing or for the investigation of nu-

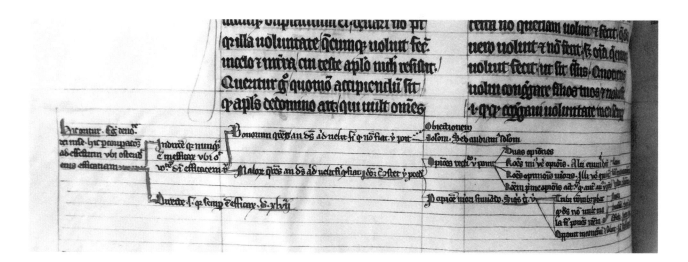

2.5 London, BL Add. 10961, fol. 79v, detail. Courtesy of the British Library Board.

ances of writing behavior. For that, we need to consider page layout as well. Our Parisian student, with his attempt to use every square millimeter of his parchment, is an exception. Most manuscripts had margins, thus providing, since at least the early Middle Ages, an intriguing arena for interaction between the earlier and the later, between the professional scribe and the reader, between the formal and the informal.[12] The central columns hosted a prior (relatively) fixed and shared text. The margins usually contained the posterior, idiosyncratic, personal responses of specific readers.

This rough association of private and public writing with margins and column is not rigid and has its exceptions. Commenting usually started as a personal response to texts, but when it was rich, interesting, and authoritative enough to be copied further, it sometimes crossed over into the formal realm as a whole commentary, either laid out around the original text or as a separate primary work, a paratext that became a text in itself. Glosses and commentaries were copied by professional scribes into the layout as a frame in smaller letters. Scattered marginalia could, as scholars and philologists well know, crawl into the organic text by mistake, and finally, customers could ask to have them copied by the scribe as well. BL Add. 10961 is probably an example of this practice.

The textual modifications made during such transmissions were generally very light touches of phrasing and wording. There does not seem to be any attempt by copyists to keep to a certain visual form. Their only constraint was the length of the text, depending on their free use of abbreviations, letter size, and the width of the page or column, and they played with it freely. Given the advantage of already knowing how the entirety of the divisions and convergences looked, they could plan the space better in advance but did not necessarily strain to do so. All this can be nicely demonstrated in the case of the manuscript tradition of Richard of Fishacre's commentary on

THE HABIT

the *Sentences*. In several manuscripts, text divisions are entirely omitted. At other times, copyists decided to locate them in the margins, and at others, they embedded them into the column.[13] HTs featuring identical contents and divisions do not necessarily share the same general shape, and finally, the wording of the nodes in the HTs slightly differs. While regular texts were copied word by word, the HT seemed to copyists to be a less fixed, articulated, and "sealed" entity. This corresponds well with my argument in chapter 1 about its prearticulated nature.

An intriguing case of a commentary in a somewhat fluid state, in which it was not clear to the copyist whether a diagram was an external or an integral part of the commentary, is that of the postill (commentary) on the Gospel of John attributed to the thirteenth-century Dominican successor of Thomas Aquinas as a master of theology in Paris, William of Alton. The commentary exists in two manuscripts, Assisi, BC 49 and Saint-Omer, BM 260, yet while the texts are closely related, they nevertheless differ in significant details. The Assisi version is more discursive. It includes substantial, unique sections missing in the Saint-Omer version, and some of the text divisions differ conspicuously in essential matters.[14] Nevertheless, "the systematic appearance of virtually identical material in both versions is difficult to explain as the work of two independent reporters, however skilled."[15] Bellamah suggests that the Assisi text is dependent on the Saint-Omer text but confesses to the hypothetical nature of this assumption.

The two versions differ in another salient feature that Bellamah did not take into account: the margins of the Assisi manuscript are often densely populated with HT distinctions, executed with special ruling and care by the same hand that copied the main text in the columns, while the Saint-Omer codex features absolutely none. I do not want to enter the tricky waters of determining the development of this text, since there is insufficient information about its history. I do wish, however, to note that somewhere in the long process of revision and distribution of the work, the same idea made its way into a column of one manuscript as a regular sentence, while in the other it was positioned in the margin as an HT. The Saint-Omer codex has the following in the running columnal text at folios 113v–114r: "*quod credebatur Christus propter vitae sanctitatem, Helias propter vite austeritatem, propheta propter doctrinam*" (For Christ was believed because of the sanctity of his life, Elijah because of the austerity of his life, the prophet because of his teaching). The Assisi version contains no such sentence in the corresponding section. But in the margins, the little HT transcribed in figure 2.6 appears, among others:

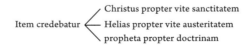

2.6 Assisi, BC 49, fol. 8v, transcription

This inside-outside dynamic between margins and column leads us to the various places people chose to diagram in this dual space. We may distinguish four typical cases of HT positioning on the page:

1. Marginal: The HT lies in the margins, closely interacting with the text located in the columns but independent from it.
2. Parasitic: The running text in the columns constitutes the nodes, while the root and branches are attached to the column from the margins.
3. Embedded: The HT is completely inside the column, woven into the fabric of the text by the hand of those executing the columns.
4. Tapestry: One or several HTs occupy an entire page or more. Such pages, constituted of diagrams only, could be either unorganized notes or organized (alphabetically, thematically) "published" sets of charts designated for the eyes, minds, and pleasure of readers.

2.1 DIAGRAMMING AS A FORM OF MARGINAL ANNOTATION

While HT diagrams were drawn on all parts of the medieval page, the vastly disproportionate majority thrived in the upper, bottom, or side margins, either as an organic part of extensive annotation or as the only form of glossing. They were seldom by the hand of the scribe who copied the main text in the columns and often by the hands of subsequent users, mostly in not overly formal script and without special ruling. Annotation inside codices was expected and encouraged by bookmakers, who, since at least the thirteenth century, produced textbooks such as the *Organon* (logic), the *Sentences* (theology), and the *Articella* (medicine) with margins that are ample in the extreme, sometimes divided into small columns themselves. At times, these notes singled out and re-presented the information in the main columns in an HT format. Figure 2.7 illustrates the manufacture of such a visual "translation." This is a typical page from a thirteenth-century copy of the *Sermones ad status* by Gilbert of Tournai (OFM, d. 1284).[16] The different colors of ink suggest that a second hand visibly distinguished the properties of stars using slash marks, then collated them into two HTs in the margins.[17] Such re-presentations, visual translations or performance, to use the terminology of discourse and practice of Chartier, characterize many of the HTs we shall see in the Aristotle survey in the next section, as well as in other textbooks.

At other times, HTs added material to that which appears in the column, enriching and elaborating the discussed subject by way of original observations or by juxtaposing relevant information from other authors. In London, BL Egerton 633, for instance, the annotator to Peter Lombard's *Sentences* added several useful distinctions made by Hugh of Saint-Victor,

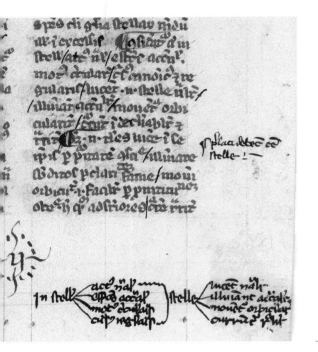

Column:
⁋Consideratur autem in stellis / actus naturalis / effectus accidentalis / motus circularis / cursus canonicus et regularis / Lucent enim stelle naturaliter / illuminant accidentaliter / movent orbiculariter / currunt indeclinabiliter et regulariter. [One should consider the stars' natural act / accidental effect / circular movement / canonical and regular course. For the stars beam naturally / illuminate accidentally / move circularly / run unchangeably and regularly.]

margin:

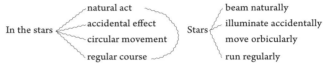

2.7 Assisi, BC 486, fol. 13r, detail

who was Peter's contemporary theologian, in the form of HTs. Below the Lombard's prologue, for instance, he put the one translated in figure 2.8.

2.8 London, BL Egerton 633, fol. 1r, translation.

On another occasion, at the bottom margin of a section dealing with the image of the Trinity in human beings, this hand added an elaborate HT classifying various trinities in the human creature, together with references to specific places in Augustine's *On Trinity* in which each is discussed or mentioned, creating thereby through the marginal HT a singular polyphony of sources (figure 2.9).

CHAPTER { 2 }

2.9 London, BL Egerton 633, fol. 18v, translation.

There is trinity in [man]
- external man
 - in the senses
 - external shape of the body
 - its image impressed in the senses, or the sense formed by the image — acc. to Aug. bk. 11 The Trinity, ch.8
 - the will that directs the senses toward the sensible object
 — [..] of these is an image of the trinity [...] but a certain index or vestige bk. 11 ch. 16
 - imprinted in interior cognition by the senses
 - animal memory
 - vision of the thinking mind — bk. 11 ch.9
 - will conjoining both
- internal man, and this man is only the rational mind since man excells animals, as said in bk. 11, ch. 1
 - in the inferior reason
 - rational memory of things happening in time
 - contemplating those things
 - love conjoining both
 — on which bk.13 ch.48 and bk.14 Ch.5. And these are not .. of the supreme trinity but an index as said in bk 12 Ch. bk.14 Ch.
 - in the superior reason
 - in one way
 - mind
 - notion — on which see bk. 9, and you have on this trinity more evidently there Ch. 8, 9, & 14
 - love
 - in another
 - memory
 - understanding — On which bk. 10 particularly 3, and bk.14 ch.9 up to 15
 - will or dilection
 — These.. to the same.. image of the supreme trinity as manifestly.. bk.9, 10, & 14.. since they remain in the soul...

This trinity according to which there is an image of supreme trinity
- according to its unity, it is in the notion of the mind which always remains in the mind together with its perpetuity
- according to manifestation in open cogitation, which comes to mind and goes in time

this you have from bk.14 On trinity Ch.5 and 6 at the end, and from Ch.13, 14 and 21 at the end

Naturally, diagrammatic annotation such as this not only aided the producer's cognitive processing at the time of production. It was also meant to last and serve the reader on the next consultation of the codex, as well as later users. We learn this from traces of several revisions and drafts, such as those found in Oxford, Balliol College 195. This is another fine manuscript of Peter Lombard's *Sentences* with generous margins, likely executed in thirteenth-century France, but which has spent most of its life in England. On its first blank page, a later hand has added a commentary on the prologue in exceedingly small script, as well as a list of the Lombard's forbidden opinions, which was a common addition to copies of the *Sentences*. The next pages host occasional annotations by several hands. Most of these glosses are HTs, all seemingly by the same annotator. He drew many in clear black ink, while others are in pale, almost illegible, lead. In some cases, however, the ink diagram was written *over* the "drafty" one, and a comparison betrays that light modifications were involved in such revisions.

The diagram in folio 36r, for instance, distinguishes two senses of "being born": a general sense, which is the reception of being from something else (*esse ab alio*); and a more strict, proper sense. This distinction allows theologians to determine that the Holy Spirit is born in one sense but not in the other. A closer look at the first draft reveals that the HT used to have a third branch. This third sense, being born "in the most proper sense of the word" (*propriisime*), is defined as producing an animating being from an animating being (*animans de animante*) and refers to Richard of Saint-Victor, but the redactor chose finally to omit it.[18] The diagram in folio 139v addresses the acts proceeding from the gift of knowledge, one of the seven gifts of the Holy Spirit. This HT went through changes of wording, the addition of examples, and integration of a portion of text that at first stood apart, above the diagram. The prologue was elongated and each branch in the ink version was further enriched with reasoning that related to one of three differences between the gift of knowledge and the gift of wisdom.

Folio 141v (figure 2.10) presents an interesting case where modifications were made in order to strengthen a specific sense of symmetry in an attempt to classify the Ten Commandments properly. Figure 2.11 is the draft version; figure 2.12 is the final one.

Certainly, there are some odd mistakes here in assigning the correct number of each commandment to the corresponding terminal node. The second and third must have been wrongly switched, the third being related to word of mouth and the second, making idols, to a deed. The eighth, "Do not steal," has nothing to do with the mouth. Strangely, these errors were not corrected in the ink version. What *was* changed was the order of the nodes. The first version highlights a certain symmetry, as the triad heart-mouth-deed repeats in the first branch and then in the second part of the second one. Nevertheless, the original order of the Ten Commandments does not

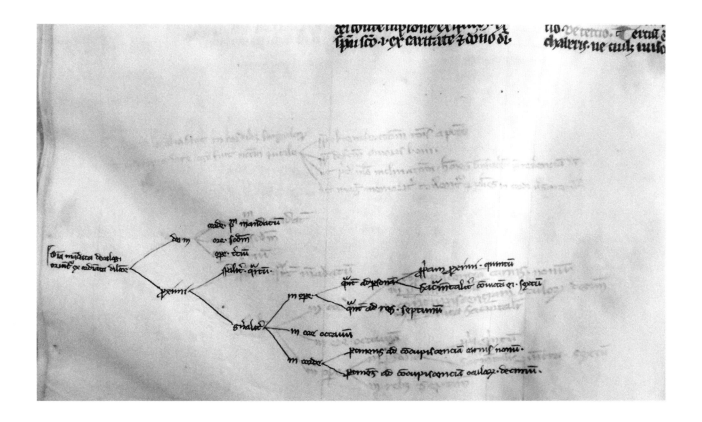

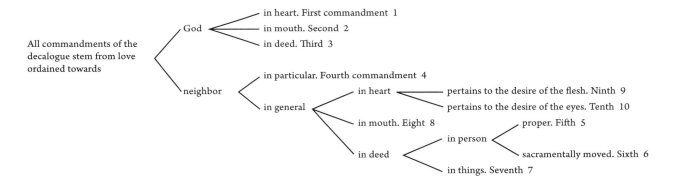

follow this symmetrical structure, and if we read the diagram from top to bottom, it results in the series 1, 2, 3, 4, 9, 10, 8, 5, 6, 7.

The author decided not to ink the first diagram on that page and to arrange the HT so that the commandments would unfold orderly from one to ten. This resulted in an inverted triad of deed-mouth-heart in the love of neighbor/general category (figure 2.12).

2.10 (top) Oxford, Balliol College 195, fol. 141v, detail: an inked revision of an erased, draft HT. Courtesy of the Master and Fellows of Balliol College, Oxford. 2.11 (bottom) Oxford, Balliol College 195, fol. 141v, translation of the erased draft version.

THE HABIT

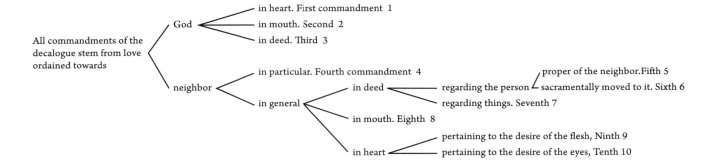

2.12 Oxford, Balliol College 195, fol. 141v, translation of the inked version. Courtesy of the Master and Fellows of Balliol College, Oxford.

Empty pages in codices were used for drafting HTs as well. Gerard of Abbeville, a distinguished master of theology living in the thirteenth century, held in his library a fine copy of Richard of Fishacre's commentary on the *Sentences*, featuring not only the set of text division diagrams that usually accompanied copies of this work but many others added by several hands in the margins. Folios 8r–12r of this codex, lying between the exquisitely fashioned list of contents and the beginning of the commentary itself, seem empty at first sight. But they are actually covered with almost illegible script. Folios 9r, 10v, 11r, and 12r are crowded with the vestiges of multiple diagrams; some are thematic distinctions, some text divisions (on text division, see section 5.2).[19] The lines are very crooked and messy and lead hither and thither to continuations in various places on the page, and many are erased with a strikethrough, betraying their draft status. One of these draft HTs appears to be a very rough equivalent of a fine diagram in the main hand of the manuscript on folio 59v, a partial text division for distinctions 42 and 43 in book 1. Others I managed to decipher had no parallel.

Besides the glimpses they afford into technicalities of craft, such drafts disclose that the externalization of structure in such a succinct form enables one to easily manipulate it. Furthermore, they may help us answer an important question regarding cognitive strategies, and visualization in particular: that is, whether people not only convert content from mode A of representation to mode B but are also able to think *within* mode B. Think of a native speaker of English who is able to converse in Spanish but first forms her answers in English and translates them in her mind before replying, as opposed to a native English speaker who can think, so to speak, directly in Spanish. The examination of marginalia demonstrates that paradigmatic writing often renders bits of information that were previously encoded in regular writing in the main text. But these drafts, together with glosses diagramming new ideas and divisions, hint that medieval schoolmen also "did the thinking" within the diagrammatic mode.

Finally, marginal HTs could, as noted above, be copied further as part of full magisterial commentaries, and thus move from a performance of reader-

ship to being part of authorship. The layout of Walter Burley's commentary on Aristotle's *Ethics* in Paris, BnF Lat. 6459, for instance, looks like the work of a professional scribe, who executed the commentary in a neat, formal layout, with the Aristotelian text in bigger letters at the center, framed by surrounding commentary with nicely executed HT diagrams.[20]

Distribution: A Quantitative Analysis in the Field of Logic

Several crucial points must be addressed now in order to deepen our understanding of the nature of diagrammatic marginal annotation. The first relates to its true distribution in the scholarly community. Which part of the scholarly population engaged in the practice: was it a small segment of the community, or was paradigmatic writing an indispensable part of scholastic writing, practiced by all, or something in between? The second inquiry regards the degree of creativity. As argued in the introduction, the question of whether a certain act or object is the result of a productive, creative habit is crucial for the study of scholarly habits, indeed to the definition of something as a habit in the first place, in all its different meanings, from Aristotle to Bourdieu. Cognitive abilities range along a broad spectrum with different levels. Writing, for instance, extends from the ability to sign one's name to fully developed writing skills. Similarly, there is an enormous difference between one who copies a preexisting HT and one who generates them freely, just as someone may remember several words in a foreign language while another speaks it fluently. I will demonstrate below that among the population of manuscript annotators, paradigmatic writing constituted an extremely widespread habit, diverse in its intensity and also personal and creative.

Neither one nor ten case studies can support claims for a broad, cultural phenomenon or assess its distribution and characteristics. We are trying to ascertain the visualizing skills of an anonymous mass. To investigate such questions, therefore, we must leave aside the method of representative examples and turn to statistical analysis. One option would be to search for HTs in a random sample of Latin manuscripts from a certain library, sifted from liturgical, hagiographical, patristic, or bureaucratic works, such as missals, lectionaries, saints' lives, or cartularies. Let us visit, for example, the digital archives of the Franciscan *Biblioteca comunale* of Assisi and browse through 170 such manuscripts which are dated to the thirteenth and fourteenth centuries. There are 54 (31.7%) that feature at least one HT, whether marginal, parasitic, or embedded. This picture does not change much if we move to France and examine a similar sample of 130 manuscripts in the Bibliothèque nationale de France collection of digitized manuscripts, with the same parameters. In this group 34 (26.1%) manuscripts contain at least one HT. These are solid shares, suggesting significant popularity among writers

and an extremely high potential of passive familiarity with the form among readers (supposing that a reader sees more than five codices during his or her life).

There are several difficulties with such too-wide and too-blind samples when it comes to nuances, however. The units are too idiosyncratic, differing in shape, size, time of composition, content, audience, general level of annotation, and other variables. We know too little at this stage about the general population of extant manuscripts of this period. We know even less about how extant collections relate to the actual state of affairs in the Middle Ages.[21] Diverse survival rates of genres and specific works might cause significant overrepresentations and underrepresentations and distort the picture heavily.

I therefore decided to conduct a much more refined survey, sampling, rather than collections, a well-defined, representative, and sufficiently homogeneous corpus. The Aristotelian logical corpus, often supplemented with Porphyry's *Isagoge*, Gilbert de la Porrée's *Liber de sex principiis*, or Boethius's *Liber divisionum*, makes a particularly good corpus for studying the habit of paradigmatic annotation for four reasons. *First*, because of the order of studies in the medieval curriculum, the *Organon* had a fundamental role in shaping the thinking and visualization habits of students and masters. *Second*, it covers a broader segment of society, for all students and masters attended the faculty of liberal arts, while far fewer proceeded to the advanced faculties of canon and civil law, medicine, and theology. *Third*, this popularity resulted in a large number of surviving manuscripts, constituting a large enough corpus to allow for sufficient assessment.

Four, unlike, for instance, systematic theology, logic manuscripts also include other types of diagrams. This allows one to define the peculiar nature of HTs quite sharply and to distinguish the particular practices and skills they entail. Latin scholars before the late twelfth century were familiar with two widely known diagrams in the context of logic: Porphyry's Tree, usually accompanying the *Isagoge*, and the Square of Opposition, appearing often in the *De interpretatione*. Porphyry's Tree appears in manuscripts from at least the early ninth century and has enjoyed popularity ever since. It represents the various *genera*, each more inclusive than the other, to which individual human beings pertain (animals, etc.), pointing out the *differentia* of each genus, that is, the property by which this group is further divided. This iconic diagram has received intensive scholarly attention, including stimulating studies by Umberto Eco and Ian Hacking, who took it as an opportunity to discuss the philosophical meaning of tree-diagramming and to address the difference between logical hierarchies and ontological ones.[22]

The Square of Opposition diagram has received much scholarly attention as well, including a dedicated conference, and has provided, to use Parsons's words in his comprehensive entry in the *Stanford Encyclopedia of Phi-*

losophy, "a foundation for work in logic for over two millennia."[23] Scholars assume today that although Aristotle stated the principal relations between the four types of categorical propositions, he did not invent their diagrammatic representation. The first known scholar to refer to such a diagram explicitly was Apuleius of Madaura (second century). His *De interpretatione* refers the reader to a "quadrata formula" featuring a "superior line" and an "inferior line."[24] Throughout the Middle Ages, versions of the square became iconic and were incorporated into the Aristotelian text either by scribes or by users. We shall see that the HT situation is very different.

I have defined as the surveyed population all known complete, nonfragmentary manuscripts containing Aristotle's texts of the new logic, and more specifically those containing the *Posterior Analytics* and at least one other treatise of the *Organon*, relying on the ever-valuable studies and catalogs of Lacombe and Minio-Paluello,[25] but leaving out the *supplementa* to the *Aristoteles Latinus*. This amounts to 240 complete manuscripts, which are already a sample of the sum total of unknown such manuscripts produced in the Middle Ages. Its biases may include a preference for preserving beautiful, illuminated manuscripts on good-quality parchment and paper or simply those with cleaner margins; such manuscripts may have been more likely to have been better cared for and therefore have survived disproportionately beyond their true share during the time of their actual use. If so, then the results below are even more striking.

Out of the population of 240 manuscripts I have closely examined, I chose a sample of 71 (29.58%), listed in table 2.1. The choice of manuscripts for the sample depended upon availability, whether personal (my ability to visit the libraries in question) or public (which manuscripts were digitized and uploaded online). It is therefore what statisticians call a "convenience sample." Such samples are considered valid and representative as long as the criterion of choice cannot affect the representativeness of the sample. Luckily, this is so in our case, for the decision to digitize in most current projects is not tied to the existence of HT marginalia, and selection was not affected by my own secret wishes.[26] The sample includes manuscripts from both vast collections such as the Bibliothèque nationale de France, the various Vatican collections, the British Library, and the National Library of Spain in Madrid and from smaller ones.

The problem with statistical analyses of manuscripts versus, say, copies of the same printed edition is that although in comparison with other medieval manuscripts this specific group is relatively homogeneous,[27] the codices still vary in form and content: some do not include all the treatises constituting the *Organon*; some include other texts as well. This difference has been taken into account when relevant. The rate of diagramming activity per manuscript, for instance, was calculated and adjusted according to the composition and the relative length of the texts the manuscript comprises.

TABLE 2.1. List of Manuscripts Included in the *Organon* Survey

CITY	LIBRARY	COLLECTION NUMBER
Amiens	BM	403, 404
Assisi	BC	286, 296, 327, 658
Avranches	BM	224, 227
Cambridge, MA	Harvard University	Lat. 38
Charlesville-Mézières	BM	39, 250
Florence	BML	Plut. 89 sup.76, Plut. 11 sin. 1, Plut. 11 sin. 2, Plut. 11 sin. 3, Plut. 11 sin. 5, Plut. 11 sin. 7
London	BL	Burney 275; Harley 3272
	Wellcome Library	55
Madrid	BNE	1563, 1564, 3126
New Haven, CT	Yale University	Beinecke Marston 88
Oxford	Balliol College	253
	Bodl.	Canon. Lat. Class. 188
Paris	BnF	Lat. 6290, 6291, 6291A, 6292, 12956, 16599, 17806
Reims	BM	869
Saint-Omer	BM	620
Uppsala	Bibl. Regal. Univ.	C. 599
Vatican City	BAV	Arch. Basil. S. Petri H.5 Borgh. 18, 33, 56, 58, 73, 108, 130, 131, 133 Chigi E. V. 149 Ottob. 1149 Pal. Lat. 986, 987, 988, 992, 996, 1006 Reg. Lat. 2036 Ross. 400 Urb. Lat. 1312, 1318 Vat. Lat. 2068, 2114, 2117, 2976, 2977, 2113, 4543, 10683
Vienna	ÖNB	166, 273, 2370, 2374, 2407

The fact that we are dealing not with a single text but with a *set* of texts, however, provides us with an opportunity to compare users' behavior across different texts, an interesting feature that would have been missed had only one text been examined. However, compromises had to be made. Passed from one user to another over a long period, many manuscripts were annotated by several hands, some almost contemporary with that of the main scribe, others much later. To simplify analysis, therefore, all diagrams in one codex, even when written by different hands, were counted as if they were by the same user.

Distribution and Intensity

Was paradigmatic writing a minority practice, the province of a few "visual" individuals, or was it a sufficiently widespread phenomenon to represent the visualization skills and cognitive strategies of a significant part of the community of scholars? To assess the distribution of the phenomenon in general and the probability that a medieval student would encounter a specimen,[28] the first query posed to the database was "How many manuscripts include *at least one* HT?" The result was 52 out of 71 manuscripts examined: 73.23% (with confidence interval from 62% to 84% of the population). Some manuscripts, however, lack HTs because they display no annotation whatsoever, whether verbal or diagrammatic. To neutralize this dependency, the same calculation was performed just for manuscripts identified as "highly annotated."[29] The result now climbs to 39 out of 44 manuscripts: 88.6% (with confidence interval from 75% to 96%).

Both results suggest that the chance of encountering HTs was very high, and the probability of producing an HT if one had already engaged in annotating a codex was even higher. It *was* a highly common reading and annotating strategy, shared by the great majority of schoolmen. At the same time, however, it is significant that there are a few annotators who heavily annotated a copy of the *Organon* without drawing a single HT. This finding indicates that this habit was only semi-institutionalized. What do I mean by this term? Let us draw a scale. One end of it is an "entirely personal" practice and the other "fully institutionalized." At the first end we may place the visualization habits of modern historians. In their private notes, some of my colleagues draw arrows, circles, or employ various colors, as I do. These annotations, however, display a variety of forms. They are rarely formally shared with peers or students (although sometimes we draw this way on the board) and almost never in publications. Now, let us fly all the way to the institutionalized habit of modern linguists of generative syntax. Students of generative syntax see tree analyses of sentences from their first, introductory courses. They see them on the board and in textbooks and articles and submit assignments in which they are obligated to draw such trees. All trees are relatively identical in form; all practitioners learn to use them, and they indeed use them, without exception. Similarly, there are no mathematicians today who do not use digits and symbols and who instead write their proofs purely verbally. The almost identical nature and high distribution of HTs suggest that the medieval habit should be positioned close to the institutionalized end. But the small number of heavily annotated manuscripts lacking any HTs tells us that this was also a matter of preference and one could definitely do without it. It should therefore be understood as a semi-institutionalized practice.

How often did scribes and users employ this mode of visualization if they had already done so at least once? On every page or only very rarely? To gain at least an estimate of intensity of use, I have calculated the number of diagrams per manuscript. Two problems were taken into account. First, manuscripts differ in their composition; second, the texts themselves differ in length. Length was calculated not according to the number of folios but according to composition, with other, non-*Organon* texts excluded. It seems plausible that a longer codex would contain more diagrams than a shorter one, and thus the number would reflect length rather than the user's diagrammatic activity. We neutralized this source of variation and adjusted numbers accordingly.[30]

As noted above, one major methodological difficulty is that we counted diagrams by all different hands in one manuscript, but what we are after is not manuscripts but annotators' habits. The best would have been to provide counts for each different hand, but this would have resulted in further complications, such as the need to treat one manuscript as several in the general account, or the fact that later annotators already see the previously drawn diagrams and might therefore avoid making such again, which may have distorted the overall impression as well.

The average number is 16.8 diagrams per manuscript (out of manuscripts in which there is such activity),[31] but two manuscripts are populated with an extremely high number of diagrams, with 115 and 137 diagrams respectively. Without these two outliers, the average number of diagrams per manuscript falls to 12.4.[32]

The following diagrams present a more detailed picture. Figure 2.13 shows the number of diagrams per manuscript: 10 manuscripts with one

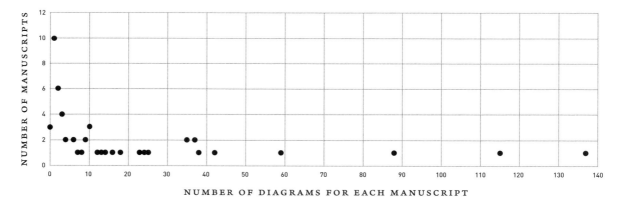

2.13 Number of diagrams per manuscript

diagram only, 6 containing two, and so on. The pie chart in figure 2.14 presents the same information divided into segments.

The numbers in figure 2.14 are not adjusted for the length of the texts and the composition of the manuscript, for when they are adjusted the re-

CHAPTER { 2 }

sult remains the same. There is a correlation between the length of the texts in a manuscript and the total number of diagrams it contains, but surprisingly, it is very weak (0.16). This suggests that, contrary to what we would expect, the total length of textual matter might not be an important factor in predicting the total number of diagrams it contains, a fact that I cannot explain sufficiently yet but that I hope my next investigation into variance of behavior will clarify. The figures suggest, however, interesting behavioral patterns. First, "only once" is highly common, occurring in a fifth of all manuscripts. Almost half of the case studies (47%) include 1–4 diagrams per manuscript: common behavior is therefore quite occasional rather than intensive or systematic. More than a quarter of our manuscripts feature 5 to 14 diagrams, a modest but steady behavior. Furthermore, more than 25% show quite intensive activity by individual or successive users, who appear highly inclined to represent information in this way, with numbers of diagrams per manuscript ranging from 16 to 88. Two outliers occupy the far end of the scale. BAV Chigi E. V. 149, with 115 HTs, has no particular features except high activity in general, including doodles. The gold medalist, however, with 137 HTs, is in fact the result of one, systematic decision. BAV Pal. Lat. 996 owes its high score to text divisions running throughout the manuscript (on which see section 5.2).

2.14 Distribution divided into groups

Originality of Themes

I noted above the importance of assessing originality and freedom of application. How would we know readers are not just copying from one or from a few manuscripts that include such diagrams? The simplest procedure is to see if a set of identical diagrams recurs. If there is a fixed set of diagrams that can be traced to a few manuscripts of origin, it is more likely a matter of transmission and passive copying than a personal practice of organizing one's thoughts. In the same vein, the more unique diagrams we find in the same corpus, the more personal paradigmatic writing would appear to be. One difficulty may obscure results: different readers who read the same portions of texts, especially texts already set verbally as lists or divisions, are likely to produce similar diagrams independently of each other.

As the longest texts and the most diagram rich, I took the *Analytica priora* (23 manuscripts with at least one diagram) and the *Topica* (20 manuscripts with at least one diagram) for two representative case studies, transcribing all the diagrams in the sample and comparing them with one another. In this limited sample, no two manuscripts share identical full sets of diagrams. Neither did I identify any shared subsets. A few individual diagrams, however, do recur. Six manuscripts of *Topics* feature an HT diagram showing six modes of contrarieties.[33] Eleven *Prior Analytics* contain one

or several HTs representing the generation of syllogisms in one or more of Aristotle's three *figures*, according to all possible combinations of premises (universal/particular and affirmative/negative), designating the utility of each combination. Not all manuscripts, however, include diagrams for all three figures; some also feature trees that show further combinations with aspects of modality.

The "six contrarieties" diagram is almost identical in all manuscripts. Yet when it comes to the *figures*, although the subject matter is identical, it does not usually result in identical graphical forms. I have noted and reproduced two of these in chapter 1 (figures 1.17 and 1.18). Only two are precisely identical. Others differ from these two and from each other in details such as the use of letters designating the nature of the premises (*a-e-i-o*), the order of combinations, the convergences at the end, or the addition of the total sum of "useful" and "not useful" combinations. As noted earlier, the degree of discursiveness varies as well. While some are extremely laconic ("affirmative") others include full, long phrases providing reasoning and examples.[34] Two other cases show a similar picture.[35] This variety does not suggest the parroting of a single template. It is more plausibly the result of a general inspiration of the sort of "I have seen a good diagram of this somewhere, let me make one too," and/or of the popularity and significance of this specific subject matter. An indication of this popularity is that the same information (almost—only the useful combinations are memorized and further complications are encoded) was also formatted in these days as a coded mnemonic rhyme to be learned by heart, known as the "*Barbara Celarent*."[36]

Philologists and historians look for patterns, recurrences, and avenues of transmission. Since I am dealing with only a sample, a full survey, as well as a study of the specific transmission lines of individual texts, is likely to produce more recurrences. Results are also affected by the lost manuscripts which may have been sources to copy from. Surely, there were masters, students, and scribes who copied HTs they liked into their own books as they did with verbal glosses as well. Some of these trees could also migrate to or from other works on logic (say, by copying an HT from a codex of Peter of Spain's *Summulae* into the margins of the *Posteriora*). But the most significant result of this comparison turned out to be its decisive nonresult: the vast majority of the diagrams are unique. Had there been only a few exemplary manuscripts adorned with HTs from which everyone else copied, or even if copying a set was a widespread practice, we would have seen more recurrences and subsets, especially if we take into account that similarity can also result from independent reworking of the same subject matter. The cases detailed above are exceptions that prove the rule: annotators produced HTs spontaneously, according to individual will and personal needs.

The abundant variety of subject matter corroborates my understanding of the habit's productiveness and its personal nature as well. Annotators

distinguished the several meanings of terms like "necessary," "contingent," "difference," and "species." They compared commonalities and highlighted differences with regard to species, properties, and so on. There are HTs enumerating all cases in which a conclusion is true or all the necessary conditions for a syllogism. There are the figures discussed earlier—combinations of propositions at the end of each terminal node. One could find their utility or truth-value, as in flowcharts which also covered combinations of necessary propositions with contingent ones and further complexities. Some used the HT technique to connect letters like *a*, *b*, or *c* used symbolically, depicting their relations or combinations and experimenting with the technique in original ways.[37] In at least one case there are also HTs *explaining* the "*Barbara Celarent*," a clear indication of the different functions of these means; others explicate the octagon diagram. Two manuscripts feature text divisions that differ from each other (on such text divisions, see section 5.2).[38] An entirely different application of paradigmatic writing is found in Uppsala, Bibl. Regal. Univ. C. 599 (figure 1.10). This scribe, working around 1486, used the HT principle for nothing but the titles marking the beginning and end of the treatises (on this practice, see section 4.2).

Texts Inviting Readers?

Is there any pattern in decisions to diagram one text more than others, or is the decision entirely reliant upon individual tendencies, in that one master chooses to arborize the *Isagoge* heavily, while another does so with the *Perihermeneias* or the *Topics*? The picture that arises from the data displays great personal variation. Table 2.2 demonstrates the variety of choices as to what to diagram by showing the individual choices in each manuscript from those manuscripts that have 10–42 diagrams. The highest number for each is marked. Manuscripts are identified here by their serial number in the introduction to the critical edition of the Latin *Posterior Analytics*; works are identified by the first word or words of their name. Zero (0) indicates that the text exists in the codex but has no marginal HTs, while a blank space means that the text is not included in the codex at all.

Clearly, choices vary. In one manuscript there are 31 HTs on the *Topics* and only 1 on the *Priora*, while in another, there are 4 on the former and 23 on the latter. Three manuscripts have their highest number on the *Categories*, while four did not embellish it with even 1. Annotators differed, thus, not only in the general intensity of their use of HTs but also in the texts they diagrammed intensively or less intensively. A more refined picture is achieved from an additional type of analysis. To find out if there are texts that are more prone to being diagrammed, we compared the number of diagrams that a text was expected to have with the number of diagrams it actually had

TABLE 2.2. Distribution of Diagrams according to Texts within Middle-Range Manuscripts

263	261	11	6	170	2	238	242	70	267	5	66	72	180	148	281	698	ARISTOTELES LATINUS NO.
1	**4**			0	0		**8**	2		0	7		**16**				Isagoge
8	3		0	0	0		3	**14**		0	**8**		5				Predicamenta
0	0	**5**	0	0			1	2			0	3					Perihermeneias
0	0	0	3	0	**9**	3		1	5	2	**31**	4	4	14	**13**	11	Topica
0	3	**10**	3	**6**	3	**13**	**9**	4	0	**9**	1	6	**23**		10	**17**	An. priora
0	0	0	0	5	2	0	8	0	0	4	3	6	7	1	3	2	An. posteriora
1	0	0	1	2	0	0	1	1	0	8	0	4		0	12	12	Elenchi
	0	0		0				0	0		0			1			Six Principles

2.15 Expected share of diagrams in texts versus actual share

(considering the lengths of the texts and the number of manuscripts they appear in). Results appear in figure 2.15.

This graph shows that the type of text does indeed influence frequency, but only slightly. The *Isagoge*, *Categories*, and *Prior Analytics* are annotated two or three times more than expected; the *Posterior Analytics*, far less than expected. The *Sophistici elenchi*, *Topics*, *Perihermeneias*, and the *Six Principles* are annotated at around their expected share. This is too small a sample, of course, but together with the table, it strongly suggests that the amount of paradigmatic writing was influenced by the text in question, but to a small degree. Some texts mildly "invited" their annotators to visualize them more than others, whether because they contain more explicit divisions and subject matters more easily converted into such trees or simply because they were studied more than others. Note, however, that different texts within one manuscript differ, sometimes considerably, in the number of glosses, whether verbal or diagrammatic, in their margins—a datum I have not taken into account. Thus, it is possible that what we see here reflects differences in the general annotating activity.

Those Who Don't Know, Those Who Don't Care: Levels of Execution

The manuscripts sampled also differ greatly in level of execution of paradigmatic writing and thus demonstrate the deep reach of this practice beyond specialists of fine writing and decoration. The great majority of Porphyrian trees, as well as most squares or hexagons or octagons of oppositions in the surveyed manuscripts were executed by the principal scribe, mostly in a prearranged space inside the column, sometimes in the margins. Almost all the HTs, however, are written in scripts different from that of the original scribe and are marginal.

Very few annotators seem to err in the act of arborizing itself, but the few errors betray the very fact that HT diagramming is a practice that had to

be learned. Complete misunderstanding is rare, and the two examples I have found do not come from this survey. BAV Pal. Lat. 634 is a rare example of someone who tried to imitate the form of HTs but failed in understanding its principles. This codex of Gregory IX's *Decretales* (canon law) contains multiple notes which look like HTs until one actually reads the nodes. These are simple sentences whose parts were divided arbitrarily between nodes according to no paradigm, and the division makes no sense as such. Assisi, BC 298 shows a similar mock HT.

While such annotators show complete ignorance of the technique except for its appearance, Vienna, ÖNB 2370, folio 124v, betrays a more accidental mistake. It has four HTs in the lower margin of *Sophistici elenchi* 2, 165a38–b9, the third of which attempts to explain what distinguishes the four types of *disputatio* from each other (figure 2.16).

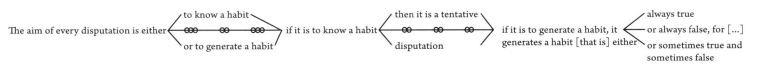

2.16 Vienna, ÖNB 2370, fol. 124v, translation

While the first split makes sense, instead of dividing the upper category further, the author merged the lines and repeated the content of the upper category and then split it again into two branches that should in fact be one. These converge again to form what should have been the second category of the first split. It is easy to imagine here someone *hearing* the words "Omnis disputatio aut est ad habitum cognoscendum aut ad habitum generamdum. Si est ad habitum . . ." and continuing to write without understanding that the division of the upper branch is now introduced, rather than new content. The correct way to arborize this content must have been something like figure 2.17, which I found in the margins of another manuscript long after I produced a similar reconstruction.[39]

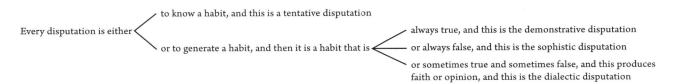

2.17 Paris, BnF Lat. 6576, fol. 1v, translation

However, these are the exceptions. Most diagrammers were versed in the technique of graphical division. But this habit also had a technical aspect of design: knowing how to plan the space properly and to allocate adequate space for nodes by estimating their number and the length of the words. Elsewhere I have shown in detail that in browsing BAV Vat. Lat. 782, one can follow the scribe's improvement from one page to the next.[40] Yet fine execu-

tion required not only skill but motivation as well, and this shows nicely in the results of the *Organon* survey. Some diagrams are finely executed; others are a complete mess. BAV Borgh. 133 is perhaps the most lavish. Dated to the thirteenth century, it was produced with extremely broad margins, inviting extensive annotation. The marginal and interlinear notes, as well as the diagrams, are written by a hand seemingly a bit later than that of the original scribe. The one who produced them furnished them with red and blue ink, so that they would perfectly match the red and blue in the main text. The space is arranged clearly and beautifully. Paris, BnF Lat. 17806, another thirteenth-century codex, features well-organized and colorful *figurae* as well. The vast majority, however, contain simple-looking HTs in the usual brown or black ink, in a cursive script, with unruled but usually sufficiently straight lines, and display no traces of prior drafting. From time to time, improper spatial planning resulted in squeezed lines. Like the messy notes of Madrid, BNE 1564 and Saint-Omer, BM 620, they seem to have been written just for the eyes of those who drew them, and, like several scholars I know, even they might have had difficulties deciphering their own notes.

Two peripheral phenomena round out this observation concerning the practice as partly private and informal: HTs in informal notes and funny doodling that populate both the margins and the flyleaves of these manuscripts. The last pages of Amiens, BM 404, just after the end of the *Topics*, are covered with dense script, dating to 1282.[41] These pages contain regular writing and simple one-split HTs summarizing different materials from the liberal arts curriculum: the four elements, their qualities and their matching seasons and humors; three senses of *ratio*; the four Aristotelian causes; cosmic triads according to Aristotle, Plato, Galen, and Macrobe; and several meanings of *possibilitas*. These are planted between edifying epigrams like "knowledge is a tree whose root is most bitter and its fruit most sweet; he who abhors its bitterness shall not taste its sweetness."[42] A previously empty page in BAV Borgh. 33 hosts trees listing the three powers of the soul and their subdivisions, next to one listing eleven sorts of improper use of one's state in life: a wise man without [good] deeds, an old man without piety, a youth without obedience, a rich man without almsgiving, and so on and so forth. On Oxford, Balliol College 253, folio 267v, an anonymous hand listed in the form of an HT various benefits of studying logic, for those who needed a reminder.[43] A different hand listed the different ways by which logicians, natural philosophers, and theologians form definitions. Folio 119v of BAV Borgh. 133 is covered with notes, including diverse HTs dealing with natural movement, the essence of natural form in matter, etc.

Twenty-six manuscripts feature human heads, animal heads, or other funny doodles sketched in amateurish hands on margins and flyleaves. There does not seem to be any serious aim behind them but pure quill-freedom, a sense of humor, and more than a grain of boredom. They are all too similar

to doodles coming from our pens and our distracted minds during lectures, when laptops are out of our reach. The medieval page, like the minds of its users, was much more than a disciplined, one-purpose instrument. It was a place in which to get bored and to wander with no purpose in the trails of one's extended mind with quill in hand.

2.2 PARASITIC, EMBEDDED, AND TAPESTRY FORMS

Whether formal commentaries or informal glosses, the margins were paratexts, records of readerly activity in the periphery or backyard of the codex, both in the shadow of real texts and distinct from them. Horizontality, however, made it easy for authors both to use the column itself as part of an HT or completely to invade the main stage, tearing little holes in the fabric of the columns. I call the former "parasitic" and the latter "embedded." Parasitic forms were created as writers attached lines, with or without a text at their root, to the side of the running text of the column, so that the branches point to the line where each item begins. Assisi, BC 469, Matthew of Aquasparta's (OFM, 1240–1302) autograph of sketches and drafts for sermons, features a great many such parasitic lines. Often only one root is attached, or no root at all, but at times the parasitic lines contained subdivisions.[44]

The embedded HT, part and parcel of the column, can be spotted in informal codices with almost no margins, such as the student's notebook Paris, BnF Lat. 15652 discussed above. It occurs far less frequently in formal codices. When it does, it often characterizes particular manuscript traditions of specific works, coming closer to becoming part of what was perceived as the authoritative text. One such work was Bonaventure's popular devotional treatise *On the Triple Way* (*De triplici via*), which in some versions features a spectacular display of embedded HT diagrams (for examples, see Paris, BnF Lat. 3574, fols. 71r ff.; BnF Lat. 14976, fol. lxxxvi; both available online).[45] Some users applied the different types—parasitic, marginal, embedded—interchangeably. Oxford, Bodl. Laud. Misc. 511, for instance, a thirteenth-century preacher's handbook slightly larger than a pocket book, displays all the forms above.[46] The bottom margins of most of its pages are covered with marginal HTs re-presenting distinctions in the sermons hosted in the main columns, but the codex also features a good number of embedded diagrams, as well as a parasite such as the one seen in figure 2.18.

At times, the preacher even drew in the margins lines that shoot out from one point without any text as an icon indicating the existence of a distinction in the column and without bothering to extend the actual parasite lines all the way to the text (fols. 101r, 157v, 159v). I have not encountered parasitic diagrams or mixed use in codices that are unambiguously formal, but figure 2.19 demonstrates a variety in a fine copy that may come close.

2.18 Oxford, Bodl. Laud. Misc. 511, fol. 166r

Gerard d'Abbeville, a master of theology in the University of Paris active in the second half of the thirteenth century, had an unusual collection of manuscripts, many of which he donated to the Sorbonne College's library. Executed between 1269 and 1272, Paris, BnF Lat. 16405 contains his notes for two magisterial inaugural lectures, perhaps copied after his own autograph by one of the professional scribes he was known to employ.[47] These notes include one marginal HT, more than ten embedded HTs, and several

CHAPTER { 2 }

parasitic HTs, one of which features subdivisions as well (fol. 1vb, at the left of the righthand column, from center to bottom).

Sometimes several diagrams or a large one spread all over a page or several pages; these I call the *tapestry* form. They can be either unorganized or well arranged for "publication" as a set. Blank pages between works and flyleaves invited users to cover them with HTs as well as with other texts and pen trials. They represent a slightly different situation from the marginal activity, for one does not draw an HT that stands in direct relation to a specific place in the text, as a visual translation, paraphrase, or commentary of it, but dissociates bits of information from the continuum and context so that they stand on their own. An example of an unorganized tapestry page can

2.19 Paris, BnF Lat. 16405, folios 1v–2r

THE HABIT

be seen in figure 2.20, a flyleaf facing a thirteenth-century copy of Thomas Aquinas's commentary on Aristotle's *Physics*, covered with HT schemata (for discussion, see section 3.1).[48]

Finally, a few authors were so fascinated by this technique that they produced entire compositions in the form of sets of diagrams, either many small ones arranged one below the other in columns, or large and extensive ones, sometimes spreading over two facing pages (an opening). The visual layout in these cases became organic and essential to some of these works in a way that copyists could still ignore but frequently followed. We see such tapestries in collections of theological, legal, and medical *distinctiones* beginning in the very early thirteenth century (see chapter 3); in sets of HTs or opening-width charts constituting the entire letter-writing guide of Lawrence of Aquilegia around 1300 (see section 4.2 below); in the body of Thomas Le Myésier's *Breviculum*, the fourteenth-century introductory guide to Raymond Lull's art (discussed in chapter 1); and in some beautiful fifteenth-century examples of Latin grammars (section 4.3).

2.20 (facing) Paris, BnF Lat. 16153, flyleaf

2.3 BEYOND THE CLASSROOM

Finally, there are the things that choice of language can tell us about situated practice. While the relation between Latin diagramming habits and their Greek counterparts remains an open question, the direction of influence from Latin to other languages in the West is much clearer and goes hand in hand with the dissemination of scholastic thought and scholarly knowledge itself. I will briefly address the vernacular French and the scholarly Hebrew cases, which I have found instructive regarding the reconstruction of the contexts of paradigmatic writing. There are also several Middle English examples,[49] and I hypothesize that there might be examples in Middle High German and Italian as well.

Toward the end of the thirteenth century, paradigmatic writing occurs in French in all areas into which learned culture diffused: in mendicant pastoral work, in bureaucracy, and in lay aristocratic learning contexts. In a codex of sermons by Eustaches d'Arras, a Franciscan friar, the reader, one Etienne of Abbeville, drew small HTs in the bottom margins of a few pages. He alternated between Latin and French, noting the French distinctions with the word "*gallice*," thus translating the matter in the column twice: from Latin to French and from text into paradigmatic writing.[50] Preachers were not the only agents of scholarly habits. Government officers were educated in the universities and other centers of learning, and so writing norms crawled there as well. Figure 2.21 transcribes an excerpt from a page from the *taille* of the year 1292, the famous tax registers of Paris. Paradigmatic writing serves there to group several people living in the same household and paying

their taxes together and links them as a group to the details of their location and amount of payment. Thus, instead of writing "Quentin Amadour, Lotier Bonavite, and Otelin Enfegat from the companionship of escale [paid] this sum," the writer fitted all three into the vertical list of payers and combined them toward the right at the end of the sentence, as seen in figure 2.21.

Finally, there were the aristocracy and the king, for whom philosophy

Q uentin amadour
L otier bonaiute ⟶ de la companignie de lescale .xlvi. lb
O telin enfegat
P andouffle
I uste espiciers ⟶ devant sainte kateline .iiii. lb
I ehan bonin monnoier
H enri Guill'
R enier courcon ⟶ en la meson pierre le coquillier .vi. lb
H enri bone aventure

2.21 Paris, BnF Fr. 6220, fol. 1r, transcription

was translated into French, transmitting not only ideas but also habits of reading and visualizing. The classic case is Nicole Oresme's translation and commentary project. Latin copies of Aristotle's *Ethics, Politics,* and *Economics* frequently included marginal HTs, and these found their way into Oresme's French commentaries as well. Claire Sherman has shown the extent of this project and its political and cultural importance and has detailed the lavish and sophisticated use of visualizations and illustrations, including HTs.[51] She correctly notes that in one diagram in the frontispiece "the inscriptions and the second and first instructions lead the reader to generic definitions and classifications of basic terms and concepts. Oresme's verbal directions compress and summarize ideas that occur in parts of the text physically separated from the frontispieces."[52] There is no need, however, to argue as she does that this diagram continues similar figures Oresme produced in his scientific translations, as in *Traité de l'espere.* Paradigmatic writing is only loosely related to these forms of visualization. As an agent of transmitting knowledge available only to readers of Latin to aristocratic laymen and laywomen eager for knowledge but formally uneducated, Oresme initiated them into not only Aristotelian political ideas but also forms of reading and patterns of thought inherent in HTs. In Paris, BnF Fr. 542, another copy of Oresme's commentary on *Ethics,* we see in the margins small and simple HTs in French drawn in a hand and ink that differ from those of the original scribe, testifying to the active use of the text by a lay reader.

Scholastic culture diffused not only to an increasingly broader vernacular audience but also to an ancient scholarly tradition practiced in the very cities and areas where universities flourished: Jewish-Hebrew intellectual culture. Only recently have two rich volumes of studies and texts appeared

that demonstrate how wide and varied were these channels of transmission from Latin to Hebrew in the fields of logic and natural philosophy in Provence and Italy during the fourteenth and fifteenth centuries.[53] Petrus Hispanus's popular logic textbook, for instance, was translated into Hebrew as *Ha-higayon* (ההגיון) no fewer than eight times and is found in multiple manuscripts. The most popular translation was that by Avraham Avigdor Ben-Meshulam, who studied in the fourteenth century in Montpelier and was well acquainted with scholastic scholarship and culture. London, BL Add. 18277, a fifteenth-century paper copy of his translation, includes four HTs, probably copied and translated from the Latin together with other glosses. Paris, BnF Heb. 926, copied in 1472, includes the *Higayon* as well as Averroës's middle commentary on the Aristotelian *Organon* and features both vertical and horizontal trees, as well as many other glosses.[54] Turin, National University Library A I 14, a fifteenth-century codex written in the Provençal script of Hebrew, perhaps for the learned physician Rabbi Mordechai Nathan, contains multiple HTs in the margins of the pages of Gersonides's commentary on the Hebrew translation of Averroës's middle commentary on Aristotle's *De interpretatione* and *Prior Analytics*, including complex *divisiones textus*.[55]

But perhaps most intriguing is not the translation of the practice in the field of logic but its trickling into peculiar, original discourse: that of a scholastic-like discussion of halakhic laws in London, BL Add. 22090. The same hand that wrote the manuscript, presumably that of Mordechai Nathan, also drew a few simple HTs regarding a halachic (rabbinic legal) issue on the flyleaves. A fifteenth-century manuscript now in Oxford, written in a Provençal Hebrew hand, features an HT spreading across an entire opening. The HT comes just after the prologue of a yet unedited and unknown anonymous extraordinary text, poetical and scholastic at the same time. It delineates the parts of the arguments the author plans to refute, its root being הכחשת השואל הראשון תפרד לשלושה ענפים (The refutation of the first inquirer/inquiry shall be divided into three branches). Each branch divides further into what the author calls *badim* (smaller branches) and then *alim* (leaves).[56] I cannot tell at this point, however, whether this HT is the result of unrepresentative use by a singular writer well acquainted with Christian culture or a precious trace of a wider practice.

2.4 CONCLUSION

The haphazard survival and the idiosyncratic nature of medieval manuscript culture sometimes make quantitative analyses impossible. There are simply too many variables to consider, too many particularities to allow clean examination of parameters. But as we proceed into the High Middle

Ages, idiosyncrasy is reduced, allowing at least good estimations. I hoped to demonstrate in this chapter how a quantitative analysis of a large sample contributes to a deep portrait of a collective scholarly habit. It enables us to support a surprising but sufficiently grounded assessment of the broad distribution of the use of HTs in the population (answering, "But are you sure it is not only a few individuals?"); to formulate a general idea of intensity of use; and, together with qualitative analysis, to estimate the degree of free generativity ("But weren't they just copying from one source?"), unity, and institutionalization involved.

Drawing tree diagrams in the margins of logical manuscripts, and as we shall see in part II, in manuscripts of all other disciplines of the medieval university, was not the private invention of individuals but the individual expression of a shared mode of thought. A very large percentage of the readers were aware of the option as passive readers; a tremendously large percentage of annotators employed it actively. Nevertheless, the latter differed greatly in their usage. Most outlined only a few bits of information, others deployed the technique more intensively, while a few others employed it constantly. The results demonstrate that the application of this habit was free and original. A surprisingly small number of diagrams recur, and the choices to diagram this or that text or part of it are independent rather than the result of graphical parroting. There are, however, some texts that seem to attract more diagramming than others, a finding which refines the subtlety of the interaction between textual calls and readerly responses.

If paradigmatic writing is so current and cognitively effective, why is it (besides the convenience of separating text and figures) that most of the diagrams appear in the margins? Anthropology of writing sets as one of its aim the understanding of which forms of writing are considered legitimate and which illegitimate, and in which contexts. Is the visual less "legitimate" in general? Are these personal or semipersonal working tools we do not wish to expose in the public sphere of refined products, much as we do not sell the working tools together with the chair we have made? Or perhaps both the margins and the visual form a zone free of the constraints imposed on formal written expression? The rich and varied material evidence here and in the next chapters reveals that HT diagramming was mostly a paratextual, personal activity, belonging within the inner, nonpublic rooms of the scholarly workshop (though not exclusively) rather than put on display in the front of the shop. It was primarily done by glossing readers and flourished in the margins of textbooks or in formal renditions of commentaries. Although embedding was somewhat technically challenging, HTs sometimes intruded into the column area, but these examples appear mainly in informal codices or in very specific texts. Nevertheless, there were specific works, primarily works framed as study aids or abridgments, that put HTs center stage, in beautifully executed and finely elaborated tapestry folios.

Only in these cases has the visual become an organic part of authorial intention, authorship, and the "published" text. In all other cases, copyists could ignore it or convert from one mode to another, implying that the HT visualizations were part of the copyists' performance rather than solely the authorial "original" script, and that the decision to include them or not was up to the individual copyist.

Usage may have varied between different disciplines and genres. But since all students first undertook liberal arts studies, it is well confirmed now that late medieval masters and students in Europe's centers of learning were well versed in this particular technique. Regarding Panofsky's thesis and its critics, results demonstrate that *a* visual expression—not necessarily the one expressed in architecture—of the ramifying, hierarchical mode of thought was deeply and widely diffused within scholastic culture from the turn of the thirteenth century. Regarding Ong's thesis, results prove that externalizing and spatializing knowledge in the form of horizontal, multilevel diagrams had nothing to do with print or particularly with Ramus. Centuries earlier, it was a widespread practice employed by the great majority of the scholarly population on parchment and paper. What is missing from this analysis, however, is a better understanding of the diffusion of this habit across subject matters and disciplines. Part II will take up this task, demonstrating the impressive diffusion of this form in all scholastic fields of knowledge and reconstructing the field-specific functions and uses of the technique.

PART II

Habits should be studied not only with regard to how many people act in a certain way or how often they do so but also with regard to how varied the situations are in which they do so. As I have shown above, an infinite number of issues may be written paradigmatically, and almost any coordinated sentence can be represented as an HT. Groups of things, or just "things that share something," are all around us. Yet the fact is that, unlike punctuation marks such as the period or the question mark, HT diagramming was not applied in all possible cases but only occasionally and to specific bits of information. The question that guides this part is therefore that of subject matter: how and whether this technique was applied to specific subfields in the medieval academic world.

HTs are like a dense jungle, and to guide readers safely through its tangle, we must survey large areas in quick steps. Like those twelve-countries-in-a-single-week tours, we shall consider only exemplars of major types, leaping over hundreds of other manifestations without lingering on the peculiarities of each manuscript, though many of them definitely merit deep analysis. The next three chapters provide glimpses into applications in chosen fields by way of a few case studies. They support the argument that HTs were used in all faculties and highlight certain favorite topics of these faculties. They cannot, however, support claims regarding the relative intensity of use within each field. Swift tours such as these must also fall short of comprehensiveness with regard to full explanations of specific doctrines or disciplinary terminology. I have tried to choose examples that do not require extensive acquaintance with the respective fields and to suggest the fewest possible references for general reading about each of them.

This part comprises three chapters, each divided into several sections. Chapter 3 presents the most popular and also the most vaguely defined use of this technique: to distinguish terms and concepts. I discuss the intellectual tool of distinction and its versatility for illustrating fields of meaning, algorithms of procedures, intertextual relations, and divisions of diverse kinds, using examples from the fields of philosophy, biblical theology, law, and medicine. Since examples from logic and systematic theology featured in part I, they are not treated here.

Chapter 4 addresses the application of the technique to highlight linguistic structures. It first engages applications to the layout of rhyming patterns; then diagrams serving to demonstrate epistolary formulae and structures in manuals of *ars dictaminis*—the medieval art of letter writing; and, finally, the use and non-use of HT diagramming to present grammatical morphologies.

Chapter 5 delves into the intriguing phenomenon of diagrams representing textual structures in the faculties of liberal arts, theology, and, to a certain extent, medicine. It addresses diagrams representing the hierarchical structure of theological treatises, studies diagrams that illustrate the inner,

highly hierarchical medieval analyses of argumentative texts, and ends with meticulous structural analyses of narrative, where the relation between one line and multilevel structure is perhaps the most intense. I conclude the chapter with a discussion of the implications for scholastic perceptions of textuality and authorship, followed by a brief presentation of parallels to the *divisio textus* in twentieth-century narrative analyses.

{ 3 }

Structures of Concepts

Distinctions

The most popular and probably the earliest subject matter for horizontal tree diagrams (HTs) was *distinctiones*. *Distinctiones* were concise lists enumerating and distinguishing (hence their name) different senses of a concept or a word, different purposes of an action, different causes, and so on.[1] They embodied, therefore, the cognitive procedure of distinction, an essential tool for clarification, articulations, and problem solving in scholastic theological discourse, as well as in philosophical, legal, and medical fields. A classic solution for a problem that involved conflicting authorities, for instance, could be offered by showing that one author intended the first, more general meaning of a certain term, while the other opted for a second. Difficulties and doubts benefited from clear distinction as well. According to a famous story about Thomas Aquinas, while he was still a young and shy student in Albert the Great's school, he was assigned the role of respondent during a disputation on a difficult issue. He refused out of modesty but being forced to obey, he prepared himself well.

On the day of the disputation he responded to the question at stake with arguments and with a three-membered, most beautiful distinction, so brilliantly and clearly that one could make no other determination. Friar Albert therefore said: "My son, you should not take the place of respondent but that of the determiner." Thomas most reverently replied: "Master, I cannot see how I could respond otherwise to the question." "Well," said Albert, "now solve the question with this distinction," and presented him with four arguments which were so difficult that he believed Thomas would not be able to solve them. Thomas responded most sufficiently, to the amazement of Albert, who is said to have said, in a spirit of prophecy: "We used

Note: 'Distinctio' may refer to
- a textual unit, by which one may refer to a place in the text, e.g. 'book 1 distinction 3', as in Peter Lombard's *Sentences* or Gratian's *Decretum*.
- the cognitive procedure of distinguishing one thing or sense from another.
- the result of such a procedure, which may be expressed orally, written in regular lines, or as HT.
- short units of the type above, distinguishing diverse senses or causes of spiritual senses in biblical theology and preaching. This is a particular case of nr. 3.

3.1 London, BL Egerton 633, fols. 15v–16r. Courtesy of the British Library Board.

to call him a speechless ox; but he shall make in his teaching such a roar that it will be heard in all the world."[2]

This distinctive mode of thinking, knowledge organizing, and problem solving could be expressed by oral speech or in the columns of a codex as a regular part of the string of written speech. Yet when it was externalized in the margins, the HT form ruled without dispute. The margins of many manuscripts of Peter Lombard's *Sentences*, for instance, the textbook of theology used by students like Thomas and masters like Albert, were often glossed with HTs of varying distinctions, as seen in figure 3.1, a typical opening from London, BL Egerton 633.[3]

The intellectual tool of distinction and its graphical expression were applied in the classrooms of all four major faculties of the medieval university and to different matters. I will treat the trivial language arts in a separate

chapter. Here we shall begin with some examples from philosophy, proceed to biblical *distinctiones*, followed by *distinctiones* in the fields of law and, finally, medicine.

3.1 NATURAL PHILOSOPHY, METAPHYSICS, ETHICS

The masters and students who frequently annotated their logic books proceeded to do so when they studied other branches of philosophy at the same faculty of arts. Can we reconstruct the reading and processing strategies employed by a young student or master of arts, the peculiar nature of his interacting with terminology and ideas of philosophers who lived more than a thousand years before? Our first example of sporadic HT marginal annotations comes from Paris, BnF Lat. 16084. This is a fine copy from the end of the thirteenth or beginning of the fourteenth century, containing Aristotle's *Metaphysics* and Averroës's commentary. The annotator here applied the HT form to the distinction of senses in Aristotle's terminology. A handful of pages feature HTs, all addressing several senses of key terms like "necessary" (fol. 51v), "disposition" (63v), "*passio*" (64r), and "privation" (64r). Some HTs translate faithfully Aristotle's verbal distinction: the visualization is an act of further explication in a long chain of clarifications. But particularly telling is the distinction to the term *passio*. Aristotle (1022b15–20) distinguishes senses of *passio* thus:

One sense of *passio* is a quality in which the thing can be changed and turn white into black, sweet into sour, heavy into light, etc. Another sense of *passio* is the [actual] change and activations of such qualities. *Passio* has also the specific sense of those changes and motions of species which are harmful, especially harming and saddening.[4]

How would you expound that? In what discussion do the commentators engage here? Averroës, known to the Latin world as Aristotle's chief commentator, elaborates only a little. On the first sense, he explains that it is a potency by which a thing transforms from one contrary to the other (e.g., from white to black) and relates it to matter. Proceeding to the next sense, Averroës paraphrases Aristotle's words to "some passive accidents of the first matter" like heat and coldness. The third sense, he expounds, is there to show the specifically negative sense of the second. Averroës does not engage in any inner divisions. Now our anonymous annotator enters the conversation on the page, trying to understand the text as well. First, between Aristotle's words, with an interlinear gloss, he explicates further the term "quality" —"that is, a natural potency, passive and not active...." At the beginning of the third sentence, where the Latin omits the noun, he adds it

above, noting that "the noun here is *passio*." In the slim margin to the left, he proceeds to the explication of active and passive qualities. On the right, he numbers three senses (this is not trivial either: Thomas Aquinas understood there to be four).⁵ Then, at the bottom, he draws an HT embodying the next cognitive operation he applies to the text with his quill: further categorization. He introduces the HT with the first person, "I think it should be thus" (*puto sic*) and groups the first two senses of *passio* into *passiones* of the body, distinguished from the third, which he identifies as the *passio* of the soul. Try reading this passage yourself with the cognitive habit of classification in your mind and a ready pencil in your hand. Would you categorize it thus? My immediate response, for instance, was to group together the last two: the first sense is the quality, while the other two are the transmutations themselves, whether in general or in a specific negative sense. The body/soul distinction did not occur to me. The issue here, however, is the mere procedure: I would probably not have thought of drawing and grouping in the first place. Such distinction does not seem significant to a modern eye.

A previous HT in the same manuscript may suggest how paradigmatic writing not only expressed this distinctive mode of thinking visually but also helped readers come up with new ideas for grouping and correspondences. The margins of folio 51v contain a division-in-progress of the different senses of "necessary," translated and designed as faithfully as possible in figure 3.2 (fuzzy lines in the original). The annotator began by placing a number to the side of the column, close to the line where each of the four senses are enumerated. He then produced a simple HT, dividing the term into the four senses already defined in the text, bringing examples from Aristotle as well as Averroës. To the right of this list, the first three were grouped by the title "respectively," while the fourth one is termed "absolutely"—terms which appear in neither Aristotle's nor Averroës's texts. Then he further defines the "respective" group according to their matching respects: with respect to being, with respect to well-being, etc. An additional small line connects this HT with another right below it, "note that there is a force . . . ," which splits

¶necessary
- ¶without which a thing cannot maintain being, it is its cause of maintenance, like food and breath in animals — with respect to being, in the genus of material being
- ¶without which the things cannot be complete, like taking a preventive medicine regarding weakness, as happens etc. — ¶respectively — with respect to well being, so that without it, it would not achieve its end
- ¶forcing and prohibiting, like a king forcing Socrates to kill Plato — with respect to the forcing or prohibiting agent
- ¶that which cannot be transformed or found other than as it is — ¶absolutely — in the genus of formal being

3.2 Paris, BnF Lat. 16084, fol. 51v, translation

into three. Another on the left enumerates three types of absolute necessity. If this annotator could produce the diagram again, we might imagine, he might have first split "necessary" into two—respective and absolute—and then split each of these into its subdivisions.

Paris, BnF Lat. 16096 shows a similar rearranging of a text in the column by the annotator, the text now being Avicenna's *Metaphysics*, tract. 2, cap. 4, dealing with the relation between form and matter. On the side of the relevant lines in the columns, there are letters from *a* through *i*. The HT begins with the phrase "A relation between form and matter is," splits into two, and then, in a less organized and more cramped script, divides the cases further and further to present all other types of relation. The reference letters are attached at the beginning or end of each branch. Converting the principal text into a list and then into a hierarchical HT, the annotator shows previously hidden inner relations between the senses, reorders them (*h* is higher than *e*, *f*, and *g*), and at the same time remains close to the principal text with the aid of the reference letters.

HTs were also used to develop new ideas rather than reorganize the material of the columns. Paris, BnF Lat. 6319 contains several of Aristotle's works on nature. It features some complex marginal diagrams annotated by several hands, adding insights to the central text. A complex HT in the margins of book 1 of *De generatione* elaborates on the notion of continuity according to matter and form (fol. 137r); a set of diagrams in a different hand deals with causation (fol. 262r); and so on and so forth.[6] My favorites are two HTs in the margins of the first page of book 2 of Aristotle's *Metaphysics*. The first recalls and elaborates the famous opening words to book 1, regarding the natural human desire to know. Yet just below, the author draws an HT listing the reasons why, alas, so many avoid study nevertheless (figure 3.3).

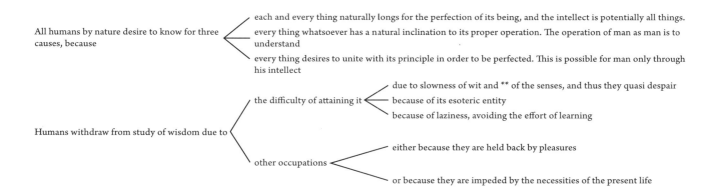

3.3 Paris, BnF Lat. 6319, fol. 243r, translation

Marginal HT glosses in philosophy also take a more formal shape, as in the next example. Paris, BnF Lat. 6459 is a nicely executed copy of Walter Burley's (1275–1344) commentary on Aristotle's *Ethics*. It is arranged as a framing gloss, encircling the original Aristotelian text, with a good number of HT diagrams. Most of them are short, like the three translated in figure 3.4.

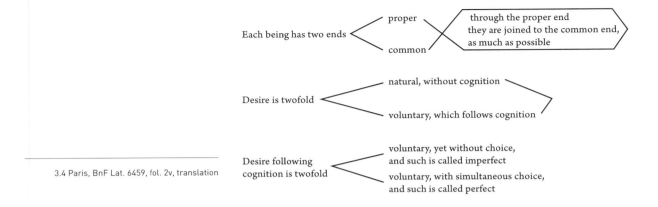

3.4 Paris, BnF Lat. 6459, fol. 2v, translation

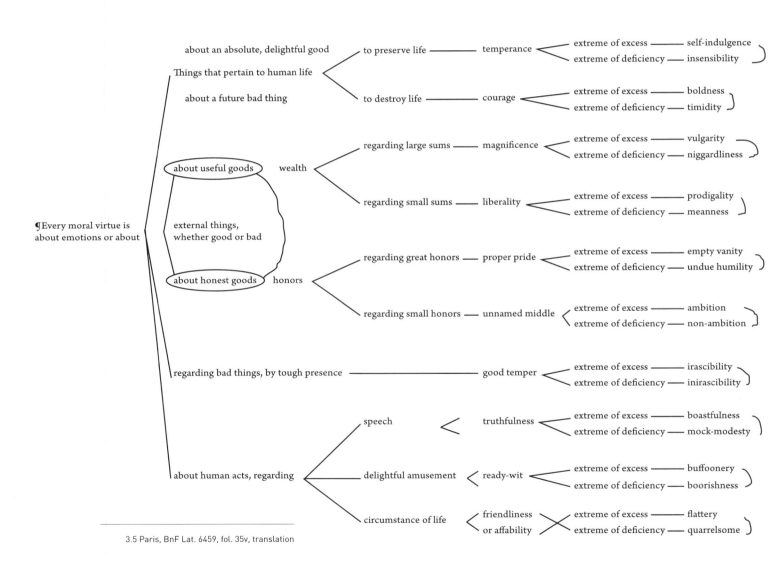

3.5 Paris, BnF Lat. 6459, fol. 35v, translation

It also features, however, complex examples, such as the one spreading over more than half a page at folio 35v, nicely summarizing *Ethics* 2.7 by showing the Aristotelian idea of virtue as the golden middle way. Each virtue is the middle way between two extremes, both metaphorically and visually (figure 3.5).

HTs were used when reading more practical branches of natural philosophy as well. In a marginal gloss to a fourteenth-century copy of the Pseudo-Aristotelian *Physiognomia*, there is an HT summarizing the types of signs by which one can "physiognomize," that is, assess the character of people or animals by investigating their bodily features.[7] This annotator saw no need to display the features themselves or enumerate their diverse significations in HTs, yet others did. Paris, BnF Lat. 6520 is a beautiful fifteenth-century copy of Albert the Great's *On Animals*, produced for the learned Leonello d'Este (1407–50), marquis of Ferrara, Modena, and Reggio and the patron of the University of Ferrara.[8] The margins are mostly empty, but on the pages regarding physiognomy we find fourteen small HTs converting bits of the rich information in Albert's text. They present the respective virtues of men opposite those of women; different properties of hair and the mental characteristics which they signify; the moral characters associated with excessive curliness of the hair. Since the survey proceeds from head to toes, several HTs about eyebrows and eyes follow, from general matters like listing the qualities that should be considered in judgment (color, shape, motion, etc.) to more specific aspects, like animals that have small pupils. Then the HT annotation ceases.[9] Were some of these used while practicing physiognomy? No one can tell. It is remarkable, however, that the only type of figure that accompanies this subject matter, that concerns such extremely visible items as bodily parts, is the conceptual HT.

The field of natural philosophy might raise intriguing questions about matters that were not paradigmatically written, therefore, especially for nineteenth- or twentieth-century readers who are used to thinking about the kingdoms of nature hierarchically in terms of orders (e.g., mammals) or families (e.g., canine) and to diagramming natural objects that *are* visible. Was this technique used to reconstruct not only conceptual procedures and matters but also families of animals? What about plants sharing the same botanical properties? Although natural philosophy looks at the world and could have found (or imagined) groups of different kinds, common and distinct features, combinations, or in short everything that HTs demonstrate well, the technique seems to be only very sporadically applied to such potential distinctions. Arguments from silence or absence are always risky. In the jungle of manuscripts, which I have traversed by way of narrow trails, there may be some HTs showing the hierarchical structure of animals, plants, or minerals, or of things rather than ideas about them. But even if there are, they must have been rare. Manuscripts of arithmetic, geometry, and meteo-

rology feature beautiful, rich diagrams, but rarely HTs. I have perused dozens of manuscripts containing Sacrobosco's *On the Sphere*, which are filled with beautiful diagrams, tables, and mild annotation. They had no HTs.[10]

Philosophical HTs do not seem to be collected into organized tapestries, and I have not yet found any philosophical work summarized or authored in the first place as a series of HTs except for Thomas le Myésier's work discussed in chapter 1. Unorganized and informal tapestries of HTs do, however, occur. Oxford, Bodl. Digby 55 is a miscellany of philosophy, ranging from grammatical texts to commentaries on Aristotle's *Physics* and the group of short Aristotelian texts known as the "little natural works" (*parva naturalia*), and it features some embedded HTs. Folios 47r–48r are tapestry pages, summarizing book 5 of the *Metaphysics* in HT diagrams. This is the point in the text where Aristotle explains fundamental concepts like *initium, causa, elementum, natura*, and, as we have seen at the beginning of the chapter, also *passio, dispositio*, and others—a classic example of a text "calling out" to be diagrammed. In most cases the HTs follow Aristotle faithfully, while at times they add further groupings on the right with additional observations ("these two are natural privation") or comments such as "and this is . . . according to the commentator." Figure 3.6 translates three distinctions relating to "cause."

As far as I have seen, philosophical HTs do not contain references to specific sources in their terminal nodes. There does not seem to be any attempt to present or create intertextuality by linking different places within

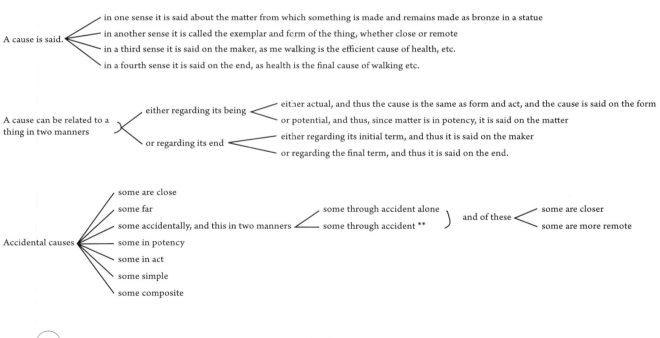

3.6 Oxford, Bodl. Digby 55, fol. 47r, translation

one text or several texts (say, senses of "necessary" in the *Topics* and in the *Metaphysics*, or in Avicenna and Averroës), such as we shall see in theological and legal *distinctiones*. Nor do they seem to travel from one context to another in the same lively, flexible manner of HT units of biblical *distinctiones*. Still, although they have never enjoyed the systematization, creativity, organization, and wide distribution of their biblical sisters, a limited form of dissociation from textual context that the diagrammatic mode enables is evident at times. A sense of the nature of such "floating," semi-independent HTs can be caught if we look at the content of an unorganized tapestry page someone scribbled on the free space he had on the flyleaf facing Thomas Aquinas's commentary on Aristotle's *Physics*. This is a selection of roots and their branching nodes, ordered roughly from top to bottom (Paris, BnF Lat. 16153; for a photo, see figure 2.20):

+ When the natural philosopher defines, he differs from the rest of the *artifices* [from the logician, because . . . / from the mechanic . . . / from the mathematician . . . / from the metaphysician . . .]
+ Note that there are movements [from the soul . . . / and toward the soul . . .]
+ Opinions on the soul [The first philosophers opined about the soul thus . . . / Democritus . . . / Pythagoras . . . / Anaxagoras . . . / Empedocles . . . / Diogenes][11]
+ *Vox* is a signifying sound, because every *vox* signifies [a concept / an emotion / by convention / by nature; etc.]
+ Intellect [imaginative power / possible / agent / speculative]
+ Life is discerned in every living thing by three indices [growth / detriment / nourishment]
+ Everything that moves, moves either [by action, and this in two manners . . . / or by itself . . .]
+ An object of the senses is [in potency . . . / in act . . .]
+ Color is [in habit or in potency . . . completely in act . . .] (This is a relatively complex scheme with further subdivisions and convergences.)

All these topics relate to natural philosophy, the subject of the text in the codex, but they are extracted without any reference to their sources and thus stand on their own feet. Particularly interesting is the uppermost HT, which distinguishes the experts in each discipline, a favorite topic for HTs in philosophical manuscripts and a true expression of Aristotelian spirit as well as boundary work of the self-definitions of the disciplines. Here, it regards the particular use of the method of definitions in each discipline. In the same vein, Oxford, Bodl. Digby 55 divides the considerations of *vox*, some of which are relevant for natural philosophers, while some are not (fol. 106r); the annotator of Paris, BnF Lat. 6319 divides the disciplines by their consideration of causation (fol. 262v).

A cluster of topics relates to the soul, the structure of which attracted many medieval philosophers and theologians. This was a classic type of subject to present as an independent HT: clear, hierarchical, useful for diverse discussion, and deeply fundamental. The five HTs I have found dealing with the powers of the soul differ from one another slightly, as all readers who have already read chapter 2 probably expected.[12] One such soul diagram on a separate page of Paris, BnF Lat. 14717, in a late fifteenth-century hand, is partially translated in figure 3.7. It divides the powers of the soul into five, starting with the vegetative powers and ending with the intellective, and between them the sensitive, appetitive, and motive powers. In figure 3.7 I have not included the complete text of each leaf on the right, which describes the operation of the power in question, because of its length.

3.7 Paris, BnF Lat. 14717, fol. 219r, translation

The one who used the free space on the last page in BAV Borgh. 296 preferred as a principal division the distinction between rational and irrational powers, as well as a different division of the motive powers, leaving no appetitive power appropriate to the irrational part of the soul. Another, in BnF Lat. 14719, focused only on the vegetative, sensitive, and intellective powers and their divisions. An annotator of BAV Borgh. 33, folio 65v, added

to a simple division of the powers of the soul the respective moral aspects, such as relating the nutritive power to gluttony.

Diagrams of the soul's structure demonstrate the conceptual emphasis typical of the HT way of visualizing knowledge. The soul is unitary, but it functions as a complex organizing principle of the entire body. While the external and internal senses were located in different areas of the head and were therefore available for illustrative anatomic presentation, the range of the soul's powers comprised also the vegetative and the intellective soul. The vegetative soul was considered holistically corporeal rather than associated with any specific organ, and therefore invisible. The intellective soul was invisible in its essence. The HTs describing the soul bear no similarity to the real, invisible soul but portray the way one should think about its powers, and thus, somewhat ironically, these HTs do indeed represent it visually.

3.2 BIBLICAL DISTINCTIONS

Distinction of senses and other things received a special flavor when applied to the colorful world of metaphors and narratives of the Bible. HTs in the field of theology, whether systematic or biblical, feature in the margins of Bible manuscripts, in the margins and sometimes embedded in the columns of commentaries on biblical books, in codices of the late twelfth-century *Historia scholastica* by Petrus Comestor (d. 1178), and in collections of sermons, and finally, they are collected in independent tapestry works. I will not discuss here the lively practice of annotating the margins of Peter Lombard's *Sentences* with subtle *distinctiones* of a doctrinal nature (for which see the first two chapters) but will focus on distinctions related to exegesis and homiletics. One gets a taste of their variety of themes by simply glancing over the first distinctions in one of the earliest collections, Peter the Chanter's alphabetically arranged *Distinctiones Abel* (late twelfth century):

+ Abel is called the beginning of the Church because . . . [four reasons]
+ Among those adhering to God, some do it for . . . [four purposes]
+ The comings (advents) of Christ are four . . .
+ Abyss means . . . [five spiritual meanings]
+ The natural emotions are four: first is love . . .
+ Human emotions are called legs, because . . . [four reasons][13]

Generating such a *distinctio* entailed discovery of parallel sets and orders and the definition of a group that had only been implicit, whether this implicitness was due to the lack of clear differences between members or because their similarity had gone unnoticed or unarticulated for any other

reason. In the latter case, the effect of the HT is very similar to the cognitive effect of metaphor and its relation to tree-thinking as defined by Eco in *From the Tree to the Labyrinth*. Surveying medieval scholastic thought on metaphor, Eco considers their acquaintance with Aristotle's *Poetics* (as well as with Averroës's commentary and the Ciceronian and grammatical traditions) and particularly the key point that "to use metaphor well implies an ability to see the likeness in things" (1456b6, "*Nam bene metaphorizare est simile considerare*" in William of Morbeke's translation).[14] In light of this acquaintance, Eco wonders at the fact that the schoolmen never developed any theory of metaphor as an instrument of knowledge. As Rosier's studies have shown, theologians did discuss the "first sense" and "second sense" of phrases such as "the fields smile" (*prata riddent*). But Eco argues that such metaphors were never developed to the colorful extent that they might have been. Although Roger Bacon and others addressed the emotional, moral, and aesthetic aspects of metaphor, and despite the richness of poetic practice, Eco concludes that Latin writers did not address its cognitive aspects.

What does Eco mean precisely when he refers to "metaphor's cognitive effect"? And what accounts for this relative absence? After a long discussion of the definitions of analogy, symbol, allegory, and figural speech, Eco proposes his own definition of metaphor. A certain unit of meaning, he argues, is first analyzed with regard to its components. Then, in order to generate a metonym or a metaphor, one may take one of these components—for example, that a cup is a receptacle—and use the first unit to represent another form of receptacle. "Metaphor," he states, "imposes a comparison between two entities that were previously separated, thereby increasing our knowledge."[15] Identifying thus the common property that two different things share brings that property to the forefront and turns it into a new genus or category.[16] In this property of the metaphor, Eco finds the explanation for the lack of scholastic metaphoric cognitive theory: "The doctrinal thought of the Middle Ages is unable to wean itself away from the model provided by the *Arbor* [of Porphyry], and as a consequence, . . . it finds itself in difficulties when it comes to talking about the multiplicity of properties that enter into play in metaphorical substitutions."[17] The schoolmen refused to theorize this play, he suggests, because it would mean that classification and trees are only practical, pragmatic instruments rather than representations of the world as it truly is. It would be to confess that the Porphyrian tree is not ontological and that the universe is not "a single organizational model."[18]

I agree with Eco that the lack of theorization he notes is interesting, but I find it extremely difficult to accept the reason he proposed, if only because at this stage of the book, and undoubtedly after reaching its end, readers already know that there is nothing the schoolmen did more easily and flexibly than generate practical, pragmatic trees of infinite kinds, which are not the Porphyrian tree and are hardly bound to a single organizational model

of the universe, be it the universe in their own mind or the one outside it. The most intriguing lack in Eco's own work, though, is his complete silence about *distinctiones* literature in general, particularly their graphical tree form.

In light of the close compatibility of metaphor with the tree form, as two cognitive models that isolate similar properties, it is illuminating that many biblical theological *distinctiones*, though certainly not all, center on figures such as metaphor, allegory, and the spiritual senses of scripture. They thus develop an "intellectual play, a devout delight in the discovery and highly articulate presentation of multiple senses."[19] In these *distinctiones*, the schoolmen did precisely what Eco said they did not, that is, systematically unfold the breadth of metaphors. The distinctions that address significations have, generally speaking, three common forms:

1. "*x* is called/denotes/signifies [*dicitur/notat/signat*] . . ."
2. "*x* is called *y* because . . ."
3. "*x* is . . ." (properties of *x* that may then be matched with a parallel set of properties)

Modern scholars of metaphor, and figural thought in general, perceive metaphors as a mapping process that takes place across two "domains." Metaphor maps the properties of a well-understood "source domain" into a less known or understood "target domain." Thus, in the metaphor "the sun smiled at us," we take "smiling" from the source domain of human beneficent expressions and actions to describe the beneficence of the sun, in the target domain of the natural world. Working in the opposite direction, when we say that "Dina was warm toward us," we import warmth from the physical source domain into the target domain of human relations.

The first sort of distinction, "*x* signifies . . . ," distinguishes different senses of a word or an object, either proper-literal or spiritual-figurative.[20] The root of an HT presents one source domain, which branches into various target domains. The opposite model, that is, putting the target—say, "virtue"— on the left as the root and then listing several objects that signify it, is rare, if not entirely absent, although it might have been logical and useful as well. One of the earliest collections of *distinctiones*, containing only "*dicitur*" distinctions, was composed by the influential theologian and poet Alan of Lille.[21] His prologue gives such a clear insight into the theological motivation behind this unfolding of senses that it is worth quoting here in full:

And thus, so that the theologian would not assert something wrong as true; so that the heretic would not confirm his error by a false interpretation; so that the Jew would be prevented from a literal understanding; and so that the haughty man would not insert his own ideas into the Holy Scriptures—we have thought it worthy to distinguish the significations of the theological words, give the reasons for the

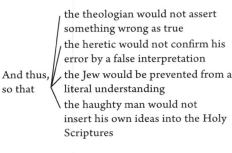
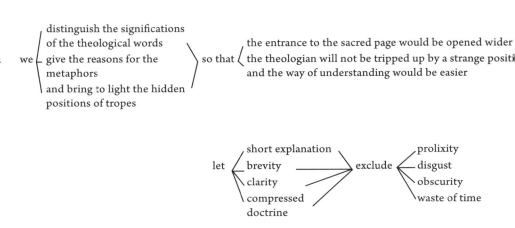
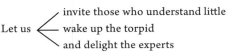

metaphors, and bring to light the hidden positions of tropes, so that the entrance to the sacred page would be opened wider; so that the theologian will not be tripped up by a strange position and the way of understanding would be easier. Let us invite those who understand little, wake up the torpid, and delight the experts; and thus, the diverse senses of terms, which lie unrecognized in different places of the sacred page, shall be brought to the light of manifestation by the explanation of this little work. Let the short explanation exclude prolixity; brevity take away disgust; explanation, obscurity; and compressed doctrine, waste of time.[22]

Alan has in mind four dangerous groups who represented constant challenges to the church, increasingly so in his time: theologians, heretics, Jews, and presumptuous, overly interpreting exegetes. Already the Pseudo–Peter of Poitiers's gloss to Peter Lombard's *Sentences* positioned theologians on the edge, warning them not to cross the boundaries set by the Fathers.[23] New readings of the Bible, particularly of the New Testament, literally and spiritually, had a significant role within most of the groups designated by ecclesiastical authorities as heretical. This was also the time of live and textual interreligious disputations with Jews, who were traditionally understood to read according to the flesh. To prevent falling into the abyss of hermeneutical error, Alan's distinctions sought to mark the proper and thus safe trails clearly.

Alan's primary goal in unfolding the different senses is therefore to limit and regulate the freedom of association and personal exegesis. Aristotle's *Topics*, in the margins of which so many HTs were drawn, clearly instructed how to avoid fallacies by distinguishing senses of terms (1.18). Explicitly inspired by Aristotle, Alan is worried all the more by such errors in the field of divine matters. As Valente has shown, his contemporary Peter the Chanter was inspired as well by the philosophical discourse on fallacies and shows in his *De tropis loquendi* an acute awareness of equivocation and of the practice of solving contradictions and fallacies by distinguishing diverse senses of a term.[24] In the case of spiritual senses, however, and following Augustine,

who distinguished between the sense of words and the "sense" of real things, the stress here is on the spiritual senses of the things themselves (i.e., the meaning of rainbow in the literal sense of scripture rather than the sense of the *word* "rainbow").

Alan wished to control the creative potential of hermeneutical and analogical-associative-metaphorical thought. Yet the *distinctio*, particularly in its HT form, encompasses not only the imposition of order but also the inherent absurdity of any attempt to regulate our associative thoughts, our always-seeking-new-analogies minds. By externalizing associative cognition on the page, it expresses the duality of the technique, creating a seemingly stiff hierarchy and order while allowing flexibility and creativity. Despite the intention to "freeze" spiritual senses, the technique (essentially generative, exciting, and delighting as Alan noted) insinuates to the readers, almost provocatively, that they may add items or exchange existing ones for others, taken from other sermons, biblical commentaries, philosophical works, or, as the genre developed, directly from nature. "The collections become ever more lengthy as time goes on—not in increased number of entries, but in increased length of the individual entry."[25]

A second popular class of *distinctiones* dealing with figural speech was constituted by those focused on only one source-target pair, providing different reasons for their relation, usually by noting their similar properties. To this group belong *distinctiones* such as "why Christ is called a lamb" or "why emotions are called legs." In most cases, these are represented by simple one-split HTs, but sometimes they branch to further subtleties of subclassifications. Such is the elaborate marginal HT in William of Alton's commentary in Assisi, BC 49: "sin is called darkness," translated in figure 3.8. (The references were omitted from this translation. All are biblical but the last one, which is attributed to the Muslim astrologer Abu Mashar, d. 886.)

Such visual analysis instructs us that y signifies x, not only thanks to one or several common properties that x and y share but owing to different

3.8 Assisi, BC 49, fol. 5r, translation

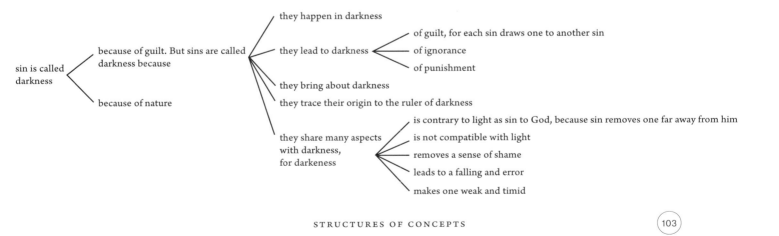

sorts of relations, such as "*x* happens during *y*," "*x* leads to *y*," or "*x* originates in *y*." Furthermore, metaphors are understood to be related to other pairs of source and target domains. In the case of "*x* (sin) is called *y* (darkness), since it leads to *y*," *y* is not simply darkness but three additional things that are called darkness: the darkness of guilt, of ignorance, and of punishment. Only the last category of links is a general, somewhat unorganized class of "sharing many properties." Some draw analogies between body and soul, which the readers are supposed to complete on their own. People are prone to fall when it is dark—sin leads the soul astray to error. Darkness weakens the human body—and sin weakens the soul. Two items are linked to a complementary conceptual metaphor, namely, "God is Light." As darkness is to light—contrary and incompatible—so is sin to God.

Such analyses do not remove obscurities of equivocation; nor do they regulate interpretation. Rather, they aim at a deep investigation of the nature of one metaphor. This investigation reveals that source and target domains in metaphorical thought are not dependent on a thin thread of one similar property but are bound with several threads of relationship. The act of interpretation is refined. How precisely, in the verse you wish to interpret now or preach upon, are legs emotions? Is it in their capacity to move man from one thought to another, as legs carry the body from one place to another? Or do they lead one astray from the right path? One may have thought on one of these, but it makes one consider other options as well, and thereby create a novel world of thought that had not previously existed.

The example from Petrus Comestor that Barney brings to the use of such a distinction, "honey is knowledge," demonstrates how such an investigation works.[26] Honey is knowledge, not because honey and knowledge share one characteristic in common, but because they share several. Yet the significant move here is not the mere recognition of similarities but the illumination of hidden qualities. The writer/preacher uses the distinction of four types of honey to distinguish four types of knowledge, which are defined only thanks to this superimposition of a scheme from the source domain. Other properties are unfolded as well: honey nourishes, but might also puff up or sting, like knowledge. Does knowledge sting? How? The fact that this very question arises shows the power of weaving such thick webs between targets and domains.

In their classic *Metaphors We Live By*, Lakoff and Johnson demonstrate that metaphor is not a poetic, extraordinary linguistic phenomenon but a crucial part of common human speech, of thought and action in the world. One of their most memorable arguments was noting that metaphors are not "individuals" but belong to "families" of a general conceptual principle. Thus, to take their first and most famous example, this group of sentences may be generalized under the conceptual metaphor "Argument is war":

Your claims are *indefensible*.
He *attacked* every weak point in my argument.
His criticisms were *right on target*.
I *demolished* his argument.
I've never *won* an argument with him.[27]

Verbal metaphors are therefore anchored in metaphorical concepts, and they reveal systematic patterns. To take another of their examples, a great variety of expressions, like "I'm feeling up," "My spirits rose," "You're in high spirits," can be generalized into the conceptual metaphor "Happy is up" or to a broader metaphor of orientation, "Happy is up; sad is down." By generating the type of *distinctiones* that enumerate different reasons, the schoolmen performed a similar systematization, extracting from several different occasions a general metaphorical equation such as "Christ is Light." This same approach toward conceptual generalization is seen also in the use of cross-references in the *Distinctiones Abel*. If you go to the entry "God afflicts man for five reasons" (*affligit Deus hominem 5 de causis*), you will not find it splitting into five; it sends you instead to "punishment" (*pena*), where the fivefold division is fully worked out.

Finally, there were distinctions that separated one concept in the source domain into components but did not link them to a target domain. The structural relations in the source domain could then be superimposed on another subject, thus highlighting structural features that mirrored one another in the target domain and that may have been heretofore hidden. Such an intention may have lain behind the annotator's decision in figure 2.7 to branch off only the properties of stars, although the text in the column also provides a target, applying these properties to the prelates of the church. Detached from that application, a skilled preacher may then use the properties of the stars to find or generate a mirror structure in a new target domain.

HT distinctions delineate new trails to traverse not only in the mind but also across textual layers. Points in which the same words, terms, concepts, objects, or events appeared were dissociated from the continuous biblical text and connected to each other.[28] In many cases the specific place in scripture where the object had this sense was explicated by attaching *lemmata*: references and/or the first words of the relevant verse. The layer of the authorities in whose writings this spiritual sense appeared remained invisible, as most were unacknowledged.[29] By doing so, the *distinctiones* linked meanings that were, as Alan put it, scattered in different places in scripture and the classics, but they also invited one to an open realm of hermeneutics. In this imaginary space of the textual corpora, *distinctiones* functioned like the magical means of transportation in fantasy literature, by which one travels instantly to distant locations or to other universes. In J. K. Rowling's world

of *Harry Potter* these are ordinary objects turned magically into portkeys. *Distinctiones* transport the reader from one sentence, idea, or scene to several others at once, weaving webs across the text that associate them. The HT distinction externalized a new neural-textual web, not replacing or displacing the biblical narrative but woven above and below it.

Such portkeys were given, as noted before, to readers and users on different literary occasions. When placed in the margins of a biblical book or commentary,[30] they offered the reader of the text a key to a labyrinth of intertextuality and conceptual interrelationships, in addition to that already constructed in the body of the running commentary, without interrupting its flow. Consider manuscript Tours, BM 121, containing an anonymous (Dominican?) commentary on the Gospel of Matthew. Readers following the commentary in the principal columns could hardly guess into which distant textual places the diagrams below would take them. Thus, for instance, the commentary at folio 2v has only a brief comment on the phrase "*liber generationis*" (Mt 1:1). But the dazzling breadth of "*liber*" (book) is fully unfolded in the extensive marginal diagram translated in figure 3.9, which enumerates the different things called a "book" throughout scripture and explicates the metaphors further by specifying what is written in each such "book."

Such doors into multiple magic corridors leading to other now-associated texts, ideas, or scenes broaden the readers' echo-boxes and delight their intellects by stimulating, and at the same time gently manipulating, their associative paths. "It is to leap with the mind in a way that gives pleasure in itself,"[31] or as Alan mused: "a delight for experts." Durand of Huesca elaborated on the rhetorical aesthetics of the distinction for the preacher in a prologue to his collection, around the year 1210:

Lux, dux sermonis, distinctio fons rationis
Artibus et donis, locuples sceptrum Salomonis
Qui non distingit, non mira poemata fingit
Verba decus cingit, pia que distinction pingit

[That leader, light of the sermon, the distinction, fountain of reason / in devices and gifts as opulent as Solomon's scepter // Whoever does not distinguish does not fashion wondrous poems / Elegance encircles the words that the pious distinction paints][32]

Figurative language and metaphor perform this colorful task in a particularly charming and surprising way. But this effect occurs also through *distinctiones* of other kinds. In the commentary on the Gospel of John 1:23 (*vox clamantis in deserto*) in Assisi, BC 49, folio 8v, for instance, the diagrams in the bottom margin list for the reader these contexts, together with references:

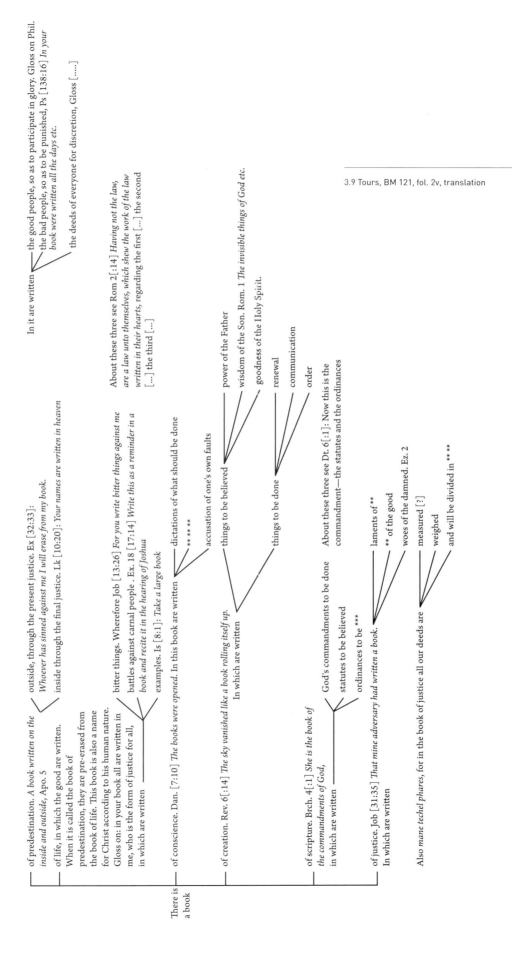

3.9 Tours, BM 121, fol. 2v, translation

+ *A shout was made to* [four groups: those who are afar, asleep, etc.]
+ *Christ shouts through* [five media: scripture, John, his blood, etc.]
+ *He* [i.e., Christ] *is called a voice because* [four reasons]
+ *One reads of five who were called voices of God . . .*

A view of history and doctrine is opened wide on the bottom margin of the page, where being a voice in the desert may be contextualized. Similarly, while the running commentary in Tours, BM 121, folio 8r, comments upon Herod's order, the margins enumerate four actions by which Herod figures the devil; four other historical instances in which children were ordered to be killed; and nine senses of "way" (*via*), classified into "ways of life" and "ways of death." Indeed, from the very beginning of the technique, it was clear and even highlighted that metaphors are malleable and that the same objects may easily stand for opposite features, good and bad. (See figures 1.3 and 1.4, *fumus* and *horses,* in chapter 1 for examples.)

The independent, noncontextual nature of the distinction in its neat graphical packaging as an HT facilitated borrowing, importing, exporting, and reuse of such information units in and out of different contexts. As noted above, *distinctiones* not only were attached to texts but were also shepherded from different sources into alphabetically, thematically, or biblically arranged collections, a genre unto itself.[33] When presented as HTs, which was certainly not the case in many manuscripts,[34] their layout consisted of chains of short HTs in a tapestry form.[35] The earliest collections, those of Peter Chanter, Peter of Poitiers, Alan of Lille, and Praepositinus of Cremona, were compiled in the last quarter of the twelfth century, and they were followed by many others in the thirteenth century, the golden age of the genre, before slowly fading out of fashion in the fourteenth.[36] They provided theologians, preachers, and perhaps also poets (or masters like Alan who wore all hats)[37] with an extremely flexible, valuable, and awe-inspiring instrument, essential to the new style and format of sermons that centered on a verse or even a word. The HT visualization helped to generate, manipulate, reorganize, and memorize them. Since this application of *distinctiones* has al-

Distinctions are like portkeys
- because portkeys quickly transport the graspers from one place to another and so do distinctions from one scriptural place or context to another
- because the enchanter can turn almost any inanimate object into a portkey, just as almost every thing in the world can signify multiple things and be a root of a distinction
- because they transport to a location predetermined by their makers
- because portkeys can be used mistakenly by muggles, as distinctions by unauthorized preachers
- because portkeys can transport to destinations that are unmappable and protected against most forms of magical access and therefore should be authorized; associative thinking can provoke illicit interpretations as well
- because portkeys may be enchanted to transport the grasper only at a given time, and the preacher uses distinctions only in the appropriate time during the sermon
- because they can transport many to the same location at once

ready been discussed at length in scholarship, I will not expand on it here.[38] By using one or two such *distinctiones* as a skeleton for sermons, preachers used their magic portkeys to lead their listeners masterfully on surprisingly pleasing adventures in the textual land of the Bible and of the mind, into "an investigation of the layered wealth of meanings to be found there."[39]

3.3 CANON AND CIVIL LAW

Those who acquired the habit of paradigmatic writing during their primary years in the faculty of liberal arts, both as students and as masters, applied it to their advanced studies, not only in the faculty of theology but also in the faculties of canon and civil law.[40] Legal manuscripts are known to be particularly intriguing.[41] They survive in large numbers, frequently richly executed, sometimes splendidly illuminated, and often systematically glossed with commentaries framing the main text. The most common diagrams in the medieval legal context were the Tree of Consanguinity and its sister diagram, the Tree of Affinity.[42] These helped readers, mainly canonists and theologians, understand the intricacies of legal and illegal marriages between relatives, according to the permitted degree of relation. Not only were these figures widely distributed and known since the early Middle Ages, they also enjoyed the privilege of having their own instruction manual, the *Ad arborem* by Robert Kilwardby (d. 1279), a Dominican theologian who instructed users on how to deal with the lines and calculate what they needed.[43] Several manuscripts of this work include an HT that represents the structure of the treatise itself (on HTs representing text structure, see chapter 5).

Legal manuscripts featured a variety of visual aids assisting their users in orienting themselves within complex mazes of canons and decrees and committing them to memory while alleviating their boredom with relevant cartoon-like figures.[44] HT diagrams feature in the margins as well, though perhaps less frequently than they do in logical or theological textbooks. Figure 3.10 shows a page from a manuscript of Gratian's *Decretum* with several such distinctions enveloping the main text of together with other notes. The *distinctio*—as an intellectual tool, not necessarily in its HT layout— served the needs of both canon and civil jurists perfectly, as their task was "essentially a synthetic one, that is, the one of relating later pronouncements of the legislator to preceding ones while revealing the lack of contradiction between them," resolving antinomies and examining passages "not in isolation but in relation to the whole."[45]

Legal theory and practice require one to notice the peculiarities of cases that may look the same and to adjudicate them accordingly.[46] Consider, for example, BAV Pal. Lat. 624. This is a copy of Gratian's *Decretum* (or *Concordantia discordantium canonum*), one of the most widely disseminated

and popular textbooks in the canon law faculties since its composition in the twelfth century.⁴⁷ This thirteenth-century codex was produced with a continuous commentary in the upper and side margins. Its bottom margins, however, are especially wide and clean, and every few pages they host a finely executed HT in a later hand.⁴⁸ The first diagram on folio 5v (figure 3.11) distinguishes different kinds of custom (*consuetudo*) and appears in at least six manuscripts.⁴⁹ It is an "algorithmic" tree: like the *figurae* of the syllogisms, which determined at each terminal node whether the particular case defined during reading the diagram is "useful" or not, each terminal node here ends with a determination of whether or not such a custom must be observed. ⁵⁰

3.10 (facing) Munich, Bayerische Staatsbibliothek clm 28175, fol. 22v, several HTs in a Bolognese copy of the *Decretum Gratiani*

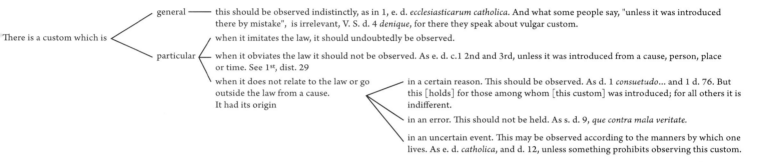

3.11 BAV Pal. Lat. 624, fol. 5v, translation

The HT on folio 88v (figure 3.12) addresses the popular discussion topic of ignorance of the law and of the fact. It shows how different cases entail different treatment—whether exempt or not.⁵¹

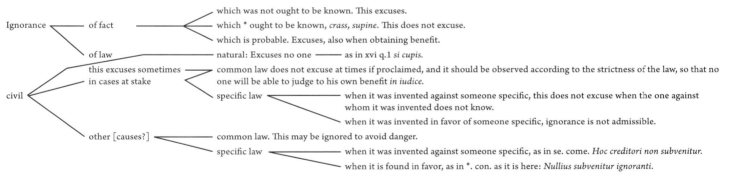

3.12 BAV Pal. Lat. 624, fol. 88v, translation

BAV Pal. Lat. 696 is a copy of the *Breviarium extravagantium* by the Italian canonist Bernard of Pavia (d. 1213), a collection of ancient canons which were not included in Gratian. The manuscript contains multiple HTs, mostly in the upper margins. These are used to distinguish procedures for different cases. Thus, for instance, the diagram on folio 57v deals with the burial of adults, dividing cases as to whether the deceased are residents or not, then according to whether they chose a specific place, and so on. Another,

STRUCTURES OF CONCEPTS

on folio 82v, distinguishes conditions regarding marriage engagements, with each branch ending with *tenebit* or *non tenebitur* (will hold or not). HTs were used also to list cases related to the judicial procedures themselves. A diagram in the margins of a short excerpt of Gregory IX's *Decretals* enumerates all cases in which an appeal shall not be admitted in court.[52] An HT to the Justinian codex of civil law enumerates all cases in which an agreement is annulled.[53]

While such flowcharts and distinctions may represent the majority of applications of paradigmatic writing in legal discourse, there is some indication of employing its potential for regrouping or double grouping items, using it to think about inner classifications. Such posterior grouping may be the case in folio 114r of BAV Pal. Lat. 696 (figure 3.13). This is a diagrammatic footnote to the decree of Pope Alexander III *Super eo*, dealing with school violence. The decree determines at the end that "[i]f, however, these disciples or *clerici* hit each other, they should go for their absolution to the Apostolic See."[54] The HT annotation softens and qualifies this general rule by listing its exceptions. Its third column suggests commonalities shared by subgroups of these excepted cases, whether because they are mentioned in the same decree or because "these [should be treated] more attentively—they were excepted only in order that we would not be sent to Rome." This seemly unplanned regrouping caused a bit of a mess, which I tried to follow closely on figure 3.13:

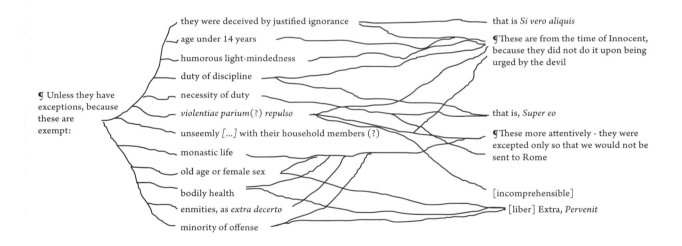

3.13 BAV Pal. Lat. 696, fol. 114r, translation

Legal discourse was, as it has always been, anchored essentially and tightly in its authoritative textual corpora. Many HTs, therefore, display references at the ends of their terminal nodes, mostly cited by the prevailing reference abbreviation system in legal theory and usually beginning with *ut*

CHAPTER { 3 }

(as in . . .). Often, a distinct column was assigned to the references, as can be seen in BAV Pal. Lat. 624, folios 14v, 15r, 16v, 17v, etc., or in this simple example from folio 11r in figure 3.14:[55]

3.14 BAV Pal. Lat. 624, fol. 11r, transcription

As with theological *distinctiones*, such referenced *distinctiones* served as portkeys to different parts of those corpora, creating new links within a canonical network and thereby enhancing its cohesion and holistic nature. While the main text, for instance, claimed that a bishop should consult his clergymen regarding ordination, the author of the diagram in the margin below the main text noted three additional cases in which the bishop should do so, each case mentioned in a different place in this volume and in other works, creating thereby a new group of "occasions by which a bishop should consult his clergymen."[56] Referencing *distinctiones* also allowed the reader to impose a new organizational scheme on the sequentiality of a collection of canons. The diagram in BAV Pal. Lat. 624, folio 42v, distinguishes the different procedures in cases of the ordination of a serf to the priesthood, depending on whether the serf's lord was aware of the ordination or not and if he knew but resisted. Almost all the references in the terminal nodes are to canons in this or the following folios, but not in their original order and sometimes to the same canon.

Paris, BnF Lat. 4289, a fourteenth-century codex containing Sicard of Cremona's *summa* of canon law, boasts a good number of embedded and parasitic forms of HTs. I did not find unorganized tapestries or full-page charts in the fields of canon and civil law. What would the legal equivalent be of preacher manuals using distinctions? Perhaps court speeches, minute books, or *consilia*. Vincenzo Colli, an expert in this field, has not seen HTs in such manuscripts, though this might be a matter of the rarity of manuscripts of this sort.[57] Back to the classroom, there is at least one example, however, quite early, of an organized tapestry work (which we have already met in chapter 1): that of Richard de Mores (Ricardus Anglicus, 1161–1242). An Anglo-Norman doctor at Bologna, Richard compiled several works abbreviating and elucidating aspects of Gratian and other glossator canonists by way of summaries, verses, and any pedagogical tool he could think of. Inspired by fellow theologians and the Paris schools,[58] he then compiled his collection of distinctions summarizing key points relating to Gratian's *Decretum*.[59] The diligent reader, he promises in the prologue, will be able to find

there fine distinctions as well as succinctly summarized novel insights that are usually discussed by the doctors at great length.[60] Richard's *distinctiones* consist mostly of two-level *distinctiones*, but occasionally, there are more complex examples, with up to six levels. Many *distinctiones* are of the *dicitur/est* type, distinguishing senses of terms or types of things. Others provide the student with an outline of the matter discussed in a certain section of Gratian, emphasizing what should be known on this or that topic, such as the one in figure 3.15.[61]

3.15 BAV Vat. Lat. 2691, fol. 12v, translation

3.4 MEDICINE

Next to the advanced faculties of theology, civil law, and canon law in medieval universities was the prestigious and lucrative faculty of medicine. The theoretical approach to medicine taught there owed most of its corpus and doctrinal framework to the Greek, Roman, and Arabic traditions. While we do not know enough about the Greek and Roman periods, Arabic manuscript traditions employ a variety of means to visualize medical information, whether through detailed anatomical illustrations or by tables and diagrams of diverse sorts.[62] One intriguing example of the dynamics of transmitting layouts together with their content to the Latin world is Ibn Buṭlān's influential eleventh-century guide *Taqwīm al-sihhah* (*The almanac of health*).[63] It has a unique layout, based on about forty tables spreading over the pages. Ibn Buṭlān himself explains the importance of this graphical choice in his prologue, and both he and other Muslim writers noted that the concision afforded by the tabular format is especially suitable for impatient practitioners less interested in theory. The earlier copies of the Latin translation, the *Tacuinum sanitatis*, made around 1250, retained this layout more

or less accurately,[64] but later copyists of the fourteenth century abandoned it in favor of endowing the work with lavish, richly pictorial, and clearly not practice-oriented illustrations.[65] Other luxurious medical manuscripts featured anatomical illustrations of different kinds. The method of *diaeresis,* or division into *genera* and *species,* was predominant in this Greco-Arabic tradition,[66] and the Arabic medical manuscript tradition also includes works of Galen written by way of successive trees very similar to HTs (see the *tashjīr* diagrams mentioned in chapter 1). Whether they influenced the Latin manuscript traditions is a matter for future investigation, but one way or another, the habit must have diffused from the other faculties as well.

O'Boyle has observed that "students apparently devoted a good deal of time outside the classroom to reproducing a variety of schematic diagrams." On the other hand, in contrast to my findings in the *Organon* survey, he argues that "the fact that so many copies survive which bear a striking uniformity of content and design suggests that archetypes or templates may have circulated among scholars in the faculty." O'Boyle divides these diagrams into roughly three types, each associated with a particular textbook:

1. Large diagrams that were intended to provide an immediate visual representation of the formal structure and basic theoretical content of a work, particularly found in Galen's *Tegni*.
2. *Divisio textus* diagrams, frequent in the *Aphorisms*. About this type, see chapter 5.
3. Smaller diagrams used by students "to present the broader theoretical context of a particular issue being addressed in the text," as in copies of the Johannitius's *Isagoge* or Theophilus's *Urines*.[67]

A brief glance at examples reveals these different behaviors and contexts. Paris, BnF Lat. 16174 is a typical textbook, copied sometime during the mid-thirteenth to the mid-fourteenth century. It includes Hippocrates's *Aphorisms*, *Prognostica,* and *De regimine*, as well as Galen's commentary and Galen's *Tegni*. Its first one hundred folios contain seventy small HTs in at least two hands.[68] Folio 116v boasts a large, whole-page HT (see figure 1.20), described verbally by O'Boyle.[69]

The annotators of this volume applied HTs for different matters, but particularly causal relations. A simple instance in folio 25v enumerates three causes for suffocation, the HTs on folio 35v enumerate causes as well, and the amusing one with a face on folio 52v enumerates all factors that lead to the generation of the choleric humor. Several notes address a reader in the second person: "you must know these" (fol. 51r), "with these four you will be able to diagnose whatever you like" (51r), and so on. Figure 3.16 shows a distinction of a symptom traced into its closer and more remote causes, guiding the reader, as in logic and law, through a kind of questionnaire-

algorithm. Is the breathing difficulty caused by pain or inflation? And if by pain, is it a small or a frequent pain?

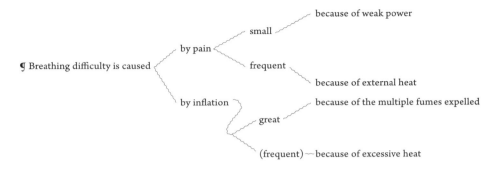

3.16 Paris, BnF Lat. 16174, fol. 57r, translation

In the margins of the Hippocratic discussion of crisis (fol. 72v), the turning point in the development of a disease, the annotator added six HTs. One of these divided crisis into good and bad, then each into sudden or quick, converging to its consequence, either health or death. Another divides crisis in children into those occurring by sleep and by sweat; another distinguishes eight cases in which crisis is good, and so on and so forth. Figure 3.17 reproduces two such simple HTs. Notice the unusual direction of reading required by the branching in the former and the unusual design of the latter.

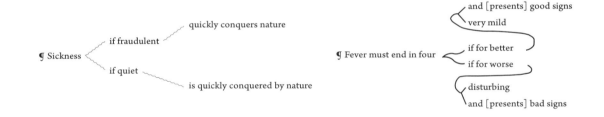

3.17 Paris, BnF Lat. 16174, fol. 73v, translation of two of three HTs

London, BL Harley 3140, another *articella* collection of medical treatises from the fourteenth century, abounds with marginal HTs far exceeding the material in the columns. Its folio 2r, the first page of Johannitius's introduction (*Isagoge*), includes HTs detailing causes of each humor according to the Aristotelian four causes; the natural and unnatural states of each humor divided further and further and ending with specific states and their names; and for dessert, at the very bottom, an HT of a text division (figure 3.18).

London, Wellcome Library 49, or the "Wellcome Apocalypse," prepared around 1420, is as far as a manuscript can be from scribbled student marginalia.[70] It is a beautiful, lavishly executed manuscript containing nearly three hundred drawings and dozens of German and Latin texts relating to a variety of topics, ranging from medical to theological and moral issues, and

has received intensive scholarly attention. Between the eye-catching illustrations lie only a few, modest HTs, in a section dealing with the humors. The HT translated below is one of four diagrams which visualize causation and physiological explanation according to the classic humoral theory. Each of the four deals with one of the humors and divides according to the potential problems it causes, the specific place in the body where it occurs, its quantity, and other parameters, until at the terminal nodes we find the specific disease.[71] They therefore beautifully illustrate the theoretical principles of humoral medicine, from the fundamental cause to its specific symptomatic expressions. Figure 3.19 presents the HT of bile.

Like philosophical *distinctiones* and unlike legal and theological ones, medical HTs do not create any intertextuality or even refer to the textual

3.18 London, BL Harley 3140, fol. 2r. Courtesy of the British Library Board.

3.19 London, Wellcome Library 49, fol. 43r, translation

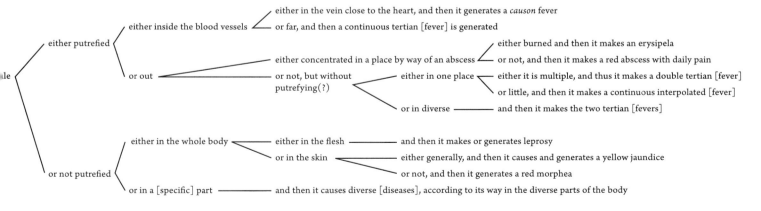

STRUCTURES OF CONCEPTS

117

authorities by lemmata. They were occasionally dissociated from a paratextual existence to create unorganized tapestries. Folios 9r–14v of BAV Pal. Lat. 1229, a compilation of medical treatises dated to the middle of the fifteenth century, are dense informal tapestries of simple and complex HTs summarizing medical matters, mainly from Isaac Israeli's *De urinis* detailing diverse properties of urine according to quantity, quality, and so on. A user of BAV Pal. Lat. 1084, a collection of medical treatises, employed the technique to represent multiple divisions as well. Folio 44v, which was once blank between two texts, was covered with HTs detailing lists of materials: herbs, species, and minerals good for purifying the humors or for specific medicines.

I have not found any organized collection of medical HT *distinctiones* like the sophisticatedly arranged theological ones. We do have, however, an example of a medical tapestry work. The "Tabula" on the *Vita brevis*, attributed to Arnald of Villanova (ca. 1240–1311), is an abridgment of Hippocrates's *Aphorisms* by way of HT diagrams.[72] A nice copy of this popular work, extant in nineteen manuscripts and printed at least twice, can be seen in BAV Pal. Lat. 1268, completed in 1434.[73]

3.5 CONCLUSION

My main purpose in this chapter has been to demonstrate the use of paradigmatic writing in all major disciplines and institutional faculties of the medieval university by way of examples: liberal arts, theology, law, and medicine. Its employment is remarkably coherent across the disciplines in terms of the way the diagrams look and the reading strategies they represent, particularly the externalization of the process by which one identifies, reconstructs, or imposes conceptual structures and organizational schemes on a central, authoritative text. There are nuances of use, however. Philosophical and medical HTs do not bear traces of their textual origins by way of references; they rarely travel elsewhere beyond a specific text and were not gathered into organized collections. Both law and theology, however, make creative use of the form, in order to link and juxtapose different points from broad textual corpora. Biblical theology in particular takes the distinction of meanings into colorful, subtle places and, in general, shows more flexibility of use, sometimes organizing HTs into collections and applying them beyond the classroom.

{ 4 }

Structures of Language

The intellectual procedures and products of distinction, discussed in the previous chapter, were rendered visible by an instrument playing on the interfaces of thought, speech, and writing. The present chapter gathers together applications that direct this tool, in a somewhat reflective manner, to language itself as its object. I shall first address the use of paradigmatic writing to highlight sonic patterns and then to teach how to write formal letters, closing with the teaching of grammatical doctrines and structures. While all these subjects relate to the trivial arts, I shall not address horizontal tree diagrams (HTs) of rhetorical theory and concepts, such as those appearing in glosses for Cicero's works. These demonstrate the same behavior described in the previous chapter but rather explore the peculiar uses of the technique to highlight specific language structures.[1] Since language is in the center, translations would miss the whole point. Instead, I shall provide transcriptions in the original Latin and, to facilitate understanding of the principles of the technique, English examples fashioned after Latin models.

4.1 VERSE AND RHYME

Since antiquity, poetical texts have enjoyed a special, immediately recognizable layout.[2] Often, the length of lines was not dictated by the spatial constraints of the material medium but by aspects of poetic form that functioned as intrinsic constraints, such as prosody of meter or, in modern times, meaningful pauses. As Bourgain has argued in her definition of *versus*, it is the property of verse that it does not proceed continuously as prose does, "*découpé selon la dimension strictement contingente et materielle du cadre d'écriture.*"[3] While sound primarily dictated the appearance of the written poem, visuality at times imposed its own authority. In premodern Greece, India, Islam, and Europe, and up to the twenty-first century, poets have been experimenting with visual poetry, figurative poetry or "pattern-poems" (*carmina figurata*), in which differing lengths of lines trace the shape of a sword, arrow, wing, cross, column, or more complex figures, against a blank background or one made out of letters.[4] But even when not iconic and blatantly visual, every written poem possesses a visual dimension, stimulating

the eye as much as the ear. "The seen poem" as referred to by Huisman, has its own semiosis.[5]

To what extent can layout mimic the primarily sonic nature of the poetic endeavor? How can visuality convey structural features and shape the experience of reading a poem aloud or in silence? The distinct "*découpé*" line frames a metrical unit such as a hexameter or pentameter. The practice of separating the first letter of each line (*littera notabilior*), seen in Western manuscripts since at least the ninth century,[6] even further emphasizes the autonomy of the line and the recognizability of the poem as such. Early medieval scribes used indentation and sometimes *majuscules* and even more dramatic means in some cases to indicate the beginning of subunits longer than a verse like stanzas and strophes.[7] One scribe of Paris, BnF Lat. 1154, for instance, framed each strophe with a bold green curly line. Twelfth- and thirteenth-century scribes used paragraph marks in red or alternating colors.[8] Gradually, simple bracketing of the kind that indicates "this is a group," as discussed in chapter 1, was used to indicate stanzas in Latin, English, and French poetry.

At about the same time, medieval scribes began to employ the principle of paradigmatic writing to visualize rhyming patterns. Although not always central to poetic expression, rhyme accompanied Latin poetry in one way or another since the early Middle Ages.[9] Especially popular was the internal rhyming of two parts of hexameter, known as "Leonine rhyme," as in Poe's *Annabel Lee*: "For the moon never *beams* without bringing me *dreams*" (italics added). Leonine rhymes were popular in the ninth century and became even more so in the tenth, becoming an essential feature of medieval hexameter. In the late eleventh century, poets began to explore even more complex patterns of rhymes and of strophe structure, and it is then that we also encounter graphical attempts to visualize rhyme.[10]

Unlike meter or prosody, which cannot be signified in writing without using special marks, the sonic effect of similar sounds potentially has a visible parallel in phonetically based scripts. The arrangement of lines one below the other facilitates detection of sound recurrence at the beginning (anaphora or alliteration) or end of the metrical unit (rhyme). This opens the way to further enhancements of this effect and control of the reader's attention to it by applying the HT principle of converging the common and splitting the distinct. To use the example above, Poe's line would look like figure 4.1.

This technique is even more effective when it comes to caesural, interlaced, or crossed rhyme. Sonic similarity inside the lines may easily escape the eye, while the ear would immediately sense it, as in this layout of Henry Longfellow's *A Psalm of Life* ("what the heart of the young man said to the Psalmist"):[11]

For the moon never b ⟶ eams
without bringing me dr ⟶

4.1

Not enjoyment, and not sorrow is our destined end or way
But to act that each to-morrow find us farther than to-day

But the ear would be no match for the eye in catching the scheme when it is displayed as in figure 4.2.

```
Not enjoyment and not s ⟩              ⟨ is our destined end or w ⟩
                          orrow                                    ay        4.2
But to act that each tom ⟩              ⟨ find us farther than tod ⟩
```

Multiple examples of such designs in poetry appear in medieval manuscripts.[12] Neither Bourgain nor Parkes, who addressed this graphical phenomenon, noted that this is part of a general and cross-disciplinary habit. Both refrained from precisely determining its earliest appearance as well. The earliest examples they bring are of the second half of the twelfth century, and both recognize that "from the thirteenth century onwards some scribes preferred more 'diagrammatic' layouts in order to display the structure of the stanza."[13] True, the "tree" in the term "horizontal tree" that I coined in chapter 1 may seem to be strained here. However, this layout works according to the principles defined in chapter 1 (indicating distinctions and commonalities with horizontal splits and convergences) precisely as more typical HTs and therefore undoubtedly belongs to our story. I chose three examples demonstrating the variety of contexts in which the technique was applied to visualize rhyme: the *Carmina Burana* manuscript, a famous and carefully designed codex of poems; a theoretical-pedagogical treatise on rhyming; and a religious, ekphrastic hymn to the Virgin Mary. Finally, I shall examine the use of this technique in ornate titles and colophons. While sharing the same basic principle with other HTs, the context of this specific application deviates from the contexts I have addressed so far. All instances are embedded in the column, proudly formal and decorative. They have nothing to do with a peripheral response to a principal text, whether as representation of information or as a comment.

Munich, Bayerische Staatsbibliothek clm 4660—the famous *Carmina Burana* codex—was compiled in south Tyrol around 1230.[14] It is a beautifully executed, illuminated codex, containing a dazzlingly rich collection of Latin and High German poems of diverse kinds on various subjects. While most of the poems are rhymed, not all of them are designated *versus* or even laid out in separate lines. The scribes apply the HT technique only occasionally, and only to metrical verse. In folio 4v, transcribed in figure 4.3, the scribe demonstrates the inner rhyme of the first five lines of the *versus* and the peculiarity of the sixth, which does not share this structure. The identical ending into which the first five lines converge is placed in the column of the second part, elevated only a little from the continuation of the line.[15]

4.3 Munich, Bayerische Staatsbibliothek clm 4660, fol. 4v, transcription

Note that this verse could be represented also by converging the entire first part of each of the first five lines, since the phrase "*Cur homo torquetur*" (why is man afflicted) is identical in all of them. The scribe, however, chose not to do so. He converged only the lines featuring the -*etur* ending, which repeats in the second column, preferring to emphasize the symmetry between the two parts of each line. Such symmetry is demonstrated again in the poem "*Fervet amore Paris*" ("Paris burns with love," fols. 76v–77r; *Carmina Burana,* no. 103), which was composed perhaps during the first half of the twelfth century. Both middles and endings of each couplet rhyme here. All couplets, except the first one, conform to this pattern, like so (figure 4.4):

4.4 Munich, Bayerische Staatsbibliothek clm 4660, fol. 77r, transcription

Positioning the common sound on the same imaginary vertical line of the second part of each line complicates the natural flow of eye movement during reading and slows it down. This complication, rather than facilitation, of reading is achieved also by merging not only the common syllable but also the entire sound cluster, including the vowel of the preceding syllable. This isolates its consonant from the natural reading strategy, which prefers division into syllables. The scribe thus focuses the reader's attention on the orthographic, visual, and phonetic aspect instead of following phonological rules and keeping syllables together, taking the emphasis on visuality over sound to an extreme.

This poem, however, also betrays the failure of even phonetically based scripts to perfectly visualize sounds and their similarity. Amy Winehouse may sing and rhyme, "You went back to what you kn*ew*; So far removed from all that we went thr*ough*," because *-ew* and *-ough* sound very similar although they look completely different.[16] Such incongruence hampers our scribe on the last couplet on this page, where *c* and *q* had to be left in the "difference zone," although they sound the same and are an integral part of the quadruple rhyme /ekus/, rhyming *equus* (horse) and *ca[e]cus* (blind) (figure 4.5).

4.5 Munich, Bayerische Staatsbibliothek clm 4660, fol. 77r, transcription

Our second example comes from a theoretical treatise on rhyming, and it exhibits more on the potential and limits of visualizing poetic sonic effects. BAV Pal. Lat. 1801, from the late twelfth or early thirteenth century, contains a metapoetic treatise about different kinds of verse. It was once thought to be an independent treatise but is now considered to be the last part of the *Summa dictaminum* that Bernard of Bologna composed in the mid-twelfth century. The author presents each kind of rhyme with a short description and an example or two.[17] "Tailed" rhymes (*caudati*), he explains to the reader, are those whose endings agree in their sound. His first example follows in a continuous script, the metrical units separated from each other by a point and a rubricated, enlarged initial letter. The *verba-herba* rhyme may easily escape those readers who would not imagine themselves reading it aloud:

*Hoc modo * Gata camena veni cordis mei cincipe verba * Nam parili voto viridi residemus in herba ***

On the facing page, however, the layout changes. No reader would miss the point now (figure 4.6):

Laudibus eximiis Bernhardi facta not ⎱
Et studio celebri bona nos ad metra par ⎰ emus

4.6 BAV Pal. Lat. 1801, fol. 50v

Even when possible, the scribe does not always apply convergence. In folio 51r, he addresses verses of the *pariles colligati* type—verses with similar dactyls and spondees alike—with an example of four lines. The first two lines lack the last syllable: it should have been *mori-eris* and *cruci-eris*.[18] The scribe probably forgot to add the shared part altogether. But they do contain internal rhyming, *amico-inimico* and *dico-amico,* which is not seen graphically. Only the other two lines exemplify it graphically (figure 4.7). Notice that even in these two last lines, not all the shared or identical syllables are marked by convergence. *Signa* repeats twice in the same place but is not converged. *Tuorum* repeats as well, but only *-orum* converges, so that the symmetry between the rhyming of the first part and the second is clear.

En ut amico vere tibi dico non mori

Ex inimico mortis amico ne cruci

4.7 BAV Pal. Lat. 1801, fol. 51r

"Circular" rhymes, in which each line ends with the exact same word, lend themselves easily to the paradigmatic technique, and the four lines in the example for this pattern in BAV Pal. Lat. 1801 indeed converge on the single word *orbi*. But other types of rhymes demonstrate the technique's shortcomings when employed in service of this complex subject matter, for it fails to depict other patterns of recurrence. In this manuscript "tripartite tailed dactylics" and "reciprocal" verses, for instance, look the same as the simply tailed ones above, rendering visible only their common ending consonance. "Retrograde" rhyming involves repeating words in a different order, such as "*nil meditatur homo; sed homo qui nil meditatur*" or "*semina misit homo; sed homo qui misit semina,*" but such a play enjoys no visual parallel. This pedagogical systematic text evidently makes use of visualization to demonstrate the principles of rhyming beautifully and clearly. But every technique has its limits.

Our third case comes from a religious context. Codex Oxford, Balliol College 195 is a fine copy of Peter Lombard's *Sentences*, with margins full of horizontal schemata about various topics of theology (on this codex, see also chapter 2). The very last folio hosts an intriguing, unedited ekphrastic hymn in 104 lines. In its coda, the author explains that the hymn is offered as a *votum* to the Virgin Mary. Throughout the text, however, Mary speaks in the first person. She implores the one who passes, perhaps through a gate or a doorway of some sort, to turn toward a certain work of art whose

subject is herself: a dove holding an apple in its beak. The hymn explains in detail why the dove symbolizes Mary, demonstrates the parallels between her and Eve to interpret the symbol of the apple, and refers to other parts of this unknown artistic object that seems to present figures of happy and unhappy men and two *tabulae* depicting the five scenes known in iconography as "the joys of the Virgin."[19]

Most of the verses are simple leonine hexameters. The first couplet converges only at the end, although it also features an internal rhyme in the middle; twenty-five couplets feature interlaced rhymes marked by convergences at the middle and at the end. One couplet features convergences at the beginning, the middle, and the end; and the word *femina* opens each of the three lines of a triplet. As noted above, the decision regarding which common element should be highlighted by convergence varies from one scribe to another.[20] Whereas the scribe of the *Carmina Burana* codex chose to include all the common elements of the word (type A, figure 4.8), the scribe of Balliol College 195 avoids breaking the syllable, preferring to converge distinct, whole syllables, even if that means not showing the entire rhyming sonic cluster (figure 4.8, type B). Thus, *mundus* and *iocundus* look like they share only *-dus* (rather than *-undus*), and *manum* and *humanum* converge only on *-num*. Type A gives the reader the rhyme in its entirety, but the break between consonant and vowel makes reading more difficult, whether aloud or silently. Type B discloses less but is more natural and therefore easily legible.

```
       A                      B
   m  ⟩                    mun  ⟩
      ⟩undus                    ⟩dus
  ioc ⟩                   iocun ⟩
```

Except for shared syllables, the scribe of Balliol College 195 shows the reader also the recurrence of whole words like *fuit, pomum, refert,* or *tabula*. Anaphora of three consecutive verses looks thus (figure 4.9):

```
              ⟋ fefellit sic femina falsa repellit
     femina ⟵— dampnavit de dampno sed relevavit
              ⟍ peccatum [iam] non sit ei reprobatum
```

And the only couplet which employs both internal rhyme and anaphora enjoys this shape (figure 4.10):

```
              ⟨ hoc po ⟩         ⟨ mater miserabilis E ⟩
   perdidit   ⟨        ⟩  mum    ⟨                     ⟩ va
              ⟨ unde do ⟩        ⟨ paradisi sic sibi se ⟩
```

4.8 Two options to converge common syllables

4.9 and 4.10 Oxford, Balliol College 195, fol. 203v, transcription. Courtesy of the Master and Fellows of Balliol College, Oxford.

STRUCTURES OF CONCEPTS

4.11 Oxford, Balliol College 195, fol. 203v. Courtesy of the Master and Fellows of Balliol College, Oxford.

All in all, the masterful poetic use of four rhyming patterns catches the eye of the viewer of the page in figure 4.11 immediately. It captures the intriguing move from one visual form—an art object—to verbal description (the poem), and then to another profoundly different visual form (the diagrammatic poem). Was this poem ever carved on the artistic object it describes and speaks for? And if so, did the carvers keep the diagrammatic form? I wish I knew the answer.

CHAPTER { 4 }

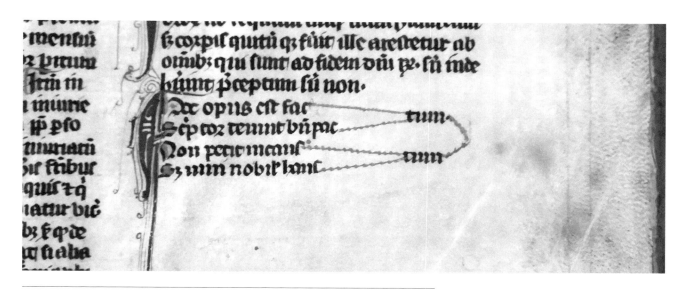

4.12 Oxford, Bodl. 344, fol. 505r

Finally, versification appears in poetic-codicological contexts, such as colophons and titles. An example of such a colophon is spotted on the last page of Henry of Braxton's *Book on the Laws of England*, in Oxford, Bodl. 344, seen in figure 4.12: "*Hoc opus est factum; scriptor tenuit bene pactum/ non petit incaustum/ sed vini nobilis haustum*" (This work is done / the scribe has well fulfilled his pact // he does not ask for ink / but for a drink of noble wine).

A far more elaborate example is the colophon-like verses of a twelfth-century scribe called Rainaldus, working in Anchin Abbey.[21] Rainaldus and his colleague illuminator Oliver ended their redaction of one form of visual poetry, a copy of Hrabanus Maurus's poems, with a colophon in an HT style. Stretched over two large pages, Rainaldus describes their work with two types of verses. The first takes the form *aab/ccb* (*versus tripartiti caudati*, trochaic tetrameter with sectional rhyme, or "tail rhyme"):[22]

Laus crucis melita latius agnita complacet orbi
Qui veteris cruce solvitur a truce carcere morbi

This is presented in figure 4.13.

4.13 Douai, BM 340, fol. 48v, transcription

```
Laus crucis meli ─────── ta ─────────── complace or ─
latius agni ─────────                                  ╲
                                                        bi
Qui veteris cru ───────                                ╱
solvitur a tru ──────── ce ─────────── carcere mor ─
```

STRUCTURES OF CONCEPTS

The second has an *abcabc* rhyme scheme, which results in the form of an accordion. The colophon-like use may be related to the decorative titles of works in medieval manuscripts, an example of which we have seen in the Uppsala *Organon* manuscript (figure 1.10). This may also be the antecedent for the use of paradigmatic writing in frontispieces of the print era, with examples such as the frontispieces of Hobbes's *Optics* (figure 1.6).

The few examples out of very many that I chose to explicate here show an exceptional application of the habit in question and testify to an intriguing attempt to visualize one of the most specifically sonic aspects of orality, experimenting with the very idea of writing as mirroring sound, while at the same time undermining it. Could HTs be used to exemplify other aspects of language use? The next section will show one especially attractive application.

NOTA: I must note here a better-known sister practice of bracketing to show the structure of rhymed stanzas and tail rhymes. Strong, Tschann, Parkes, and Purdie have all noted the use of brackets to indicate rhyme and structure in manuscripts containing Anglo-Norman and Middle English tail rhymes. This practice involved bracketing the two rhyming lines with the bracket's point directing the reader to the third tail line, which is positioned in a separate column on the right. Tschann saw as intentionally ironic the decision to mark Chaucer's evident parody of this sort of rhyme in such a fashion, indicating to the reader the *ars*-poetic element of this specific story.[23] Purdie has shown how widespread the use of the "graphic tail rhyme" was in nonparodic contexts.[24] Through diverse manuscripts, she shows how difficult it was for scribes to execute it finely and in an orderly manner and how, despite these evident inconveniences, they struggled to do so. She, too, traces the beginning of this practice to the end of the twelfth century; it was extended to plays and lyrics from the turn of the fifteenth and sixteenth centuries on. Following Parkes, she relates it to the Latin practice described above. While bracketing has here the function of grouping the first two lines, it does not signify further convergence of any sort. The repeating sound is not converged, and the third part should not repeat but be read after the two, somewhat like the colophon discussed above. It can, however, show hierarchy by regrouping. As Purdie notes, "Rhyming tail-lines are themselves often connected by a further set of brackets to their right, grouping the lines of the poem in straggling sixes like a stack of horizontal family tree diagrams."[25]

The link connecting the two practices is assumed to be the manuscript of the tail-rhymed Anglo-Norman *Vie de Thomas Becket* by Beneit, a monk of Saint-Alban writing in the 1180s, for the scribe of one of its earliest fragments experimented with both practices to a certain extent.[26]

4.2 LETTER WRITING (ARS DICTAMINIS)

Formal letters may be the most typical example of the intricate play between rigid structure and flexibility of subject matter. Authors of legal appeals, letters of recommendation, administrative letters, and, to a certain extent, even love letters closely follow established models and ready-made phrases, while tailoring them to their needs. Writers constantly employ formulaic salutations, farewell greetings, and other phrases to construct their own epistles, carefully adapting these formulae to honor the position of the addressee and the matter at stake. One way to teach the writing of such letters is to imitate examples, and indeed, exemplary letters have been in circulation for centuries. But since the late eleventh century, epistolography has been shaped into a veritable art: the *ars dictaminis*.[27] *Dictamen* masters in medieval schools, and later in the universities, trained students who were keen to learn this practical art, one that would prove crucial to their future careers. The great masters, many of Italian origin, composed treatises on the general structure of the letter, prescribed rules of composition, provided multiple model letters, and suggested formulaic phrases. Such manuals were extremely popular, first in Italy and later throughout Europe, until around 1470, when the popularity of *ars dictaminis* declined.[28]

The more that arts emphasize form and paradigm, the more they are prone to applying mechanical aids, and HTs proved particularly suitable. The most beautiful application of paradigmatic writing to the epistolary art is inarguably in the widely circulated *tabulae*[29] of the *Practica sive usus dictaminis*, composed by the traveling rhetorician Lawrence of Aquilegia around the year 1300. The *Practica* is laid out as a tapestry, as it is composed entirely, except for a short prologue that was sometimes appended, of sets of HTs. The charts are ordered according to the addressee, then follow the inner structure of the epistle according to the parts into which medieval letters were usually divided: greeting (*salutatio*), *captatio benevolentiae*, presentation of the situation (*narratio*), petition (*petitio*), and conclusion (*conclusio*). The first set of charts, for instance, concerns letters to the pope and includes a chart for each of the parts (except the *captatio benevolentiae*). Each HT lists alternative options for phrases, adjectives, titles, and other content words and gives the general structure in which they should be arranged, including links of function words, such as *quod* (that, because) or *eapropter* (therefore).

The HT form serves Lawrence to teach both lexicon and syntax. Aware of the large number of alternatives, both he and later copyists and authors suggest that the user add whatever fits his or her needs best (while most of the tables are supposedly authored by and addressed to men, some include feminine options such as "daughter" or "mother"). Following the lines and

4.14 The first HTs for salutation and narration in an appeal to the pope, after Paris, BnF Lat. 11414

4.15 (facing, top) An English paraphrase of the second chart

choosing the relevant option at each juncture, then filling in the required names and place-names where "*talis*" is used, the epistle comes into being almost by itself. This is, in fact, the opposite of the procedure that readers performed in the margins in the examples discussed in previous chapters: instead of processing a regular, sequential text and converting it into a diagram that reveals its structure, they used a diagram to generate a linear text.

Try for yourselves to write a salutation and narration to the pope in Latin using the algorithm in figure 4.14. You may choose to address the pope as "most saintly" or "most merciful" (you may not even understand the title you choose). In the place of the addressee fill in Emperor Frederick or the king or duke or count of such and such a place, in whose name, supposedly, you write. Then choose one of the greetings. If you insist on understanding, compose a narration by following the English example in figure 4.15, a rather free paraphrase of the Latin.

Fortunately for us, there are also diagrams for petitions and conclusions. Before you know it, you have an exemplary epistle in your hands. Of course, you may want to use just partial, short formulae for this or that part of the letter. Lawrence's HTs were popular for centuries and survived in many copies. But they were not the only HTs in the manuscript history of the *ars dictaminis*. At the end of a fourteenth-century copy of Pons of Provence's *Summa dictaminis* (authored before 1252) in Paris, BnF Lat. 8653, the scribe appended a series of diagrams demonstrating various ways to begin a narration. Each diagram is assigned a letter of the alphabet and is preceded by short introductory phrases such as "or you may rather begin with the abla-

tive phrases" or "or in this manner." All diagrams instruct readers to combine words of each group by following the lines in a mix-and-match fashion.

The formulae differ from each other mainly in the order of parts of the sentence, with permutations such as starting with a first-person singular verb or with an ablative phrase and so on as far as the flexibility of Latin syntax permits. Often the suffix of the ablative, dative, or adverb is assigned a separate node. While some patterns are short, with two or three levels or positions, formula *L* includes seven, and *K* no fewer than nine. Not everything can be taught this way, however: between patterns *I* and *K*, the author inserted a longer comment instructing how to proceed from such a beginning. One may add, he notes, a clause beginning with "that," such as "*quod ego sum*" (that I am), or with a form of oblique speech common in Latin, by which the subject of what is said takes the accusative case and the verb assumes the infinitive form "*me fore*" (me to be). In English, we could suggest either "that I go" or "of me going."

Minor casual slips in the mechanical procedure also appear occasionally. In diagram *F*, for instance, "*vestre*" (to your . . .) should of course not be joined to "*vobis*" (to you, pl.) or "*tibi*" (to you, sg.). But such slips do not interrupt the work of the machine much. Figure 4.16 transcribes the first nine paradigms. The result of a random trail in *E* would be "*mea cupit humilitas indicare*" (my humility desires to indicate) and another trail would result in "*mea desiderat simplicitas declarare*" (my simplicity wishes to declare).

Paris, BnF Lat. 14174, written toward the end of the thirteenth century, similarly includes seven tapestry pages of HTs between one *dictamen* treatise and another (fols. 19r–22r) in a less formal manner.[30] These exemplify a wide range of potential structures, from multiple options for opening sentences to different ways to express unfortunate circumstances suffered as a student in Paris or to address knights and barons.

In a beautiful chapter on epistolography in his *Rhetoric in the Middle Ages*, Murphy argues that Lawrence's *Practica* was the ultimate result of a

STRUCTURES OF CONCEPTS

a

Insinuatione	presentium	dominationi	
Reseratione	presentis pagine	discretioni	
Declaratione	huius paginule	nobilitati	
De...tione	istius ordule	strenuitati	
Significatione	huius petiorii	paternitati	
In...atione	scripti huius	fraternitati	
Indi..	presentium litterarum	probitati	vestre vel tue
Tenor	istius scripti	sanctitati	
Apertione	scripture istius modi	honestati	
Notificatione	istorum capitum	benignitati	
E..clea..one	presentium	religioni	
	ista literatoria	caritati	
	presentis paginule	pietati	
		mansuetudini	
		societati	
		dilectioni et huiusmodi	

clareat	venerand		
pateat	honorand		
liqueat	metuend		
apareat	diligend		
notum fiat	peramand		
clarum fiat	excellent	er — e	
aptum fiat	precellent		
declaretur	divulgat		
manifestetur	appertissim		
insinuetur	g..no..t		
significetur	provulgat		
notificetur	nominat		

b vel sic dimissis illis verbis *clareat liceat pateat* etc.

Significo
Notifico
Aperio
Resero
Insinuo — venerand etc. ut supradictum est
Enucleo
Clarifico
Notum facio
Apertum facio
Manifestum facio

c
vel sic dimissis illis verbis: *clareat pateat* etc., et illis: *significo notifico* etc. et iis *venerande honorande*

cupio declarar
desidero demonstrar
Afficio plurimum reserar — e et huiusmodi
opto non modicum indicar
peropto siquidem aperuer?

d
vel sic:

insinuare	desidero
significare	apto non modicum
indicare	voloquam plurimum
enucleare	peropto siquidem
	cupio

e vel sic: Insinuatione presentium etc. ut supra

	cupit	simplicitas	declarare
	desiderat	parvitas	demonstrare
mea	peroptat	insufficientia	indicare
	affectat	humilitas	aperire
	disponit	ignorantia	reserare
	proponit	et huiusmodi	et huiusmodi

f

significo	vobis	presenti pagina	
notifico	tibi	presenti paginula	
aperio	domination	presenti petitione	
resero	discretion	presenti cedula	
insinuo	nobilitat	presenti epistola	
enucleo	strenuitat	huius carte presentia	
notifico	paternitat	... indicio	
notum fit	vestre — fraternitat — i	... presentium	
apertum fit	probitat	presentibus litteris	
clarum sit	sanctitat	istis apicibus	
manifestum sit	honestat	presenti scripto	
clareat	benignitat	presenti rescripto	
pateat	religion		
liqueat	mansuetudin		
apareat	dilection		
declaretur	societat		
insinuetur	et hiis similia		

g vel econtra potes incipere per ablativos in hunc modum

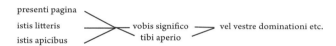

presenti pagina
istis litteris
istis apicibus
vobis significo
tibi aperio
vel vestre dominationi etc.

h vel sic

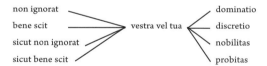

non ignorat
bene scit
sicut non ignorat
sicut bene scit
vestra vel tua
dominatio
discretio
nobilitas
probitas

i vel sic

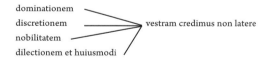

dominationem
discretionem
nobilitatem
dilectionem et huiusmodi
vestram credimus non latere

Istis modis poteris narrationem in epistola prescriptam factum cum poteris incipere narrare vel per verbum indicativum vel infinitivum verbi gratia: significo vobis presenti pagina quod ego sum in tali studio et sic facio factum meum etc. vel sic: significo vobis presenti pagina me fore in tali studio et ibidem facere factum meum In rescripta epistola sic potest incipere:

4.16 Paris, BnF Lat. 8653, fols. 4r–4v, transcription of charts A to I

As the {dean / professor / head / academic advisor} of such and such, I am writing to you {in support of / as a recommendation for admitting / on behalf of} Dr. A — to your academic program

long process of increasing uniformity in the dictaminal tradition, "the final step in an automatizing tendency which had been an undercurrent in the *ars dictaminis* from its earliest days." Understanding the combinatory, mechanical power of the diagrams, he designated this process the dead end of an art decaying into mere mechanics, perhaps a danger lurking for every art. In particular, Murphy pointed at the easiness and paucity of requirements achieved by automatization: "Simply put, the *Practica* attempts to make letter writing a skill that is possible to any person capable of copying the letters of the alphabet. No command of artistic principles or rhetorical theory is necessary and indeed even a knowledge of the language is probably unnecessary."[31] Although I teased you to do just that myself, this is of course a bit of an exaggeration. First, there is a consensus today that the decay of the *ars dictaminis* resulted from different historical circumstances.[32] Second, mechanics can be used artistically. While Lawrence and others sifted through sample letters and real ones for expressions, analysis of particles produced new combinations and permutations that could never be found in exemplary letters. Also, while the HT enables one to compose (in the most literary meaning of the verb—that is, to arrange ready-made parts into phrases and clauses), no master of *dictamen* could provide the content needed for the special, idiosyncratic needs of his aspiring students in real-life situations. At the very least, the readers-users needed to know some Latin in order to choose from the options, and as these are not exhaustive, users had to be able to add their own content. Finally, the issue is how to put into practice what one already knows from grammar lessons in a proper syntactical and stylistic manner in those specific cases of situated, ritual expressions where style is free only to a limited degree. The wealth of websites devoted to the issue hints that even in their native tongues, people resort to exemplary formulae when they wish to address someone formally. This is not language in its natural, flowing aspect but in its ritualized aspect.

In his *Speculum dictaminis*, Lawrence suggests that "it is better to work from form rather than material."[33] Unlike a theoretical explanation such as "put the ablative before the verb," or providing a heap of examples as both his predecessors did and his subsequent humanists will do, he and others ingeniously use paradigmatic writing to demonstrate structure and at the same time invest it with diverse matter to enliven and clarify it. The wealth of matter and the fact that this slot can contain several alternatives highlight the form and yet enable the user to make his or her own mixture. The different paths available by using these multiple-choice trails produce a wealth of variations. Indeed, the infinite potential of these HTs is explicit, as the lists frequently end with "and so on" or "and similar to these." Versions of the *Practica* differ significantly from each other, as different scribes who copied it took great liberties in adding, replacing, or omitting certain phrases, accepting the open invitation implied in HTs to play and add.[34]

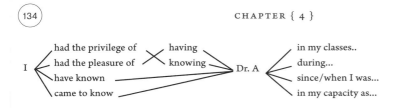

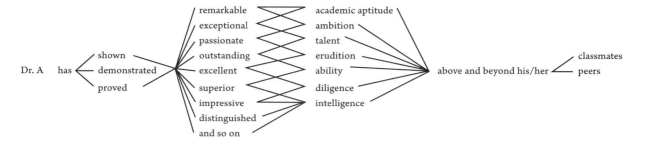

The image of the author is not the one who imitates fine examples or an educated layman, like Erasmus, having intimate and eloquent conversation with an absent friend.[35] This ingenious device teaches the paradigm in a triple manner, combining theoretical explanation, syntactic modeling, and vocabulary, and enabling one to work with both form and matter through the dialectical play between formulae and concrete components. Yet unintentionally, these HTs, more than any of the others we have seen and shall see, touch upon the essence of language itself in an intricate interplay between patterns, structure, vocabulary, and specific situations—the intriguing interface between syntax and lexicon and between the syntagmatic axis and the paradigmatic one. They offer an algorithmic way to think about language, and at the same time they implicitly reflect human linguistic algorithms. In other words, they offer a machine with which to extend the mind, and implicitly, they reconstruct the mind as such a machine. It is a short step from here to the algorithmic thought of artificial language machines.

4.3 GRAMMAR

It may seem a short step now from applying the principles of HT diagramming to rhymed verse—that is, from breaking the seemingly atomic unit of the word into particles—to applying it to lexical morphology, where this break reveals a true grammatical paradigm; and another short step from structuring idiomatic forms of expression to exemplifying general syntactic structures.[36] Latin is known for its rich morphology. Nouns, verbs, and other parts of speech can be demonstrated as composed of a common stem, to which different suffixes are attached according to case, tense, gender, person, aspect, and so on. As HTs are all about showing paradigms and highlighting the common and the distinct, the conjugation paradigm *amo* (I love), *amas* (you love), and *amat* (he or she loves), for instance, could easily be visualized as in figure 4.17.

4.17

STRUCTURES OF CONCEPTS

Also, closer to rhyming convergences, HTs may single out stems by showing how different stems of the same group share the same suffix (figure 4.18).

4.18

The technique was perfectly suited to exemplifying the morphology of composite words, like the verbs *conficio, adficio, deficio, interficio, perficio*, all ending in *ficio* (do); or decomposing *im-possi-bili-tas* (impossibility) and *im-muta-bili-tas* (immutability) into their shared components. Latin morphologies thus make almost obvious candidates for HT representation. Furthermore, as explained in chapter 1, HTs are based on the properties of natural language, especially coordinate structures, by visualizing the syntagmatic and paradigmatic axes. They are therefore extremely suitable for demonstrating precisely such linguistic features, visualizing sentence structure, syntactical roles of clauses and participles and so on, just as we saw with letter writing.

In her studies of medieval linguistics, Law has been highly aware of the growing use of visual features in grammar books during the scholastic period, as compared with the early Middle Ages. In her *History of Linguistics in Europe* (2003), as well as in articles, she has argued for a gradual shift in the way grammarians understood the potential of visual layout for highlighting morphological paradigms. Early medieval manuscripts "showed little interest in the formal structure of words and sentences." When explicating morphological paradigms, they mostly listed the forms of exemplary words in running lines, whether the entire conjugated words (*amo amas amat*) or just the suffixes (*amo as at*). The teaching and study of language were primarily aural based and even the metalanguage used to describe morphology was aural oriented: while "syllable" and "sound" are in current use, one had to wait until the sixteenth century to have a term for "suffix." Only rarely, she contends, did they realize the potential of writing the forms in vertical columns, which would have made it easier to observe paradigms. It was in the scholastic period that "[a] few drew tree diagrams in the margins to make visible the implicit structure of the doctrine. At first a marginal aid (in both senses!), diagrams gradually came to play an important role in the presentation of grammatical doctrine."[37]

The increased use of diagrams that Law has observed in the field of grammar was, as the reader knows already at this stage, not specific to grammar but occurred in all fields of academic knowledge. Yet what I wish to

argue here is that despite extraordinarily favorable conditions, grammarians had not realized the specific potential of paradigmatic writing for their subject matter, that is, for the demonstration of the specific linguistic paradigms themselves, as in the nonmedieval examples I fashioned in figures 4.17 and 4.18. Law brings as examples for visualizing linguistic doctrine typical twelfth-century vertical tree diagrams of the type discussed in section 1.1. Vertical branching can hardly serve to highlight structures of words and sentences, which in European languages are generally written horizontally. But the HT form, current since 1200, fits very well. Also, words were broken to demonstrate rhyme, which in most cases was based on this very morphology. The examples from the *ars dictaminis* show application to specific sentence and phrase structure. Finally, grammar masters were already employing HTs for other matters, as we are about to see. All the conditions were therefore set and the material "calls out" for it. Yet applications such as the ideal ones suggested above just do not appear. Or if they do, they are very rare.

The habit of paradigmatic writing was applied to diverse metagrammatical matters, some elementary and others pertaining to the realm of sophisticated speculative grammar. Many diagrams were drawn in the margins of authoritative textbooks. Bruges, BM 534, for instance, contains a heavily glossed copy of Priscian's *Institutiones grammaticae*, which along with Donatus's *Ars grammatica* served as a classical intermediate-level textbook for Latin grammar. In folio 15v the principal text in the column discusses questions and responses about places:

If I should ask "to what place?," you will answer "here" or "there," "home" or "to military service," "to Rome" or "to Italy"; but if I should ask "where?," you would answer "here" or "over there," "at home" or "in military service," "in Rome" or "in Italy." For such locative questions can be answered not only by means of adverbs, but even by means of any noun signifying place; questions asking, "to which place" are headed by "quo"; "in which place" by "ubi"; "from which place" by "unde"; "through which place" by "qua."[38]

The gloss in the margins expands in much greater detail on local adverbs and locative cases for places, then summarizes the long note with the HT in figure 4.19.

4.19 Bruges, BM 534, fol. 15v

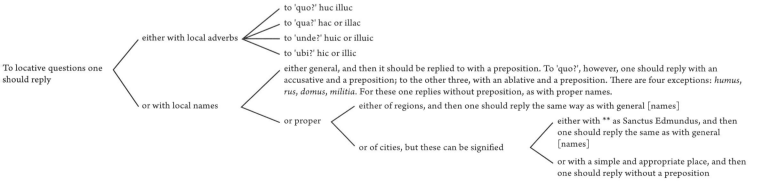

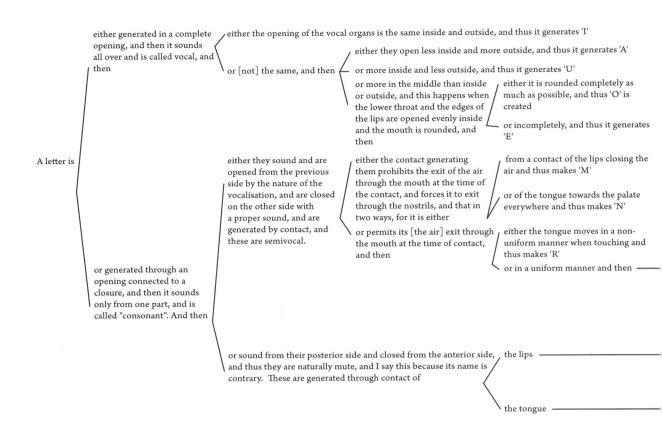

Cambridge, Gonville and Caius College 341_537 contains numerous such HTs as well, enumerating and classifying diverse theoretical notions on grammar in a similar fashion to the distinctions we have seen in chapter 3, such as three senses of "transitive," two senses of "case," three types of "construction," classification of cases into transitive and intransitive, and their like. Oxford, Bodl. Digby 55 takes us further into speculative investigations. Folios 126r–151v host an anonymous late thirteenth-century text called "good materials on grammar, followed by questions" (*bona materia de grammatica cum quaestionibus subsequentibus*). This treatise includes several embedded HTs.[39] One three-level diagram on folio 126r divides and subdivides different approaches to sounds (*vox consideratur*) and assigns each approach to its relevant discipline: philosophy of nature, grammar, logic, or rhetoric. Another (figure 4.20) is a six-level impressive HT summarizing a long and complex discussion of phonetic concerns by classifying all Latin letters (the word *littera* means here both the graphical sign and the sound) according to their articulation in the vocal organs. The reading from left

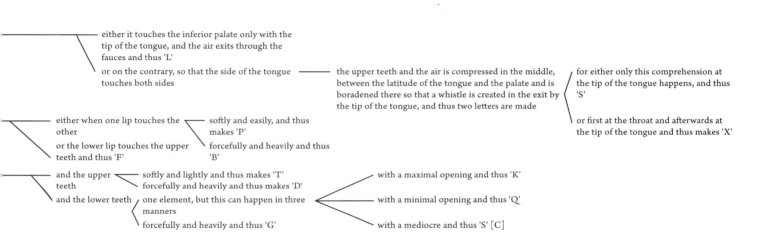

to right parallels in a way the production of sound.⁴⁰ There is no doubt, therefore, that grammarians used HTs for metaexplanations on language.

Let us return to the intriguing lacuna of *not* showing the morphological paradigms of declensions and conjugations directly, that is, with the words themselves splitting and converging, as in the ideal figures 4.18 and 4.19. Consider Florence, BML Plut 34.47, a mid-thirteenth-century glossed copy of Alexander of Villedieu's *Doctrinale*, a versified grammar textbook written around 1200, which contains few marginal HT diagrams. The diagrams in folios 46r and 46v address the conjugation of verbs in the future optative and imperative moods, in a somewhat confused and insufficiently planned shape. But what they diagram is the verbal explanation of the rules rather than the conjugated verbs themselves. The nodes are, for example, "in the present tense" or "active like *ama* and in the plural *amemus*," rather than "*am*" or "*emus*."⁴¹

4.20 Oxford, Bodl. Digby 55, fol. 128v

	nom.	Gen.	dat.	acc.	voc.	abl.	nom. pl.	gen.	dat.	acc.	voc.	abl.	
Hec est agnitio prime declinationis quod nominativus terminat in	a	e	e	am	a	a	e	arum	is	as	e	is	ut musa
	as	e	e	am	as	a vel e	—	—	—	—	—	—	ut Eneas
	es	e	e	am	a	a vel e	—	—	—	—	—	—	ut Anchises
	am	e	e	am	am	am	—	—	—	—	—	—	ut Adam

	nom.	gen.	dat.	acc.	voc.	abl	nom. pl.	gen.	dat.	acc.	voc.	abl.	
Hec est agnitio secunde declinationis quod nominativus terminat in	er	i	o	um	er	o	i	orum	is	os	i	is	ut faver
	ir	i	o	um	ir	o	i	orum	is	os	i	is	ut vir
	ur	i	o	um	ur	o	i	orum	is	os	i	is	ut satur
	um	i	o	um	um	o	a	orum	is	a	a	is	ut templum
								nisi fit per cincopam ut duum pro duorum					
	us	i	o	um	e vel a	o	i	orum	is	os	i	is	ut dominus
													exceptis duobus neutrum, scilicet vulgus, pelagus quorum vocativus in us [...]
	eus	i	o	um	en	o	ut penteus						et in omnibus masculinis ut ditus agnus que [..] in us et propriis nominibus....

4.21 Florence, BML Plut. 25 sin. 05, fol. 26r/28r.

Florence, BML Plut. 25 sin. 05 is a thirteenth-century miscellany of grammatical treatises by Alexander of Villedieu (b. ca. 1175), John of Garland (b. ca. 1180), and others. Folios 25r–30v (original foliation) form a group of folios between two treatises; some are blank but others contain texts in a small, informal script. On folio 26r (in the original foliation, or 28r in the later one), a scribe copied an anonymous poem on grammar.[42] He bracketed each four-line stanza but did not converge the rhyming syllables. Immediately afterward appear five hybrid HT-tables, one for each of the five declensions of Latin nouns (the first of which is transcribed in figure 4.21). At the root of the HT, he did not position the stem of an exemplary noun but the phrase "This is the knowledge of the first declension, whose nominative ends in." It then splits into five, but to show the particular declension of each of these subgroups, the author moves from paradigmatic writing to tabular representation. The table form indeed serves this sort of information much better, though paradigmatic principles could be of help, for while nouns of each group have different nominative forms, in other cases they are mostly quite similar. All the subgroups of the second declension, for instance, have the suffix *-i* in the genitive and *-o* in the dative and ablative cases, but since tabular reasoning dominates, *i* simply repeats in every line. They are not converged, a procedure that could have greatly helped anyone wishing to remember the material.

CHAPTER { 4 }

Declension through HTs becomes somewhat more visible in BAV Pal. Lat. 1755, a beautiful manuscript executed ca. 1473 in Heidelberg, Germany. The titles claim the text is an abridgment of two famous grammar textbooks: Donatus's *Ars grammatica* and the second part of Alexander of Villedieu's *Doctrinale*. This is a tapestry work made entirely of finely planned HT charts, many of which spread across a whole folio.[43] The opening folios, 1v–2r (figure 4.22), display the first full chart that survived, in which the explication of the second declension continues. A clever play with the order of words generates a clear division into singular and plural, then to the respective cases, using the HT's flexibility to include examples and exceptions. The sentence resulting from the trail through the upper branches, for instance, reads "In the second declension in / the singular / the vocative ends / in / *-er* / when the nominative ends in / *-er*, / as in / *magister*, / unless—owing to sound change—it changes to *-re*, as in / *Leander Leandre*." Unlike in the hybrid tree-table, the eminent, general features of the declension come clearly to the front, while the different endings of nominative nouns are treated in detail in the branch for each specific case, like all other exceptions. Nevertheless, while the common features of the main group are thus highlighted, if one wishes to extract the declension of just one subgroup of nouns, such as neuter ones, graphics will be of little help.

The following charts explicate in a similar manner the third declension with all its subgroups according to their endings. Then follow the fourth and fifth declensions, declensions of the pronouns in the first, second, and third person, then conjugations of verbs (fols. 27r ff.), all beautifully demonstrated. Paradigmatic writing appears on almost every page, interlaced with explanations in running lines up until the end of the codex, and occasionally combined with tables (e.g., fol. 17v).[44] Visual? Yes, and marvelously so. Is the subject matter morphological paradigms? Yes. But the technique is still not applied to the words themselves by breaking them up to highlight the paradigm in the manner suggested earlier. The diagrams depict the structure of the *explanations*.

The same goes for syntax. Paradigmatic writing is implicitly built on identifying paradigms of sentence structure, in order to show structures of other kinds. The *ars dictaminis* diagrams do not depict explanations of how to write epistles (with nodes such as "every narration should include . . ."). They depict the alternative phrases themselves, exemplifying syntactical structures and governing rules (*Regimen,* "government," in medieval theory of syntax refers to the influence of one word on another, as when a certain transitive verb requires its object to be in the accusative case). But we have such HTs only for epistolary idiomatic and ritualized expressions. I have not yet found medieval manuscripts in which HTs are used this way to teach or study general syntactical relations or to explicate long and difficult Latin prose sentences. Tree visualization has existed for centuries and has

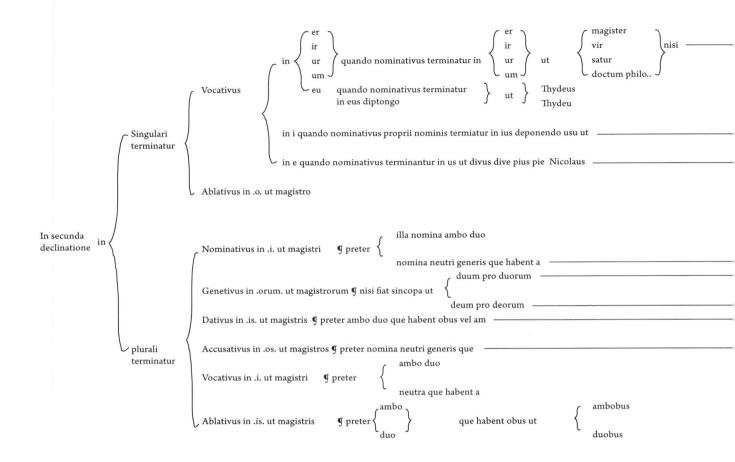

been used in proximate fields. But it was not applied to this specific subject matter. Perhaps such ideal types as the ones I suggested at the beginning were too out of context. If we break up the word itself, we cannot include any explanatory material, such as noting that this is the second person or the genitive, for instance. In a table, metaexplanations are allocated to the heads of the columns and the beginnings of the lines. The strength of the HT resided, for these users, in its embodiment of explanations rather than in exemplifying inner structures.

Finally, however, the most illustrious example in the field of grammar shows the paradigm, among myriad other creative uses of lines and colors. Uppsala, Bibl. Regal. Univ. C. 678, a late fifteenth-century south German codex, is an extraordinary grammar, which received the recognition it deserves with the publication of an edition carefully executing each graphic detail, together with a beautiful facsimile and a thoughtful discussion.[45] Since the

──────── per methatesim fanat in re, ut ⎰ Leander Leandre
　　　　　　　　　　　　　　　　　　　⎨ Eander Eandre, quia olim terminabantur in is
　　　　　　　　　　　　　　　　　　　⎱ Theater theatre

　　　　　　⎰ Pantous Pantou　　　　　　　　　　　　　　　　　　　　　　⎰ pantu
　¶Nota ⎨　　　　　　　　　　⎬ nos Latini abiicimus s et dicimus ⎨
　　　　　　⎱ Melampous melampou　　　　　　　　　　　　　　　　　　　　⎱ melanpu

──────── Laucentius Laucenti Vincentius Vincenti [etc.]

──────── Nicolae preter ⎧ filius o fili vel filie secundum antiquos
　　　　　　　　　　　　　⎪ deus o deus
　　　　　　　　　　　　　⎨ augnus o agniis vel augnue
　　　　　　　　　　　　　⎪ vulgus o vulgus　　　que sunt neutri generis vel masculini
　　　　　　　　　　　　　⎪ pelagus o pelagus
　　　　　　　　　　　　　⎪ populus o populus vel popule, fluvius o fluvius
　　　　　　　　　　　　　⎩ chorus o chorus

──────── ut scamna　　　　¶preter ambo duo
──────── talentum pro talentorum meum pro meorum tuum pro tuorum vicum pro vicorum

──────── priamidum pro priamidorum
──────── bobus duobus

──────── habent a ut scamna

4.22 BAV Pal. Lat. 1755, fols. 1v–2r, transcription (the singular divides only to vocative and ablative, because the other cases were already treated in the now-lost preceding pages)

editors have already studied it in detail, I shall be brief. Lineation in the form of paradigmatic writing and grouping is used to explain almost every subject on every page in myriad ways. The author applies it, and frequently, to the linguistic paradigms themselves, to declensions and conjugations, as well as to the demonstration of syntactical features. Explaining the idea of a pronoun, for instance, he shows that it substitutes for the name by setting it on the same paradigmatic axis and grammatical position as that of a proper name. For the first time, lines are used to present conjugations, marking the common stem and its several suffixes. The base form of the present tense remains unbroken, as if it begets all others rather than being composed from a stem and a suffix like all the others. For forms such as *portatum est* or *portatum fuit*, however, the representation obeys the HT principle, with *portatum* splitting into *est* and *fuit*. Latin grammar books of the early modern period, after the time frame studied here, employed this technique heavily, sometimes on every page, for different matters, in different pedagogical and material conditions.

{ 5 }
Structure of Texts

The previous chapter demonstrated the uses of paradigmatic writing to highlight structures of versification and formal letters, as well as morphology and syntax to a more limited degree. We move now to the more intricate and complex endeavor to explicate the structures of extended textual units, indeed much longer than couplets or epistolary salutations. We have already encountered horizontal tree diagrams (HTs) that unfold a theme to show that the end of each trail matches a specific text of a corpus. Different aspects of syllogisms are shown to be discussed by different books of the *Organon*; at Paris, BnF Lat. 6319, a complex division of philosophy displays how the branches of natural philosophy are treated by different books of Aristotle's natural works (fol. 135r). Madrid, BNE 9726 does the same by dividing considerations of mobile objects (fol. 82v). A division of the biblical canon in BAV Vat. Lat. 22 into clusters of books employs HTs as well. But what about internal divisions of carefully woven, coherent texts?

 Texts are and have always been complex mechanisms. But it seems that only in two periods in Western intellectual history has their structural complexity drawn keen scholarly attention: the scholastic period and the second half of the twentieth century. In both periods, schoolmen, structuralists, and computational linguists have found tree visualization a helpful form by which to both analyze texts and present their analyses. The first section of this chapter discusses HTs representing the structure of multichaptered theological questions. The two following sections address HT diagrams of the *divisio textus* type: diagrams in textbooks that represent the structures of biblical narrative or systematic argument. We are dealing now with extremely intricate structures and large objects of analysis, including entire chapters and books. As I heartily wish readers to understand these techniques, and as both genres are typical to the scholastic period and merit explication, I present only one or two detailed case studies in each subcategory, with brief references to others meant to demonstrate that this is a general phenomenon that extends far beyond singular occurrences.

5.1 ORIENTATION AND COMPOSITION: THEOLOGICAL QUESTIONS

The *quaestio* is perhaps the most characteristic genre of scholastic writing.[1] First, there was the typical basic unit: a short yes-or-no question; arguments in favor of one opinion; arguments opposing them (*sed contra*); solution; and replies to the set of arguments for the opinion opposed to the determination. This ministructure in itself did not receive much HT representation, perhaps because it was so rigid and clear. Nevertheless, already in the twelfth century, but increasingly so in the thirteenth, there were masters who made a considerable effort to assemble, rewrite, redact, group, and arrange separate *quaestiones* into larger ones, these large ones into tractates, and tractates into entire broad-ranging *summae*. Some theological summae were arranged after the general plan of Peter Lombard's *Sentences*, others after another principle ("the good," for instance), but there were infinite variations, hundreds of choices to be made regarding the proper and most reasoned order for arranging and clustering the discussed topics.[2] When grouped and ordered, linking phrases were added between the *questiones* and tractates to sew them together and to account for their specific order, such as "Having discussed X, let us proceed to Y" or "Since X is very much related to Y and Y presupposes Z, let us ask about Y." To make explicit this reasoning, short prologues were added before diving into the arguments, announcing and enumerating the questions to be treated.

Since at least the mid-thirteenth century, theologians drew HTs in the margins of such texts to display the inner structures of complex questions, detailing their parts and particles. In chapter 2 I briefly noted how a student in the 1240s employed paradigmatic writing to this end. The root was either a thematic title such as "on the movement of angels," a more discursive formulation such as "about angels it will be asked," or just "here we shall ask," while the nodes specified the questions themselves, such as "whether or not angels move locally." Although *quaestiones*, *membra*, treatises, etc. could be arranged to compose entire books and summae with up to ten levels of division, the HTs that survived were mostly simple diagrams with no more than three levels. The simple HT in figure 5.1 is exemplary. It is one of several handsome HTs added in the lower margins of Toulouse, BM 737 by one of the copyists (other hands in this collection of questions did not attach HTs).

It is asked about the efficacy of prayer
— which prayer is effective and for which reasons
— which is not effective and for which reasons
 — first, what are the conditions for it to be effective
 — second, what should be asked
 — third, whether perseverance of prayer is in the precept

5.1 Toulouse, BM 737 (ca. 1250), fol. 117v, translation

CHAPTER { 5 }

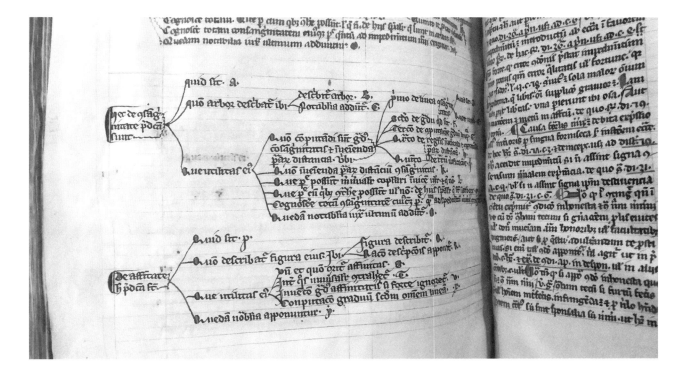

5.2 London, BL Egerton 633, fol. 402v. Courtesy of the British Library Board.

Such diagrams usually occupied the margins. A special example of an embedded, formal HT is attached to the question *"Ad arborem,"* which, while explaining how to navigate tree diagrams of consanguinity and affinity (see section 3.3), includes an appendix consisting of an HT diagramming the structure of the question itself. Each terminal node is assigned a letter that matches a letter on the left or right margin of the body text. It thus serves as a sophisticated list of contents, visualizing both the themes discussed and their inner relations. The question on "how the tree is drawn there," for instance, divides into "the tree is drawn" (*describitur*), marked as paragraph B, and "things to be noted are added" (*notabilia adduntur*), marked as C. The proper use of the tree diagrams takes up most of the treatise, divided and subdivided into diverse subtopics such as how to calculate the grade of affinity between family members. The almost identical structure of both questions—one for each tree—immediately catches the eye looking at figure 5.2.

The similarity between lists and HTs and the shared principles behind verbal prologues and visual diagrams are beautifully shown in BAV Vat. Lat. 782. This is a mid-thirteenth century codex containing a variety of scholastic questions by different masters active in the first half of that century. Its twenty-eight marginal lists and HTs of questions are not spread evenly throughout the manuscript but are concentrated in only one of its parts. This part constitutes, as the editors of the Quaracchi edition have shown, a group

STRUCTURE OF TEXTS

of questions that are related to each other by internal references and that can be attributed in considerable certitude to Alexander of Hales (OFM, d. 1245).³ Six of the twenty-eight were drawn by a significantly different hand.

First, we encounter lists, without any connective lines, as well as inconsistent attempts to visualize subdivisions by indentation. Thus, the question "*On angelic speech*" (fol. 52r) is accompanied by a numbered list of seven questions on this topic without a title. Another list, accompanying the question "*On the comparison of the contemplative with the active life*" in folio 58r, presents a mixed layout. The principal division has a separate line for each subquestion, but the subdivision of the fifth question into four sub-subquestions does not: the enumerated titles of the items are written continuously on two indented lines.⁴ The format following the question "*On sanctification*" (fol. 60r) approaches a full HT. The title is seen on the left, and its principal division into four is represented by four separate branches. The subdivision of the second subquestion has no graphical expression, and the numbered items are written in a linear form.⁵ The third subquestion's triple subdivision is, however, designated by branches in a somewhat clumsy way: their meeting point should have been the line above. Such a subdivision was better made in the next attempt, an HT of the question "*On the unity of Christ the head with the mystical body of the Church*" (fol. 64r), where the subdivision of the third subquestion is delineated with neat branches, and the principal division is marked by two framing lines.

The subdivision for the question "*On the church of the evildoers*" (fol. 66r) posed a new challenge regarding subdivision: to assign titles not only for the entire question on the first level but for its principal parts as well. The twisted lines and the exclusion of the title for the fourth part attest to the author's difficulty, or inexperience, in drawing HTs. Further down, when drawing the schema in folio 79r (figure 5.3)—which posed the most challenging case, being a three-level schema—he left sufficient room for further subdivisions. This is a "quodlibet question"—a cluster of questions "about anything you wish" addressed publicly to a distinguished master at the university. While the public event was all about the hazardous, unorganized nature of the topics, the replies were classified and ordered when edited later. This arbitrary ordering of what is in its very essence unorganized can be seen in the gap between the highly general nature of the categories and the particular nature of the questions in the terminal nodes (figure 5.3).

A comparison between the prologue and the references in the body of the text, on the one hand, and the HTs in its margins, on the other, highlights their different functions. To address these differing methods, I would like to apply here a distinction taken from the field of cognitive studies dealing with spatial perception and, in particular, its description, which will involve the cognitive function of simultaneity and unfolding noted in chapter 1. Cognitive scientists who have tackled the problem of different spatial descriptions

5.3 Alexander's quodlibetal question, BAV Vat. Lat. 782, fol. 79r: crossing lines in the original

are used to distinguishing between "route" and "survey" perspectives (parallel to the distinction between "itinerary" and "map"). Route descriptions describe the space from the perspective of one walking in it "from within." They change perspectives and use more motion verbs. Survey descriptions take an extrinsic viewpoint from above and are more static.[6]

Both perspectives can be expressed by either verbal or visual means, such as taking the listeners on an imaginary tour through that space or describing it from above. Thus, when describing a garden with words, one may say: "When you come through the main door, you see a road. If you head right, you arrive to a crossroads with three gates. If you enter through the left one, you see two walkways ahead. At the end of the right one there is a fountain. . . ." In a famous experiment Linde and Labov showed that most New Yorkers, when asked to describe their apartment, described it from a route perspective, taking the listeners on a virtual tour from one room to the other.[7] Structure was thus represented in terms of sequential events. Another person may, however, describe the same garden as "a square divided into four small ones, at the center of each there are two circles. On the meeting point of all four squares there is a fountain. . . ." Visually, you may choose to provide pictures for each juncture from a walker's point of view (the one Google Maps terms "street view") or instead supply a map of the garden from above. While both verbal and visual modes can be applied to both perspectives, it is more common to use words for a route perspective and to use the visual for a map perspective.

With this distinction in mind, let us return to BAV Vat. Lat. 782. In the first questions to which a list was added in the margins, the prologue gave the principal theme and the justification for addressing it. The marginal list, however, provided no such information. Its only advantage was that whereas the prologue informed the reader only about the number of questions to be discussed and then turned to discuss the first of them, the list specified their

subject as well. The long prologue to the question in folio 50v, for instance, reads:

Having posed the questions that addressed the things which were made with regard to the making of all things at once, now follow questions about the same topic regarding the day in which they were said to be made. Yet since day is determined by the presence of light, and there are two lights, that is, corporeal and spiritual, the question will proceed according to these two and according to the twofold opinion of the saints. First, let us proceed according to the [opinion] that day is determined by the presence of corporeal light, as Gregory, Bede, and Jerome attest. Second, we shall proceed according to the opinion that day is determined there by the presence of spiritual light, as Augustine asserts. Regarding the first, three questions will be asked. The first is, what is this corporeal light, what is its effect and utility, and will it ever cease to exist? Regarding this subject six [questions] will be asked. The first is, what was this corporeal light by whose presence the day was made . . . ?[8]

The list below betrays nothing of all this. In fact, there is not even a general title for the group. Yet while this prologue shows the route to the first question and then enters the discussion, the list provides the reader with the exact content of each of the questions to follow. This map function greatly improves in the next HTs that included titles and subdivisions as well. The prologues never betray more than the number of the principal questions. The reader discovers that there is a subdivision only when the relevant question begins: only after moving through the corridor does one realize that another juncture awaits. In the case of the *quodlibet* question (figure 5.3), for instance, all the reader of the text in the column knows in the beginning is that the discussion will address the Holy Scriptures and "some things in it." Some miles further into the arguments, as the reader arrives at the second part, he discovers that it includes four parts, with questions dealing with God, evil angels, the soul, and hell. The only way to know *which* issues about hell are to be addressed there is to advance linearly and wait patiently for the fourth part. A quick look at the HT, on the other hand, gives the full structure and content. In other words, it provides a survey perspective.

The HTs in the manuscripts discussed above seem to be posterior visual representations of preexisting texts. But were such drawings also used to outline programs for prospective texts, in the way architectural plans are employed by architects—that is, not only as "models of" but as "models for"? Not only as representations of an already-existing text but as part and parcel of the generation of texts? One intriguing manuscript that may help with tackling this problem is Assisi, BC 186. Bonaventure's autograph draft notebook, it holds theological questions in different states of completion, ranging from mere sketches to fully edited texts. It provides a glimpse into the working strategies of one of the greatest theologians of the thirteenth

century.[9] The manuscript has twenty-seven marginal HTs. Although some of the questions in the codex have been identified by previous scholars as authored by theologians other than Bonaventure, none of these has an HT attached.[10] The most surprising finding is, however, that only five of these twenty-seven (18.5%) completely agree with the matching text in the columns, a case we have not encountered in marginal distinctions at all. Three of these five belong to the same group ("*De anima*"). One HT that belongs to the group "*On miracles*" has no matching text at all (!).

How can these discrepancies be explained? What came first—the outline or the text? Reconstructing thinking and editing processes using static products is always difficult for historians, and it must involve a pinch of imagination. One hypothesis is that Bonaventure wrote a text and then drew a suggestion for a broader structural context; another is that he first drew an outline and then realized it only partially. The group of five HTs on the subject of angels in folios 92–93 may support the latter suggestion.

Out of three questions enumerated in the first HT in the left-hand column of folio 92v (figure 5.4), only the first has a parallel text in the column.[11] The same happens in the right-hand column and with regard to the fourth HT at folio 93v. A blank space was left at the lower part of the page. Was it destined to house the texts of these other questions?[12] Similar blanks appear in the section on miracles.[13] Not only do the HTs of this group contain more questions than those actually discussed, but they also present a reasoned hierarchy that is lacking from the text, in which the questions just begin without any prologue. Thus, on folio 93va (figure 5.5) the HT has a title "*On the cognition of the angel*" (*De cognitione angeli*), which divides into a branch of questions *regarding the object of cognition* (*quantum ad cognoscibile*) and a branch *regarding its mode* (*quantum ad modum*). This structural context has no trace in the text of the two questions we do have in the columns. Indeed, only the first two and perhaps part of the third are there, followed by a blank space. The plausible interpretation is that this is a later plan into which these questions will be put.

A similarly intriguing case is the question "*On heaven*" (*De caelo*, fol. 91v), for which the columns contain the text of six questions out of the nine enumerated in the HT, followed immediately by a question on a different topic. The unexecuted titles in the HT are followed by the notes: "look for the second distinction of the second [book of Peter Lombard's *Sentences*]" and "the thirteenth," respectively, where indeed such subjects are discussed. Similar references can be seen in another HT, precisely for those questions that are missing in the matching text. A probable hypothesis would be that the drawing was made after writing, as a prospective plan for a future, revised text in which this material-to-be-looked-for would find its proper place. Outlining by way of HTs was therefore an integral part of the composition process. Moreover, it is possible that the very drawing of

this prospectus might have clarified for Bonaventure the need for additional materials in order to complete a comprehensive treatment of the different heavens.

A different discrepancy that supports the impression that drawing HTs was involved in editing occurs in the question "*On venial sin.*" The almost illegible marginal HT presents the subquestions in a different order to that in the actual text in the columns, a comparison of which is presented in table 5.1. The HT seems to be a proposal for a different order. In the column text, the title of the last question is stated only after responding to the first five, with no continuation. In the HT it has a logical place: having discussed difference we discuss commonalities. It is reasonable therefore to assume that Bonaventure began by writing these first five questions. Perhaps he initially intended only the first two, as these are the only ones mentioned in the brief prologue, then others came to mind. He sketched solutions to all five, then added a sixth issue, but did not actually develop it. Thereafter, he drew a different, better outline encompassing all six, moving the first two to the end and positioning the new question after that which had now become the first.[14]

Bonaventure's autograph may contain a wealth of drafts, but where are the final products? Henquinet argued that several texts from this manuscript served Bonaventure for his commentary on the *Sentences*.[15] A strong indication for the HT as an intermediary phase between the draft and the edited commentary is to be found in one of these texts: the question "*De baptismo,*" which made its way into the formal commentary almost verbatim.[16] Consider the comparison between the draft, the HT, and the final text that was printed in the *Great Edition* in table 5.2. The HT is closer to the edition than to the manuscript text on several points. In line 3 of table 5.2, concerning the problem of vocal expression in the sacrament, the manuscript text has "*queritur de forma verborum, et primo . . .*" (it is asked about the form of the words, and first . . .), whereas both the HT and the edition have "*secundo*"

5.4 (facing) Assisi, BC 186, fol. 92v: note also the pale traces of an incomplete schema (dealing with a different issue) just below the upper text on the left-hand column

5.5 (above) An HT from the group on angels, "On angelic cognition," Assisi, BC 186, fol. 93v

STRUCTURE OF TEXTS

TABLE 5.1. Comparison of Text and Schema for the Question *"On Venial Sin"* (Assisi, BC 186, fol. 17v)

TEXT	SCHEMA
[prologue] It is asked whether venial sin might become a mortal sin or not. And first, whether by repeating it; second, whether by advancement	
That it does by repeating . . .	(3) [whether venial and mortal sin] differ according to their species
Second, it is asked whether by progressing it becomes mortal . . .	(-) [whether venial and mortal sin] might be used univocally regarding something
Third, it is asked whether venial and mortal sin differ according to their species	(4) [whether mortal sin] exceeds venial infinitely
Fourth, it is asked whether mortal sin exceeds venial infinitely . . .	(5) with respect to which servitude is greater
Fifth, it is asked in respect to which of the two servitude is greater . . .	(1) Whether venial sin becomes mortal sin by repeating it or not
replies to the above five questions	
[-] whether venial and mortal sin might be used univocally regarding something [title alone, a blank space follows]	(2) whether by progressing or not

Note: Numbers in parentheses in the right column represent the original place in the text.

(second). Line 4 shows that the issue of the necessity of faith in a specific article is located a few pages further along, on folio 71r. Nevertheless, a *signe-de-renvoie* in the right margin of folio 67r marks the same location it has in the HT and in the edition. Finally, line 5 shows that the text introduces the next question as "*queritur de forma vocabuli*," whereas both the HT and the edition introduce it as a separate, second question entitled "*de forma verbi*."

The concise presentation of parts in HTs, therefore, not only enabled better orientation but, as shown in other chapters, also helped scholars to manipulate and reorganize units, imagining potential structures while writing. Several scholars have attempted to explain the efficacy of diagrams in problem solving. One explanation suggests that it is due to "implicit" or "emergent" properties, which stem from the analogical rather than propositional character of most diagrams.[17] But more relevant to this case is perhaps the explanation of efficacy as a result of mental animation. Hegarty has proved by following eye movements that conclusions about a diagram were achieved using a "mental animation of the depicted machine"; that is, diagrams enabled people to imagine the manipulation and movement of parts.[18] Composing the question "*On venial sin*," Bonaventure could similarly manipulate the order of its parts. Moreover, he could plan and revise the plans of his texts. Visualization enables the eye to have a simultaneous

Plate 1. Oxford, Balliol College 253, fol. 1r. Opening folio of an *Organon* codex with a historiated initial depicting a teaching scenario, marginal glosses, and two HTs. Courtesy of the Master and Fellows of Balliol College, Oxford.

This page contains a medieval Latin manuscript in heavily abbreviated Gothic cursive script that cannot be reliably transcribed without specialist paleographic expertise.

Plates 2 and 3. London, BL Egerton 633, fols. 15v–16r. Courtesy of the British Library Board.

Plate 4. Karlesruhe, Badische Landesbibliothek, Cod. St. Peter Perg. 92, fol. 11v

TABLE 5.2. Comparison of a Question on Baptism in Assisi, BC 186's Running Text in the Column, the Schema in Its Margins, and the *Great Edition* of the Commentary

BONAVENTURE'S COMMENTARY ON THE SENTENCES (4.64)	TITLES IN THE HT IN ASSISI, BC 186, FOL. 66V	TEXT IN ASSISI, BC 186, FOLS. 66V–68V (AND 71R)
Ad intelligentiam huius partis quaeritur de quidditate baptismi. Et circa hoc duo principaliter.... Primo quaeritur de his quae pertinent ad *integritatem* sacramenti.... Circa primum quaeruntur tria	(1) Queritur hic primo de quiditate baptismi Primo quantum ad ea que sunt de *integritate* sacramenti. circa primum tria:	
Primo quaeritur quid sit baptismus *a parte elementi* (text: *quid sit baptismus secundum suam essentiam*)	(1.1) Primo utrum quid sit baptismus *a parte elementi*	Primo queritur quid sit baptismus secundum suam essenti
Secundo queritur utrum expressio verbi vocalis sit de integritate baptismi	(1.2) *Secundo* utrum de integritate eius fit expressio vocalis verbi	Queritur de forma verborum, et primo utrum <utrum> in sacramento baptismi debeat exprimi verbum vocaliter[?]
Tertio utrum necessaria sit ad integritatem baptismi fides alicuius articuli	(1.3) Utrum necessaria sit fides alicuius articuli	[A marginal signe-de-renvoie on fol. 67r to fol. 71r, where one finds the question "utrum necessaria sit fides alicuius articuli"]
consequenter est quaestio de *forma verbi*	(2) Secundo quantum ad *formam verbi*	Queritur de forma vocabuli...

grasp of the whole, to jump from point to point easily, to notice multiple possible links between parts, and to make new combinations. I confess that experimenting with the technique to revise drafts for chapters of this very book, I was at first skeptical, but it worked like magic. Spatial manifestation enables one to practice what Tversky terms "constructive perception" and innovation. As she points out, "constructive perception ... depends on messy lines."[19]

One may object here by saying that planning texts by prior designing is a common medieval procedure. In his *Poetria nova* (ca. 1210), for instance, Geoffrey of Vinsauf advised his reader not to hasten to write down his poem. First, like a man who intends to build a house, he should have its general plan in mind:

The inner design of the heart measures out the work beforehand; the inner man determines the stages ahead of time in a certain order; and the hand of the heart,

rather than the bodily hand [author's italics], forms the whole in advance, so that the work exists first as a mental model rather than as a tangible thing.... Let not your hand be too swift to grasp the pen.... Let the inner compasses of the mind lay out the entire range of material.[20]

Yet the novelty of these attempts is precisely their use of the bodily hand, of the externalization as explicated in chapter 1. Goody's notion about literacy and lists applies to this case as well:

The *graphic* representation of speech ... is a tool, an amplifier, a facilitating device, of extreme importance. It encourages reflection upon and the organization of information, quite apart from its mnemotechnic functions. It not only permits the reclassification of information by those who can write ... but it also changes the nature of the representations of the world (cognitive processes) for those who cannot do so.[21]

We also see here clearly the function of categorization and abstraction. Like Goody's lists, the actual drawing of ramified trees of questions facilitated parsing, categorization, and classification of textual units and ideas, as "the perception of a pattern" or of a relationship "is primarily (though not exclusively) a visual phenomenon."[22] It made the structure of the otherwise too-long chain of words explicit and easier to manipulate, and thus made it easier to create more complicated structures.[23] In the next stage, categorization paved the way for new questions. General ambitious designs resulted in new symmetrical concerns, new "rooms" to be filled, and new questions to be dealt with. Like Goody, I would not claim that "the classification system itself is created by writing,"[24] but it certainly promoted this scholastic style of thought as it reflected it.

5.2 ANALYSIS: ARGUMENT

Wearing the hats of both authors and commentators, the schoolmen imputed to ancient authors their conceptions of the deep relations between doctrine and structure. Reconstructing the underlying structure of authoritative texts would lead them, they believed, to a deeper understanding.[25] Accordingly, at the very same time that they envisioned the sophisticated baroque structures of the summae, they developed interpretive techniques of text division.[26] Since the early thirteenth century, *divisio textus*, a scholastic mode of analyzing textual structure, was almost obligatory in commentaries on Aristotle, Peter Lombard, and the Bible and probably reflected classroom lectures on these books as well. While earlier commentators occasionally provided a principal division into the parts of the texts they were explicat-

ing, the scholastic hierarchical, progressive division into smaller units was a radically new and different practice.[27] Boyle's description of the *divisio* offers us a useful point of departure: "Starting with the text as a whole, one articulates a principal theme in the light of which one divides and subdivides the text into increasingly smaller units, often down to the individual words . . . [and consequently] each verse stands in an articulated relation not only with the whole but ultimately with every other part, division, and verse of the text."[28]

Linguistic analysis of single sentences inspired modern structural narratology.[29] Did medieval grammar similarly inspire textual analysis? From what we know of Latin curricula and the speculative grammar of the twelfth and thirteenth centuries, the answer is likely negative. A more likely source, yet only to a limited degree, can be located in classical rhetoric. The *divisio textus* assumes an ability, developed in the context of rhetorical studies, for recognizing and naming the functions of different parts of the text. Terms such as *narratio*, *redarguitio*, and *commendatio* are present, as we shall see below, in our diagrams, though perhaps less frequently than one would expect. Classical and medieval rhetorical theory emphasizes the general importance of organizing the orator's materials. It even recommends that the orator include a "division" as part of his speech (the third out of six), by means of which "we make clear what matters are agreed upon and what are contested, and announce what points we intend to take up."[30] It also recommends the use of enumeration, "when we tell by number how many points we are going to discuss."[31] The medieval commentator who makes a *divisio textus* may be viewed, therefore, as taking the position of the author, enumerating the parts of the primary text to be discussed. However, ancient divisions and enumerations are still only acts of parsing and naming. Classical rhetorical theory did not encourage subdivision or structural analysis of the relations *between* these parts, something that lies at the heart of the scholastic *divisio*. The scholastic method of grouping and regrouping that resulted in an overall structure is unique.

Many of the most intriguing aspects of the minigenre of text divisions remain understudied. This has a lot to do with the responses of modern readers, who usually feel that "the thirteenth century divisions of the text carry the art of boredom to its perfection."[32] Part of what makes these divisions difficult to swallow is that most scholars, especially those using modern editions, encounter text divisions only in their verbal form, which often follows a pattern such as "The book has three parts. . . . The first part divides into two. . . . The first of these sections divides into three," and so on and so forth, written in the same running lines in which the rest of the commentary is written.[33] Often, the entire division is not initially presented but unfolds along with the commentary. Verbal descriptions of complex structures are destined almost by their nature to be tedious and difficult to process cog-

nitively. Yet university masters also represented such text divisions as HTs, which facilitate deeper study and appreciation of the analytic potential of text divisions and shed new light on how medieval schoolmen understood textuality. We shall first look at what they reveal about authoring argumentative texts (section 5.2), then about narrative (section 5.3).

The technique of text division was broadly applied to the study of theoretical texts, both philosophical and theological. In the study of medieval philosophy and theology, it is often met with embarrassment or complete ignorance in the face of the lengthy, detailed descriptions of the structure of a text that seem to have nothing at all to do with the philosophical and theological ideas it conveys. Cultural historians, however, can recognize in this neglected textual area the crystallized fascination of medieval schoolmen with structure and their unique, sensitive, and amazingly detailed approach to studying a text and (re)constructing their image of the author as a highly systematic architect of themes and arguments. The first image of an author we shall examine is that of Aristotle, the Greek philosopher; the second is that of Peter Lombard, the twelfth-century Parisian theologian.

Aristotle

The assumption that Aristotle carefully composed and edited the works that have reached us through Andronikus's edition for public dissemination is no longer accepted. It is now assumed that what we possess are lecture notes, "texts which he . . . kept for his own use, not for that of a reading public." "His arguments," observes Barnes, "are concise. There are abrupt transitions, inelegant repetitions, careless allusions. Paragraphs of continuous exposition are set amongst staccato jottings. The language is spare and sinewy." "The reader who opens his Aristotle and expects to find a systematic disquisition on some philosophical subject or an orderly textbook of scientific instruction," he continues, "will be brought up short."[34] Medieval readers had this very expectation. Despite—or perhaps because of?—the nature of the Aristotelian texts, medieval schoolmen's working hypothesis was that in order to truly understand them, one should find the reasoning behind their form by minutely reconstructing underlying authorial operations.

Our case is taken from a large set of *divisio* diagrams that run throughout the margins of BAV Pal. Lat. 996, a beautiful codex of the *Organon* executed in Italy around 1275.[35] To obtain a genuine taste of this method and the difficulties it poses to cognition, you may consult the English translation of the opening chapter of the *Prior Analytics* quoted below together with a translation of the matching diagram the annotator drew in the upper margin, analyzing the chapter's structure (figure 5.6).[36] The textual units are identified by their opening words, which are underlined. The first unit in each

new division usually lacks such a lemma, since it is clear where it begins. Most divisions have either two or three branches, but at times the division has four or even five. Unlike the division of the book of Job, which we shall examine in section 5.3, such multiple divisions appear in the first levels rather than at the level of the terminal nodes.[37] The average number of levels per diagram is very high. A single diagram, using a *signe-de-renvoie* that allows it to branch further on the next page or just below, may easily include up to nine or ten levels.

To facilitate orientation, I divided the Aristotelian text into the smallest units and underlined the opening words (lemmata) of each. In the diagram in figure 5.6, I use these translated lemmata to mimic the medieval reading, and they are in italics rather than underlined. I use A. J. Jenkinson's translation:

We must first state the subject of our inquiry and the faculty to which it belongs: its subject is demonstration and the faculty that carries it out demonstrative science.

We must next define a premiss, a term, and a syllogism, and the nature of a perfect and of an imperfect syllogism; and after that, the inclusion or noninclusion of one term in another as in a whole, and what we mean by predicating one term of all, or none, of another. A premiss then is a sentence affirming or denying one thing of another.

This is either universal or particular or indefinite. By universal I mean the statement that something belongs to all or none of something else; by particular that it belongs to some or not to some or not to all; by indefinite that it does or does not belong, without any mark to show whether it is universal or particular, e.g. "contraries are subjects of the same science," or "pleasure is not good."

The demonstrative premiss differs from the dialectical, because the demonstrative premiss is the assertion of one of two contradictory statements (the demonstrator does not ask for his premiss, but lays it down), whereas the dialectical premiss depends on the adversary's choice between two contradictories.

But this will make no difference to the production of a syllogism in either case; for both the demonstrator and the dialectician argue syllogistically after stating that something does or does not belong to something else.

Therefore, a syllogistic premiss without qualification will be an affirmation or denial of something concerning something else in the way we have described;

it will be demonstrative, if it is true and obtained through the first principles of its science; while a dialectical premiss is the giving of a choice between two contradictories, when a man is proceeding by question, but when he is syllogizing it is the assertion of that which is apparent and generally admitted, as has been said in the *Topics*.

The nature then of a premiss and the difference between syllogistic, demonstrative, and dialectical premisses, may be taken as sufficiently defined by us in relation to our present need, but will be stated accurately in the sequel.

I call that a term into which the premiss is resolved, i.e. both the predicate and that of which it is predicated, "being" being added and "not being" removed, or vice versa.

A syllogism is discourse in which, certain things being stated, something other than what is stated follows of necessity from their being so. I mean by the last phrase that they produce the consequence, and by this, that no further term is required from without in order to make the consequence necessary.

I call that a perfect syllogism which needs nothing other than what has been stated to make plain what necessarily follows; a syllogism is imperfect, if it needs either one or more propositions, which are indeed the necessary consequences of the terms set down, but have not been expressly stated as premisses.

That one term should be included in another as in a whole is the same as for the other to be predicated of all of the first. And we say that one term is predicated of all of another, whenever no instance of the subject can be found of which the other term cannot be asserted: "to be predicated of none" must be understood in the same way.

5.6 BAV Pal. Lat. 996, fol. 197r, translation

The structure of this section according to our anonymous glossator is thus (figure 5.6):

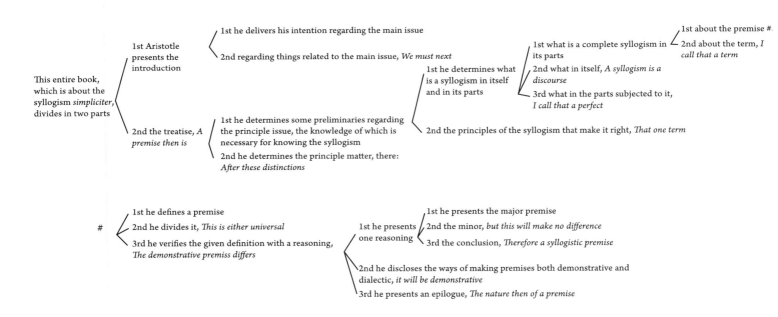

Since this is the first diagram of the *Prior Analytics*, it outlines the general structure of the entire text, then zooms in to the opening, leaving the bottom branches undeveloped. The first division, into a brief introduction (*proemium*) and the treatise itself (*tractatus*), may seem merely rhetorical, but our anonymous author appended another little HT to his division as well, to clarify its epistemological significance (figure 5.7):

⟨ by the introduction, the ignorance of negation is removed
by the treatise, the ignorance of disposition is removed ⟩ when these are removed, knowledge is generated

Petrus Hispanus, the thirteenth-century scholastic logician, notes that Aristotle distinguishes two kinds of ignorance in the *Posterior Analytics*. One may know absolutely nothing about a certain subject, not even of its existence, and therefore would not even try to inquire about it. This is the ignorance according to which a baby does not know his geometry. On the other hand, one may already know about a thing, perhaps very little but enough to know vaguely of its existence. In this case, there is already a disposition that could be matured into a habitus of true *scientia*.[38] Aristotle's writing itself, therefore, proceeds according to the development of a knowledge *habitus*: the *proemium* targets the first type of ignorance and generates a disposition to be developed by the body of the text.

The correspondence of structure to learning process becomes more evident as the next steps unfold, defining basic concepts and laying a foundation before addressing the core issue at stake. Aristotle himself explicates his intentions and offers a basic outline for what comes next, noting that "we must next define a premiss, a term, and a syllogism, and the nature of a perfect and of an imperfect syllogism; and after that, the inclusion or noninclusion of one term in another as in a whole, and what we mean by predicating one term of all, or none, of another." Our divider, however, follows him only to a limited extent. First, Aristotle's remark relates only to the matters to be discussed in the first two chapters, making readers wait until then to know the content of the next part. However, the diagram offers them a rough glimpse into the entire treatise, dividing it into preliminary knowledge, a necessary preparation to digging into the syllogisms, and the heart of the discussion. Furthermore, while the text enumerates the short issues to be discussed successively, the divider suggests a significantly more structured reasoning. First, he gives the entire first part a title. It is all about "what is a syllogism," whether in itself or in its parts. Then he analyzes it into a five-level structure. This analysis demonstrates how an exemplary philosopher actually "determines" issues. As we follow the process, we find the operations very closely identified with the Aristotelian and scholastic method: Aristotle defines, divides, confirms, and uses rhetorical elements

5.7 BAV Pal. Lat. 996, fol. 197r, translation (continued)

such as epilogue. The last terminal nodes demonstrate, in an amusingly reflective manner, that Aristotle's very explanation of syllogism is built as a syllogistic structure: a major premise, a minor premise, and a conclusion.

The principle of division into an introductory part and the core text—*proemium* and tractate, *proemium* and execution—recurs also in inner levels, such as in the interior division for the second part, and in the divisions of other works in the codex. It is noteworthy, however, that the text does not lend itself to, nor does the author aim to impose upon it, a rigid, single format. While principles of division repeat, each section differs from the other, and the division slides easily from one operation to another, to generate ever-changing structures. The text is a result of multiple authorial strategic operations, which in themselves compose others: Aristotle narrates, teaches, proceeds, removes doubt, shows, distinguishes, treats, expounds, gives a cause, presents a difference (*narrat, docet, prosequitur, removit dubitaionem, ostendit, distinguit, agit, exponit, dat causam, ponit differentiam*), etc. and in the *Sophistici elenchi* also manipulates his opponent (*instruit opponentem*). The dynamic of the diagram from left to right is a complex dynamic of authorship, recovering a live, active author. It is a reconstructed image of the mind of another.

Peter Lombard

Is this the image not only of a philosopher but of a theologian as well?[39] Do philosophers and theologians compose in the same fashion? Peter Lombard wrote his *Sentences* in the middle of the twelfth century, before the practice of divisions reached the zenith of its popularity in the thirteenth and fourteenth centuries. He was satisfied with dividing his work into four books. In the early thirteenth century, Alexander of Hales is credited with assigning more importance and prestige to the book, placing it in a central position of the curriculum, writing a commentary that was more substantial than previous glosses, and dividing each book into sections called "distinctions" to facilitate cross-reference and teaching. In most of the standardized manuscripts since that time, each such distinction opens with a large pen-flourished initial and its serial number is noted in the side margin. Quickly, these were divided again into chapters, noted in the side margins as well. Finally, most of the copies included also inner-column rubrics parsing the text, telling the reader the content of the next section, such as "response," "here about the reason why the Holy Spirit is a gift," and the like.

Paris, BnF Lat. 15323 features all the above verbal and visual paratextual devices, but these did not satisfy one of its users. In the upper margins of each distinction he added a text division representing the structure of the entire distinction or of one of its parts. At times his parsing repeats the

parsing and titles that were already visualized by the rubrics, but often it differs. Dividers were therefore not discouraged by the fact that the text was already standardly divided into distinctions, chapters, and headings. On the contrary, they used the numbers of chapters and distinctions to mark sections in their personally crafted and elaborate divisions, digging deeper and deeper to reconstruct the points where structure and message interlace.

The most important message was the medium. Our annotator began with verbal divisions, then after several pages changed strategy to drawing them as HTs. While the rubrics are woven into the running lines and thus obey sequential imperatives, the HT conveys a notion of hierarchical structure. Demonstrating the rhetorical and argumentative role of each book, distinction, chapter, and sentence, the HTs visualized that art of argumentation in a way no verbal prologue can. The margins were usually able to host these quite sophisticated and complex structures, but at times, they required full pages.[40] I dare to propose that at a certain level of complexity text divisions just cannot truly be grasped verbally.

The earliest known diagrammatic divisions of the *Sentences* are those of Richard of Fishacre, a Dominican friar active in England in the 1240s whom we have already met. Richard, as I mentioned earlier, explicitly refers to his diagrams, introducing them in expressions such as "I have drawn this division as a ramifying tree thus," "I have drawn for you the division of this distinction so that you see it before you," ". . . whose division is drawn thus." These unique remarks may suggest that while the practice was already at least several decades old, its application to this type of extensive text division, which was new in its own right, was novel enough to call for explication. Richard's diagrams formed such an integral part of his commentary that not only did most of the copyists copy and integrate them as embedded diagrams, but modern editors also understood the importance of publishing them. The majority of diagrammatic text divisions, however, were not part of any full commentary and await scholars to notice them in the margins.

An attentive look at Richard's diagrammatic divisions reveals that Peter Lombard's craft of composition involves two types of layers. The first levels of Richard's trees organize themes hierarchically and logically. The only authorial action is to "deal" (*agit*) with this issue and then with another. Themes are organized mostly by general, basic schemes such as dealing with topic X generally and then particularly; by the four Aristotelian causes; or by questions such as "what is X?," "why?," "how?" A recurring formal rhetorical principle of division in these primary levels, which we have already seen in analyses of Aristotle, is divisions into "introductory" and "executive" parts.

As we move our eyes to the right of the HT, toward the terminal nodes—that is, into the microstructures of writing—the second type of layer unfolds and we see argumentation in action, of a kind very similar to what we have seen in Aristotle. These parts feature a great variety of autho-

rial actions, among which are "presents" (*ponit*) a doubt (*dubitationem*), an opinion (*opinionem*), an authority in favor on one side (*auctoritatem ad unam partem*) or a refutation (*destructionem*); "says" (*dicit*); "promises" (*promittit*); "proves" (*probat*); "confirms" (*confirmat*); "asks" (*quaerit*); "determines" (*determinat*); "solves" (*solvit*); "asserts" (*asserit*); "dissolves" (*dissolvit*); "enumerates" (*enumerat*); "inquires" (*inquirit*); "shows" (*ostendit*); "replies" (*respondit*); etc. The nodes are so saturated with verbs that the text of the master comes to life, seemingly animated by the actions of a very present human agent.

Some recurring minipatterns and building blocks of argumentative writing can be extracted from these HTs, such as the common couples shown in figure 5.8.

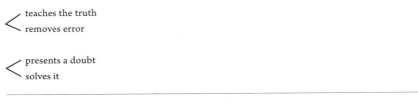

5.8 Common minipatterns

More complex structures, however, although constructed of a limited number of simple building blocks, show endless variations of combinations, as we have seen in Aristotle, with no presumption to impose on them sym-

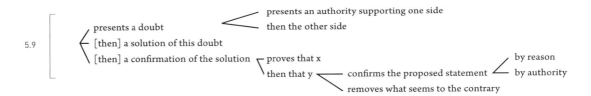

metry or rigid structures. Figure 5.9, for instance, shows a part of Richard's division of book 2, distinction 3.[41]

In section 2.1, I touched on the question of whether the same textual subject matter in some way guides people's minds toward representing it by a similar diagrammatic pattern. One might assume that highly argumentative texts would provoke analytic minds to analyze them in the same way. After all, we all recognize introductions, problems, affirmations, and proofs, don't we? Yet each master provided his students with his own text division, leading one to wonder about the extent to which these analyses of thematic organization and argumentative technique differ from each other. Would not the same structure be reconstructed by all? To examine this question, let

us compare three diagrams that were drawn in the thirteenth and fourteenth centuries on the first page of the second book of the *Sentences*. The first is Richard of Fishacre's, following Long's edition; the second was drawn by an anonymous hand in the upper margins of Paris, BnF Lat. 15323 (hereafter AP); and the third, another anonymous division, appears in both London, BL Add. 10960 and BL Add. 10961 (hereafter AB).[42]

On my office wall, I hung the entire text next to three long sheets of parasitic diagrams, so that I would be able to clearly *see* what is going on. The book medium forces us to take different measures to follow the comparison. Try, at least a little, to go there with me, if only to experience how sophisticated this intellectual game is and how visualization is crucial for playing. The entire text of this distinction can be found in Giulio Silano's translation of *The Sentences*, 2:3–8. I have divided the text into all the existing segments proposed in these three divisions (twenty-nine in all), then marked each by its first words in the English translation, so readers who wish to can follow. This list appears on the right side of each of figures 5.10–5.12.

Each division differs slightly from the others, not only in the hierarchical organization of the units and in their titles but in the cuts between the units themselves. Let us begin with the external layer, the thematic organization. AB perceives the second book as dealing with the power of God as it shines through creation. Then, however, he centers on man, dividing the book into a discussion of man's creation (distinctions 1–20) and his fall (21 to end). Since everything was created for man, he explains, one should address first the establishment of the universe (*conditio rerum*). Nature is positioned as merely a preparation for moral, anthropocentric concerns. This part then divides into a general and a particular discussion. Richard and AP, however, set the universe as the overall principle for the entire book, then move on to divide it into a general discussion of the universe and a particular one on the universe's parts. Human fall and sins are simply part of the universe.

Remaining on this layer, comparison shows that some units have a dual, Janus-like function, being interpreted as either the epilogue of one topic or the introduction to the following topic, a phenomenon we shall see also in analyses of narrative structure in the next section. Thus, although all three believe that the first distinction deals with the universe and the next distinction with its parts, Richard analyzes the paragraph beginning with "From the foregoing" as an introduction to the discussion on the parts of the universe and contends that the last sentence opens the executive part.[43] AP and AB, however, identify this sentence as the conclusion of an inner part of the previous discussion.

Going deeper, the three do not share the same degree of resolution in the same places: AP is more detailed in the microlevel in almost every section, but regarding the last unit, it is Richard who breaks it into tiny pieces. Structure differs on many minor points. All three identify the part up to

```
On creatures ─┬─ On the universe ─┬─ what was created ─┬─ teaching truth                                                                          Scripture, indicating
              │                    │                    └─ removing error ─┬─ first of Plato ─┬─ removing the error ─┬─ 1st of his one...           In the beginning
              │                    │                                       │                  │                      └─ 2nd of his other...         For Plato held
              │                    │                                       │                  │                                                     For a creator is
              │                    │                                       │                  └─ refuting the doubt that originated therefrom       and properly speaking, to create
              │                    │                                       │                                                                        And yet it is to be known
              │                    │                                       │                                                                        For when he is said
              │                    │                                       │                                                                        Therefore just as it happens
              │                    │                                       └─ 2nd of Aristotle                                                       But Aristotle
              │                    │                                                                                                                The Holy Spirit
              │                    │                                                                                                                of the one for whom
              │                    ├─ and why, i. e. efficient cause                                                                                And so let us believe
              │                    │                                                                                                                But no one can be sharer
              │                    │                                                                                                                And he distinguished
              │                    │                                                                                                                And so if it is asked
              │                    └─ and for what purpose ─┬─ for what purpose was the spiritual creature created                                  And if it is asked
              │                       final cause           │                                                                                       And so, when it is asked
              │                                             │                                                                                       And just as man
              │                                             ├─ for what purpose the corporeal                                                       And so man was placed
              │                                             │                                                                                       For, as the Apostle says
              │                                             │                                                                                       Concerning man
              │                                             └─ for what the creature ─┬─ first reason ...                                           It is also usual to ask
              │                                                combined of the two. i.│                                                             To this it may first
              │                                                e. man                 ├─ second...                                                  Secondly, it may be said
              │                                                                       └─ third...                                                   Souls were also
              └─ On the parts of ─┬─ An introductory part ─┬─ says what has been said                                                                From the foregoing
                 the universe     │                        ├─ what should be said                                                                    And since we must treat
                                  │                        └─ what is the purpose of what should be said                                             so that the teaching
                                  └─ An executive part                                                                                               Concerning angelic nature
```

5.10 Richard of Fishacre's division of book 2, distinction 3, of Peter Lombard's *Sentences*

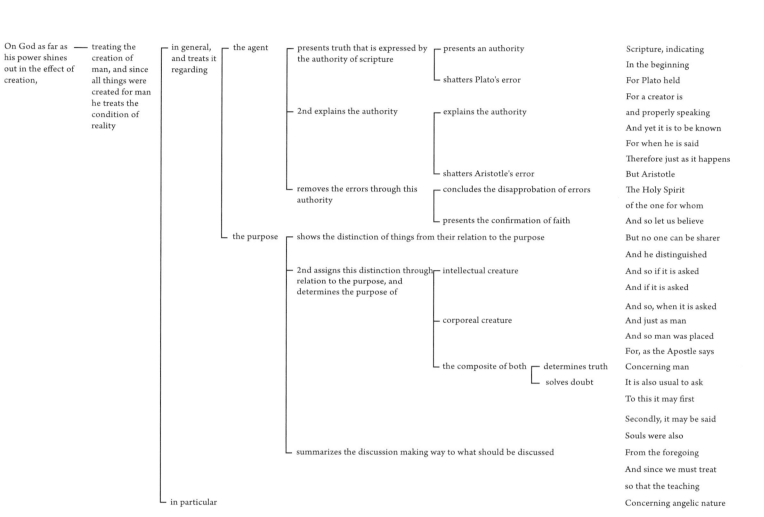

5.11 A marginal division of book 2, distinction 3, of Peter Lombard's *Sentences* in London, BL Add. 10960 and 10961.

- On creation
 - On creatures in general
 - 1st he discusses the creatures regarding their exit from the principle
 - 1st by authority he shows the truth of faith against all errors of those assuming...
 - 2nd ... these errors
 - 1st Plato's
 - 1st shows how by authority Plato's error is ruined
 - 2nd as evidence for what was said he explains certain ambiguous words...
 - 2nd Aristotle's
 - 3rd summarizing he concludes the truth of faith
 - 4th keeps explaining that God's will and goodness rather than necessity are the reason for creating...
 - 2nd regarding their relation to the final purpose
 - 1st shows for what was the spiritual creature created
 - 2nd treats its distinction
 - 3rd concludes the causes of creating the rational creature
 - 2nd for what was the corporeal nature created
 - 3rd moves doubt from what was said and solves
 - 1st raises the question why soul was united to body
 - 2nd brings three reasons for it. 1st [...] 2nd [...] 3rd [...]
 - 4th concludes from the preceding sayings the order of what should be treated
 - in particular

5.12 A marginal division of book 2, distinction 3, of Peter Lombard's *Sentences* in Paris, BnF Lat. 15323

────────────────────────────	Scripture, indicating
├── 1st presents Plato's error	In the beginning
└── 2nd assigns *** and doing from which the destruction is clear	For Plato held
	For a creator is
	and properly speaking
├── 1st shows that these words do not suggest movement in God as they do in us	And yet it is
├── 2nd manifests in what sense God is said to make something	For when he is said
└── 3rd he confirms what he has said with an analogy to creatures	Therefore just as it happens
	But Aristotle
	The Holy Spirit
	of the one for whom
	And so let us believe
── 1st from the saying that God's goodness is the cause and reason for creating things he concludes the ** of the rational creature	But no one can be sharer
	And he distinguished
┌── 1st touches the purpose on the part of the agent, God's goodness	And so if it is asked
├── 2nd touches the purpose on the side of the deed, praising God	And if it is asked
└── 3rd *** both	And so when it is asked
── 1st says that the corporeal nature was made for man as man was made for God	And just as man
── 2nd concludes that man is like a middle between God and creatures	And so man was placed
── 3rd shows it by the apostle's authority and explains the authority	For, as the Apostle says
── 4th shows how one should understand the saying that man was	Concerning man
	It is also usual to ask
	To this it may first
	Secondly it may be said
	Souls were also
	From the foregoing
	And since we must treat
	so that the teaching
	Concerning the angelic nature

"But no one can be sharer" as one principal unit, but they differ in their inner divisions, in determining where precisely the refutation of Plato's error begins and ends, whether there is one error or two, and even whether the entire paragraph revolves around refutation of error or rather around scriptural authority. They all have Aristotelian concepts of causation in mind. Yet Richard recognizes the portion of the text starting from "And so let us believe" as a principal part, dealing with the question of "*why* the world was created," distinct from the preceding part about "*what* was created" and from the following one, the final cause of creation. AP and AB, on the other hand, tear it apart, understanding its first section as the conclusion for the preceding discussion that was all about the efficient cause (AP) or about creatures regarding their exit from the principle (AB). Its second part is, in their eyes, the opening to the part dealing with purposes, and even an integral part of the discussion of spiritual creatures.

Both Richard and AB recognize in this "final cause" part a clear tripartite scheme dealing with the spiritual creature, the corporeal creature, and the human creature comprising both soul and body. They do not agree, however, on the exact place where the first and the third begin, and AB poses this discussion in a framework of introduction and summary that is absent from Richard's proposed outline. AP, on the other hand, does recognize a structure framed by an introduction and epilogue and believes that there is a dual structure here which is more about argumentation technique. The Lombard, according to him, first deals with the purpose of the spiritual creature, then of the corporeal creature, that is, man. Where Richard and AB already began with the composite, he identifies the new unit as the presentation and solution of a general doubt. In the microlevel of authorial operations there are many variations as well, but this is enough, I hope, if not for following it all, then at least to understand that the headache caused by dealing with such structures in words does not ask, but cries out, for visual representation. The art of exegesis is shown here in the most explicit manner, as following an author's mind in unpacking complex ideas into a linear presentation, considering both thematic principles and doctrines and argumentative and rhetorical technique. This is what authoring meant for the schoolmen; this reconstruction of the author's actions is how they understood true analytic reading; and this reconstruction is almost inconceivable without visualization.

5.3 ANALYSIS: BIBLICAL NARRATIVE

As we turn now to the way HTs represented the structure of narrative, we confront the tension between the line and the tree, linearity versus structure, from one last angle. University theologians always felt uneasy regarding

their working with historical narrative and stories, which did not readily lend themselves to the image of proper demonstrative science. But, as Minnis beautifully demonstrated in *Medieval Theory of Authorship*, there are theoretically illuminating literary conceptions and practices which still lie hidden in the scholastic commentary tradition. The peculiar meeting point between story and rigorous observation had surprising fruits. Our current interest is, therefore, to investigate what happened when theologians applied their structural sensitivity together with its diagrammatic expression to stories. In doing so, I argue, they engaged in an implicit narratology, the art of analyzing narrative structure, plotlines, and dialogues, but this narratology becomes visible to scholarly modern minds only when, well, it *is* visible.

HTs of narrative structure appeared, like the other text divisions, in the margins of commentaries. Assisi, BC 49, folio 12r, for instance, presents the reader with no fewer than three ways to reconstruct the story of Jesus's life: one in the column and two alternatives in HT form in the margins. According to the first division, Jesus first manifests himself by miracles, teaching to edify everyone in faith and virtues alike. Then, from chapter 13 on, he manifests himself to edify only the perfect ones or his disciples, specifically through his virtues. The first marginal HT identifies chapter 13 as a division point too but categorizes the parts differently: Jesus manifests himself first through works of edification, then, from chapter 13 on, through the works of consolation. Finally, the second HT draws the line somewhere else and suggests that the first chapters address the different groups to which he manifests himself such as disciples, priests, and Samaritans; thereafter, from chapter 5 on, the text focuses on the actual words he preaches.[44]

The clear HT presentation allows us to dig deeper into the biblical *divisio* and the narrative perceptions it conveys, and we shall do this through a close inspection of a series of HT diagrams found in the lower margins of Assisi, BC 51, depicting the structure of the first three chapters of the book of Job. As in the previous section, it requires browsing back and forth between my text, the diagrams, and the biblical text, but I hope you will engage in the task, so as to experience the effect of visual representation firsthand.

The schoolmen of the thirteenth century composed a significant number of commentaries on the book of Job. Among these scholars were the Dominican masters Roland of Cremona, Hugh of Saint-Cher, Guerric of Saint-Quentin, Thomas Aquinas, and Albert the Great, as well as the Franciscans William of Middleton, Peter of John Olivi, Matthew of Aquasparta, and Richard of Mediavilla.[45] The most famous of these commentaries is Thomas Aquinas's *Literal Exposition*.[46] "One of Aquinas' more mature and polished commentaries,"[47] it presents a thorough discussion of providence and related matters and exemplifies the scholastic exegetes' new emphasis on the literal sense of scripture.[48] Although Aquinas employed *divisio textus* in other commentaries, he did not propose an explicit one in this exposition.

Boyle has suggested that since Aquinas perceived the book of Job as "a give and take narrative argument," the literal interpretation of the text was not served by such a division.[49] Jaffe, in the introductory essay to his English translation, insisted that Aquinas delineated a very clear structure, although "Thomas' reader is not made aware of this structure in advance." He proceeded therefore to fill this gap and provided one of his own.[50]

At least two late thirteenth-century manuscripts of Aquinas's exposition also compensated for this lacuna. On the last page of the first, Florence, BML Plut. 20.18, dated to before 1280, someone added an unfinished draft of a verbal *divisio textus*.[51] The second manuscript is Assisi, BC 51, dated to the late thirteenth century.[52] This codex contains one of the earliest copies of Aquinas's commentary, biblical commentaries and *quaestiones* by Matthew of Aquasparta (fols. 121–202 are said to be his autograph of the commentary on the Apocalypse), commentaries by John of La Rochelle, as well as an anonymous, decapitated commentary on Job.[53] In the bottom margins of the first folios of Aquinas's exposition in the Assisi manuscript (fols. 1r, 2r, 3r, 3v, 4r, 4v, and 5r), an anonymous hand has carefully drawn ten diagrams, depicting an unknown *divisio* of the first three chapters of the book of Job.

As in the HTs discussed above, each unit or cluster of units of the biblical surface text is assigned a name or a "title" usually indicated by its opening words or by the chapter number. The latter are frequently underlined, but in these specific HTs they are sometimes missing or appear above the title with no underlining. All in all (excluding the diagrams in Assisi, BC 51, fol. 5, which analyze Job's speech and therefore do not belong to the pure narrative), 8 diagrams describe the complete structure of the first two chapters, presenting the relations among a total of 80 terminal nodes, which are the smallest undivided textual portions. Combined in a large folio, these HTs together would have made up one tree. The HT on folio 1r shows the primary division of the entire book. In its first 2 divisions, the bottom branches remain undeveloped, while the upper branch is explicated to its end. The diagram on folio 2r departs from that second, promised branch, and the diagrams on folios 3r, 4r, 4va, and 4vb develop the branches which remained open in folio 2r. The 2 bottom branches of the diagram on folio 3r continue on folio 3v, and folio 4vc completes 4vb, whose open branch itself continues in folios 5ra and 5rb. Out of 45 divisions and subdivisions of sections of all levels, the vast majority divide into 2 (53%) or 3 (29%) branches. Divisions into more than 3 parts (18%) are usually at the last level. This author's tendency to generalize and regroup a minimal number of units results in a high number of levels, enhancing the impression of the text as highly complex. The principles of parsing vary according to the subject matter. Some have a more formal nature, whereas others are closer to the specific content. A purely formal division, for instance, appears in the HT on folio 5ra, the first division being between the "title of the coming *narratio*" and "the *narratio*."

Other principles of division follow common theological dichotomies like good versus bad; a general group such as "goods" splitting into its species (temporal and spiritual); or emotional phenomena such as mourning or sorrow and their various expressions. The sentences describing the death of Job's children are distributed into the elements composing an event, like time, place, and agent.

Significantly, parsing pays no regard to the actual surface length of the units or to formal division into chapters or verses. In fact, it favors imbalance, and like the divisions of argumentative texts, does not impose symmetry upon the text. The first division, for instance, puts almost the entire book in its first part, leaving a handful of verses to the second. The number of levels differs as well: ranging from 5 (HT on fol. 1r, units 1–3) to 15 (HT on fol. 3v). Subdivisions may result in equal-length trails, mainly toward the end of the division; or in highly asymmetrical ones, such as a first, short branch, then 2 longer ones, or other combinations. While thematic symmetry is strengthened time and again by the frequent division into 2, quantity and length were clearly not an issue for the art of narrative construction in medieval eyes.

The Narrative Function of Description

Of the curious choices embedded throughout these diagrams, I will focus primarily on several points in the first two. The first HT, showing the principal division of the book and the full explication of the opening verses, will serve to demonstrate the subtlety and interpretive force of this technique and its diverse expressions with regard to coherence and to the narrative role of a character's description; the second will serve to examine the way dialogues and argumentative exposition are tackled in the frame of narrative analysis.

Looking more closely at the HT on folio 1r (figure 5.13), we see that unlike the ideal type described above, the surface of the text—that is, the opening words of the specific textual unit—is frequently missing. You may instead use the numbers attached to the units in the appendix. In three of the five times when the opening words of the specific textual unit are not missing, they are written *above* the title without the typical underlining. The diagram begins with a twofold division of the story: the multitude of Job's sufferings, which occupy almost the entire book, and the symmetrical plurality of his comforts as described in its final chapter. This division is identical to the one made by Matthew of Aquasparta, whose commentary reveals its source in Psalms: "*secundum multitudinem dolorum meorum in corde meo consolationes tuae laetificaverunt animam meam*" (In the multitude of my anxieties within me, Your comforts delight my soul; Ps 94:19). While

the author of this diagram did not specify the precise words opening the second part, Matthew sets its beginning at 42:1.[54]

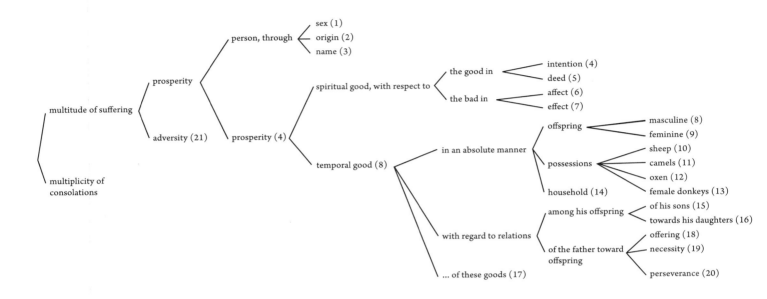

5.13 Assisi, BC 51, fol. 1r, translation

The first verses present the protagonist through his name, origin, virtues, and possessions. What are their functions in the overall structure? And why does prosperity belong in the section of the story allegedly focusing on Job's sufferings or anxieties? This is not an obvious decision. Olivi, for example, chose to accord the treatment of Job's prosperity an independent place, dividing the story into three parts—initial prosperity followed by adversity and finally good fortune—thus suggesting a ternary form and emphasizing the chiastic relation of its opening and ending (*aba* form).[55] Another contemporary Franciscan master, William of Middleton, understood all that precedes the devil's attack to be a description of Job's person as the person fit for the battle he will be subjected to later. He thus undermines the prosperity-adversity opposition altogether.[56] Matthew of Aquasparta, who, like our anonymous author, splits the "sufferings" section into "prosperity" and "adversity," explains his division by slightly changing the section's general theme. The section, he argues, aims to demonstrate Job's personal perfection, which is revealed both in times of prosperity and in times of misfortune. A similar principle guided Richard of Mediavilla. He also divided the book into two parts: persecution or perfection, and retribution. The first part presents not only Job's persecution but also his perfection, which is demonstrated in times of prosperity and anxiety alike.[57] Our author, however, conceived of the narrative role of the description of Job's

CHAPTER { 5 }

prosperity differently: it forms a background or setting for his suffering, for to understand Job's afflictions, one must first know his preceding prosperity.

This raises the question of how Job's name and place of origin participate in prosperity or perfection. Thomas Aquinas, whose exposition appears in the columns above our diagram, can be understood in both ways. At first, he argues that the description of prosperity begins only after the person of Job and his virtue are presented. The division attached to Aquinas's exposition in Florence, BML Plut. 20.18 does precisely that. According to Aquinas, prosperity begins only after "person" and "virtue," with the words *natique sunt ei* ("and seven sons and three daughters were born to him"). But he also writes that the author of the book of Job intended to depict him in the most perfect way, so as not to make us suspect that his adversities were due to anything he had done. His being a *vir*, a man rather than a woman, a mature individual but not yet an old man, accords with this perfection.[58] In the same manner, he interprets Job's virtues as spiritual goods, and the following sentences as describing the temporal goods.[59]

The author of the Assisi HT, however, found a middle way. He chose to see Job's name and origin as part of the "prosperity" section, but not a sheer *expression* of it or as a kind of good. The name of the second branch of prosperity is "prosperity" as well, suggesting that he conceived the first as a *preliminary* to the issue proper.[60] Virtues, however, were interpreted as a genuine part of the spiritual goods bestowed upon Job, as he divides this second category of "prosperity" into spiritual goods, temporal goods, and a third category, the script of which was unfortunately damaged.[61] The spiritual goods—that is, Job's virtues—are then further divided according to their relations to the good and the bad and then into even more specific subcategories emphasizing symmetrical relations to the smallest detail. This wrestling with how to understand the true place of an author's description of his protagonist and the ways it serves the author's message and the unfolding of the story, while considering different options suggested by other masters regarding the exact place of the first words within the fabric of the entire tale, required remarkable effort and subtlety. This task was facilitated, as I hope readers experience themselves as they struggle through my description, by using diagrams.

Arguments, Imbalance, Dialogues, and Repeated Patterns

The HT on folio 2r of Assisi, BC 51 (figure 5.14) develops the theme of adversity but then relegates it to the background, taking God's temptation of, or attack on, Job as this section's organizing principle. This choice in itself embodies interpretive force by refuting any possible designation of Satan as the initiator of the entire episode. All that follows is the story of

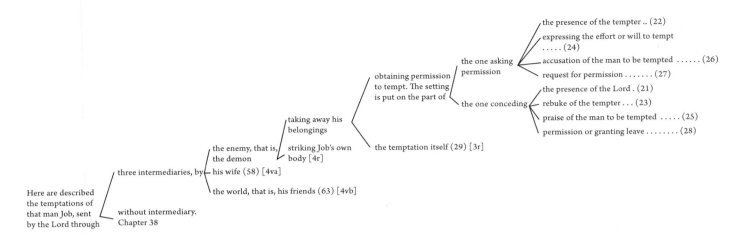

5.14 Assisi, BC 51, fol. 2r, translation (the number of dots at the end of each line signifies their order of appearance in the biblical text: one dot for the first section, two dots for the following, etc.)

God's temptation, which, the diagram tells us, is executed either through intermediaries—Satan, Job's wife, his friends—or directly, when God speaks to Job from out of the storm. These diverse events thus acquire a kind of equivalence, sharing the same role, although they differ in terms of narrative length. Job and his friends' disputation occupies more than thirty chapters, while Job's wife's temptation occupies fewer than two lines.

This quantitative asymmetry, as with that of the very first division, stems partly from the book's peculiar combination of enveloping frame story and lengthy theological discussion and might easily be solved if the disputation were entirely separated from the frame story. This is precisely what Aquinas did, distinguishing as the very first step of his commentary the *disputatio* from the *ystoria*. The anonymous author of the *divisio* in the Florentine codex followed him. Albert the Great set theory apart as well. Taking "temptation" as the organizing principle for the entire book, he divided the book into three sections: (1) the attack or temptation itself, including the preceding state of prosperity, (2) the *disputatio* between Job and his friends regarding the *cause* of temptation, and (3) Job's state after his temptation.[62] Our author, however, takes the lengthy disputation itself to be a genuine part of God's indirect temptation and attack, one way among others to challenge Job's perfection.[63]

Here, as in other cases, dividers distinguish between the occasion, condition, or setting for a principal event, on the one hand, and the event itself, on the other, strengthening coherence within units where it is not always evident but also exacerbating imbalance. The function of some actions is to launch a response or event, which forms the true center of the episode. The analysis of Satan's attack imposes a series of such asymmetrical structures on the text, each of which has a clear center of gravity. The author first distinguishes the setting (Satan's request for permission to attack Job) from the actual attack (fol. 2r, fourth division); then, on a minor scale, he distinguish-

es between two preparative stages and, again, the "attack itself" (fol. 3r, first division), then distinguishes another "attack itself" section, presenting the killing of Job's children. Narration of events, according to this anonymous commentator, is partly constructed of pairs in different levels of a preceding setting and the main, "actual" event it launches.[64]

Narrators often weave dialogues into their fabric, but the parsing and analysis of dialogical scenes are challenging. One might focus on the stops interlocutors make while exchanging words or address more general features of the conversation's dynamic. For instance, "yes" and "I totally agree," when split by a remark of the second interlocutor may be taken as two distinct units or as one expression of consent. The author of the HT on folio 2r of Assisi, BC 51 observes that the scene revolves around obtaining permission.[65] Therefore, for the sake of analysis, Satan's submission of his request precedes God's granting it. This deep structure defies the chronology of both the surface level of the text and its story, where God appears earlier. Each character is treated with four units, distinguished by their function in the dialogical act rather than by the natural division created by the verbal exchange. The titles of each section draw the reader's attention to a hidden symmetry in the setting of the scene:

SATAN	GOD
Presence	Presence
Expressing his will to tempt	Reproach
Accusing Job	Praising Job
Request for permission	Granting permission

Having shuffled the chronological sequence in this manner, our author also provides the readers with a key to reconstruct its original order. The number of dots at the end of each line (from one to eight) signifies their order of appearance in the biblical surface text: one dot for the first section; two dots for the following, etc. (see figure 5.14).

The uniqueness of this choice becomes apparent when compared with Matthew of Aquasparta's very different approach to dialogue analysis. Matthew keeps the original order and coherence by focusing on *one* interlocutor and his personal drama: Satan. The heavenly scene precedes the diabolic attack by presenting Satan's hostility. This presentation of hostility is divided into its "*occasio*" ("occasion" or "trigger") and its "manifestation." God asks Satan where he has come from and, after receiving Satan's answer, teases him by asking whether he saw his servant Job. God thus creates in several steps the context for Satan to manifest his hostility. This manifestation of diabolic hostility, according to Matthew, is the essence of the second part of the scene, which consists of Satan's reply, his request for permission to afflict Job, his reception of divine authorization to proceed, and his departure to

undertake his task.⁶⁶ This last section, Satan's withdrawal from the scene, can be conceived of in two ways: as the end of this narrative unit or as a short opening for the next narrative unit. Matthew chose the first option; our author, the second. In the HT on folio 3r, Satan's departure and the designation of the period of time for his actions form two short units preceding the description of his attack, which occupies the largest part of the diagram.

Many classic stories repeat almost identical scenes with slight variations: the wolf encounters the youngest pig, then the older brother, then the oldest; Goldilocks finds a big/midsized/small chair/cup/bed. In our story, Satan attacks twice, and the biblical author includes two almost identical celestial scenes before each attack. In both, a similarly phrased dialogue between God and Satan precedes the actions themselves: the first against Job's possessions and family, the second against his own body. The third branch of the HT on folio 2r presents the division between the attacks and proceeds to analyze the dialogue of the first scene, but the details of the second attack are not explicated. The author just notes on folio 4r that the division is exactly the same. On the other hand, on folio 4v, there are HTs that develop the two other indirect divine temptations—through Job's wife and through his friends—and painfully illustrate their structural difference. The brief wife's scene is not introduced with any remark, such as "his wife was there," while the temptation presented by his friends is preceded by an extensive preparatory description of their arrival and their expressions of sorrow.

We have examined visualized analyses of argumentative, theoretical texts in section 5.2. But the application of HTs to narrative highlights the implication of the spatialization of time and the spatial nature of narrative. Indeed, already the fundamental visual representation of a story in its material form—the page and the book—turns time into space.⁶⁷ Movement in time along this space is partially free. One may browse back several pages to recall a forgotten piece of information, meditate on a particular sentence, or take a glance at the end. At the same time, this movement is limited. The graphic forest of letters in successive lines makes it difficult to see quickly *where* to browse, thus favoring the dictated, linear progression. As mentioned in chapter 1, different aids familiar to us today were invented in the twelfth and increasingly throughout the thirteenth century to facilitate location of specific information in texts without reading all the way through, helping readers to navigate the textual space of page and codex. More and more texts and manuscripts were manufactured "for use" rather than for continuous reading, and their layout was designed accordingly. Even manuscripts of chronicles, which constituted *the* genre of linear narrative, were produced with indices and rubrics and original, visual subject signs, enabling one to create different paths of reading through a single text, depending on whether one sought information on bishops, for instance, or the history of secular emperors, or any other subject the narrative recorded.⁶⁸

The HTs analyzed here both build on and complicate this spatialization of time and the readerly freedom it entails through their unfolding and simultaneity discussed in chapter 1. Observers who look at such an HT first see one object, a story that exists in a certain manner at a single moment. It is noteworthy that in the *divisio* itself, terms such as opening, beginning, or ending are entirely absent. Yet as in a sculptural plan of a giant church portal or a complex picture or in a genealogical chart, the element of time reappears as observers move their eyes from one detail to another. It seems that, with the exclusion of two cases, were we in possession of the full text of each unit and not just its opening words, we could read the entire narrative top down. But the diagram's heart is the underlying structure and not the surface. In fact, the diagram presupposes the mental or physical existence of the surface at hand, so that one can now play with its spatial setting.

The *divisio*—both verbal and visual—prompts movement back and forth across the original narrative sequence in a series of leaps. The reader is pulled forward and backward in ever-shorter intervals, from the opening chapter to the last, then back to the beginning again, then to the beginning of the second part of the first part, etc. As HTs are read from left to right, narrative appears as the unfolding of an idea. At the same time, they enable readers to work their way back in the opposite direction, placing each detail in widening circles of context and meaning. They may also be read vertically, creating thereby abstracts of the text that differ in their increasing resolution.

The assumption that the underlying structure is an HT that always splits but never converges seems, however, to support linearity from a different aspect. As adjacent units are grouped into larger ones, there is seemingly little room for links between *non*-sequential parts, which skip over their neighboring units. In the sequence that runs 1, 2, 3, 4, 5, 6, for instance, strong ties and common features are usually found between successive units such as 2–3 or 4–5–6, while a group of, for instance, just 2 and 5 is rare. These divisions therefore leave few opportunities to interpret interlacing plotlines or something that appears in an earlier scene as a clue whose relevance will be revealed further on in the story. Although this is the typical case, scholastic commentators also conceived of less common *divisiones* whose branches interlace as well. One example is found in the anonymous *divisio* in the above-mentioned Florence, BML Plut. 20.18, which closely reflects Aquinas's implicit divisions. Following Aquinas, it demonstrates Job's virtue, as well as his care for his own and his family's moral purity, in two nonsequential sections of the text: his description (4–7) and his later pious conduct (15–20).[69] Material prosperity (8–14), the third branch, lies between these two sections. In fact, Aquinas's first division should also result in a significantly nonsequential structure. The above-mentioned distinction between the historical-descriptive part of the book and the disputation over divine

providence implies that the first part consists of the first three chapters *and* the last one, thus enveloping or framing the disputation.

Divisio diagrams could have been used, perhaps, to memorize either the commentary or the biblical text itself. If so, this memorization involved a great deal of additional interpretation, very different from that required by images such as the figures contained in the anonymous *Ars memorandi* for the Gospels.[70] Considering the remarkable increase in search and reference tools during the twelfth and thirteenth centuries, one might argue that both the *divisio* and its tree diagram should be explained in this context.[71] Indeed, the thirteenth century saw the division of the Bible into chapters, sections, and, later, verses. Vertical lists of contents and indices, which were already in use earlier, won unprecedented popularity at this time. Nevertheless, it is the very duplication of means that clarifies the great difference between these divisions and lists, on the one hand, and the *divisio* and its diagrams, on the other. Indexing and numbering chapters and verses facilitates uniform naming, meaningless in itself, which allows one to locate and refer to a textual portion precisely without relating to its context. Similarly, a list of contents allows one to jump to the right page and ignore the rest. But a vertical list of items does not represent internal relations or structure, or if it does, it is only the simplest of possible structures. The *divisio*, however, as shown above, can ignore the formal division into chapters and verses altogether, even if it occasionally refers to them for its purposes.

HTs of biblical text division therefore show very clearly the advantage of the HT form and its deep relation to the structuralism that characterized scholastic culture. The study of the *divisio textus* and its diagrammatic expression demonstrates how subtle, sophisticated, and varied their perceptions of textual coherence and narrative structure were. The series of diagrams depicting the structure of the narrative opening the book of Job is an illuminating example of this genre and of the narratological insights it conveys. The coda gives a surprising look into the remarkable affinity of this approach, its visual form and the resulting insights, with modern narratologies.

5.4 WHAT HT DIAGRAMMING TELLS US ABOUT THE SCHOLASTIC PERCEPTION OF TEXTS: AUTHORS AS ARCHITECTS, TEXTS AS WISELY MADE CONSTRUCTIONS

Compiling and dividing texts into units and presenting a text's outline in an introduction to a work are obviously not unique to medieval schoolmen. Dividing texts into more than five hierarchical levels of subdivision, verbalizing this division, and visualizing it, however, constitute a peculiar approach that characterizes scholastic writing and thinking. Diagrams, tree diagrams

included, had already been drawn in manuscripts for centuries, depicting a variety of themes. But texts were not a subject of any sort of diagram until the thirteenth century. The application of paradigmatic writing to this material, I suggest, should be understood as an expression of a broader mode of thought that is typical of scholastic culture: their perception of texts as nonsequential, modular, spatial entities.

Verbal narration in natural language, whether oral or written, is the best way to describe a sequence of events in time. It is far less effective when describing two- or three-dimensional structures or complex machines. Almost all researchers who have addressed the efficacy of diagrams have pointed out that they are most useful in problem solving when the problem involves physical dimensions or abstract dimensions, which can be treated spatially. Diagrammatic representations are advantageous principally regarding structural and spatial relations, which when represented in other ways (propositional or sequential running text) are only implicit. The use of diagrams to represent and address editing challenges as demonstrated above tells us, therefore, that the problems and objects themselves were becoming spatial, even mechanical. In chapter 2, I asked how much the nature of an idea influences the manner chosen to represent it. Such influence was demonstrated in studies of spatial descriptions described above. In the study of New Yorkers' apartments, only a minority described their apartment "from above," from a survey perspective. Their choice was affected, it seemed, by individual tendencies. Nevertheless, Taylor and Tversky have later shown that people's choices for describing spaces by route or by survey depend on the shape of the relevant space as well.[72] It is plausible to assume, therefore, that the choice to describe texts with HT-maps, which offer a survey perspective, simultaneously expressed and encouraged a new perception of texts/spaces.

In a preliminary study, Hagen followed the sudden appearance of sentence diagrams in American English grammar textbooks in the nineteenth century and the different approach to their introduction in classroom practice. Among the factors that supported this development, or "prerequisites," he suggested that "the word-centered methods of traditional grammar discouraged looking at hierarchical relationships within the sentence. Diagrams, however, are an attempt to illustrate constituency within the sentence. A second prerequisite to diagrams, therefore, was a shift in thinking about syntax to a hierarchical, sentence-based orientation."[73] Our diagrams attest to a similar shift to hierarchical orientation regarding long texts that occurred during the thirteenth century in university milieus.[74] The text-division technique reveals a perception of the text as an organic, hierarchically structured entity, in which each part has its own reasoned place, carefully designed by its author, be it Aristotle or Moses. The image that emerges from the text divisions is of a text that reflects the author's

movements, like lines tracing on the floor the movements of a skillful dancer. No word is misplaced; everything serves an extremely well-orchestrated purpose. Text is texture, marvelously crafted.[75] Text divisions answer the question "What is an author?" by answering the question "What does the author do?" I will avoid dealing here with the difficult question of medieval notions of scholarly authorship versus literary authorship. Two interesting points are worth raising, however. First, the preference to ask, "What does an author do?" as opposed to "What is an author?" aligns well with recent approaches to medieval literature.[76] Second, some postmodern accounts of authorship (following Barthes and others) raise the power of the reader against that of the author. Text divisions paradoxically do both: reconstructing an image of a constructor, the readers—each time a different reader differently—animate the author.

The application of HT diagramming to their texts and to those they commented upon tells us that the schoolmen thought about their own texts and those of others as nonlinear spaces, not as sequences of events; and not only space in general but a specifically multilayered, hierarchical one. These complex machines could hardly be planned and manipulated in one's mind alone. As I hope my readers were able to experience on their own, diagramming seems to be the only possible way to think clearly about such structures, much like the absolute need to use numerals and symbols to handle advanced algebra. Drawing HTs in the margins of their manuscripts enabled the schoolmen to see their textual cathedrals clearly, examine optional locations for parts, and conceive new structural clusters.

Teaching and experimenting with making diagrammatic text divisions, I can testify that it is perhaps the most challenging and confusing task I have given to students. It is also not surprising that scholars tend to ignore this genre altogether as too technical and mechanical. The cases studied in detail in this last chapter are the first, I believe, to show that HT diagramming not only is a technology that *facilitates* and speeds cognitive processing that could have been done in the mind alone, even if less efficiently. It also is a technology that enables people to do things they just *could not* do before, to which the mind must be extended.

5.5 CODA: BACK TO THE FUTURE—PARALLELS TO THE *DIVISIO TEXTUS* IN TWENTIETH-CENTURY NARRATIVE ANALYSES

Text division, once a lively practice, gradually lost its appeal and gave way to newer approaches. Centuries went by during which scholars applied quite different tools in the ongoing attempt to unlock texts' meanings and their authors' intentions. Then, suddenly, in the middle of the twentieth century, we encounter analogous attempts to analyze narrative structure. I will briefly

review here three landmarks in this revival, while noting their similarities to and differences from the medieval phenomenon.

In *Medieval Theory of Authorship*, Minnis notes that "the new techniques of *divisio textus* actually fostered a sort of 'structuralist' exegesis,"[77] and indeed, Roland Barthes's "Introduction à l'analyse structurale des récits" (1966) is our first case. Inspired by linguists who addressed the internal order and structure of the single sentence, he called for a science that would apply the same approach to narrative, to the discourse beyond the sentence level, aiming to reveal its organizing forms and identify units, syntax, and rules. Barthes begins by examining the level of "functions," as he calls it, beginning its analysis with a mode of parsing very similar to what we have just seen in the medieval *divisio textus*: "Since any system can be defined as a combination of units pertaining to certain known classes, the first step is to break down the narrative and determine whatever segments of narrative discourse can be distributed into a limited number of classes; in other words to define the smallest narrative units."[78]

Much like the schoolmen, Barthes insists on a semantic rather than a formal principle of parsing, ignoring the division into chapters and sentences or matters of length. Rather, the function of these units is what makes them such, whether they are smaller than a sentence or not. He also presupposes that *any* such segment has significance: "there are no waste units."[79] Units may have different characters. They may be indices, actions, or events, and in the search for functional syntax, several units should be grouped together to form a larger unit, and then an even larger one. This analysis, he explains, is different from that of the reader who "perceives a linear succession of terms," and it should be extended further to create bigger and bigger blocks of actions.

As an example of such an analysis, Barthes proposes a diagram for a scene from Ian Fleming's *Goldfinger*, which occurs in chapter 2 in the book's overall plot (here figure 5.15). As in the first Assisi diagram, Barthes does not specify the surface text at all, which for the third level (the only one detailed here) would be: "The man held out his hand. Bond rose slowly, took the hand and released it."[80]

5.15 Roland Barthes, "An Introduction to the Structural Analysis of Narrative," 255 (the original diagram is in "Introduction à l'analyse structurale des récits," 15)

STRUCTURE OF TEXTS

Unlike the medieval commentators, Barthes differentiates between the functional level and higher levels of meaning.[81] Ordering whiskey has a function such as occupying oneself while waiting to board a flight, but on another level, it is an index of modernity, leisure, and luxury, in a similar way to how the description of Job's possessions was analyzed above as signifying prosperity.[82] Medieval commentators seem to have been more ambitious in their attempt to bind these layers of meaning together.

Barthes did not pursue this direction further. In his later *S/Z*, he presents a full analysis of a story by Balzac, announcing that although he will parse the text into units, he will deliberately avoid regrouping them. He returned to the traditional medieval commentating routine, interpreting each unit for its various meanings, then moving on to the next one without addressing the general layered structure of the work.[83] Literary studies developed in other directions, and interest in the structure of narrative declined in favor of other emphases. But discourse analysis soon spread to other fields, among them cognitive psychology. Mandler and Johnson's "Remembrance of Things Parsed: Story, Grammar, and Recall" (1977) remains a highly influential classic in this field.[84] This essay sought to understand the factors influencing correct recall of stories. Mandler and Johnson attempted to elaborate the concept of story-schema and to articulate the rules of story grammar. They assumed that listeners/readers possess a generic, mental narrative structure through which they create, and later reconstruct, the stories they have read or heard. Unlike the medieval schoolmen, the authors' goal was to reconstruct this mental model and its rules rather than to understand this or that text. They limited themselves to simple folk stories with one protagonist, then parsed the basic narrative into segments of different sizes. Their parsing followed semantic and functional criteria rather than formal or linguistic ones, with no consideration of formal matters of length, just like the medieval schoolmen and Barthes. Like them, they found that "the underlying structure of a story can be represented as a tree structure which makes explicit the constituent structure and the relations between constituents."[85] Interestingly, they confessed a difficulty with the representation of conversations and dialogical stories, a difficulty we encountered earlier regarding God and Satan's heavenly scene.[86]

Searching for general story grammar rules, which they represented as formal propositions, Mandler and Johnson named segments with general labels, such as setting/event, beginning/development/ending, complex/simple reaction, or attempt/outcome. They grouped these into larger units. As in our anonymous medieval author's diagrams, they favored twofold or threefold divisions and had a diverse number of levels, the first and last branches often being much shorter than the middle ones. Figure 5.16 presents such a tree analysis for a short story about a dog.

My last modern example is taken from computational linguistics. In 1988, Mann and Thompson, who attempted for several years to develop a computer-based text generation model, published their proposal for structural analysis of natural texts, which they named Rhetorical Structure Theory (RST).[87] They too emphasized parsing, hierarchy, and coherence and found the diagrammatic mode most convenient for their purposes. Unlike Barthes or Mandler and Johnson, and like the medieval schoolmen, they were interested in all kinds of natural texts, nonnarrative and narrative alike. They proposed to begin with division into small portions or text-spans. If one aims at interesting results, they noted, this division should be a functional one, and the author's supposed intention should be taken into consideration. A first proposition, to which any scholastic would have signed on, is "When an author creates a text, it is always done in pursuit of a goal to be satisfied by the text as a whole."[88] Each couple of text-spans, they argued, forms an asymmetrical couple, one being the nucleus and the other its satellite, making imbalanced pairs very similar to those implicitly suggested by our anonymous annotator's analysis. Grouping follows diverse kinds of *relations*, such as circumstance, contrast, condition, etc. These units are then combined through such relations with others to form larger units up to the entire text.[89] Figure 5.17 exemplifies such an analysis.

Scholars agree that the *divisio* belongs to the scholastic shift into an Aristotelian mode of exegesis and, in general, into a more literal and scientific approach.[90] A similar historical context of scientific orientation and a strong influence from logic is evident in the cases reviewed here. Yet while Barthes,

5.16 Mandler and Johnson, "Remembrance of Things Parsed," 120; the text is parsed and numbered on p. 119

STRUCTURE OF TEXTS

185

5.17 Example of an RST analysis, http://www.sfu.ca/rst/02analyses/published.html

as well as Mandler and Johnson, sought *generic* grammar, the schoolmen (perhaps like some RST theorists) focused on an efficient way to explore and represent the unique coherence of *concrete* texts. Both medieval and modern approaches to text structure perceive it as a highly coherent whole, assuming that "what holds the text together is more than simply the material fact of its human author" and that its "unity must be an intrinsic conceptual unity," while emphasizing authorial intention.[91] This was partly the reason why literary theory abandoned such approaches for poststructuralism, seeking to interpret texts, not as wholes, but as rooted in broader contexts of production and power relations. Computational linguists, however, retain this focus.

But the clearest similarity between all practices is evident in that both medievals and moderns chose the tree to represent text structure. All realized that it is too difficult to handle such structures with words alone. Tree diagrams and a breadth of techniques for diagrammatic visualization are used today in fields ranging from cognitive analyses of the reading of comics to computational-linguistic work on developing parsing algorithms, automatic generation of summaries, and their like.[92] The ability to examine reading behavior and reader response to syntactically false texts has grown considerably. Linguists now manipulate sentences or sequences of texts, omit constituents, or change their order, then measure participants' reaction times to assess difficulties in completing tasks, aided by new methods such as measuring the electrical activity of the brain.[93] Such experiments demonstrated recently, for instance, that the openings and endings of scenes can be omitted or moved between larger units without damage to comprehension,[94] just as Satan's leaving to execute his attack was interpreted as the end of the heavenly scene by Matthew of Aquasparta but as the launching of his attack by our anonymous author.

CHAPTER { 5 }

APPENDIX

Latin and English Surface Text of the Book of Job Parsed and Numbered
(*Translation Follows the* English Standard Version)

Folio 1r

1) 1:1 Vir erat / There was a man
2) in terra Hus / in the land of Uz
3) nomine Job / whose name was Job
4) et erat vir ille simplex / and that man was blameless
5) et rectus / and upright
6) ac timens Deum / and one who feared God
7) et recedens a malo. / and shunned evil.
8) 1:2 Natique sunt ei septem filii / 1:2 And seven sons were born to him
9) et tres filiae / and three daughters.
10) 1:3 Et fuit possessio ejus septem millia ovium / Also, his possessions were seven thousand sheep,
11) et tria millia camelorum, / three thousand camels,
12) quingenta quoque juga boum, / five hundred yoke of oxen,
13) et quingentae asinae, / five hundred female donkeys,
14) ac familia multa nimis: eratque vir ille magnus inter omnes orientales. / and a very large household, so that this man was the greatest of all the people of the East.
15) 1:4 Et ibant filii ejus, et faciebant convivium per domos, unusquisque in die suo. / And his sons would go and feast in their houses, each on his appointed day
16) Et mittentes vocabant tres sorores suas, ut comederent et biberent cum eis. / and would send and invite their three sisters to eat and drink with them.
17) 1:5 Cumque in orbem transissent dies convivii, mittebat ad eos Job, et sanctificabat illos: / So it was, when the days of feasting had run their course, that Job would send and sanctify them
18) consurgensque diluculo, offerebat holocausta pro singulis / and he would rise early in the morning and offer burnt offerings according to the number of them all.
19) Dicebat enim: Ne forte peccaverint filii mei, et benedixerint Deo in cordibus suis. / For Job said, "It may be that my sons have sinned and cursed God in their hearts."
20) Sic faciebat Job cunctis diebus. / Thus Job did regularly.

Folio 2r

21) 1:6 Quadam autem die, cum venissent filii Dei ut assisterent coram Domino, / Now there was a day when the sons of God came to present themselves before the LORD

22) affuit inter eos etiam Satan. 1:7 Cui dixit Dominus: / and Satan also came among them. 1:7 And the LORD said to Satan,

23) Unde venis? Qui respondens, ait: / "From where do you come?" So Satan answered the LORD and said,

24) Circuivi terram, et perambulavi eam. 1:8 Dixitque Dominus ad eum: / "From going to and fro on the earth, and from walking back and forth on it." 1:8 Then the LORD said to Satan,

25) Numquid considerasti servum meum Job, quod non sit ei similis in terra, homo simplex et rectus, ac timens Deum, et recedens a malo? 1:9 Cui respondens Satan, ait: / "Have you considered My servant Job, that there is none like him on the earth, a blameless and upright man, one who fears God and shuns evil?" 1:9 So Satan answered the LORD and said,

26) Numquid Job frustra timet Deum? 1:10 nonne tu vallasti eum, ac domum ejus, universamque substantiam per circuitum; operibus manuum ejus benedixisti, et possessio ejus crevit in terra? 1:11 / "Does Job fear God for nothing? 1:10 Have You not made a hedge around him, around his household, and around all that he has on every side? You have blessed the work of his hands, and his possessions have increased in the land. 1:11

27) sed extende paululum manum tuam et tange cuncta quae possidet, nisi in faciem benedixerit tibi. 1:12 Dixit ergo Dominus ad Satan: / But now, stretch out Your hand and touch all that he has, and he will surely curse You to Your face!" 1:12 And the LORD said to Satan,

28) Ecce universa quae habet in manu tua sunt: tantum in eum ne extendas manum tuam. / "Behold, all that he has is in your power; only do not lay a hand on his person."

Folio 3r
(since part of this diagram is trimmed, I left several sections unspecified)

29) Egressusque est Satan a facie Domini. / So Satan went out from the presence of the LORD.

30) 1:13 Cum autem quadam die filii et filiae ejus comederent et biberent vinum in domo fratris sui primogeniti, 1:14 nuntius venit ad Job, qui diceret: / Now there was a day when his sons and daughters were eating and drinking wine in their oldest brother's house; 1:14 and a messenger came to Job and said,

31) Boves arabant, et asinae pascebantur juxta eos: 1:15 et irruerunt Sabaei, tuleruntque omnia, et pueros percusserunt gladio: et evasi ego solus, ut nun-

tiarem tibi. / "The oxen were plowing and the donkeys feeding beside them, 1:15 when the Sabeans raided them and took them away—indeed they have killed the servants with the edge of the sword; and I alone have escaped to tell you!"

32)

33)

34)

35) 1:16 Cumque adhuc ille loqueretur, venit alter, et dixit: Ignis Dei cecidit e caelo, et tactas oves puerosque consumpsit: et effugi ego solus, ut nuntiarem tibi. / While he was still speaking, another also came and said, "The fire of God fell from heaven and burned up the sheep and the servants, and consumed them; and I alone have escaped to tell you!"

36)

37)

38) 1:17 Sed et illo adhuc loquente, venit alius, et dixit: / While he was still speaking, another also came and said,

39) Chaldaei fecerunt tres turmas, et invaserunt camelos, et tulerunt eos, necnon et pueros percusserunt gladio: et ego fugi solus, ut nuntiarem tibi./ "The Chaldeans formed three bands, raided the camels and took them away, yes, and killed the servants with the edge of the sword; and I alone have escaped to tell you!"

40)

41) 1:18 Adhuc loquebatur ille, et ecce alius intravit, et dixit: Filiis tuis et filiabus vescentibus et bibentibus vinum / While he was still speaking, another also came and said, "Your sons and daughters were eating and drinking wine

42) in domo fratris sui primogeniti, / in their oldest brother's house,

43) 1:19 repente ventus vehemens irruit / and suddenly a great wind came

44) a regione deserti, et / from across the wilderness

45) concussit quatuor angulos domus: quae / and struck the four corners of the house,

46) corruens oppressit liberos tuos, et mortui sunt: et effugi ego solus, ut nuntiarem tibi / and it fell on the young people, and they are dead; and I alone have escaped to tell you!"

Folio 3v

47) 1:20 Tunc surrexit Job, / Then Job arose

48) et scidit vestimenta sua: / tore his robe

49) et tonso capite / and shaved his head

50) corruens in terram, / and he fell to the ground

51) adoravit, / and worshiped.

52) 1:21 et dixit: Nudus egressus sum de utero matris meae, / And he said, "Naked I came from my mother's womb

53) et nudus revertar illuc. / And naked shall I return there.
54) Dominus dedit, / The LORD gave
55) Dominus abstulit; sicut Domino placuit, ita factum est. Sit nomen Domini benedictum. / and the LORD has taken away. Blessed be the name of the LORD.
56) 1:22 In omnibus his non peccavit Job labiis suis, / In all this Job did not sin
57) neque stultum quid contra Deum locutus est. / nor charge God with wrong.

Folio 4r

58) [2:1–2:6 Factum est autem, cum quadam die venissent filii Dei, et starent coram Domino . . . / Again there was a day when the sons of God came to present themselves before the LORD, . . .]
59) 2:7 Egressus igitur Satan a facie Domini, percussit Job ulcere pessimo, / So went Satan forth from the presence of the Lord, and smote Job with sore boils
60) a planta pedis usque ad verticem ejus; / from the sole of his foot unto his crown.
61) 2:8 qui testa saniem radebat, / Then Job took a piece of broken pottery and scraped himself with it
62) sedens in sterquilinio. / as he sat among the ashes.

Folio 4va

63) 2:9 Dixit autem illi uxor sua: Adhuc tu permanes in simplicitate tua? / Then his wife said to him, "Do you still hold fast to your integrity?
64) Benedic Deo, et morere. / Curse God and die!"
65) 2:10 Qui ait ad illam: Quasi una de stultis mulieribus locuta es: / But he said to her, "You speak as one of the foolish women speaks.
66) si bona suscepimus de manu Dei, mala quare non suscipiamus? / Shall we indeed accept good from God, and shall we not accept adversity?"
67) In omnibus his non peccavit Job labiis suis / In all this Job did not sin with his lips.

Folio 4vb

68) 2:11 Igitur audientes tres amici Job omne malum quod accidisset ei, / Now when Job's three friends heard of all this adversity that had come upon him
69) venerunt singuli de loco suo, Eliphaz Themanites, et Baldad Suhites, et Sophar Naamathites. / each one came from his own place—Eliphaz the Temanite, Bildad the Shuhite, and Zophar the Naamathite.
70) Condixerant enim ut pariter venientes visitarent eum, et consolarentur. / For

they had made an appointment together to come and mourn with him, and to comfort him.

71) 2:12 Cumque elevassent procul oculos suos, non cognoverunt eum, et / And when they raised their eyes from afar, and did not recognize him,

Folio 4vc

72) exclamantes / they lifted their voices
73) ploraverunt, / and wept
74) scissisque vestibus / and each one tore his robe
75) sparserunt pulverem super caput suum in caelum. / and sprinkled dust on his head toward heaven.
76) 2:13 Et sederunt cum eo in terra septem diebus et septem noctibus: et / So they sat down with him on the ground seven days and seven nights, and
77) nemo loquebatur ei verbum: videbant enim dolorem esse vehementem. / no one spoke a word to him, for they saw that his grief was very great.
78) 3:1 Post haec aperuit Job os suum, et maledixit diei suo . . . / After this Job opened his mouth and cursed the day of his birth.
79) [Beginning of chapter 38]
80) [Beginning of chapter 42]

Epilogue

In my third year of doctoral studies, having worked until then exclusively with printed editions, I finally sought out the many relevant texts about Paul's ecstasy, prophecy, and other states of consciousness which I needed but which remained unedited. The Martin-Grabmann Institut in Munich then had a collection of microfilms relevant to my needs and a rich theological library. I thus found myself sitting alone in a small room in Munich looking at microfilms through one of those big machines designed for that end, hastily copying images onto my laptop, the cutting-edge technology of the time. While scrolling through one of these films, a little scheme caught my eye. "Hey," a warm feeling swept through me with an epiphanic surprise. "I make these too!"

Presenting this research to different audiences over the years, I witnessed similar reactions again and again. People would enthusiastically approach me after the lecture showing me their own diagrammatic notes, moved by the strange feeling of connection with the everyday practices of scholars who lived centuries before them. Historical research, however, constantly moves between sympathy and estrangement, and sympathy might mislead us so that we fail to recognize otherness as such. As I pursued the project, my sense of alienation increased. Experimenting with HT annotation both alone and together with students in Israel, we all felt that it was more difficult than it seemed at first and that adapting it would take a certain amount of training. The high level of medieval engagement with this scholarly practice raised eyebrows. I learned to recognize the specificities of this very specific type of diagram, distinguishing it from other techniques of visualizing information and from other visual behaviors. There was something different here after all: diagrams playing on an illusive borderline between natural language and regular writing, stretching it, but not entirely, into the image, the abstract, and the visual; a different culture, obsessed with divisions and painfully keen for clarity.

Porphyry's famous text does not necessarily call for visualization. Visualization can be either encouraged or repressed by historical conditions and norms of intellectual behavior. The present analysis has clearly shown that although specific formulations of information may demand a kind of visualization, they do not call to just anybody, at anytime, or in any place. They do not call often or at all to my twenty-first century students, and even

in the period under investigation, readers responded differently to this call. HT diagramming is a cultural, historical phenomenon. It flourished and decayed. While diagrams in general, including tree diagrams, had existed in the West centuries before the end of the twelfth century, the specific form of the HT emerged only then, out of previous vertical schemes such as genealogical diagrams and trees, out of innovative layouts and the development of punctuation, and possibly inspired by an intensive Byzantine tradition. While many modern scholars draw lines and arrows in their scholarly notes, make mind maps, and occasionally use curly braces, modern scholarly culture in general does not encourage HT diagramming.

The HT form constitutes a unique interface between written language and conceptual thought. It employs spatiality in a very distinct, limited manner. Standing very close to linear written speech, it involves regular patterns of reading behavior and thus plays very close to the field of punctuation marks, where the curly brace eventually found its place. It marks the common and the distinct and thus singles out groups or lists and expresses inner relations within such groups, as well as possible combinations of their members. It is intuitive to read then, and easy, though not intuitive to produce. This materialization of cognitive operations both reflected and interacted with inner mechanisms. Examining these simple drawings led medieval authors and readers to see actual operations of the brain anew, analyzing, distinguishing, grouping, and combining, manipulating parts, refuting modules, constructing structures. It enables one to see before one's anatomical eyes what had once been allocated solely to the inner eye, that is, the working of the brain itself.

The one scheme I spotted that afternoon as I sat before the microfilm machine drew my attention to hundreds more iterations. As the second chapter demonstrates, HT drawing was extremely available for passive readers to encounter and highly practiced among scholars actively engaging in annotation. These diagrams are not a singular, unique set of beautifully colored diagrams, prepared by a certain individual, but are the result of a common habit of a multitude of anonymous scholars. Indeed, it became clear that drawing HTs was a cultural phenomenon. Deeper study of the specific expressions of this habit gradually revealed that it was more of a behind-the-scenes practice and technique than a lavish formal means for authors to transmit information to their readers. The schoolmen wrote paradigmatically, mostly in the margins of textbooks, as a form of interacting with the text they were reading. Both annotators and copyists who copied HTs responded to their hybrid nature between formulation of ideas and full verbal articulation: their behavior shows that the visual was perceived as less fixed than the authoritative text and therefore more liable to be molded by the performer. The habit was so embedded in people's minds that the choices whether to use it and in what fashion, the degree of intensity of use,

and which specific units of information to highlight were free and personal.

Scholars of the thirteenth to fifteenth centuries drew HTs to clarify, abbreviate, and manipulate diverse units of ideas. They used the technique to visualize algorithms of logical operations; to abstract and to categorize meanings of philosophical terms; to weave together new webs of meanings and connect different places in the same text and between different texts; to lend coherence and depth to textual corpora in law and theology; to encourage and regulate metaphorical associations; to package procedures and ideas and thus let them travel independently and land in other contexts; to rearrange texts according to new conceptual principles; to visualize the phonetic charms of rhyme; and to compose formulae of greetings and salutations. Readers employed it to orient themselves within long and highly complex texts, to reconstruct them as reasoned, hierarchically conceived constructions, to penetrate their meaning, and then to compose new texts as authors. They practiced this habit in the classrooms of all faculties in almost all subjects, and then outside the university, as meditating monks, as Jewish scholars dealing with logic and Jewish law, as preachers pleasing and edifying their congregations, and as royal bureaucrats facilitating the calculation of tax payments.

Can such activities be proved to be crucial for purely intellectual discoveries? Did the "how" significantly influence the "what"? Were there ideas the schoolmen could reach *only* through this specific technique? In the history of technology, the border between a tool facilitating or accelerating familiar operations and a tool opening up new avenues is often blurred. A thin line separates calculating with a pencil something we could also do in our heads from helplessly depending on that tool to perform operations that are beyond the capabilities of our minds had we not such aids. HT diagramming enabled people consciously to conceive of structures of increased complexity, structures beyond what can be simply hosted in one's mind. I would dare to suggest that some highly structured theological works, such as the *Summa Halensis* and Aquinas's *Summa theologiae* and their fourteenth-century successors, could not have been written or read without visualizing their structure externally. Moreover, few could generate or follow the textual divisions we see in medieval texts without this tool. These are precisely the phenomena modern scholars tend to ignore, for without having the right tools, they get dizzy and confused by their verbal parallels.

But can we link microprocedures with "big ideas," new tools with new insights? This question cannot truly be answered, I believe, partly because bridging between microprocedures of perception, processing, and creativeness and discoveries and solutions for advanced problems remains a challenge to cognitive studies in general. The technique we have followed improves microcognitive procedures of comprehension, analysis, distinction, and composition characteristic of primary stages of creative thought.

Distinction in general, as noted in chapter 3, was used by students such as Aquinas to solve intricate theological problems. But I cannot point to a specific, concrete case where the *visualization* of such a distinction made a desired breakthrough, and I suspect no such reconstruction can be argued for. The value of improving speed of understanding or clarity of analytical procedures like categorization in the generation of "true" innovative ideas evades definitive demonstration. Yet it is this very fundamental, mundane nature of what is happening during the composition and use of HTs that also makes the phenomenon so deeply embedded and thus historically interesting.

The evidence of this behavior supports previous assessments of centuries-long processes in the history of Western literacy and intellectual culture. It was part of the long process of the efforts of Western European scholars since the twelfth century to organize increasing quantities of texts and ideas, old and new, by constantly improving inventive institutional and intellectual means. The diffusion of HT drawing fits into the larger narrative of the growing use by medieval scholarly society of visual markers and page layouts, the changing balance between the ear and the eye and the increasing dominance of the latter, perhaps even farther than our systems go. Finally, it is a part of a history that is yet to be written. Communicating with the conceptual phase of half-verbal thinking through diagramming, the spread of HTs marks a phase in the centuries-long process in which a growing number of members of society learned to think with instruments, to expand their minds and their cognitive abilities to process and create.

Historians of art have shown that the geometrical arrangement of matter that was current in diagrams in manuscripts "was applied and developed, pictorially and artistically, in both miniature art and monumental paintings" and that the diagrammatic mode is immensely significant to the understanding of medieval art in general.[1] Yet art historians might also take the results of this study in other directions, not only the study of other diagrams but also estimating anew medieval habits of vision, taking into account that in the thirteenth to fifteenth centuries a significant number of potential viewers of art were actively engaged in a basic form of visualizing behavior.[2] It is important, however, to remember again that my results show a very specific form of visual thinking, which rarely involved allegory or pictorial imagery.

Scholastic culture is shown here in its coherence, in its pursuit of complexity and simplicity, order and creativity, simultaneously. Behavior, although different in nuances, crossed disciplines and faculties, reflecting and keeping the coherence of scholastic thinking habits, a coherence that is often lost when focusing only on specific traditions. This finding deepens our understanding of the ways in which scholastic culture imposed itself on its individual members, forcefully impressing thinking and visualizing habits on their minds and bodies alike. In *Diagramming Devotion* Hamburger

encourages searching for the desire imbued in diagrams. If there was any desire behind these hundreds of diagrams, I would say it is a genuine, highly intense desire for truth, clarity, and sharpness, along with a peculiar affection for structures. It encouraged the schoolmen to try and reach the conceptual level of their brains as directly as possible, while trying not to lose the benefits of natural language and articulation.

Finally, the HT form in itself—as embodying both firm structure and alternative options of reading—and the patterns of behavior and application to content shown in the previous chapters reflect an underlying premise that order does not exclude creativity. The metaphor of the tree embodies potential growth. Remember the letters and the text divisions: when cautiously prepared, they might at first give the impression of a tight—too tight—texture in which every phrase has a well-reasoned place. But when we truly dive into the practice or engage in it ourselves, as every medieval master had to do, we find that items can be joined into diverse configurations. This was a passion to find order, not in the world, but in the minds seeking to understand it, and it entails therefore a powerful understanding—perhaps only half aware—that the structures of the mind and of the world are different. As we have seen throughout the book, most of the objects of the technique were not animals, plants, or stars: they were mental, conceptual structures, reflecting and enhancing, sometimes replacing, internal neural webs and flourishing when directed toward products of the human mind—metaphors, language, texts. Hierarchy and order carry, to the modern ear, negative associations of stiffness, and one could get an impression of a culture favoring rigidity and strictness. But the image of this habit as it has been unraveled throughout the book is of the playfulness and creativity of organizing and restructuring. Paradigmatic writing facilitates the extraction of general patterns and their application to something else, such as writing an introduction after the structure revealed in another introduction, or imposing one-size-fits-all structure on several text divisions or compilations of questions; but it does not seem to be used this way. Ministructures repeat, but larger ones—never. What we have seen throughout the book is not one tree, reflecting a well-organized universe, but multiple trees of ever-changing and growing minds. Medieval people were fascinated by structure and order, but more so by constructing and reconstructing, ordering and reordering.

The roots of this habit penetrated so deeply into Western minds that during the sixteenth, seventeenth, and eighteenth centuries, publishers printed more and more embedded HTs and annotators continued composing them in the margins of their printed books. I would not presume to provide here the next chapters in the history of HT diagramming and the curly brace from the invention of print to the opening credits of *Casablanca*.[3] A few notes, however, on the centuries immediately following 1500 are in order. First, the present study challenges the constant use of the term

"Ramist charts" or "Ramist-style diagrams" for describing a phenomenon that was widespread more than three centuries before Peter Ramus.[4] While such diagrams may have been strongly associated with his methods in later periods, early modernists should be careful not to see the mere employment of this graphic tool, and the urge for presentational clarity it reflects, as sufficient indication of genuine Ramist influence.[5]

Second, the early appearance and establishment of HTs in a wide variety of topics also pull the carpet out from under Ong's hypothesis that such spatialization of knowledge was significantly associated with, even indebted to, the medium of print.[6] There is simply no support for the idea, still dominant in some circles, that the organization of knowledge in a sophisticated fashion by way of such charts relied on the new resources of typography. Print contributed nothing specific to this practice, and there does not seem to be any significant change in the form and principles of HTs between medieval manuscripts and the printed books of the sixteenth and seventeenth centuries. Complex tapestry-form HTs (full-page or an entire work made of HTs) were produced as early as the thirteenth century. If anything, it was more difficult to produce such diagrams with the new technology. It is far easier to produce them by hand, slightly manipulating the size of letters and spaces on demand, than properly set a page for print. Print mimicked the freedom of the doodling hand only with difficulty.

While the form and principle remained unchanged, material and intellectual contexts changed significantly. Preachers were not so keen for distinctions anymore; the *ars dictaminis* declined, together with its charts; text division faded as an analytical technique and found new life as formal methodical HTs presenting the structure of a book's contents or summarizing its doctrine, usually added at the beginning of the book by the printer. Multiple new topics were presented this way, as HTs became more dominant in the sphere of public writing, beyond the strictly pedagogical context or the "abridgment" genre. New venues were opened, from frontispieces to memorial plaques to notation of multi-instrumental music, and the occasional medieval use of HTs in bureaucratic contexts was expanded. Whether people used it in personal handwritten notes in the same way as their medieval predecessors and to what extent is yet to be studied.

Visual thinking is not a monolithic skill. Other species of diagrams and conceptual visual expressions flourished and decayed over the proceeding centuries, and students developed new techniques of diagramming and taking notes. While the findings here stand in opposition to Berger's contention that students of logic did not visualize information in their personal notes before the Renaissance, it is clear that the other modes of visual thinking she describes stood on their own, while sometimes interacting with HT diagramming. The same applies for Eddy's findings on diagramming skills in the Enlightenment.[7]

Medieval academic culture positioned itself as a significant stage in a historical process by which a wide European scholarly community, rather than individuals, began to train its members to communicate with their minds and with their visual-conceptual capacities by way of external, yet not ephemeral, means, rather than copy existing diagrams, write or draw on wax tablets, or simply process and manipulate ideas exclusively in their heads. In the next centuries, thinking-with-things conquered more and more territory as growing numbers of people were and are becoming habituated to externalizing their emotions and thoughts on a regular, even daily basis, from keeping laboratory notes to making grocery lists. External aids for calculation have been elaborated and multiplied throughout the early modern and modern periods.[8] Children were taught to judge and correct their moral character by producing tables of good and bad deeds.[9] Writing and rewriting long, personal letters and diaries in growing numbers, the learned men and women of the next centuries used the page for introspection, to reflect upon, create, criticize, perfect, and manipulate their selves.[10] A topos in high school movies has one teenage character writing down pros and cons in order to decide whether to engage with someone romantically. The tight schedules of modern lives could not even be imagined, let alone realized, without appointment calendars. Since at least the eighteenth century and up to our own day and our current technological capabilities, writers have cultivated the fantasy of externalizing their entire self and life in comprehensive autobiographies, or by creating "total records."[11]

While externalization dominates modern life, gluing people to their smart-indeed-phones, the specific, historical phenomenon of HT drawing has left only faint traces. Somewhere around the middle of the eighteenth century, the form seems to lose its overall appeal. Two decades into the twenty-first century, students and professors are making very little use of the HT form of diagramming, except, perhaps, in France, where I witnessed its enduring use in class, both by scholars taking notes and by professors writing on the board. In everyday life, many of us, it seems, learn to use a curly brace in informal writing for grouping items set in a vertical list, but we usually do not extend it to several levels if we are not explicitly instructed to try it. No community of scholars, to the best of my knowledge, produces complex HTs as a regular strategy for reading and analysis. Formal, institutional use survived only in certain subfields of mathematics and linguistics. And yet we all have the curly brace on our keyboards. Since use of the method has decayed, I, an Israeli-educated scholar, had to intentionally train myself in HT diagramming, especially in drawing multilevel ones. I *felt* my brain working differently as I did so. This was what I had aimed for beginning in my very first year at university and what I still feel history is all about: playing with thinking differently from what we are used to, looking through others' eyes.

EPILOGUE

Acknowledgments

Writing this book has shown me once and again the strength of intellectual friendship and the power of long-standing institutions. For the past eight years I have been speaking to and with multiple colleagues and friends about this project. Somehow, these little, unimpressive drawings incited engagement from listeners all over the world, who kindly shared with me their ideas, sent me diagrams they had seen in manuscripts, referred me to articles, or showed me their own scribbled notes. These responses of enthusiasm and belief helped me during difficult years of establishing my way in the academic world. It was your interest and warm responses that confirmed for me the value and interest of this project.

In principio was my postdoctoral stay as a Rothschild fellow at the Institut de Recherche et d'Histoire de Textes (IRHT-CNRS), Paris, the best place one can be to work on manuscript culture, then at Avenue d'Iéna under the energetic director Nicole Bériou. I especially thank Dominique Poirel for his endless kindness, passion, and subtle observations, and Patricia Stirnemann and Claudia Rabel, whose kindness and cheerful little room I will always remember fondly. Claire Angotti, Sophie Delmas, and Francesco Siri have remained esteemed colleagues and dear friends. The very first draft of what would become section 5.1 of this book was written during this fellowship. I thank Patricia Stirnemann and Reviel Netz for their comments on that draft, and dearest Susan L'Engle, who accepted the piece for *Manuscripta*. Charles Burnett believed there was a book waiting to be written about this already at this very early phase. I did not believe it at the time, but there it is.

The soil that enabled this research tree to grow from that little seed, however, was the Hebrew University of Jerusalem on Mount Scopus. Today's academic world leans increasingly on external funding and competitive grants. The old system of hiring a young researcher to a tenure-track position and paying a salary; the time and breath given thereby to conceive new ideas and engage in projects without having to waste one's time and energies on writing applications for research instead of truly researching; the community of colleagues and students of a faculty: that was my grant, and I shall always be grateful.

I am also happy to thank the Hebrew University and the Faculty of the Humanities for a small internal grant and then a significant prize (Polon-

sky Prize for Originality and Creativity in the Humanities). Dror Wahrmann loved the project from our very first meeting in the cafeteria of Giv'at Ram and remained supportive in multiple ways. Raz Chen-Morris, Moshe Sluhovski, and Yitzhak Hen read and commented on the final draft of the manuscript. Eithan Grossman discussed with me linguistic aspects.

I have watched Ray Schrire grow to become an exciting colleague. He was always willing to share discoveries and ideas, to count diagrams in the Vatican library, or to send examples found in early print and in grammar books; and is constantly happy to discuss problems, doubts, and solutions and cooperate in somewhat strange enterprises. I owe much to my students in the courses "Knowledge in the Middle Ages" and "Medieval Cognition," as well as to the scholars and students in the Israeli Institute of Advanced Studies winter school on textual practices, both for their comments and for the diagrams I asked them to produce. Amos Bronner helped in the earlier stages of the project, hunting for diagrams in the digitized manuscripts of Assisi; Yuval Gabay helped with the bibliography toward the end.

Naama Cohen-Hanegbi read the section on medicine, while Yossi Ziegler helped with translation of some medical terms. Yossi Schwartz read the section on philosophy, and Susan L'Engle read the one about law. I thank all of them, but as the saying goes, I keep the responsibility for errors all to myself. I have benefited greatly from illuminating comments, suggestions, and constant encouragement from members of the Israeli Institute of Advanced Studies group "The Visualization of Knowledge in the Middle Ages": Adam Cohen, Marcia Kupfer, Mary Carruthers, Jeffrey Hamburger, Jossi Chajes, and Linda Safran in particular. I thank also the intriguing group gathered by Pierre Chastang and Claire Angotti to study the power of lists in the Middle Ages: the article I wrote for the volumes edited by those two groups was my first opportunity to provide a general account of the phenomenon as such. I was honored also to share the ideas of the second chapter and disclose the plan of the book in the "expert meeting" in Leiden assembled by Mariken Teeuwen, Irene O'Dally, and Irene van Renswoude. I also wish to thank Andrew Dunning, Stephen Burney, Eyal Poleg, Yoni Moss, Susanne Rischpler, David Runciman, Jamie Fumo, and Lisa Devriese.

Ori Weisberg edited the first draft of the manuscript with care. I imagined a book that will demonstrate its argument in its very materiality and layout, re-creating the reading experience of a medieval scholastic manuscript, with tens of diagrams. I did realize, however, the needs and constraints of contemporary publishers and readers and wondered whether publishers would cooperate. With such dreams and doubts I approached Karen Merikangas Darling of the University of Chicago Press. Karen welcomed the book with enthusiasm and support from the very beginning, understood the spirit, and gathered a great team. I thank Caterina MacLean and Tristan Bates, who grappled with production matters, and Deirdre Kennedy for

her assistance with the marketing aspects. Pam Bruton copyedited the text with extraordinary precision, a remarkable eye for details, and efficiency. Jill Shimabukuro, the graphic designer, bore courageously with the author's unusual requests. Tamar Rotman made the index with skill and speed. A special grant from the Israeli Science Foundation enabled all of us to make the book you are reading now.

Yael Arbel, Alon Schab, Lydia Schumacher, Renana Bartal, and Hilla Rotberg gave me their precious friendship throughout the highs and lows of the road. The book is dedicated to them and to my family: to the greatest life partner one can wish for, Udi Wahrsager, for being in general, for bearing with me, but also for illuminating discussions on linguistics and cognition; to my mother, brother, and sister; and last but not least to my sweet, beloved *gurim* Dor and Yaara.

Notes

INTRODUCTION

1. Derrida, "Plato's Pharmacy."
2. Plato, *Phaedrus* 274e–275a. I have used Harold N. Fowler's translation from the Loeb series, with minor changes.
3. The classic first article focusing on the way people interact with external representation, rather than focusing on modeling what happens in the brain alone, was on diagrams: Larkin and Simon, "Why a Diagram Is (Sometimes) Worth Ten Thousand Words." On later developments in external cognition theory, see the summary in Rogers, *HCI Theory*, 32–35. Two short introductory surveys of cognitive approaches to diagrammatic thought are Blackwell, "Diagrams about Thoughts about Thoughts about Diagrams"; and Kulpa, "Diagrammatic Representation and Reasoning." For more recent and helpful discussions of diagrams from an external-cognitive approach, see Krämer and Christina Ljungberg, *Thinking with Diagrams*, esp. the introduction and Valeria Giardino's essay (77–101).
4. Chambers and Reisberg, "Can Mental Images Be Ambiguous?" See also Sloman, "Diagrams in the Mind?," 7.
5. Anderson and Helstrup, "Visual Discovery in Mind and on Paper." See also Verstijnen et al., "Creative Discovery in Imagery and Perception."
6. Davies, "Display-Based Problem-Solving Strategies in Computer Programming."
7. Dogan and Nersessian, "Conceptual Diagrams in Creative Architectural Practice"; Purcell and Gero, "Drawings and the Design Process."
8. Tversky, "Obsessed by Lines," 15.
9. Clark and Chalmers, "Extended Mind." Clark elaborated the theory, developed it significantly, and responded to critics in his *Supersizing the Mind*.
10. Sutton, "Exograms and Interdisciplinarity."
11. On the idea of cognitive history, see Nersessian, "Opening the Black Box"; Netz, *Shaping of Deduction in Greek Mathematics*, esp. 19–20 for the distinction of cognitive history from cognitive science; and Gooding, "Cognition, Construction and Culture."
12. On history and Extended Mind Theory, see esp. Sutton, "Exograms and Interdisciplinarity."

13 Blackwell, "Diagrams about Thoughts about Thoughts about Diagrams," 81.

14 A selective, nonexhaustive list primarily in early modern and modern history includes Tweney, "Faraday's Notebooks"; W. H. Sherman, *Used Books*; Grafton, *Culture of Correction in Renaissance Europe*; Blair, *Too Much to Know*; Daston, "Taking Note(s)"; Yeo, *Notebooks, English Virtuosi, and Early Modern Science*; Cevolini, *Forgetting Machines*; Eddy, *Rewriting Reason*.

15 A nonexhaustive list includes Rouse and Rouse, "*Statim invenire*"; Parkes, *Pause and Effect*; Saenger, *Space between Words*; Carruthers, *Book of Memory*; Teeuwen and Renswoude, *Annotated Book in the Early Middle Ages*.

16 Crosby, *Measure of Reality*; Kusukawa, *Picturing the Book of Nature*; Berger, *Art of Philosophy*; Bender, *Culture of Diagram*. David C. Gooding's work ranges from his earlier studies on Michael Faraday to later general-philosophical models of visualization in science, esp. "Visualising Scientific Inference" and "Visual Cognition."

17 I will address specific studies in the relevant places. For some broad-view studies, see M. Evans, "Geometry of the Mind"; Hamburger, *Diagramming Devotion*, chap. 1; Kupfer, Cohen, and Chajes, *Visualization of Knowledge in Medieval and Early Modern Europe*.

18 Holsinger, *Premodern Condition*, 96.

19 Holsinger, *Premodern Condition*, chap. 3. Laurence Petit's English translation of Bourdieu's afterword to *Gothic Architecture and Scholasticism* is provided in the appendix to *Premodern Condition*, 221–42.

20 For a study of late medieval habitus in the modern sense of the word, see Algazi, "Scholars in Households."

21 For some recent discussions, see Hamburger and Bouché, *The Mind's Eye*, esp. the contributions by Hamburger, "The Place of Theology in Medieval Art History: Problems, Positions, Possibilities," 11–31, and by Andreas Speer, "Is There a Theology of the Gothic Cathedral? A Re-reading of Abbot Suger's Writings on the Abbey Church of St.-Denis," 65–83. For the desire to find such parallels long after Panofsky, see Michael Camille, who wished "[i]n something of the same spirit . . . to take this representation of a scholastic argument and compare it to the dynamic dialectical architecture of the late thirteenth century" (Camille, "Illuminating Thought," 359).

22 Jean Claude Schmitt identified this lacuna in "Les images classificatrices," 313.

23 See the essays published from 1994 to 2009 and assembled in Moretti, *Distant Reading*.

24 For an attempt to assess the popularity of a mnemonic device—the Guidonian hand—statistically by the number of manuscripts featuring it, see Mengozzi, *Renaissance Reform of Medieval Music Theory*, 61–81.

25 Derolez, *Palaeography of Gothic Manuscript Books*; Buringh, *Medieval Manuscript Production in the Latin West*. For Mariken Teeuwen's project and database, see her "*Marginal Scholarship: The Practice of Learning in the Early Middle Ages*" at https://www.huygens.knaw.nl/marginal-scholarship/.

CHAPTER 1

1. Richard of Fishacre, *In Secundum librum Sententiarum*, 5, 25, 179, 219, etc.
2. Thomas Migerius [Le Myésier], *Opera Latina*, throughout. The diagrams that are not horizontal trees are called *figurae* as well. Nicole Oresme also uses this general term for other sorts of visuals; see Paris, BnF Fr. 9106, fol. 161ra.
3. Schmitt, "Les images classificatrices."
4. For details on the work, author, and the manuscript, see Sharpe, "Richard Barre's Compendium Veteris et Noui Testamenti."
5. Shown by Irene O'Daly in a paper given at the "Art of Reasoning" expert meeting in Leiden, November 2017. In the field of canon law, see the beautiful Munich, Bayerische Staatsbibliothek clm 28175 for numerous HTs as well as a few vertical tree diagrams (e.g., fols. 30v, 31r).
6. For general accounts of the medieval diagrammatic mode and for ample literature citations, see Hamburger, *Diagramming Devotion*, chap. 1; Cohen, "Diagramming the Diagrammatic."
7. For multiple medieval examples of both kinds, see Murdoch, *Album of Science*, esp. pts. 4–5.
8. On such images, see Berger, *Art of Philosophy*.
9. On music and arithmetic, see Huglo, "L'étude des diagrammes d'harmonique de Calcidius au Moyen Âge"; Huglo, "Les diagrammes d'harmonique interpolés dans les manuscrits hispaniques de la *Musica Isidori*."
10. Richer of Saint-Remi, *Histories* 3.56–61 (vol. 2, 87–98); Jaeger, "Gerbert versus Othric."
11. On which see, e.g., Verboon, "Medieval Tree of Porphyry." See also the works cited in chapter 2 below.
12. See section 3.3.
13. The diagram is fully described in Murdoch, *Album of Science*, 238, no. 215.
14. For illuminating comparisons of diagrammatic models with nondiagrammatic designs in manuscripts and other artifacts, see Hamburger, "Haec Figura Demonstrat," 31–32.
15. On which see esp. Reeves and Hirsch-Reich, *"Figurae" of Joachim of Fiore*; Hamburger, "Haec figura demonstrat," 31–32.
16. They may inspire such diagrams, however. See, for instance, the artistically beautiful miniature initials in London, BL Burney 275 studied by Camille in his "Illuminating Thought." Many of these initials feature trees representing the structure of the art and its members to which the text relates. They differ from HTs in their figurative, vegetal nature, in their verticality, in their lack of discursive elements, but most of all in the codicological and social context of their production.
17. Schmitt's distinction between "*vision-image*" and "*vision-lecture*" ("Les

images classificatrices," 313) is very useful here, as is his argument of the simplified nature of late twelfth- and early thirteenth-century figures. I disagree, however, with the evolutionary model he suggests.

18 For examples, see BAV Pal. Lat. 996, throughout the manuscript and as shown in figure 5.6. See also Oxford, Bodl. Digby 55, fol. 128v, where the continuation is inserted in a free space between the branches. The translation in figure 4.20, however, does not reproduce this effect but shows the complete diagram that would result from combining the parts according to the signs.

19 For full-color images and analysis, see Corran, "Understanding a Selection of Medical, Theological and Poetic Diagrams," esp. 13, 17, 18.

20 Parkes, "Reading, Copying and Interpreting a Text in the Early Middle Ages," 93.

21 Saenger, *Space between Words*, 261–76.

22 Rouse and Rouse, "*Statim Invenire*"; Kwakkel, *The European Book in the Twelfth Century*. See also the publications in the Utrecht Studies in Medieval Literacy series such as Mostert, *Organizing the Written Word*.

23 For an earlier example, see BAV Vat. Urb. Gr. 35, fol. 21v (ca. 1000 CE). For later examples (fourteenth century?), see Florence, BML Plut. 31.35 and Plut. 71.35. For a general account of marginalia in Byzantine manuscripts, see Mondrain, "Traces et mémoire de la lecture des textes." For editions of scholia that also contain the diagrams, see Bülow-Jacobsen and Ebbesen, "Vaticanus Urbinas Graecus 35"; Share, *Arethas of Caesarea's Scholia on Porphyry's "Isagoge" and Aristotle's "Categories."*

24 For the oldest example, see BAV Vat. Sir. 158, fol. 17r (ca. 800 CE); see also New Haven, Yale University, Syr. 10 (1225 CE). I thank Yonatan Moss for introducing me to the Syriac theological graphic distinctions in Moses bar Kefa's texts on paradise and on the soul and for translating one of them for me. The German translation of Bar-Asher's *On the Soul* notes the existence of schemata but reproduces none (Braun, *Moses Bar Kepha und sein Buch von der Seele*, 47). On Syriac *pulaga*, see Gottheil, "A Syriac Fragment"; Hugonnard-Roche, "Introductions syriaques à l'étude de la logique"; King, "Why Were the Syrians Interested in Greek Philosophy?," 75. For examples of *tashjīr*, see Savage-Smith, "Galen's Lost Ophthalmology and the *Summaria Alexandrinorum*," 127.

25 Safran, "Prolegomenon to Byzantine Diagrams." On the possible influence of Byzantine script and Latin Carolingian minuscule, see Bishoff, *Latin Paleography*, 101.

26 For selected bibliography, see Koehler, "*Byzantine Art in the West*," 61–67; Weitzmann, "Various Aspects of Byzantine Influence on the Latin Countries from the Sixth to the Twelfth Century"; Kitzinger, "Byzantine Contribution to Western Art of the Twelfth and Thirteenth Centuries." Demus (*Byzantine*

Art and the West, 185–87) underlines the importance of illuminated manuscripts.

27 See esp. the essays collected in Ebbesen, *Greek–Latin Philosophical Interaction.*

28 For transcriptions and explanation of the principles of such diagrams, see Bülow-Jacobsen and Ebbesen, "Vaticanus Urbinas Graecus 35"; Share, *Arethas of Caesarea's Scholia on Porphyry's "Isagoge" and Aristotle's "Categories,"* esp. the diagram appendix at 231–51. Marginal Greek "boats" and vertical *diaereses* feature not only in purely logical texts but also in the margins of other works of Aristotle. See, e.g., the multiple figures in Paris, BnF Gr. 1854.

29 E.g., the glosses in the fourteenth-century Florence, BML Plut. 31.37 and Plut. 58.29.

30 See, e.g., Giulio Pace, *Aristotelous Organon Aristote[l]is Stagiritae pe[ri-]pateticorvm principis Organum* (1597). The translator Bembo used BAV Vat. Gr. 1777 and executed faithfully the diagrams there, seen on many pages of BAV Vat. Lat. 4560.

31 I quote here Pechmann and Zerbst, "Activation of Word Class Information," 233, summarizing Garrett, "Analysis of Sentence Production"; Levelt, *Speaking*; Levelt, Roelofs, and Meyer, "Theory of Lexical Access in Speech Production."

32 Levelt, "The Speaker's Linearization Problem," 305.

33 *Oxford Dictionary of Media and Communication,* accessed January 22, 2019, http://www.oxfordreference.com/view/10.1093/oi/authority.20110803100305767. Most modern dictionaries of linguistics, however, prefer to define paradigmatic relations versus syntagmatic relations without referring to any visual or spatial horizontal-vertical metaphor. De Saussure (*Course in General Linguistics,* 122–27) himself used the terms "syntagmatic" and "associative" without referring to axes.

34 Angelo Clareno, *Chronicle or History of the Seven Tribulations of the Order of Brothers Minor,* 6.

35 Progovac, "Structure for Coordination," 241. For a clear presentation of the problem and at the same time the beauty of the flexibility of coordination, see Sag et al., "Coordination and How to Distinguish Categories." On coordination in general, see Haspelmath, "Coordinating Contructions."

36 Grant Goodall, "Coordination in Syntax," in *Oxford Research Encyclopedia of Linguistics,* http://oxfordre.com/linguistics/view/10.1093/acrefore/9780199384655.001.0001/acrefore-9780199384655-e-36. In my simplified explanation I relate here only to the elliptical source of coordination, but as Goodall and others have demonstrated, avoiding repetition is not the only motivation for such structures.

37 Kirsh, "Intelligent Use of Space."

38 On coordination and intonation, as well as other forms of grammaticalization or nongrammaticalization of coordination, see Mithum, "Grammaticalization of Coordination," 332; Haspelmath, *Coordinating Constructions*, 4, 10.

39 The diagram described here is in BAV Pal. Lat. 624, fol. 42v.

40 Pechmann and Zerbst, "Activation of Word Class Information."

41 Long, "The Science of Theology according to Richard Fishacre," 98.

42 Clark, *Supersizing the Mind*, 45–46.

43 BAV Vat. Lat. 2691, fol. 1r; Silano, "'Distinctiones decretorum' of Ricardus Anglicus," 88–89.

44 Hamesse, *History of Reading*, 109.

45 On Thomas Le Myésier and the manuscripts of this work, see Hilgarth, *Ramón Lull and Lullism in Fourteenth Century France*; Römer and Stamm, *Breviculum*. The manuscripts are Karlsruhe, Badische Landesbibliothek Cod. St. Peter Perg. 92 (fourteenth century) and Paris, BnF Lat. 15450.

46 "Intentio, quare feci fieri picturam subsequentem, fuit duplex. Prima intentio fuit, ur sciretur origo, a quo et quomodo orta est ars ista et aliae Raimundi artes et libri. Alia causa est propter solatium, quia talia inspicere multotiens excitant animam ad bene agendum et bona" (Römer and Stamm, *Breviculum*, 3).

47 "Et quia etiam oportet uti litteris significantibus diversa.... Quapropter figuras visibiles, ubicumque erit necessario, describere proponimus" (Römer and Stamm, *Breviculum*, 67).

48 "Haec figura est... sicut alphabetum primum et instrumentum visibile.... figuram enim visibilem facio, ut apparet, ut facilior sit inceptio doctrinae eorum, qui alias et altas scientias non noverunt, et ut sit primum obiectum unum entis" (Römer and Stamm, *Breviculum*, 53).

49 "Haec secunda figura vere nata est a prima, tamquam a matre, scilicet ab aurea, de qua secunda erat prima impregnata vel in ea implicata" (Römer and Stamm, *Breviculum*, 77).

50 "Per hanc enim praesentem figuram prima, scilicet aurea, ostendit et movet et deducit membra sua et extendit, et per iuncturas graditur et elucidat partes intrinsecas entis" (Römer and Stamm, *Breviculum*, 78).

51 Cf. Römer and Stamm, *Breviculum*, 23.

52 "Ratio, quare has figuras visibiles facio, stat in hoc, ut, cum videntur statim aperte, multa per visionem earum ad memoriam simul et semel reducuntur. Etiam figura in imaginatione concipitur. Et per memoriam ad intellectum reducitur, et per subsequentem voluntatem diligitur. Et sic anima per consequens in visione figurae, acquirendo scientiis, multipliciter delectatur" (Römer and Stamm, *Breviculum*, 78). Cf. "utilis est etiam, quia statim per eam visam potest homo scire et recordari ea, quae sunt essentialia hominis principia" (Römer and Stamm, *Breviculum*, 92).

53 "In cognitione autem huius figurae intendo procedere per hunc modum, videlicet ab infimo et inferiori et magis vili respectu aliorum ascendendo.

Processum vero de antecedentibus figuris fecimus descendendo, et modo procedemus in partibus hominis ascendendo" (Römer and Stamm, *Breviculum*, 86).

54 On the ambition of seeing and encompassing all at once, see also Römer and Stamm, *Breviculum*, 82, 87, 92.

55 "Utilitas huius figurae stat in hoc, quia in aperto uno solo intuitu apparet, quot sint scientifica, et quae sunt, et quomodo intelligunt. Omnis ergo conclusio affirmativa sive etiam negativa, contradicens huic figurae vel alicui membro eius, pro certo erit falsa. Et eius opposita est vera et tenenda" (Römer and Stamm, *Breviculum*, 78; cf. 82, 92).

56 Most people can judge by the eye the number of items without counting them (an operation called "subitizing") up to four items, or much bigger numbers if the items are arranged in specific patterns that can be learned.

CHAPTER 2

1 King, "Why Were the Syrians Interested in Greek Philosophy?," 75, citing *The Historia monastica of Thomas Bishop of Marga, A.D. 890* (London, 1893), 80.

2 O'Meadhra, "Medieval Logic Diagrams in Bro Church, Gotland, Sweden."

3 Champion, *Medieval Graffiti*.

4 For the relationship between typographers and publishers and tombstone layouts, see Newstok, *Quoting Death in Early Modern England*, 82–83; Fowler, *Mind of the Book*, 14–15.

5 This observation may, however, be due to the current state of documentation in this field or to a gap in my own research into existing corpora. The French epigraphy project covers only the period up to 1300. I found no use of paradigmatic writing in its two dozen volumes. Nor has the German inscriptions project, which covers up to 1650, yielded results. Brass monuments require more exhaustive research as well. But those I have seen have included no paradigmatic writing. See Favreau, *Epigraphie médiévale* (Turnhout: Brepols, 1997); Favreau et al., *Corpus des inscriptions de la France médiévale* (all volumes except two available at http://www.persee.fr/collection/cifm); Deutsche Inschriften Online, http://www.inschriften.net. On medieval brass commemorative plaques and incised slabs showing figures and texts, see the various articles by Sally F. Badham and Malcolm Norris. I have also consulted (January 2019) the website of the Monumental Brass Society, http://www.mbs-brasses.co.uk/Otley%20Brass.html.

6 For an extensive collection and discussion and visual depictions of medieval classrooms, see Orme, *Medieval Schools*.

7 For a handsome French chart of arithmetic dated to 1450–75, see Princeton, Princeton University 228.

8 On the use of paper in medieval Europe, see Burns, "Paper Comes to the West"; Müller, *White Magic*, esp. 22–28.

9 I use the masculine pronouns here and throughout the book although women may well have practiced this habit since there were grammar teachers for girls, female copyists and bookmakers, and nuns who had access to scholastic manuscripts. They were in all likelihood, however, a minority.

10 Saenger, *Space between Words*, 273–76; see also A. Taylor, "Into His Secret Chamber."

11 Chenu, "Maîtres et bacheliers de l'Université de Paris v. 1240"; Glorieux, "Les années 1242–1247 à la faculté de théologie de Paris."

12 For some core insights on the realms of the margins in general and particularly in the early Middle Ages, see Teeuwen, "Marginal Scholarship: Rethinking the Function of Marginal Glosses in Early Medieval Manuscripts"; Teeuwen and Renswoude, *Annotated Book in the Early Middle Ages*.

13 Compare, for instance, the scribal decisions appearing in Bologna, Biblioteca universitaria di Bologna 1564 with those in Paris, BnF Lat. 15754.

14 Bellamah, *Biblical Interpretation of William of Alton*, 169–74.

15 Bellamah, *Biblical Interpretation of William of Alton*, 171.

16 On Gilbert of Tournai's *Sermones ad status*, see Burghart, "*Remploi textuel, invention et art de la mémoire.*"

17 For such slash marks separating items in lists without diagrams, see Klagenfurt, Studienbibliothek 10, fol. 3r, and many of the following folios (in red ink).

18 The reference is probably to Richard's *De trinitate* 5.18.

19 This drafting hand in pale script is seen in the margins of a few other folios, as well as on the empty pages at 133–34 and 188.

20 Copies of Nicole Oresme's French commentaries on Aristotle preserve the diagrams in a similar way, carefully reproducing them over and over again in the same places in the text.

21 For attempts to calculate survival rates and for detailed cases of problems arising from unknown factors and over- and underrepresentation, see Buringh, *Medieval Manuscript Production in the Latin West*.

22 Eco, *From the Tree to the Labyrinth*; Hacking, "Trees of Logic, Trees of Porphyry"; Verboon, "Medieval Tree of Porphyry."

23 Parsons ("Traditional Square of Opposition," 10) discusses the square's doctrine but not the diagram. See also the papers in Béziau and Payette, *Square of Opposition*. For several medieval images, see Murdoch, *Album of Science*, 62–71.

24 Londey and Johansen, "Apuleius and the Square of Opposition," 166.

25 Lacombe, *Aristoteles Latinus*; Aristotle, *Analytica posteriora*, ed. Minio-Paluello and Dod.

26 It may be, however, that illuminated, luxurious manuscripts on good-quality

parchment and paper, or even manuscripts with cleaner margins, were prone to be carefully and deliberately maintained over the years and therefore survive beyond their true share in the time of their use. Whitewashing the margins may have influenced survival as well. If so, then the results are even more striking.

27 Erik Kwakkel is working on the developing standardization of codices and textbooks during the twelfth and thirteenth centuries, but his work in this field is still unpublished.

28 Three manuscripts that fit the required profile and that contain diagrams but not in a text of the *Organon* were included in the group as well.

29 "Highly annotated manuscript" was defined here as a codex that has more than fifteen pages that each contain several notes.

30 Four technical notes about counting: (1) The rule is one root = one diagram. A complex diagram with multiple levels or multiple nodes is treated the same as a simple one with two short branches. This is because what I measure is the number of times one decides to formulate an idea in this manner. I also did not include in the count lines connecting "*homo est iustus*" to "*homo non est iustus*," since these are not HTs as defined in chapter 1. (2) In the case of two or three *divisiones textus* that are framed as a set and it is clear that one part on the same page continues the other (see Florence, BML Plut. 11 sin. 1), I have counted them as one. I did so also in the case of multiple sets of the type "*omne a est b*" (see Assisi, BC 286, fol. 15v). (3) In BAV Chigi E. V. 149, which has numerous diagrams, in sections where there were one to three diagrams on each page, I calculated the average number in each section. (4) Marginal diagrams were sometimes trimmed by later binders. When several words and at least one branch remained, the diagram was counted as one.

31 Standard deviation 27.7.

32 Standard deviation 17.3.

33 See Assisi, BC 327, fol. 83v; Florence, BML Plut. 11 sin. 3, fol. 105v; Paris, BnF Lat. 17806, fol. 105v; Paris, BnF Lat. 16599, fol. 145v; BAV Pal. Lat. 992, fol. 9v; Oxford, Balliol College 253, fol. 106r.

34 For a similar diversity, compare the trees for types of contingency in BAV Borgh. 73, fol. 147r, and Borgh. 133, fol. 16v.

35 Four manuscripts of the *Analytica priora* feature an HT of convertibility of propositions. Two are completely identical (Paris, BnF Lat. 12956, fol. 149r, and Paris, BnF Lat. 17806, fol. 166r). The other two (Saint-Omer, BM 620, fol. 2v; Paris, BnF Lat. 16599, fol. 2v) differ both from this pair and from each other in significant details. Assisi, BC 286, fol. 42r, and Paris, BnF Lat. 16599, fol. 130r, feature an almost identical HT that classifies syllogisms and matches each type with a book of the *Organon*. Oxford, Balliol College 253, fol. 92v, presents the same division in a less discursive manner, but the division is not associated with the *Organon* at all. Paris, BnF Lat. 12956, fol. 148r, on the other hand, presents a division of syllogisms that does match

with the books, but by way of an entirely different reasoning. If Paris, BnF Lat. 12956 reflects borrowing, which is doubtful, then it was a creative borrowing.

36 On the mnemonic verse "*Barbara Celarent*" and its predecessors, see De Rijk, *Logica Modernorum*, 2:401–3.

37 See esp. Paris, BnF Lat. 17806, fols. 198r, 200r, 208r, etc.

38 Florence, BML Plut. 11 sin. 1; BAV Pal. Lat. 996, fol. 240r.

39 The upper margin of London, BL Arundel 383, fol. 292v, presents an identical sort of error, resulting in the same form of alternating divisions and convergences, as the writer repeats a node and presents it as the root for a new division instead of subdividing it directly at its first occurrence.

40 Even-Ezra, "Schemata as Maps and Editing Tools."

41 Lacombe, *Aristoteles Latinus*, no. 410 (vol. 1, 439).

42 "Scientia est arbor cuius radix est amarissima, cuius fructus est dulcissimus. Qui abhor[r]et eius amaritudinem non gustabit eius dulcedinem."

43 "Logica vera notificat; falsa condempnat; obscura clarificat; dubia certificat; ingenium acuit; studium gratificat, etc."

44 For more examples, browse also Assisi, BC 51, fol. 103r, or Paris, BnF Lat. 14425.

45 In a 1499 print preserved now in the Bayerische Staatsbibliothek in Munich, the lines are missing, but the word arrangement remains that of the tree: Bonaventura, *De triplici via* (Montserrat: Johann Luschner, 1499), available in digitized form at https://bildsuche.digitale-sammlungen.de/index.tl?c=viewer&l=en&bandnummer=bsb00070427&pimage=17&v=5p&nav=.

46 For an excellent detailed study of this manual, see O'Carroll, *Thirteenth-Century Preacher's Handbook*.

47 Metzger, "*Gerard of Abbeville, Secular Master*," 66–67, 164.

48 Another example is Gerard d'Abbeville's copy of Richard of Fishacre's commentary on the *Sentences* (Paris, BnF Lat. 15754), where a complex HT spreads all over fol. 65bis. Empty half-pages between different works could serve as a fitting playground as well: a good example is Assisi, BC 286, fols. 40v–41r.

49 See, e.g., the fifteenth-century codex Oxford, Bodleian Library Ashmole 1498, containing Richard Bloxham's *The tretice of Konwyng of Medycinez*, and features a series of trees about medicine. For one opening showing a tree spreading across both pages, see Wakelin, *Designing English*, 124–25.

50 Paris, BnF Lat. 15956, alternating French and Latin. See fols. 258r, 258v, 275r, 280v (Latin), 270r, 271r (vernacular, "*nota gallice*"). On these notes, see Delmas, *Un Franciscain à Paris au milieu du XIIIe siècle*.

51 C. R. Sherman, *Imaging Aristotle*, 191, fig. 50. See Paris, BnF Fr. 9106, fols. 161r, 164r; BnF Fr. 208, fol. 166r; BnF Fr. 204, fol. 164r; BnF Fr. 125, fol. 167v; Avranches, BM 223, fols. 160r, 162v.

52 C. R. Sherman, *Imaging Aristotle*, 191.

53 Fidora, Hames, and Schwartz, *Latin-into-Hebrew*.

54 See Paris, BnF Heb. 926, fols. 2r, 19v, 31r, 52r, 68r.

55 For HTs in Turin, National University Library A I 14, see fols. 19v, 35r, 37v, 39v, 40v, 41r, 44r, 45v–46r, 47r, 48r, 51r, 56v, 57r, 62v, 68v–69r, 70v, 71r, 72v, 73r, 74v, 75r–v, 77r–v, etc. Charles H. Manekin, who drew my attention to this manuscript, suggests that the book was written or copied for Rabbi Mordechai Nathan, as some glosses contain his signature (private communication, January 13, 2019). The same signature appears in London, BL Add. 22090, according to Roth, "Mordechai Nathan and the Jewish Community in Avignon." BL Add. 22090 contains two HTs, reproduced and transliterated on p. 14 of Roth's article.

56 Oxford, Bodl. 2042 / F 19327, fols. 12a–17a (ca. 1463–94). I am grateful to Yakov Mayer, who "made the connection," and to Pinchas Roth, who generously shared with me images and transcriptions.

CHAPTER 3

1 According to Stephen Barney (personal communication) several of the manuscripts of the *Distinctiones Abel* with HTs predate 1200. Rome, Bibl. Angelica, 257 is perhaps the oldest manuscript with Peter's distinctions mingled with others and may be as old as 1185. See also Paris, BnF Lat. 3388.

2 "Quod ille recusabat ex humilitate, nil sentiens de se magnum. Tandem sicut verus obediens ad respondendum se non segniter preparavit et die disputationis proposite questioni simul et argumentis per trimembrem distinctionem pulcerimam respondit adeo luculenter et plene, quod nullam determinationem aliam facere oportebat; propter quod frater Albertus: fili, inquit, non tenes locum respondentis, sed determinantis. Cui cum omni reverencia respondit: Magister non video, quod aliter possum respondere ad questionem. Tunc magister ait: Modo respondeas ad questionem per illam distinctionem; et fecit ei quatuor argumenta tam difficilia, ut omnino se ei crederet conclusisse. Ad que, cum frater thomas sufficientissime respondisset, fertur magistrum Albertum dixisse per spiritum prophetie: Nos vocamus istum bovem mutum, sed adhuc talem dabit in doctrina mugitum, quod in toto inundo sonabit" (Calo, *Vita S. Thomae Aquinatis*, 27). The same story with slight changes is told by Tocco on p. 79 and by Bernard Gui on p. 177.

3 On the *Sentences* and its importance for scholastic theology, see Colish, *Peter Lombard*; Rosemann, *Story of a Great Medieval Book*.

4 "Passio dicitur uno modo qualitas qua possibile est transmutari album in nigrum et dulce in amarum et grave in leve et alia et cetera. Et alio modo transmutationes et actiones istorum. Et dicitur magis specierum transmutationes nocentes et morus, et maxime nocivi et maxime

contristantes. Occasiones autem maxime et delectabilia et contristabilia dicuntur passiones" (*Metaphysics* 1022b15–20, text from Paris, BnF Lat. 16084, fol. 64r).

5 Thomas Aquinas, *Sententia libri Metaphysicae* b. 5 l.20 n. 8–11 (Corpus Thomisticum online edition).

6 The bottom diagram, by the way, shows a posterior classification similar to the one above on necessity, converging, on the right, the three first senses as "*secundum quid*" and the last as "absolute" (fol. 263v).

7 Venice, Biblioteca San Marco Lat. VI, 49, fol. 299r. See Devriese, "Physiognomy in Context," 116.

8 See the notice to this manuscript at https://archivesetmanuscrits.bnf.fr/ark:/12148/cc65622c.

9 Fols. 11r–12r; cf. Albertus Magnus, *De animalibus,* bk. 1, tract. 2, chap. 2 (ed. Stadler, 1916–20, pp. 47–48).

10 For an HT diagram on musical tones, see Amiens, BM 404, fol. 242v.

11 The division into branches in this HT is not clear, for some items continue a line later or begin in the middle of a line, and there are no connecting branches. Also, the first item is in fact another title.

12 For more HTs of the potencies of the soul, see BAV Borgh. 296, fol. 328r; Paris, BnF Lat. 6319, fol. 1r; BnF Lat. 14719, fol. 194v; BnF Lat. 15173, fol. 164r; BnF Lat. 16149, fol. 82r.

13 For a sensitive analysis of the Chanter's distinctions and reinvention of allegory, see Barney, "Visible Allegory."

14 Eco, *From the Tree to the Labyrinth,* chap. 2.

15 Eco, *From the Tree to the Labyrinth,* 104.

16 Eco, *From the Tree to the Labyrinth,* 163, 165.

17 Eco, *From the Tree to the Labyrnth,* 169.

18 Eco, *From the Tree to the Labyrnth,* 169.

19 Barney, "Visible Allegory," 91.

20 For more examples, see Rouse and Rouse, "Biblical Distinctions in the Thirteenth Century," 28.

21 On Alan's *distinctiones*, see G. R. Evans, "Alan of Lille's Distinctions"; Dahan, "Alain de Lille et l'exégèse de la Bible."

22 "Et ideo ne falsum pro vero affirmet theologus, ne ex falsa interpretatione errorem confirmet haereticus, ut a litterali intelligentia arceatur Judaeus, ne suum intellectum sacrae Scripturae ingerat superbus, dignum duximus theologicorum verborum significationes distinguere, metaphorarum rationes assignare, occultas troporum positiones in lucem reducere, ut liberior ad sacram paginam pandatur introitus, ne ab aliena positione fallatur theologus, et sit facilior via intelligendi; minus intelligentes invitet, torpentes excitet, peritiores delectet; et sic diversae vocabulorum acceptiones, quae in diversis sacrae paginae locis jacent incognitae, in lucem manifestationis reducantur praesentis opusculi explanatione; ut brevior explanatio prolixitatem

excludat, brevitas fastidium tollat, expositio obscurum, compendiosa doctrina [*f. ad.* temporis] dispendium" (Alan of Lille, *Liber in distinctionibus dictionum theologicalium*, in *Patrologia Latina*, ed. Migne, 210, 687C–688C).

23 Rosemann, *Story of a Great Medieval Book*, 49.
24 Valente, "Alain de Lille et Prévostin de Crémone sur l'équivocité du langage théologique," and the rich literature she cites there on fallacies.
25 Rouse and Rouse, "Biblical Distinctions in the Thirteenth Century," 31.
26 Introduction to Barney, *"Distinctiones Abel" of Peter the Chanter*.
27 Lakoff and Johnson, *Metaphors We Live By*, 4.
28 Poleg, *A Material History of the Bible, England 1200–1553*, chap. 1.
29 On the marginal to nonexistent role of attributions in *distinctiones* collections, see Rouse and Rouse, "Biblical Distinctions in the Thirteenth Century," 29.
30 On the material and codicological aspects of Bibles and biblical glosses, see Smith, "Glossed Bible"; Boynton and Reilly, *Practice of the Bible in the Middle Ages*.
31 Barney, "Visible Allegory," 91.
32 Text and translation (with minor modifications) after Rouse and Rouse, "The Schools and the Waldensians," 105. The date of the work is discussed on 93. This manuscript, New Haven, Yale University Beinecke Marston 266, dated to the early thirteenth century by the Rouses, does not present the distinctions as HTs. The scribe does, however, use the technique to present the rhymes in the verses of this prologue. On this technique, see section 4.1 below.
33 For a detailed description of the state of research regarding collections, their dating, principle of organization, editions, etc., see Rouse and Rouse, "*Statim Invenire*," esp. 214–17; Bataillon, "Intermédiaires entre les traités de morale pratique et les sermons"; Rouse and Rouse, "Biblical Distinctions in the Thirteenth Century"; Delmas, "Les recueils de distinctions sont-ils des florilèges?"; Barney, introduction to *"Distinctiones Abel" of Peter the Chanter*, and the extensive literature cited there.
34 See, e.g., Paris, BnF Lat. 16489, the *distinctiones* of Nicholas Biard, as well as many other copies. The HT format was definitely not the rule.
35 See also Lesley Smith's short discussion of Robert Grosseteste's *Templum Dei* in her *Masters of the Sacred Page*, 155–58.
36 For the development and decay of the *distinctiones* genre, see esp. Rouse and Rouse, "Biblical Distinctions in the Thirteenth Century," 35–37.
37 For possible use of *distinctiones* associated with figural speech by poets, see Barney, "Visible Allegory," 102; de Vries, "*Unde dicitur.*"
38 For two individual case studies, see Rouse and Rouse, *Preachers, Florilegia and Sermons*; O'Carroll, *Thirteenth-Century Preacher's Handbook*.
39 Rouse and Rouse, "*Statim Invenire*," 217.
40 For a general introduction to medieval canon law, see Brundage, *Medieval*

41 For a general study of the production of legal manuscripts for university use, see Soetermeer, *Utrumque Ius in Peciis*; Smura, "Manuscript Book Production and Urban Landscape"; Radding and Ciaralli, *Corpus Iuris Civilis in the Middle Ages*.

42 On the Tree of Consanguinity, see Teuscher, "Flesh and Blood in the Treatises on the *Arbor consanguinitatis*."

43 On this treatise, see Worby, *Law and Kinship in 13th Century England*, 85–91. A list of manuscripts of the work is provided in n. 101.

44 L'Engle, "Readers in the Margins"; L'Engle, "Proactive Reader"; Frońska, "Turning the Pages of Legal Manuscripts"; Bertram and di Paolo, *Decretales Pictae*.

45 Silano, "'Distinctiones decretorum' of Ricardus Anglicus," 27 (on the early history of using distinctions in legal discourse, see 21n55).

46 For a survey of the distinction as a common conceptual tool in twelfth-century canon law, see Meyer, *Die Distinktionstechnik in der Kanonistik des 12. Jahrhunderts*.

47 Wei, *Gratian the Theologian*.

48 Fols. 1v, 2r, 2v, 5r, 5v, 6r, 11r, 11v, 14r, 15v, 16v, 17r, 17v, 18r, 19r, 19v, 20r, 21r, 21v, 22r, 22v, 23v, 24r, 25r, 26v, 32r, 32v, 35r, 38r, 40r, 42v, etc.

49 See Weigand, "Das Gewohntheitrecht in frühen Glossen zum Dekret Gratians," 94–96. Cf. Munich, Bayerische Staatsbibliothek clm 28175, fol. 7v, which hosts dozens of beautiful HTs as well.

50 Cf. the distinction for the same matter in BAV Vat. Lat. 2691, fol. 1r, bottom.

51 On the popularity of this topic among the glossators and their treatment of it, see Roumy, "L'ignorance du droit dans la doctrine civiliste des XIIe–XIIIe siècles," esp. 5 and 15; Lottin, "Le problème de l'*Ignorantia Iuris*' de Gratien à Saint Thomas d'Aquin."

52 BAV Vat. Lat. 97, fol. 226r. For more examples, see BAV Pal. Lat. 659, fols. 8v, 9v, 10r, 10v, 12r, 12v.

53 Paris, BnF Lat. 16911, fol. 12v.

54 "Ceterum si ex odio iidem scolares vel scolares clerici sese percusserint, pro sua absolutione debet ad apostolicam sedem venire." In Friedberg's edition the second *scolares* is *saeculares*; *debet* is *debent* (Friedberg, *Corpus Iuris Canonici*, 2:889–90).

55 Paris, BnF Lat. 16906, fol. 2r, shows references added later at the end of each branch.

56 BAV Pal. Lat. 624, fol. 19r.

57 Personal communication, September 2018.

58 Taliadoros, "Law, Theology, and the Schools."

59 On the *Summa brevis* and other works, see Silano, "'Distinctiones decretorum' of Ricardus Anglicus," 15–16.

60 See BAV Vat. Lat, 2691, fol. 1r; Silano, "'Distinctiones decretorum' of Ricardus Anglicus," 88–89.
61 Cf. Silano, "'Distinctiones decretorum' of Ricardus Anglicus," 485.
62 For several explained examples, see Murdoch, *Album of Science*, 302–27.
63 For an edition of the text and a French translation, see Elkhadem, *Le "Taqwim al-sihha" (Tacuinum sanitatis) d'Ibn Buṭlān*.
64 Paris, BnF Lat. 6977 retains the diagonal design of the tables, while BnF Lat. 15362 does not but still contains very fine tables.
65 Hoeniger, "Illuminated *Tacuinum sanitatis*," esp. 53; Moly-Mariotti, "Le *Taqwim-as-sihha*."
66 On *diaeresis* (division, distinction) in Galen, see Tieleman, "Methodology."
67 O'Boyle, *Art of Medicine*, 254–56.
68 HTs diagrams can be found on fols. 2v, 8r (2), 9v (3), 11r (3), 11v, 12r (2), 13r, 14v (2), 15v (2), 18v, 22v (2), 23v, 33r, 33v, 35r, 35v, 36v, 49r, 50v, 51r (3), 52v (2), 54r, 54v, 57r (2), 62v, 64v, 65r, 67r, 67v, 69r–v (2), 70r, 71v (2), 72v (6), 73v (3), 74r, 75r, 76v (2), 86r, 86v, 87v (2), 99r, 99v (2), 102r, 104r. Numbers in parentheses indicate the number of HTs on the same page when there is more than one.
69 O'Boyle, *Art of Medicine*, 256.
70 For a detailed description and analysis of this manuscript, see Saxl, "Spiritual Encyclopaedia of the Later Middle Ages," esp. appendix 2 (137–42) by Otto Kurz dealing with the medical section and its parallels. The figure of the man on fol. 43r is a parallel to others, such as in Paris, BnF Lat. 11229, but the HTs do not appear there. See also Désautels, *Apokalypse, ars moriendi, medizinische Traktate, Tugend- und Lasterlehren*.
71 For another version of this HT in a far less elegant design, see BAV Pal. Lat. 1229, fol. 10r.
72 Several *tabulae* were attributed to Arnald of Villanova, all of dubious authority. See de Villanova, *Commentum in quasdam parabolas et alias aphorismorum series*. For Arnald's "Repetitions" on the *Ars brevis*, see de Villanova, *Expositio*.
73 De Villanova, *Expositio*, 174–79, 328–33. For the complete list of manuscripts, see http://db.narpan.net/cerca_arnau.php?obra=4898.

CHAPTER 4

1 O'Daly, "Managing Knowledge"; O'Daly, "Diagrams of Knowledge and Rhetoric."
2 On the layout of poetry in general in the West, see Parkes, *Pause and Effect*, chap. 8; Huisman, *Written Poem*.

3 Bourgain, "Qu'est-ce qu'un verse?," 253.
4 Bohn, *Modern Visual Poetry*, 16. Hamburger, in his *Diagramming Devotion*, includes all relevant bibliography for Rabanus Maurus's famous visual poems. For Gerbert of Aurillac's pattern poem, see Brockett, "Frontispiece of Paris, Bibliothèque nationale, Ms. Lat. 776." George Herbert (1592–1633) engaged in this style in the early modern period.
5 Bohn, *Modern Visual Poetry*, 15; Huisman, *Written Poem*, 33.
6 Parkes, *Pause and Effect*, 98.
7 Bourgain, "Qu'est-ce qu'un verse?," 270–75; Parkes, *Pause and Effect*, 97.
8 Bourgain, "Qu'est-ce qu'un verse?," 276.
9 Norberg, *Introduction to the Study of Medieval Latin Versification*, chap. 6.
10 Norberg, *Introduction to the Study of Medieval Latin Versification*, 40.
11 Longfellow, *Poems*, 141.
12 Bourgain, "Qu'est-ce qu'un verse?," 277.
13 Parkes, *Pause and Effect*, 98–100.
14 On the manuscript, see de Hamel, *Meetings with Remarkable Manuscripts*, 330–75.
15 For an edition of a fuller version of this poem called "Pena" or "De adversitate," with a third part for each line, see Dinkova-Bruun, "Notes on Poetic Composition," 332; and her translation in "Book of Job in Latin Biblical Poetry," 328.
16 Winehouse, "Back to Black."
17 Turkan, who has closely studied the manuscript tradition of Bernard, argues for its inclusion in Bernard's *Summa dictaminum* (or *Liber artis omnigenum dictaminum*). She also dates BAV Pal. Lat. 1801 to the second half of the twelfth century: Turkan, "Le *Liber artis omnigenum dictaminum* de maître Bernard." For more about treatises on rhyme and meter in the twelfth century, see Leonhardt, *Dimensio syllabarum*; and the valuable editions in Mari, *I trattati medievali di ritmica latina*.
18 Completed after the text in Meyer aus Speyer, *Radewin's Gedicht über Theophilus*, 36.
19 On the genre of verses explaining artistic objects, see Arnulf, *Versus ad picturas*; Treffort, *Paroles inscrites*.
20 See also the example in Parkes, *Pause and Effect*, 99–100, where he shows how, while the disyllabic rhyme in a four-line stanza is *-era*, a fourteenth-century scribe has converged only the *a*.
21 On this interesting manuscript, see Gameson, "A Scribe's Confession," with a picture of the relevant folios on 70.
22 I found a useful introduction to this scheme in an old article by Caroline Strong: "History and Relations of the Tail Rhyme Strophe."
23 Tschann, "Layout of 'Sir Thopas,'" 8.
24 Purdie, *Anglicizing Romance*, 66.
25 Purdie, *Anglicizing Romance*, 68.

26 Purdie, *Anglicizing Romance*, 42–44.

27 For general studies devoted to the *ars dictaminis*, see Camargo, *Ars Dictaminis, Ars Dictandi*. A very useful work is the detailed census in Pollack, *Medieval and Renaissance Letter Treatises and Form Letters*. See also individual studies by Benoît Grévin and Anne-Marie Turkan.

28 The reasons for its decline are thoroughly discussed in a special issue of *Rhetorica* 19, no. 2. Martin Camargo's introduction summarizes the different approaches.

29 The term *tabula* fits well here, but we should note that the *tabulae* of Boncompagno, for instance, did not necessarily appear in this layout, though they may have been accompanied by tables. Thus, Boncompagno has written a work called "Quinque tabule salutationum" as well as a "Liber X tabularum" but Paris, BnF Lat. 8654 presents the first, and Munich, Bayerische Staatsbibliothek clm 23499 presents the latter, as regular texts. "The Five Tables" is edited in Voltolina, *Un trattato medievali de "ars dictandi."*

30 The manuscript contains also a set of HT distinctions of general rhetorical issues on fols. 13v–15v.

31 Murphy, *Rhetoric in the Middle Ages*, 259. On Lawrence in general, see 258–63; and Jensen, "Works of Lawrence of Aquileia."

32 The *ars dictaminis* is thought now to have declined much later, toward the end of the fifteenth century. Alessio and Ward agree that letter-writing manuals in general changed their status and contents owing to the increased importance and prestige of oral discourse, to the identification of official discourse as civic oratory, and to seeing letters increasingly as private and literary. Camargo, "Waning of Medieval *Ars Dictaminis*"; Ward, "Rhetorical Theory and the Rise and Decline of *Dictamen*."

33 Murphy, *Rhetoric in the Middle Ages*, 259.

34 Compare, for instance, the salutations to higher ranks (*maiores*) of diverse kinds (cardinals, bishops, parents) in Paris, BnF Lat. 11414 and 15015.

35 On Erasmus and the changing predominance from professional to personal, see Rummel, "Erasmus' Manual of Letter-Writing."

36 This section has benefited greatly from a continuous conversation with Ray Schrire, who is working on early modern grammars.

37 Law, *History of Linguistics in Europe*, 131–33.

38 English translation after Luhtala, *Grammar and Philosophy in Late Antiquity*, 121.

39 Law, "Why Write a Verse Grammar?," 74n134. On scholastic phonetics, see Law, *History of Linguistics in Europe*, 168–71. The fact that these are embedded, rather than marginal, diagrams is not necessarily an indication of a shift from the margins to an organic part of the argument but may derive from the informal nature of the codex, which does not have ample enough margins to begin with.

40　Embedded diagrams of this sort featured in fifteenth-century grammar codices as well. See, e.g., Paris, BnF Nouv. Acq. Lat. 667.

41　The marginal HTs on Paris, BnF Lat. 8156, fol. 35r, have nodes solely constituted by the suffix, but the root is not the stem of the word but "forms of the superlative."

42　Edited by Gueri, "Una recensione malevola di un contemporaneo al doctrinale e al Grecismus."

43　For another fifteenth-century rendering of Donatus's *Ars grammatica* by way of HTs, see Porrentruy, Bibliothèque cantonale jurassienne 30, fols. 1r–61r.

44　For more arborizations of grammatical matter, see BAV Pal. Lat. 1765 (Landsberg, 1456), fols. 32v, 122v–125r, and Pal. Lat. 1767 (year 1419), fol. 194v.

45　Facsimile, edition, and study: Asztalos et al., *Die "Seligenstädter Lateinpädagogik."*

CHAPTER 5

1　This section incorporates material published in Even-Ezra, "Schemata as Maps and Editing Tools."

2　The development of the genre of the summa up to 1215 is accounted for in Colish, "From the Sentence Collection to the *Sentence* Commentary and the *Summa*." On the structure of these texts, see also Berndt, "La théologie comme système du monde."

3　On the manuscript, see Pelzer, *Bibliothecae Apostolicae Vaticanae codices manuscripti recensiti*, 96–110; Alexander of Hales, *Summa theologica* 4, Prolegomena ad lib. 3, 136–37, as well as broader description and study on 188–93. This group of questions (series 4 in the Prolegomena's description) occurs on fols. 46v–89v. The lists and HTs are found on fols. 48r, 49v, 50v, 51v, 52r, 53v, 56v, 57v, 58r, 60r, 62r, 64r, 66r, 67v, 69r, 71r, 73v, 75v, 77r, 79r, 81v, 83r, 86r, 88r. There are schemata in the distinctly different hand also on fols. 89v, 98r, 101r, and 102v, as well as four distinctions (fols. 102v, 108v, 109r, 109v, 124v).

4　The frame form features also the HTs on fols. 62r, 64r, 69r, 77r, as well as all HTs by the later hand from fol. 83r on.

5　The running script proceeds to the next line in the middle of the question (between "*fuit*" and "*in*").

6　H. A. Taylor and B. Tversky, "Perspective in Spatial Descriptions," 377. For examples of texts taken from the two perspectives, as well as "mixed" descriptions, see 379, table 1.

7　Linde and Labov, "Spatial Structures."

8　"Positis questionibus que sunt a parte factorum circa hoc quod est omnia

simul fieri, sequuntur circa idem quaestiones ex parte diei in qua narrantur fieri. Cum autem dies determinatur ex presentia lucis duplex autem est lux, scilicet corporalis et spiritualis. Secundum hec duplex est processus in hac questione secundum duplicem sanctorum [or: supradictorum] opinionem. Primo enim procedamus secundum quod dies ibi determinatur fieri ex presentia lucis corporalis sicut attestantur Gregorius, Beda et Hieronimus; secundo procedamus secundum quod dies ibi determinatur fieri ex presentia lucis spiritualis sicut testatur Augustinus. Circa primum tria queruntur. Primum est quid esset huius lux corporalis et quis eius effectus et utilitas et utrum desiit. Circa quod queruntur vi. Primum est que fuit ista lux corporalis ex cuius presentia fiebat dies. . . ."

9 The attribution to Bonaventure was first argued for by Henquinet in his "Un recueil de questions annoté par S. Bonaventure" and "Un brouillon autographe de S. Bonaventure." Halcour ("Tractatus de transcendentalibus entis conditionibus") doubted it, arguing that the text and the manuscript may very well be by Bonaventure, but this is not certain. In my opinion his arguments are rather weak and do not address the points brought up by Henquinet. Henquinet's identification was confirmed by Ermengildo, *S. Bonaventura e la questione autografa "De superfluo."* It was also strongly favored by Torrel in his "Un *De prophetia* de S. Bonaventure?," 251–55, in which the state of the question and further literature are summarized as well. I am convinced by Henquinet's argumentation, and my own study of the HTs has provided no reason to change my opinion.

10 Henquinet, "Un brouillon autographe de S. Bonaventure," already identified several questions as not authored by Bonaventure but copied from other sources. Doucet (*Summa Fratris Alexandri, Prolegomena*, 146) further identified several more as authored by Alexander of Hales, John of La Rochelle, and Odo Rigaldi.

11 The HT has as a title on the left "De hac attributione que est simplicitas essentie et circa hec queritur utrum," then divides into three: (1) *angelus sit compositus ex quo et quod*; (2) *utrum ex materia et forma*; (3) *utrum ex materia corporali et forma*. The short text on fol. 92va begins without a prologue.

12 The space is filled with notes for a different subject, written in a thin, pale script. These notes themselves include an incomplete schema. Of the other two schemas in this group, the third presents six questions, but only one has a matching text, with no matching blank spaces; the fifth matches the text almost completely (excluding two missing questions).

13 Assisi, BC 186, fol. 25r. For a similar case, see the question "*On fate*" on fol. 26v. The last question in the HT has no parallel in the text except a blank space.

14 For another case of change of order, see the question "*On the operation of the soul in the body*," fol. 99v, where the text has 1-2-3 and the HT has 1-3-2.

15 Henquinet, "Un brouillon autographe de S. Bonaventure," 62–63.
16 *Doctoris seraphici S. Bonaventurae, Opera omnia*, 4 vols. (1885–89), 4:64.
17 Kulpa, "Diagrammatic Representation and Reasoning," 81.
18 Hegarty, "Mental Animation."
19 Tversky, "Obsessed by Lines," 16.
20 *Poetria nova*, lines 43–55, translated in Gallo, *"Poetria nova,"* 17.
21 Goody, *Domestication of the Savage Mind*, 109.
22 Goody, *Domestication of the Savage Mind*, 109.
23 Lists encourage "the ordering of the items, by number, by initial sound, by category, etc." (Goody, *Domestication of the Savage Mind*, 81).
24 Goody, *Domestication of the Savage Mind*, 105.
25 Minnis, *Medieval Theory of Authorship*, 153: "One justification for such literary division and collection seems to have been that the intentions of the *auctores* were thereby clarified. . . . Exceptional scholars, like Nicholas Trevet and Thomas Waleys, could criticize a *divisio textus* which, in their opinion, obscured instead of clarified the *intentio auctoris*."

 This introduction to *divisio textus* and the next section on narrative analysis appeared first in Even-Ezra, "Visualizing Narrative Structure."
26 On the different techniques of academic theologians, see Smalley, *Study of the Bible*, chaps. 5–6; Dahan, *L'exégèse chrétienne de la Bible*, 108–20.
27 It is assumed that the *divisio textus* was first introduced into the faculty of arts around the 1220s. See Ebessen, "Medieval Latin Glosses and Commentaries," 133–38. Alexander of Hales's *Gloss* on Peter Lombard's *Sentences* (1220s) seems to be the first theological work in which a distinctive *divisio textus* is introduced. The first scriptural commentaries are likely those of the Dominican masters Hugh of Saint-Cher and Guerric of Saint-Quentin (1230s–40s); on which see Spicq, *Esquisse d'une histoire de l'exégèse latine au Moyen Âge*, 212–13; and Smalley, *Study of the Bible*, 296–97, where she cites Vosté as suggesting that Hugh was the first theologian to introduce it. See also Dahan, *L'exégèse chrétienne de la Bible*, 271–76; Dahan, "Le schématisme dans l'exégèse médiévale." For a concise article devoted to the issue, see Boyle, "Theological Character."
28 Boyle, "Theological Character," 276.
29 See the appendix.
30 Cicero, *Rhetorica ad Herrenium* 1.3, trans. Harry Caplan, Loeb Classical Library 403 (1954, digital edition), 8–9.
31 Cicero, *Rhetorica ad Herrenium* 1.10 (trans. Caplan, 30–31).
32 Ebessen, "Medieval Latin Glosses and Commentaries," 135.
33 Online editions use the web facilities now to present the *divisio textus* visually. See, for instance, this page of the Richard Rufus project, http://rrp.stanford.edu/SMet01O.shtml, or the *Corpus Thomisticum* growing tree of Thomas Aquinas's theological summa.
34 Barnes, *Aristotle*, 5.

35 For example, for text divisions of natural works like "On the Soul," see Madrid, BNE 9726, fols. 82v, 83v, etc.

36 For a continuous text division of Aristotle's *Ethics,* see Princeton, Princeton University Garrett 102. For examples in medicine, see London, BL Harley 3140, throughout.

37 Compare the divisions into four or five parts in the *Categories,* fols. 12v, 13v, 20r, 21v, 24r, etc.

38 "De ignorantia: 'Ignorantia' dicitur multipliciter. Quedam enim est ignorantia negationis; et hoc modo puer in cunis iacens habet ignorantiam omnium scientiarum. Et dicitur hec ignorantia negationis quia nichil ponit; qui enim hanc habet, nichil novit. Alia est que dicitur *ignorantia dispositionis*; et hec est cum iam aliquis de re novit aliquid, non tamen rem novit prout est. . . . et sic distinguit Aristoteles ignorantiam in Primo Posteriorum cum agit de falsigrapho syllogismo." Peter of Spain, *Tractatus,* 163 (cf. Aristotle's *Posterior Analytics* 1.1.71a).

39 For continuous marginal annotation consisting of HTs of distinctions but also of text divisions for Thomas Aquinas's *Summa theologica,* see BAV Vat. Lat. 734, throughout.

40 London, BL Egerton 633 includes such beautiful large text divisions.

41 After Richard of Fishacre, *In Secundum librum Sententiarum,* 1:26.

42 For further examples of manuscripts of *Sentences* with marginal HT text divisions, see Assisi, BC 101, BC 102; BAV Vat. Lat. 688.

43 Cf. BAV Vat. Lat. 688, fol. 120v.

44 For HTs and lists dividing the Gospel of Luke, see Paris, BnF Lat. 15536, fols. 2r–2v, 3v, etc.

45 On the thirteenth century's revival of interest in sapiential literature, see Smalley, "Commentaries on the Sapiential Books"; Smalley, "Some Latin Commentaries on the Sapiential Books." On Job, see also Harkins and Canty, *Cambridge Companion to Job*. For modern editions, see *B. Alberti Magni O. Praed. Ratisbonensis episcopi commentarii in Iob*; Aquinas, *Expositio super Iob ad litteram*. Hugh of Saint-Cher's *Postilla* is available in several early modern prints. Luc Ferrier is working on the edition of Roland of Cremona from Paris, BnF Lat. 405. The commentary in Naples, Bib. naz. VII. A. 16 is usually attributed to Guerric of Saint-Quentin. Matthew of Aquasparta's commentary is in Assisi, BC 35. Paris, BnF Lat. 15566 (incipit "*Consumpta est caro eius a suppliciis . . .*") is attributed by Friedrich Stegmüller to William of Middleton (*Repertorium Biblicum Medii Aevi,* 4:419, no. 36).

46 Aquinas, *Expositio super Iob ad litteram*.

47 Stump, *Aquinas,* 455.

48 Smalley, *Study of the Bible,* 281–92.

49 Boyle, "Theological Character," 281.

50 Jaffe, *Thomas Aquinas,* 16–17.

51 Fol. 62vb. See the Prolegomena to the critical edition of Aquinas's *Expositio*

super Iob ad litteram, 4*, beginning with "vir erat etc. liber hic dividitur in partes duas. In prima enim ponitur quedam historia."

52 Cenci, *Bibliotheca Manuscripta ad Sacrum Conventum Assisiensem*, 183; Aquinas, *Expositio super Iob ad litteram*, Prolegomena 3*, 60*–61*.

53 Cenci, *Bibliotheca Manuscripta ad Sacrum Conventum Assisiensem*, 183–84.

54 Assisi, BC 35, fol. 4vb. Word order in the standard Vulgate is slightly different: "*Dominus quoque conversus est ad pœnitentiam Job.*"

55 "Et sicut iam dictum est, diuiditur in tres partes. Primo enim agit de prima eius prosperitate; secundo de eius aduersitate infra primo capitulo *quadam autem die*; tertio de subsequenti et finali eius felicitate infra capitulo ultimo *postquam autem locutus est dominus*" (Olivi, *Postilla super Iob*).

56 Paris, BnF Lat. 15566, fols. 6r, 8v.

57 "*Vir erat in terra Hus*. Liber iste totalis potest diuidi in duas partes. In prima agit de eius persecutione [should be: perfectione]. In secunda de perfectionis remuneratione: infra ultimo *Dominvs qvoqve conversvs est ad penitentiam Iob et subditvr et addidit qvoqve Dominvs omnia*. Prima autem pars diuidi potest in duas, quia status perfectionis consistit in duobus, scilicet ut in tempore prosperitatis seruetur innocentia et tempore aduersitatis, patientia. Ideo primo agitur de perfectione eius quoad statum prosperitatis, in secundo quoad statum aduersitatis." I thank Alain Boureau for sharing the draft of his transcription of Richard's postilla with me.

58 Aquinas, *Expositio super Iob ad litteram*, 5, lines 10–11.

59 Florence, BML Plut. 20.18, fol. 62v; cf. Aquinas *Expositio super Iob ad litteram*, 5.

60 The author seems to have drawn a second branch between *persona* and *prosperitas* and then erased it; perhaps he intended at first to locate virtue there.

61 The preceding branch ends precisely where the next diagram begins (1:5). Since superscript is frequently used here to represent the surface; since the letters *in or* at the end of the label are clearly legible; and since this letter cluster appears only once in this chapter, I am inclined to infer that this unit was supposed to be the one beginning with the words *cumque* in or*bem* (no. 17).

62 *B. Alberti Magni O. Praed. Ratisbonensis episcopi commentarii in Iob*, 17.

63 Matthew of Aquasparta divides Job's adversities into those inflicted by the devil and those by his friends but leaves the wife out (Assisi, BC 35, fol. 8rb).

64 For a modern, similar understanding of narrative as constructed of settings and events and a similar approach stressing imbalance between pairs of "nucleus" and "satellite," see section 5.5.

65 This observation too has an equivalent in modern conversational analysis, seeking to find infrastructures such as "offer-refusal," "compliment-acceptance," etc.

66 "Prima habet duas. Primo enim premitat et explicat dyaboli iniquam ac

perversam affectionem, et secunda illius prave affectionis executionem, ibi: *quadam autem die.* Circa explicandam eius personam et iniquam affectionem duo introducit. . . . Duplex autem fuit occasio, una fuit assistencia dyaboli inter angelos dei, secundo fuit excellens commendatio sancti viri," etc. Matthew keeps close track of the discursive steps of each of them. Assisi, BC 35, fols. 8vb–10v.

67 On narrative, diagram, and space, see Putzo, "Implied Book and the Narrative Text"; Putzo, "Narration und Diagrammatik."

68 Saint Alban's monastery was extremely innovative in this regard. On this consult the beautiful online British Library catalog prepared by Frońska: "Writing and Picturing History."

69 Cf. Aquinas, *Expositio super Iob ad litteram*, 6, lines 126–39. For the transcription of this text division and a reconstructed diagram, see Even-Ezra, "Visualizing Narrative Structure," appendices.

70 For such figures, see Carruthers and Ziolkowski, "Anonymous: A Method for Recollecting the Gospels."

71 Parkes, "Influence of the Concepts of *Ordinatio* and *Compilatio*," esp. 122–27.

72 H. A. Taylor and B. Tversky, "Perspective in Spatial Descriptions." The inherent problem of this study was that participants were given maps and were asked to describe them. Thus, the medium, which is survey oriented by nature, must have had considerable influence.

73 Hagen, "Early History of Sentence Diagrams," retrieved with the permission of the author.

74 On some of the codicological expressions of the schoolmen's zeal for organization and dispositions of texts, see Parkes, "Influence of the Concepts of *Ordinatio* and *Compilatio*," esp. 121ff.

75 It is an open question, however, whether and how this perception relates to similar developments in medieval prose and other literary genres. On John Gower, see Copeland, *Rhetoric, Hermeneutic, and Translation*, 206ff. On the tree structure of the *Breviari d'amori*, see Nicholson, "Branches of Knowledge," 376.

76 Green, "Introduction," 1–2.

77 Minnis, *Medieval Theory of Authorship*, 151.

78 Barthes, "Introduction," 244.

79 Barthes, "Introduction," 245.

80 Fleming, *Goldfinger*, 14.

81 Barthes, "Introduction," 256.

82 Barthes, "Introduction," 267.

83 Holsinger ("Empire, Apocalypse and the 9/11 Premodern," 96) interprets Barthes's analysis of *S/Z* as a reworking of the fourfold medieval exegesis and associates it with a larger French tendency at the time for medievalism.

84 Mandler and Johnson, "Remembrance of Things Parsed." See also the extended account in Johnson and Mandler, "Tale of Two Structures."

85 Mandler and Johnson, "Remembrance of Things Parsed," 115.
86 Mandler and Johnson, "Remembrance of Things Parsed," 114.
87 Mann and Thompson, "Rhetorical Structure Theory." See also their extended account in "Two Views of Rhetorical Structure Theory." For a comprehensive bibliography on RST, see http://www.sfu.ca/rst/05bibliographies/index.html.
88 Mann and Thompson, "Two Views of Rhetorical Structure Theory," 13. See also Mann and Thompson, "Rhetorical Structure Theory," 258.
89 For the analysis below and others, see http://www.sfu.ca/rst/02analyses/published.html.
90 Smalley, *Study of the Bible*, 296.
91 Boyle, "Theological Character," 277.
92 On tree visualizations in contemporary discourse analysis, see Graham and Kennedy, "Survey of Multiple Tree Visualisation"; Zhao et al., "Facilitating Discourse Analysis with Interactive Visualization."
93 An interesting application of such methods to comic narrative and some intriguing hierarchical diagrams are in Cohn, "Architecture of Visual Narrative Comprehension."
94 Cohn, "Architecture of Visual Narrative Comprehension."

EPILOGUE

1 Aavitsland, *Imagining the Human Condition in Medieval Rome*, 205.
2 On habits of vision and modes of cognitive perception as objects of historical inquiry, see Alpers, "Is Art History?"
3 Wallis, *Casablanca*, introductory credits, 00:40.
4 A tendency current in recent literature on Ramism as well. See, e.g., Hotson, *Commonplace Learning*, 292–93.
5 For a critique of the problematics of utilization of charts as an indication of "Ramism," see Feingold, "English Ramism," 129.
6 Hotson, *Commonplace Learning*, 293.
7 Bender, *Culture of Diagram*; Eddy, *Rewriting Reason*; Berger, *Art of Philosophy*.
8 M. L. Jones, *Reckoning with Matter*.
9 Klemann, "Matter of Moral Education."
10 Sluhovski (*Becoming a New Self*) follows such practices, showing them to be a general phenomenon of the early modern period rather than purely a matter of the Reformation.
11 A literary-philosophical perspective on this phenomenon is in Razinski, "Everything."

Bibliography

MANUSCRIPTS

Assisi, Biblioteca comunale (BC) 35, 49, 51, 101, 102, 174, 186, 286, 296, 298, 327, 469, 486, 658
Amiens, Bibliothèque municipal (BM) 403, 404
Avranches, Bibliothèque municipale (BM) 223, 224, 227
Bologna, Biblioteca universitaria di Bologna 1564
Bruges, Bibliothèque municipale (BM) 534
Cambridge (England), Gonville and Caius College 341_537
Cambridge (Massachusetts), Harvard University Lat. 38
Charlesville-Mézières, Bibliothèque municipale (BM) 39, 250
Douai, Bibliothèque municipale (BM) 340
Florence, Biblioteca Medicea Laurenziana (BML) Plut. 11 sin. 1, Plut. 11 sin. 2, Plut. 11 sin. 3, Plut. 11 sin. 5, Plut. 11 sin 7, Plut. 20.18, Plut. 25 sin. 05, Plut. 31.35, Plut. 31.37, Plut. 34.47, Plut. 58.29, Plut. 71.35, Plut. 72.3, Plut. 89 sup. 76
Karlesruhe, Badische Landesbibliothek, Cod. St. Peter Perg. 92
Klagenfurt, Studienbibliothek 10
London, British Library (BL)
 Add. 10960, 10961, 18277, 22090
 Arundel 383
 Burney 275
 Egerton 633
 Harley 658, 3140, 3255, 3272, 3360
 Sloane 981
London, Wellcome Library 49, 55
Madrid, Biblioteca nacional de España (BNE) 1563, 1564, 3126, 9726
Munich, Bayerische Staatsbibliothek clm 4660, 23499, 28175
Naples, Biblioteca nazionale VII. A. 16
New Haven, Yale University Beinecke Marston 88, Marston 266, Syr. 10
Orleans, Bibliothèque municipale (BM) 283
Oxford, Balliol College 62, 195, 253
 Oxford, Bodleian Library
 Ashmole 1498
 Bodl. 344
 Bodl. 2042 / F 19327

>Bodl. Canon. Lat. Class. 188
>Bodl. Digby 55
>Bodl. Laud. Misc. 511

Paris, Bibliothèque nationale de France (BnF)
>Fr. 125, 204, 208, 542, 6220, 9106
>Gr. 1854
>Heb. 926
>Lat. 405, 1154, 3388, 3574, 4289, 4560, 6290, 6291, 6291A, 6292, 6319, 6459, 6520, 6576, 6977, 8156, 8653, 8654, 11229, 11414, 12956, 14174, 14425, 14717, 14719, 14976, 15015, 15173, 15323, 15362, 15450, 15536, 15566, 15652, 15754, 15956, 16084, 16096, 16149, 16153, 16174, 16405, 16489, 16599, 16906, 16911, 17806
>Nouv. Acq. Lat. 667

Porrentruy, Bibliothèque cantonale jurassienne 30
Princeton, Princeton University 228; Garrett 102
Reims, Bibliothèque municipal (BM) 869
Saint-Omer, Bibliothèque municipale (BM) 260, 620
Toulouse, Bibliothèque municipale (BM) 737
Tours, Bibliothèque municipale (BM) 121
Turin, National University Library A I 14
Uppsala, Bibl. Regal. Univ. C. 599, C. 678
Vatican City, Biblioteca apostolica Vaticana (BAV)
>Arch. Basil. S. Petri H.5
>Borgh. 18, 33, 56, 58, 73, 108, 130, 131, 133, 296
>Chigi E. V. 149
>Ottob. 1149
>Pal. Lat. 624, 634, 659, 696, 986, 987, 988, 992, 996, 1006, 1084, 1229, 1268, 1755, 1765, 1767, 1801
>Reg. Lat. 2036
>Ross. 400
>Urb. Lat. 1312, 1318
>Vat. Gr. 1777
>Vat. Lat. 22, 97, 688, 734, 782, 2068, 2114, 2117, 2691, 2976, 2977, 2113, 4543, 4560, 10683
>Vat. Sir. 158
>Vat. Urb. Gr. 35

Venice, Biblioteca San Marco Lat. VI, 49
Vienna, Österreichische Nationalbibliothek (ÖNB) 166, 273, 2370, 2374, 2407

PRINTED SOURCES AND SECONDARY LITERATURE

Aavitsland, Kristin. *Imagining the Human Condition in Medieval Rome: The Cistercian Fresco Cycle at Abbazia delle Tre Fontane*. Burlington, VT: Ashgate,

2012.

Albert the Great. *B. Alberti Magni O. Praed. Ratisbonensis episcopi commentarii in Iob*. Edited by Melchior Weiss. Freiburg: Herder, 1904.

Algazi, Gadi. "Scholars in Households: Refiguring the Learned Habitus, 1480–1550." *Science in Context* 16, no. 1/2 (2003): 9–42.

Alpers, Svetlana. "Is Art History?" *Daedalus* 106, no. 3 (1977): 1–13.

Anderson, Rita E., and Tore Helstrup. "Visual Discovery in Mind and on Paper." *Memory and Cognition* 21, no. 3 (1993): 283–93.

Angelo Clareno. *A Chronicle or History of the Seven Tribulations of the Order of Brothers Minor*. Edited and translated by David Burr and E. Randolph Daniel. St. Bonaventure, NY: Franciscan Institute, 2005.

Aquinas, Thomas. *Expositio super Iob ad litteram, cura et studio fratrum praedicatorum*. In *Opera Omnia*, vol. 26. Rome: Typographia Polyglotta, 1965.

Aristotle. *Analytica posteriora*. Edited by Laurentius Minio-Paluello and Bernardus G. Dod. *Aristoteles Latinus* 4.1–4. Bruges: Desclee de Brouwer, 1968.

Arnulf, Arwed. *Versus ad picturas: Studien zur Titulusdichtung als Quellengattung der Kunstgeschichte von der Antike bis zum Hochmittelalter*. Munich: Deutscher Kunstverlag, 1997.

Asztalos, Monica, et al. *Die "Seligenstädter Lateinpädagogik": Eine illustrierte Lateingrammatik aus dem deutschen Frühhumanismus*. 2 vols. Stockholm: Kungl. Vitterhetsakademien, 1989.

Barnes, Jonathan. *Aristotle: A Very Short Introduction*. Oxford: Oxford University Press, 2000.

Barney, Stephen A., ed. *The "Distinctiones Abel" of Peter the Chanter*. Corpus Christianorum Continuatio Mediaevales. Forthcoming.

———. "Visible Allegory: The *Distinctiones Abel* of Peter the Chanter." In *Allegory, Myth, and Symbol*, edited by Morton Wilfred Bloomfield, 87–108. Harvard English Studies 9. Cambridge, MA: Harvard University Press, 1981.

Barthes, Roland. "An Introduction to the Structural Analysis of Narrative." Translated by L. Duisit. *New Literary History* 6, no. 2 (1975): 237–72. Originally published as "Introduction à l'analyse structurale des récits." *Communications* 8 (1966): 1–27.

———. *S/Z*. Translated by R. Miller. Oxford: Blackwell, 1990.

Bataillon, Louis-Jacques. "Intermédiaires entre les traités de morale pratique et les sermons: Les 'distinctiones' biblique alphabétiques." In *Les genres littéraires dans les sources théologiques et philosophiques médiévales: Définition, critique et exploitation*, 213–26. Louvain-la-Neuve: Université catholique de Louvain, 1982.

Bazan, Bernardo C. "La quaestio disputata." In *Les genres littéraires dans les sources théologiques et philosophiques médiévales*, 31–49. Louvain-la-Neuve: Université catholique de Louvain, 1982.

Bellamah, Timothy. *The Biblical Interpretation of William of Alton*. Oxford: Oxford University Press, 2011.

Bender, John. *The Culture of Diagram*. Translated by Michael Marrinan. Stanford, CA: Stanford University Press, 2010.

Berger, Susanna. *The Art of Philosophy: Visual Thinking in Europe from the Late Renaissance to the Early Enlightenment*. Princeton, NJ: Princeton University Press, 2017.

Berndt, Rainer. "La théologie comme système du monde: Sur l'évolution des sommes théologiques de Hughes de Saint-Victor à Saint Thomas d'Aquin." *Revue des sciences philosophiques et théologiques* 78 (1994): 555–72.

Bertram, Martin, and Silvia di Paolo, eds. *Decretales pictae: Le miniature nei manoscritti delle decretali di Gregorio IX (liber extra); Atti del colloquio internazionale tenuto al l'Istituto storico Germanico, Roma, 3–4 marzo 2010*. Rome: Università degli Studi Roma Tre, 2012.

Béziau, Jean-Yves, and Gillman Payette, eds. *The Square of Opposition: A General Framework for Cognition*. Bern: Peter Lang, 2012.

Bishoff, Bernard. *Latin Paleography*. Cambridge: Cambridge University Press, 1990.

Blackwell, Alan F. "Diagrams about Thoughts about Thoughts about Diagrams." In *Reasoning with Diagrammatic Representations II: Papers from the AAAI 1997 Fall Symposium*, edited by Michael Anderson, 77–84. Menlo Park, CA: AAAI, 1997.

Blair, Ann M. *Too Much to Know: Managing Scholarly Information before the Modern Age*. New Haven, CT: Yale University Press, 2010.

Bohn, Willard. *Modern Visual Poetry*. Newark: University of Delaware Press, 2001.

Bourgain, Pascale. "Qu'est-ce qu'un vers au *Moyen Âge*?" *Bibliothèque de l'École des chartes* 147, no. 1 (1989): 231–82.

Boyle, John F. "The Theological Character of the Scholastic 'Division of the Text' with Particular Reference to the Commentaries of St. Thomas Aquinas." In *With Reverence for the Word: Medieval Scriptural Exegesis in Judaism, Christianity, and Islam*, edited by Jane Dammen McAuliffe, Barry D. Walfish, and Joseph W. Goering, 276–83. Oxford: Oxford University Press, 2003.

Boynton, Susan, and Diane J. Reilly, eds. *The Practice of the Bible in the Middle Ages: Production, Reception, and Performance in Western Christianity*. New York: Columbia University Press, 2011.

Braun, Oscar. *Moses Bar Kepha und sein Buch von der Seele*. Freiburg: Herdersche Verlagshandlung, 1891.

Brockett, Clyde W. "The Frontispiece of Paris, Bibliothèque nationale, Ms. Lat. 776: Gerbert's Acrostic Pattern Poems." *Manuscripta* 39, no. 1 (1995): 3–25.

Brundage, James A. *Medieval Canon Law*. London: Longman, 1995.

———. *The Medieval Origins of the Legal Profession: Canonists, Civilians, and Courts*. Chicago: University of Chicago Press, 2008.

Bülow-Jacobsen, Adam, and Sten Ebbesen. "Vaticanus Urbinas Graecus 35: An Edition of the Scholia on Aristotle's *Sophistici elenchi*." *Cahiers de l'Institut du Moyen Âge grec et latin* 43 (1982): 55–113.

Burghart, Marjorie. "Remploi textuel, invention et art de la mémoire: Les *Sermones ad status* du Franciscain Guibert de Tournai († 1284)." PhD diss., Université Lumière Lyon 2—France, 2013.

Buringh, Eltjo. *Medieval Manuscript Production in the Latin West: Explorations with a Global Database*. Global Economic Series 6. Leiden: Brill, 2011.

Burns, Robert I. "Paper Comes to the West, 1400–1800." In *Europäische Technik im Mittelalter 800 bis 1200: Tradition und Innovation*, edited by Uta Lindgren, 413–22. Berlin: Gebr. Mann, 1996.

Calo, Peter. *Vita S. Thomae Aquinatis. In Fontes vitae sancti Thomae Aquinatis notis historicis et criticis illustrati*, edited by Domenicus Prümmer and M. H. Laurent. Toulouse: Saint Maximin, 1912.

Camargo, Martin. *Ars Dictaminis, Ars Dictandi*. Turnhout: Brepols, 1991.

———. 2001. "The Waning of Medieval *Ars Dictaminis*." *Rhetorica: A Journal of the History of Rhetoric* 19, no. 2 (2001): 135–40.

Camille, Michael. "Illuminating Thought—the Trivial Arts in British Library, Burney Ms. 275." In *New Offerings, Ancient Treasures: Studies in Medieval Art for George Henderson*, 343–66. Sutton: Stroud, 2001.

Carruthers, Mary. *The Book of Memory: A Study of Memory in Medieval Culture*. Cambridge: Cambridge University Press, 1992.

Carruthers, Mary, and Jan Ziolkowski, eds. "Anonymous: A Method for Recollecting the Gospels." In *The Medieval Craft of Memory: An Anthology of Texts and Pictures*, 255–93. Philadelphia: University of Pennsylvania Press, 2002.

Cenci, Cesare. *Bibliotheca Manuscripta ad Sacrum Conventum Assisiensem*. Assisi: Regione dell'Umbria, 1981.

Cevolini, Alberto, ed. *Forgetting Machines: Knowledge Management Evolution in Early Modern Europe*. Boston: Brill, 2016.

Chambers, Deborah, and Daniel Reisberg. "Can Mental Images Be Ambiguous?" *Journal of Experimental Psychology: Human Perception and Performance* 11, no. 3 (1985): 317–28.

Champion, Matthew. *Medieval Graffiti: The Lost Voices of England's Churches*. London: Ebury, 2015.

Chandler, Daniel, and Rod Munday. *A Dictionary of Media and Communication*. Oxford: Oxford University Press, 2011.

Chartier, Roger. *Pratiques de la Lecture*. Marseille: Rivages, 1985.

Chenu, Marie-Dominique. "Maîtres et bacheliers de l'Université de Paris v. 1240: Description du manuscrit Paris, Bibl. Nat. Lat. 15652." *Études d'histoire littéraire et doctrinale du XIIIe siècle* 1 (1932): 11–39.

Clark, Andy. *Supersizing the Mind: Embodiment, Action, and Cognitive Extension*. Oxford: Oxford University Press, 2008.

Clark, Andy, and David Chalmers. "The Extended Mind." *Analysis* 58, no. 1 (1998): 7–19.

Cohen, Adam S. "Diagramming the Diagrammatic: Twelfth-Century Europe."

In *The Visualization of Knowledge in Medieval and Early Modern Europe*, edited by Marcia Kupfer, Adam S. Cohen, and Jossi H. Chajes. Turnhout: Brepols, 2020.

Cohn, Neil. "The Architecture of Visual Narrative Comprehension: The Interaction of Narrative Structure and Page Layout in Understanding Comics." *Frontiers in Psychology* 5 (July 2014): 680.

Colish, Marcia. "From the Sentence Collection to the *Sentence* Commentary and the *Summa*: Parisian Scholastic Theology, 1130–1215." In *Manuels, programmes de cours et techniques d'enseignement dans les universités médiévales: Actes du colloque international de Louvain-La-Neuve (9–11 Septembre 1993)*, edited by Jacqueline Hamesse, 9–29. Turnhout: Brepols, 1995.

———. *Peter Lombard*. 2 vols. Leiden: Brill, 1994.

Copeland, Rita. *Rhetoric, Hermeneutic, and Translation in the Middle Ages: Academic Traditions and Vernacular Texts*. Cambridge: Cambridge University Press, 1991.

Corran, Emily. "Understanding a Selection of Medical, Theological and Poetic Diagrams in a Thirteenth-Century Book of Biblical Commentaries: British Library, Harley MS. 658." *e-British Library Journal*, 2013, accessed March 2, 2019, http://www.bl.uk/eblj/2013articles/article14.html.

Crosby, Alfred W. *The Measure of Reality: Quantification and Western Society, 1250–1600*. Cambridge: Cambridge University Press, 1997.

Dahan, Gilbert. "Alain de Lille et l'exégèse de la Bible." In *Alain de Lille le docteur universel: Philosophie, théologie et littérature au XIIe siècle*, edited by Jean-Luc Solère, Anca Vasiliou, and Alain Gallonier, 455–84. Turnhout: Brepols, 2005.

———. *L'exégèse chrétienne de la Bible en occident medieval, XIIe–XIVe siècles*. Paris: Éditions du Cerf, 2008.

———. "Le schématisme dans l'exégèse médiévale." In *Qu'est-ce que nommer? L'image légendée entre monde monastique et pensée scholastique*, edited by Christian Heck, 31–40. Turnhout: Brepols, 2010.

Daston, Lorraine. "Taking Note(s)." *Isis: An International Review Devoted to the History of Science and Its Cultural Influences* 95, no. 3 (2004): 443–48.

Davies, Simon P. "Display-Based Problem-Solving Strategies in Computer Programming." In *Empirical Studies of Programmers*, edited by Wayne D. Gray and Deborah A. Boehm-Davis, 59–76. Norwood, NJ: Intellect, 1996.

de Hamel, Christopher. *Meetings with Remarkable Manuscripts: Twelve Journeys into the Medieval World*. New York: Penguin, 2017.

Delmas, Sophie. *Un Franciscain à Paris au milieu du XIIIe siècle: Le maître en théologie Eustache d'Arras*. Paris: Cerf, 2010.

———. "Les recueils de distinctions sont-ils des florilèges?" In *On Good Authority: Tradition, Compilation and the Construction of Authority in Literature from Antiquity to the Renaissance*, edited by Reinhart Ceulemans and Pieter de Leemans, 3:227–43. Turnhout: Brepols, 2015.

Demus, Otto. *Byzantine Art and the West*. New York: New York University Press, 1970.

De Rijk, Lambertus Marie. *Logica Modernorum: A Contribution to the History of Early Terminist Logic*. 2 vols. Assen: Van Gorcum, 1962.

Derolez, Albert. *The Palaeography of Gothic Manuscript Books: From the Twelfth to the Early Sixteenth Century*. Cambridge: Cambridge University Press, 2003.

Derrida, Jacques. "Plato's Pharmacy." In *Dissemination*, translated by Barbara Johnson, 63–171. Chicago: University of Chicago Press, 1981.

de Saussure, Ferdinand. *Course in General Linguistics*. Edited by Charles Bally and Albert Sechehaye in collaboration with Albert Reidlinger. Translated, with an introduction and notes, by Wade Baskin. New York: McGraw-Hill, 1966.

Désautels, Almuth Seebohm. *Apokalypse, ars moriendi, medizinische Traktate, Tugend- und Lasterlehren: Die erbaulich-didaktische Sammelhandschrift London, Wellcome Institute for the History of Medicine, Ms. 49*. Munich: H. Lengenfelder, 1995.

de Villanova, Arnaldus. *Commentum in quasdam parabolas et alias aphorismorum series: Aphorismi particulares, Aphorismi de memoria, Aphorismi extravagantes*. Edited by Juan Antonio Paniagua and Pedro Gil-Sotres. Arnaldi de Villanova Opera Medica Omnia, 6.2. Barcelona: Fundació Noguera, 1993.

———. *Expositio super aphorismo Hippocratis "In morbis minus"—Repetitio super aphorismo Hippocratis "Vita brevis."* Edited by Michael Rogers McVaugh. Arnaldi de Villanova Opera Medica Omnia, 14. Barcelona: Fundació Noguera, 2014.

de Vries, David N. "*Unde Dicitur*: Observations on the Poetic *Distinctiones* of the *Pearl*-Poet." *Chaucer Review* 35, no. 1 (2000): 115–32.

Devriese, Lisa. "Physiognomy in Context: Marginal Annotations in the Manuscripts of the *Physiognomonica*." *Recherches de théologie et philosophie médiévales* 84, no. 1 (2017): 107–41.

Dinkova-Bruun, Greti. "The Book of Job in Latin Biblical Poetry of the Later Middle Ages." In *A Companion to Job in the Middle Ages*, edited by Franklin Harkins and Aaron Canty, 324–53. Leiden: Brill, 2016.

———. "Notes on Poetic Composition in the Theological Schools ca. 1200 and the Latin Poetic Anthology from Ms. Harley 956: A Critical Edition." *Sacris Erudiri* 43 (January 2004): 299–391.

Dogan, Fehmi, and Nancy J. Nersessian. "Conceptual Diagrams in Creative Architectural Practice: The Case of Daniel Libeskind's Jewish Museum." *Arq: Architectural Research Quarterly* 16, no. 1 (2012): 15–27.

Doucet, Vitorine. *Summa Fratris Alexandri, Prolegomena*. In *Summa Theologica seu sic ab Origine Dicta "Summa Fratris Alexandri,"* vol. 3.1, edited by Bernardini Klumper, Victorin Doucet, and the Quarracchi Fathers. 4 vols. Rome: Collegii S. Bonaventurae, 1924-48.

Ebbesen, Sten. *Greek–Latin Philosophical Interaction*. Vol. 1. Abingdon, UK: Routledge, 2016.

———. "Medieval Latin Glosses and Commentaries on Aristotelian Logical Texts of the Twelfth and Thirteenth Centuries." In *Glosses and Commentaries*

on *Aristotelian Logical Texts*, edited by Charles Burnett, 129–77. Warburg Institute Surveys and Texts 23. London: Warburg Institute, 1993.

Eco, Umberto. *From the Tree to the Labyrinth*. Cambridge, MA: Harvard University Press, 2014.

Eddy, Matthew Daniel. *Rewriting Reason: Student Notebooks as Artefacts of the Scottish Enlightenment*. Chicago: University of Chicago Press, forthcoming.

Elkhadem, Hosam, ed. *Le "Taqwim al-sihha" (Tacuini sanitatis) d'Ibn Buṭlān: Un traité médical du XIe siècle; Histoire du texte, édition critique, traduction, commentaire*. Leuven, Belgium: Peeters, 1990.

Ermengildo, Lio. *S. Bonaventura e la questione autografa "De superfluo."* Rome: Universitatis Lateranensis, 1966.

Evans, Gillian R. "Alan of Lille's Distinctions and the Problem of Theological Language." *Sacris Erudiri* 24 (January 1980): 67–86.

Evans, Michael. "The Geometry of the Mind." *Architectural Association Quarterly* 12, no. 4 (1980): 32–55.

Even-Ezra, Ayelet. "Schemata as Maps and Editing Tools in 13th Century Scholasticism." *Manuscripta* 61, no. 1 (2017): 21–71.

———. "Visualizing Narrative Structure in the Medieval University: *Divisio textus* Revisited." *Traditio* 72 (2017): 341–76.

Favreau, Robert. *Epigraphie médiévale*. Turnhout: Brepols, 1997.

Favreau, Robert, et al. *Corpus des inscriptions de la France médiévale*. 26 vols. to date. Paris: Centre national de la recherche scientifique, 1974–.

Feingold, Mordechai. "English Ramism: A Reinterpretation." In *The Influence of Peter Ramus: Studies in Sixteenth and Seventeenth Century Philosophy and Sciences*, edited by Mordechai Feingold, Joseph S. Freedman, and Wolfgang Rother, 127–76. Basel: Schwabe, 2001.

Fidora, Alexander, Harvey J. Hames, and Yossef Schwartz, eds. *Latin-into-Hebrew: Texts and Studies*. 2 vols. Leiden: Brill, 2013.

Fleming, Ian. *Goldfinger*. London: Vintage Books, 2012.

Fowler, Alastair. *The Mind of the Book: Pictorial Title Pages*. New York: Oxford University Press, 2017.

Friedberg, Emil. *Corpus Iuris Canonici*. Leipzig: Bernhard Tauchnitz, 1881.

Frońska, Joanna. "Turning the Pages of Legal Manuscripts: Reading and Remembering the Law." In *Meaning in Motion: Semantics of Movement in Medieval Art*, edited by Nino Zchomelidse and Giovanni Freni, 191–214. Princeton, NJ: Department of Art and Archaeology, Princeton University, 2011.

———. "Writing and Picturing History: Historical Manuscripts from the Royal Collection." *British Library*. Accessed January 30, 2019. https://www.bl.uk/catalogues/illuminatedmanuscripts/TourHistoryGen.asp.

Gallo, Ernest. *The "Poetria nova" and Its Sources in Early Rhetorical Doctrine*. The Hague: Walter de Gruyter, 1971.

Gameson, Richard. "A Scribe's Confession and the Making of the Anchin

Hrabanus (Douai Bibliothèque municipal, MS. 340)." In *Manuscripts in Transition: Recycling Manuscripts, Texts and Images,* edited by Brigitte Dekeyzer and Jan Van der Stock, 65–79. Paris: Peeters, 2005.

Garrett, Merrill F. "The Analysis of Sentence Production." In *Psychology of Learning and Motivation,* edited by Gordon H. Bower, 133–77. New York: Academic Press, 1975.

Glorieux, Palémon. "Les années 1242–1247 à la faculté de théologie de Paris." *Recherches de théologie ancienne et médiévale* 29 (1962): 234–49.

Gooding, David C. "Cognition, Construction and Culture: Visual Theories in the Sciences." *Journal of Cognition and Culture* 4, no. 3 (2004): 551–93.

———. "Visual Cognition: Where Cognition and Culture Meet." *Philosophy of Science* 73, no. 5 (2006): 688–98.

———. "Visualizing Scientific Inference." *Topics in Cognitive Science* 2, no. 1 (2010): 15–35.

Goody, Jack. *The Domestication of the Savage Mind.* Cambridge: Cambridge University Press, 1977.

Gottheil, Richard J. H. "A Syriac Fragment." *Hebraica* 4, no. 4 (1888): 206–15.

Grafton, Anthony. *The Culture of Correction in Renaissance Europe.* New Haven, CT: Yale University Press, 2012.

Graham, Martin, and Jessie Kennedy. "A Survey of Multiple Tree Visualisation." *Information Visualization* 9, no. 4 (2010): 235–52.

Green, Virginie. Introduction to *The Medieval Author in Medieval Literature.* Edited by Virginie Green. New York: Palgrave Macmillan, 2006.

Gueri, Domenico. "Una recensione malevola di un contemporaneo al doctrinale e al Grecismus." In *Studi letterari e linguistici dedicati a Pio Rajna,* 181–90. Milan: Hoepli, 1911.

Hacking, Ian. "Trees of Logic, Trees of Porphyry." In *Advancements of Learning: Essays in Honour of Paolo Rossi,* edited by John L. Heilbron, 221–63. Florence: Olschki, 2007.

Hagen, Karl. "The Early History of Sentence Diagrams." *Polysyllabic (blog),* last updated October 17, 2015. Accessed January 30, 2019. http://www.polysyllabic.com/?q=olddiagrams.

Halcour, D. "Tractatus de transcendentalibus entis conditionibus." *Franziskanische Studien* 41 (1959): 41–106.

Hamburger, Jeffrey. *Diagramming Devotion: Berthold of Nuremberg's Reconfiguration of Hrabanus Maurus' Poems in Praise of the Cross.* Chicago: University of Chicago Press, forthcoming.

———. "Haec Figura Demonstrat: Diagrams in an Early-Thirteenth Century Parisian Copy of Lothar de Segni's de Miss Arum Mysteriis." *Wiener Jahrbuch für Kunstgeschichte* 58, no. 1 (2009): 7–76.

Hamburger, Jeffrey F., and Anne-Marie Bouché, eds. *The Mind's Eye: Art and Theological Argument in the Middle Ages.* Princeton, NJ: Princeton University Press, 2005.

Hamesse, Jaqueline. "The Scholastic Model of Reading." In *A History of Reading in the West*, edited by Guglielmo Cavallo and Roger Chartier, 103–19. Amherst: University of Massachusetts Press, 1999.

Harkins, Franklin T., and Aaron Canty. *A Cambridge Companion to Job in the Middle Ages*. Leiden: Brill, 2017.

Haspelmath, Martin. "Coordinating Constructions: An Overview." In *Coordinating Constructions*, edited by Martin Haspelmath, 3–39. Amsterdam: John Benjamins, 2004.

Hegarty, M. "Mental Animation: Inferring Motion from Static Displays of Mechanical Systems." *Journal of Experimental Psychology: Learning, Memory, and Cognition* 18, no. 5 (1992): 1084–1102.

Henquinet, François-Marie. "Un brouillon autographe de S. Bonaventure sur le commentaire des Sentences." *Études franciscaines* 44 (1932): 633–35; 45 (1933): 59–82.

———. "Un recueil de questions annoté par S. Bonaventure." *Études franciscaines* 25 (1932): 553–56.

Hillgarth, Jocelyn Nigel. *Ramón Lull and Lullism in Fourteenth Century France*. Oxford: Clarendon, 1971.

Hoeniger, Cathleen. "The Illuminated *Tacuinum sanitatis*: Manuscripts from Northern Italy ca. 1380–1400: Sources, Patrons, and the Creation of a New Pictorial Genre." In *Visualizing Medieval Medicine and Natural History, 1200–1550*, edited by Jean A. Givens, Karen M. Reeds, and Alain Touwaide, 51–81. Burlington, VT: Ashgate, 2006.

Holsinger, Bruce. "Empire, Apocalypse and the 9/11 Premodern" (2008). In *The Legitimacy of the Middle Ages: On the Unwritten History of Theory*, edited by Andrew Cole and D. Vance Smith, 94–118. Durham, NC: Duke University Press, 2010.

———. *The Premodern Condition: Medievalism and the Making of Theory*. Chicago: University of Chicago Press, 2005.

Hotson, Howard. *Commonplace Learning: Ramism and Its German Ramifications, 1543–1630*. Oxford: Oxford University Press, 2007.

Huglo, Michel. "Les diagrammes d'harmonique interpolés dans les manuscrits hispaniques de la *Musica Isidori*." *Scriptorium: Revue internationale des études relatives aux manuscrits* 48, no. 2 (1994): 171–86.

———. "L'étude des diagrammes d'harmonique de Calcidius au Moyen Âge." *Revue de musicologie* 91, no. 2 (2005): 305–19.

Hugonnard-Roche, Henri. "Introductions syriaques à l'étude de la logique: À propos de quelques divisions de Porphyre." In *Comprendre et maîtriser la nature au Moyen Âge*, 385–408. Geneva: Droz, 1994.

Huisman, Rosemary. *The Written Poem: Semiotic Conventions from Old to Modern English*. Blumsbury: A&C Black, 1999.

Jaeger, Stephen. "Gerbert versus Othric: Spielregeln einer akademischen Disputation im 10. Jahrhundert." *Viator* 40, no. 1 (2009): 43–68.

Jaffe, Martin. *Thomas Aquinas: The Literal Exposition on Job; A Scriptural Commentary concerning Providence*. Translated by Anthony d'Amico. Atlanta, GA: Scholars Press, 1986.

Jensen, Kenneth. "The Works of Lawrence of Aquileia with a List of Manuscripts." *Manuscripta* 17, no. 3 (1973): 147–58.

Johanson, Carmen, and David Londey. "Apuleius and the Square of Opposition." *Phronesis* 29, no. 2 (1984): 165–73.

Johnson, Nancy S., and Jean M. Mandler. "A Tale of Two Structures: Underlying and Surface Forms in Stories." *Poetics* 9, nos. 1–3 (1980): 51–86.

Jones, Matthew L. *Reckoning with Matter: Calculating Machines, Innovation, and Thinking about Thinking from Pascal to Babbage*. Chicago: University of Chicago Press, 2017.

Jones, Peter Murray. *Medieval Medical Miniatures*. London: British Library, 1984.

———. *Medieval Medicine in Illuminated Manuscripts*. London: British Library, 1998.

King, Daniel. "Why Were the Syrians Interested in Greek Philosophy?" In *History and Identity in the Late Antique Near East*, edited by Philip Wood, 61–82. Oxford: Oxford University Press, 2013.

Kirsh, David. "The Intelligent Use of Space." *Artificial Intelligence* 73, nos. 1–2 (1995): 31–68.

Kitzinger, Ernst. "The Byzantine Contribution to Western Art of the Twelfth and Thirteenth Centuries." *Dumbarton Oaks Papers* 20 (1966): 27–47.

Klemann, Heather. "The Matter of Moral Education: Locke, Newbery, and the Didactic Book-Toy Hybrid." *Eighteenth-Century Studies* 44, no. 2 (2011): 223–44.

Koehler, Wilhelm. "Byzantine Art in the West." *Dumbarton Oaks Papers* 1 (1941): 61–87.

Krämer, Sybille, and Christina Ljungberg. *Thinking with Diagrams: The Semiotic Basis of Human Cognition*. Boston: de Gruyter Mouton, 2016.

Kulpa, Zenon. "Diagrammatic Representation and Reasoning." *Machine Graphics and Vision* 3, no. 1/2 (1994): 77–103.

Kupfer, Marcia, Adam S. Cohen, and Jossi H. Chajes, eds. *Visualization of Knowledge in Medieval and Early Modern Europe*. Turnhout: Brepols, 2020.

Kusukawa, Sachiko. *Picturing the Book of Nature: Image, Text, and Argument in Sixteenth-Century Human Anatomy and Medical Botany*. Chicago: University of Chicago Press, 2012.

Kwakkel, Erik. *The European Book in the Twelfth Century*. Cambridge: Cambridge University Press, 2018.

Lacombe, George. Aristoteles Latinus. 2 vols. Rome: La libreria dello stato, 1939–55.

Lakoff, George, and Mark Johnson. *Metaphors We Live By*. Chicago: University of Chicago Press, 1980.

Larkin, Jill H., and Herbert A. Simon. "Why a Diagram Is (Sometimes) Worth Ten Thousand Words." *Cognitive Science* 11, no. 1 (1987): 65–100.

Law, Vivien. *The History of Linguistics in Europe: From Plato to 1600*. Cambridge: Cambridge University Press, 2003.

———. "Why Write a Verse Grammar?" *Journal of Medieval Latin* 9 (January 1999): 46–76.

L'Engle, Susan. "The Proactive Reader: Learning to Learn the Law." In *Medieval Manuscripts, Their Makers and Users: A Special Issue of Viator in Honor of Richard and Mary Rouse*, 51–76. Turnhout: Brepols, 2011.

———. "Readers in the Margins: Pictorializing the Study of Roman Law." *Digital Proceedings of the Lawrence J. Schoenberg Symposium on Manuscript Studies in the Digital Age* 2, no. 1 (2010): article 4.

Leonhardt, Jürgen. *Dimensio syllabarum: Studien zur lateinischen Prosodie- und Verslehre von der Spätantike bis zur frühen Renaissance; Mit einem ausfuehrlichen Quellenverzeichnis bis zum Jahr 1600*. Göttingen: Vandenhoeck und Ruprecht, 1989.

Levelt, Willem J. M. "The Speaker's Linearization Problem." *Philosophical Transactions of the Royal Society of London B* 295, no. 1077 (1981): 305–15.

———. *Speaking: From Intention to Articulation*. Cambridge, MA: MIT Press, 1989.

Levelt, Willem J. M., Ardi Roelofs, and Antje S. Meyer. "A Theory of Lexical Access in Speech Production." *Behavioural and Brain Sciences* 22, no. 1 (1999): 1–38.

Linde, Charlotte, and William Labov. "Spatial Structures as a Site for the Study of Language and Thought." *Language* 51 (1975): 924–39.

Lombard, Peter. *The Sentences.* Translated by Giulio Silano. Toronto: Pontifical Institute of Medieval Studies, 2007.

Londey, David, and Carmen Johansen. "Apuleius and the Square of Opposition." *Phronesis* 29, no. 2 (1984): 165–73.

Long, James. "The Science of Theology according to Richard Fishacre: Edition of the Prologue to His Commentary on the *Sentences*." *Mediaeval Studies* 34 (January 1972): 71–98.

Longfellow, Henry W. *The Poems of Henry Wadsworth Longfellow*. Edited by Louis Untermeyer. New York: Heritage, 1943.

Lottin, Odo. "Le problème de l'*Ignorantia Iuris*' de Gratien à Saint Thomas d'Aquin." *Recherches de théologie ancienne et médiévale* 5 (October 1933): 345–68.

Luhtala, Anneli. *Grammar and Philosophy in Late Antiquity: A Study of Priscian's Sources*. Amsterdam: John Benjamins, 2005.

Mandler, Jean M., and Nancy S. Johnson. "Remembrance of Things Parsed: Story, Grammar, and Recall." *Cognitive Psychology* 9, no. 1 (1977): 111–51.

Mann, William C., and Sandra A. Thompson. "Rhetorical Structure Theory: Toward a Functional Theory of Text Organization." *Text: Interdisciplinary Journal for the Study of Discourse* 8, no. 3 (1988): 243–81.

———. "Two Views of Rhetorical Structure Theory." Paper presented in Lyon,

2000. Accessed March 22, 2016. http://www-bcf.usc.edu/~billmann/WMlinguistic/2vsend.pdf.

Mari, Giovanni. *I trattati medievali di ritmica latina*. Milan: Hoepli, 1899.

McKeyney, Lauren. *Medical Illustrations in Medieval Manuscripts*. Berkeley, CA: Wellcome Historical Medical Library, 1965.

Mengozzi, Stefano. *The Renaissance Reform of Medieval Music Theory: Guido of Arezzo between Myth and History*. Cambridge: Cambridge University Press, 2010.

Metzger, Stephen M. "Gerard of Abbeville, Secular Master, on Knowledge, Wisdom and Contemplation." PhD diss., University of Notre Dame, 2013.

Meyer, Christoph H. F. *Die Distinktionstechnik in der Kanonistik des 12. Jahrhunderts: Ein Beitrag zur Wissenschaftsgeschichte des Hochmittelalters*. Leuven: Leuven University Press, 2000.

Meyer aus Speyer, Willhelm, ed. *Radewin's Gedicht über Theophilus: Nebst Untersuchungen über die Theophilussage und die Arten der gereimten Hexameter*. Munich: Straub, 1873.

Migerius [Le Myésier], Thomas. *Opera Latina: Supplementum Lullianum I Breviculum seu electorium parvum Thomae Migerii (Le Myésier)*. Edited by C. Lohr, T. Pindl-Büchel, and W. Büchel. Turnhout: Brepols, 1990.

Minnis, Alastair J. *Medieval Theory of Authorship: Scholastic Literary Attitudes in the Later Middle Ages*. Philadelphia: University of Pennsylvania Press, 1988.

Mithum, Marianne. "The Grammaticalization of Coordination." In *Clause Combining in Grammar and Discourse*, edited by John Haiman and Sandra A. Thompson, 331–60. Amsterdam: John Benjamins, 1988.

Moly-Mariotti, Florence. "Le *Taqwim-as-sihha*, traité de médecine arabe et sa diffusion en Occident, texte et illustrations." In *Manuscripts in Transition: Recycling Manuscripts, Texts and Images*, edited by Brigitte Dekeyzer and J. Van der Stock, 41–54. Leuven: Peeters, 2005.

Mondrain, Brigitte. "Traces et mémoire de la lecture des textes: Les marginalia dans les manuscrits scientifiques byzantins." In *Scientia in margine: Études sur les "marginalia" dans les manuscrits scientifiques du Moyen Âge à la Renaissance*, edited by Danielle Jacquart and Charles Burnett, 1–25. Geneva: Droz, 2005.

Moretti, Franco. *Distant Reading*. London: Verso, 2013.

Mostert, Marco, ed. *Organizing the Written Word: Scripts, Manuscripts and Texts*. Utrecht Studies in Medieval Literacy. Turnhout: Brepols, 1999.

Müller, Lothar. *White Magic: The Age of Paper*. Translated by Jessica Spengler. Cambridge: John Wiley and Sons, 2014.

Murdoch, John Emery. *Album of Science: Antiquity and the Middle Ages*. New York: Charles Scribner's Sons, 1984.

Murphy, James J. *Rhetoric in the Middle Ages: A History of Rhetorical Theory from Saint Augustine to the Renaissance*. Berkeley: University of California Press, 1981.

Nersessian, Nancy J. "Opening the Black Box: Cognitive Science and History of Science." In *"Constructing Knowledge in the History of Science,"* special issue, *Osiris*, 2nd ser., 10 (January 1995): 194–211.

Netz, Reviel. *The Shaping of Deduction in Greek Mathematics: A Study in Cognitive History*. Cambridge: Cambridge University Press, 1999.

Newstok, Scott. *Quoting Death in Early Modern England: The Poetics of Epitaphs beyond the Tomb*. New York: Palgrave Macmillan, 2009.

Nicholson, Francesca M. "Branches of Knowledge: The Purposes of Citation in the *Breviari d'amor* of Matfre Ermengaud." *Neophilologus* 91, no. 3 (2007): 375–85.

Norberg, Dag. *An Introduction to the Study of Medieval Latin Versification*. Translated by Grant C. Roti and Jacqueline de la Chapelle Skubly. Washington, DC: Catholic University of America Press, 2004.

O'Boyle, Cornelius. *The Art of Medicine: Medical Teaching at the University of Paris, 1250–1400*. Leiden: Brill, 1998.

O'Carroll, Mary E. *A Thirteenth-Century Preacher's Handbook: Studies in MS Laud Misc. 511*. Toronto: Pontifical Institute of Mediaeval Studies, 1997.

O'Daly, Irene. "Diagrams of Knowledge and Rhetoric in Manuscripts of Cicero's *De inventione*." In *Manuscripts of the Latin Classics, 800–1200*, edited by Erik Kwakkel, 77–106. Leiden: Leiden University Press, 2015.

———. "Managing Knowledge: Digrammatic Glosses to Medieval Copies of the *Rhetorica ad Herennium*." *International Journal of the Classical Tradition* 23, no. 1 (2016): 1–28.

Olivi, Peter John. *Petrus Iohannis Olivi Postilla super Iob*. Edited by Alain Boureau. Turnhout: Brepols, 2015.

O'Meadhra, Uaininn. "Medieval Logic Diagrams in Bro Church, Gotland, Sweden." *Acta Archaeologica* 83, no. 1 (2012): 287–313.

Orme, Nicholas. *Medieval Schools: From Roman Britain to Renaissance England*. New Haven, CT: Yale University Press, 2006.

Pace, Giulio. *Aristotelous Organon Aristote[l]is Stagiritae pe[ri-] pateticorvm principis Organum: hoc est, libri omnes ad logicam pertinentes, Græcè & Latinè / Ivl. Pacivs recensuit, atque ex libris cùm manuscriptis tum editis emendauit, è Græca in Latinam linguam conuertit: tractatuum, capitum, & particularum distinctionibus, argumentísque, necnon perpetuis notis, & tabulis synopticis illustrauit. Additi sunt indices tres, vno tractatuum & capitum, altero Græcorum verborum, tertio rerum memorabilia*. Frankfurt: Giulio Pace, 1597.

Parkes, Malcolm Beckwith. "The Influence of the Concepts of *Ordinato* and *Compilatio* on the Development of the Book." In *Medieval Learning and Literature: Essays Presented to Richard William Hunt*, edited by Johnathan G. Alexander and Margaret T. Gibson, 115–41. Oxford: Clarendon, 1976.

———. *Pause and Effect: An Introduction to the History of Punctuation in the West*. Aldershot, UK: Ashgate, 1992.

———. "Reading, Copying and Interpreting a Text in the Early Middle Ages." In *A History of Reading in the West*, edited by Guglielmo Cavallo and Roger Chartier, 90–102. Amherst: University of Massachusetts Press, 1999.

Parsons, Terence. *Articulating Medieval Logic*. Oxford: Oxford University Press, 2014.

———. "The Traditional Square of Opposition." In *Stanford Encyclopedia of Philosophy*. Stanford, CA: Stanford University, 1997.

Pechmann, Thomas, and Dieter Zerbst. "The Activation of Word Class Information during Speech Production." *Journal of Experimental Psychology: Learning, Memory, and Cognition* 28, no. 1 (2002): 233–43.

Pelzer, Augustus, ed. *Bibliothecae Apostolicae Vaticanae codices manuscripti recensiti, codices Vaticani latini*. Rome: Biblioteca Apostolica Vaticana, 1930.

Peter of Spain. *Tractatus*. Edited by Lambertus M. De Rijk. Amsterdam: John Benjamins, 1990.

Poleg, Eyal. *A Material History of the Bible, England 1200–1553*. Oxford: Oxford University Press, 2020

Pollack, Emil J. *Medieval and Renaissance Letter Treatises and Form Letters*. Leiden: Brill, 2015.

Progovac, Ljiljana. "Structure for Coordination." In *The Second Glot International State-of-the-Article Book: The Latest in Linguistics*, edited by Lisa Cheng and Rint Sybesma, 241–87. Berlin: de Gruyter, 2003.

Purcell, Allan T., and John Gero. "Drawings and the Design Process: A Review of Protocol Studies in Design and Other Disciplines and Related Research in Cognitive Psychology." *Design Studies* 19, no. 4 (1998): 389–430.

Purdie, Rihannon. *Anglicizing Romance: Tail-Rhyme and Genre in Medieval English Literature*. Cambridge: Brewer, 2008.

Putzo, Christine. "The Implied Book and the Narrative Text: On a Blind Spot in Narratological Theory from a Media Studies Perspective." *Journal of Literary Theory* 6, no. 2 (2012): 383–415.

———. "Narration und Diagrammatik: Eine Vorüberlegung und sieben Thesen." *Zeitschrift für Literaturwissenschaft und Linguistik* 44, no. 176 (2014): 77–92.

Radding, Charles, and Antonio Ciaralli. *The Corpus Iuris Civilis in the Middle Ages: Manuscripts and Transmission from the Sixth Century to the Juristic Revival*. Leiden: Brill, 2007.

Razinsky, Liran. "Everything: Totality and Self-Representation, from Past to Present." *SubStance* 46, no. 3 (2017): 150–72.

Reeves, Marjorie, and Beatrice Hirsch-Reich. *The "Figurae" of Joachim of Fiore*. Translated by Beatrice Hirsch-Reich. Oxford: Clarendon Press, 1972.

Richard of Fishacre. *In Secundum librum Sententiarum*. Pt. 1: Prol., dist. 1–20. Edited by R. James Long. Munich: Verlag der Bayarischen Akademie der Wissenschaften, 2009.

Richer of Saint-Remi. *Histories*. Edited and translated by Justin Lake. 2 vols. Boston: Harvard University Press, 2011.

Rogers, Yvonne. *HCI Theory: Classical, Modern, and Contemporary*. San Rafael: Morgan and Claypool, 2012.

Römer, Gerhard, and Gerhard Stamm, eds. *Raimundus Lullus—Thomas Le Myésier, Electorium Parvum seu Breviculum, 1: Vollständiges Faksimile der Handschrift St. Peter perg. 92 der Badischen Landesbibliothek Karlsruhe; 2: Kommentar zum Faksimile*. Wiesbaden: Reichert, 1988.

Rosemann, Philipp. *The Story of a Great Medieval Book: Peter Lombard's "Sentences."* Toronto: Broadview, 2007.

Roth, Pinchas. "Mordechai Nathan and the Jewish Community in Avignon." [In Hebrew.] *Jewish Studies: An Internet Journal* 17 (2019): 1–17.

Roumy, Franck. "L'ignorance du droit dans la doctrine civiliste des XIIe–XIIIe siècles." *Cahiers de recherches médiévales et humanistes* 7 (February 2000). http://journals.openedition.org/crm/878.

Rouse, Mary, and Richard Rouse. "Biblical Distinctions in the Thirteenth Century." *Archives d'histoire doctrinale et littéraire du Moyen Âge*, 1974, 27–37.

———. "The Schools and the Waldensians: A New Work by Durand of Huesca." In *Christendom and Its Discontents: Exclusion, Persecution, and Rebellion, 1000–1500*, edited by Scott L. Waugh and Peter D. Diehl, 86–111. New York: Cambridge University Press, 1996.

———. "*Statim Invenire*: Schools, Preachers and New Attitudes to the Page." In *Renaissance and Renewal in the Twelfth Century*, edited by Robert L. Benson, Giles Constable, and Carol Dana Lanham, 201–25. Cambridge, MA: Harvard University Press, 1982.

Rouse, Richard, and Mary Rouse. *Preachers, Florilegia and Sermons: Studies on the "Manipulus florum" of Thomas of Ireland*. Toronto: Pontifical Institute of Medieval Studies, 1979.

Rummel, Erika. "Erasmus' Manual of Letter-Writing: Tradition and Innovation." *Renaissance and Reformation / Renaissance et Réforme* 13, no. 3 (1989): 299–312.

Saenger, Paul. *Space between Words: The Origins of Silent Reading*. Stanford, CA: Stanford University Press, 1997.

Safran, Linda. "A Prolegomenon to Byzantine Diagrams." In *The Visualization of Knowledge in Medieval and Early Modern Europe*, edited by Marcia Kupfer, Adam S. Cohen, and Jossi H. Chajes. Turnhout: Brepols, forthcoming.

Sag, Ivan A., Gerald Gazdar, Thomas Wasow, and Steven Weisler. "Coordination and How to Distinguish Categories." *Natural Language and Linguistic Theory* 3, no. 2 (1985): 117–71.

Savage-Smith, Emilie. "Galen's Lost Ophthalmology and the *Summaria Alexandrinorum*." In *The Unknown Galen*, ed. Vivian Nutton, 121–38. Bulletin of the Institute of Classical Studies, Suppl. 77. London: Institute of Classical Studies, University of London, 2002.

Saxl, Fritz. "A Spiritual Encyclopaedia of the Later Middle Ages." *Journal of the Warburg and Courtauld Institutes* 5 (1942): 82–142.

Schmitt, Jean-Claude. "Les images classificatrices." *Bibliothèque de l'École des Chartres* 147 (1989): 311–41.

Share, Michael. *Arethas of Caesarea's Scholia on Porphyry's "Isagoge" and Aristotle's "Categories" (Codex Vaticanus Urbinas Graecus 35): A Critical Edition.* Brussels: Ousia, 1995.

Sharpe, Richard. "Richard Barre's Compendium Veteris et Noui Testamenti." *Journal of Medieval Latin* 14 (January 2004): 128–46.

Sherman, Claire Richter. *Imaging Aristotle: Verbal and Visual Representation in Fourteenth-Century France.* Berkeley: University of California Press, 1995.

Sherman, William H. *Used Books: Marking Readers in Renaissance England.* Philadelphia: University of Pennsylvania Press, 2008.

Silano, Giulio. "The 'Distinctiones decretorum' of Ricardus Anglicus: An Edition." 2 vols. PhD diss., University of Toronto, 1981.

Sloman, Aaron. "Diagrams in the Mind?" In *Diagrammatic Representation and Reasoning*, edited by Michael Anderson, Bernd Meyer, and Patrick Olivier, 7–28. London: Springer, 2002.

Sluhovski, Moshe. *Becoming a New Self: Practices of Belief in Early Modern Catholicism.* Chicago: University of Chicago Press, 2017.

Smalley, Beryl. "Commentaries on the Sapiential Books." *Dominican Studies*, 1949, 318–55.

———. "Some Latin Commentaries on the Sapiential Books in the Late Thirteenth and Early Fourteenth Centuries." *Archives d'histoire doctrinale et littéraire du Moyen Âge* 25–26 (1950–51): 103–28.

———. *The Study of the Bible in the Middle Ages.* Notre Dame, IN: University of Notre Dame Press, 1964.

Smith, Lesley. "The Glossed Bible." In *The New Cambridge History of the Bible*, edited by Richard Marsden and E. Ann Matter, 363–79. Cambridge: Cambridge University Press, 2012.

———. *Masters of the Sacred Page: Manuscripts of Theology in the Latin West to 1274.* Notre Dame, IN: University of Notre Dame Press, 2001.

Smura, Rosa. "Manuscript Book Production and Urban Landscape: Bologna during the Thirteenth and Fourteenth Centuries." In *Text and Image in the City: Manuscript, Print and Visual Culture in Urban Space*, edited by John Hinks and Catherine Armstrong, 81–104. Cambridge: Cambridge Scholars Publishing, 2017.

Soetermeer, Frank. *Utrumque Ius in Peciis: Die Produktion juristischer Bücher an italienischen und französischen Universitäten des 13. und 14. Jahrhunderts.* Frankfurt am Main: Klostermann, 2002.

Spicq, Ceslas. *Esquisse d'une histoire de l'exégèse latine au Moyen Âge.* Paris: Vrin, 1944.

Stegmüller, Friedrich. *Repertorium Biblicum Medii Aevi.* 11 vols. Madrid: Consejo

superior de investigaciónes cientificas, Instituto Francisco Suárez, 1950–80.

Strong, Caroline. "History and Relations of the Tail Rhyme Strophe in Latin, French, and English." *PMLA* 22, no. 3 (1907): 371–420.

Stump, Eleonor. *Aquinas*. London: Routledge, 2003.

Sutton, John. "Exograms and Interdisciplinarity: History, the Extended Mind and the Civilizing Process." In *The Extended Mind*, edited by Richard Menary, 189–225. Cambridge, MA: MIT Press, 2010.

Taliadoros, Jason. "Law, Theology, and the Schools: The Use of Scripture in Ricardus Anglicus's *Distinctiones decretorum*." In *Proceedings of the Fourteenth International Congress of Medieval Canon Law*, edited by Andreas Thier, Joseph Goering, and Stephan Dusil, 1045–89. Vatican City: Biblioteca apostolica Vaticana, 2016.

Taylor, Andrew. "Into His Secret Chamber: Reading and Privacy in Late Medieval England." In *The Practice and Representation of Reading in England*, edited by James Raven, Helen Small, and Naomi Tadmor, 41–61. Cambridge: Cambridge University Press, 1996.

Taylor, Holly A., and Barbara Tversky. "Perspective in Spatial Descriptions." *Journal of Memory and Language* 35, no. 3 (1996): 371–91.

Teeuwen, Mariken. "Marginal Scholarship: The Practice of Learning in the Early Middle Ages." *Huygens*. Accessed January 22, 2019. https://www.huygens.knaw.nl/marginal-scholarship/.

———. "Marginal Scholarship: Rethinking the Function of Marginal Glosses in Early Medieval Manuscripts." In *Rethinking and Recontextualizing Glosses: New Perspectives in the Study of Late Anglo-Saxon Glossography*, edited by Patrizia Lendinara, Loredana Lazzari, and Claudia di Sciacca, 19–38. Turnhout: Brepols, 2011.

Teeuwen, Mariken, and Irene Renswoude, eds. *The Annotated Book in the Early Middle Ages: Practices of Reading and Writing*. Turnhout: Brepols, 2017.

Teuscher, Simon. "Flesh and Blood in the Treatises on the *Arbor consanguinitatis* (Thirteenth to Sixteenth Centuries)." In *Blood and Kinship: Matter for Metaphor from Ancient Rome to the Present*, edited by Christopher H. Johnson, Bernhard Jussen, David W. Sabean, and Simon Teuscher, 61–82. Oxford: Berghahn Books, 2013.

Tieleman, Teun. "Methodology." In *The Cambridge Companion to Galen*, edited by Robert J. Hankinson, 49–65. Cambridge: Cambridge University Press, 2008.

Torrel, Jean-Pierre. "Un *De prophetia* de S. Bonaventure? (Assise, Bibl. Com. 186), édition critique, avec introduction et notes." In *Recherches sur la théorie de la prophétie au Moyen Âge*, 13:251–317. Fribourg: Éditions universitaires, 1992.

Treffort, Cécile. *Paroles inscrites: À la découverte des sources épigraphiques latines du Moyen Âge (VIIIe–XIIIe siècle)*. Rosny-sous-Bois: Bréal, 2008.

Tschann, Judith. "The Layout of 'Sir Thopas' in the Ellesmere, Hengwrt, Cambridge Dd. 4.24, and Cambridge Gg. 4.27 Manuscripts." *Chaucer Review* 20, no. 1 (1985): 1–13.

Turkan, Anne-Marie. "Le *Liber artis omnigenum dictaminum* de Maître Bernard (vers 1145): États successifs et problèmes d'attribution (première partie)." *Revue d'histoire des textes*, n.s., 5 (January 2010): 99–158.

Tversky, Barbara. "Obsessed by Lines." In *Thinking through Drawing: Practice into Knowledge; Proceedings of an Interdisciplinary Symposium on Drawing, Cognition and Education*, edited by Andrea Kantrowitz et al., 15–18. New York: Teachers College, Columbia University, Art and Art Education Program, 2011. Accessed March 2, 2019. http://ttd2011.pressible.org/files/2012/05/Thinking-through-Drawing_Practice-into-Knowledge.pdf.

Tweney, Ryan D. "Faraday's Notebooks: The Active Organization of Creative Science." *Physics Education* 26, no. 5 (1991): 301–6.

Valente, Luisa. "Alain de Lille et Prévostin de Crémone sur l'équivocité du langage théologique." In *Alain de Lille le docteur universel: Philosophie, théologie et littérature au XIIe siècle*, edited by Jean-Luc Solère, Anca Vasiliou, and Alain Gallonier, 369–400. Turnhout: Brepols, 2005.

Verboon, Annemieke R. "The Medieval Tree of Porphyry: An Organic Structure of Logic." In *The Tree: Symbol, Allegory, and Mnemonic Device in Medieval Art and Thought*, edited by Pippa Salonius and Andrea Worm, 20:95–116. Turnhout: Brepols, 2014.

Verstijnen, Ilse M., et al. "Creative Discovery in Imagery and Perception: Combining Is Relatively Easy, Restructuring Takes a Sketch." *Acta Psychologica* 99, no. 2 (1998): 177–200.

Viejo, Jesús Rodríguez. "Byzantine Influences on Western Aristocratic Illuminated Manuscripts: The Fécamp Psalter (Ms. The Hague, Koninklijke Bibliotheek, 76 F 13) and Other Related Works." *Estudios bizantinos: Revista de la Sociedad española de Bizantinística* 1 (2013): 105–39.

Voltolina, Giulietta, ed. *Un trattato medievali de "ars dictandi": Le "V tabule salutationum" di Boncompagno da Signa*. Casamari: Edizioni Casamari, 1990.

Wakelin, Daniel. *Designing English: Early Literature on the Page*. Oxford: Bodleian Library, 2018.

Wallis, Hal B., prod. *Casablanca*. Burbank, CA: Warner Bros., 1942.

Ward, John O. "Rhetorical Theory and the Rise and Decline of *Dictamen* in the Middle Ages and Early Renaissance." *Rhetorica* 19, no. 2 (2001): 175–223.

Wei, John C. *Gratian the Theologian*. Washington, DC: Catholic University of America Press, 2016.

Weigand, Rudolf. "Das Gewohntheitrecht in frühen Glossen zum Dekret Gratians." In *Ius Populi Dei: Miscellanea in Honorem Raymundi Bidagor*, 91–101. Rome: Pontificia Universita Gregoriana, 1972.

Weijers, Olga. *La "disputatio" dans les Facultés des arts au Moyen Âge*. Turnhout: Brepols, 2002.

———. *In Search of Truth: A History of Disputation Techniques from Antiquity to Early Modern Times*. Turnhout: Brepols, 2014.

Weitzmann, Kurt. "Various Aspects of Byzantine Influence on the Latin

Countries from the Sixth to the Twelfth Century." *Dumbarton Oaks Papers* 20 (1966): 1–24.

Winehouse, Amy. "Back to Black." In *Back to Black* (album). Island Records, 2006.

Worby, Sam. *Law and Kinship in 13th-Century England*. Woodbridge, UK: Boydell and Brewer, 2010.

Yeo, Richard. *Notebooks, English Virtuosi, and Early Modern Science*. Chicago: University of Chicago Press, 2014.

Zhao, Jian, et al. "Facilitating Discourse Analysis with Interactive Visualization." *IEEE Transactions on Visualization and Computer Graphics* 18, no. 12 (2012): 2639–48.

Index

PAGE NUMBERS IN ITALICS REFER TO FIGURES.

absolute necessity, types, 92
Abu Mashar, 103
Alan of Lille, 101, 108
Albert the Great, 89–90, 95, 171, 176; *On Animals*, 95
Alexander III (pope), 112; *Super eo* decree, 112
Alexander of Hales, 148, 162
Alexander of Villedieu, 140; *Doctrinale*, 139, 141
algorithm, 10, 32, 33, 87, 111, 116, 130, 135, 186, 195
allegory, 6, 20, 22, 44, 49, 100–101, 196
Amiens, BM 404, 74
Anchin Abbey, 127
Andronicus of Rhodes, 158
annotation, 5, 8, 10, 11, 52, 57, 60, 63, 64, 66, 67, 72, 74, 91, 95, 96, 112, 193, 194; annotators, 63, 68, 70–73, 82, 91–93, 95, 97, 98, 105, 115, 116, 158, 163, 185, 193, 197; diagrammatic annotation, 10, 60, 64, 93, 158; HT annotation, 112, 193–94; marginal annotation, 5, 10, 57–75, 91, 93, 99
Apuleius of Madaura: *De interpretatione*, 65
Aquinas, Thomas, 56, 89, 92, 171–72, 175–76, 179, 196; commentary on Aristotle's *Physics*, 79, 97; *Summa theologiae*, 195
Aristotle, 11, 24, 25, 36, 57, 63–65, 70, 74, 91–93, 96, 102, 145, 156, 158, 159, 160, 161–64, 166, 181, 185; *Aristoteles Latinus*, 65, 72; *Categories*, 71–72; *De generatione*, 93; *De interpretatione* (*Perihermeneias*), 71–72, 81; *Economics*, 80; *Ethics*, 11, 63, 80, 93, 94, 95; *Isagoge*, 72; *Metaphysics*, 91, 93, 96, 97; new logic, 65; *Organon*, 10, 25, 57, 64–65, 66, 67, 68, 74, 81, 128, 145, 158; *parva naturalia*, 96; *Physics*, 79, 96, 97; *Poetics*, 100; *Politics*, 80; *Posterior Analytics*, 31, 65, 71–72, 161; *Prior Analytics*, 36, 69, 72, 81, 158, 160, 161; *Sophistici elenchi*, 72, 73, 162; *Topica* (*Topics*), 69, 71, 72, 74, 97, 102
Arnald of Villanova: diagrammatization of the *Vita brevis*, 118
ars dictaminis, 11, 33, 36, 44, 79, 87, 129–37, 138–39, 141, 198, 219n32
Articella, 57, 116
Assisi, BC 49, 56, 103, 106, 171
Assisi, BC 51, 171–72, 175–77
Assisi, BC 186, 150–55
Assisi, BC 298, 73
Assisi, BC 469, 75
Augustine of Hippo, 102, 150; *On the Trinity*, 53, 58
Averroës: commentary on *Organon*, 81, 91–92, 97, 100
Avicenna: *Metaphysics*, 93, 97

Bacon, Roger, 100
Barbara Celarent, 48, 70–71
Barnes, Jonathan, 158
Barney, Stephen A., 104
Barthes, Roland, 182–85
BAV Borgh. 33, 74, 98
BAV Borgh. 133, 33, 35, 74
BAV Borgh. 296, 98
BAV Chigi E. V. 149, 69
BAV Pal. Lat. 624, 109, *111*, 113
BAV Pal. Lat. 634, 73
BAV Pal. Lat. 696, 111–12
BAV Pal. Lat. 996, 69, 158, *160*, *161*
BAV Pal. Lat. 1084, 118
BAV Pal. Lat. 1229, 118
BAV Pal. Lat. 1268, 118
BAV Pal. Lat. 1755, 141
BAV Pal. Lat. 1801, 123–24
BAV Vat. Lat. 22, 48, 145
BAV Vat. Lat. 782, 73, 147, 149

Bede, 150
Bellamah, Timothy, 56
Beneit of Saint-Alban: *Vie de Thomas Becket*, 128
Ben-Meshulam, Avraham Avigdor, 81
Berger, Susanna, 198
Bernard of Bologna: *Summa dictaminum*, 123
Bernard of Pavia, 111
Bible, 7, 48, 53, 99, 102, 105, 109, 145, 156, 178, 180; biblical commentaries, 103, 172; biblical *distinctiones*, 91, 97, 99–109; biblical *divisio*, 171, 180; biblical narratives, 11, 106, 145, 170–82; biblical surface text, 172, 176, 177; biblical theology, 87, 118
bile, *117*
Boethius, 20; diagrams, 7; *Liber divisionum*, 64
Bologna, 42, 113
Bonaventure, 150–51, 153–54; autograph, 150, 153; commentary on the *Sentences*, 153, *155*; *De triplici via* (*On the Triple Way*), 28, 75
Bourdieu, Pierre, 6, 63
Bourgain, Pascale, 119, 121
Boyle, John F., 157, 172
brace, 9, 194, 197, 199
breathing, diagram, *116*
Breviarium extravagantium, 111
brevity, 9, 32, 42–44, 48–49, 102
Bruges, BM 534, 137
Buringh, Eltjo, 8
Burley, Walter: commentary on Aristotle, 63, 93

Cambridge, Gonville and Caius College 341_537, 138
Carmina Burana, 121–22, 125
Carruthers, Mary, 48–49, 201

Cassiodorus, 20
cause, *92*, *96*
Chalmers, David, 4–5
Chambers, Deborah, 4
Champion, Matthew, 51
Chartier, Roger, 50, 57
Chaucer, Geoffrey, 128
Christ. *See* Jesus
Cicero, 119
Clareno, Angelo: *A Chronicle or History of the Seven Tribulations of the Order of Brothers Minor*, 27
Clark, Andy, 3–5
codicology, 5, 8
cognition, 4–5, 31, *32*, *94*, 151, *153*, 158; associative cognition, 103; cognitive strategies, 5, 62, 67; cognitive studies, 4, 11, 148, 195; history of cognition, 5; interior cognition, 59
Colli, Vincenzo, 113
columns, 7, 9, 17, 52–57, 75, 79, 90, 93, 99, 106, 116, 136, 142, 151, 153, 175
coordination, 9, 27–31
creation, 165, *167–68*
customs, diagram, *111*

Davies, Simon P., 4
Derolez, Albert, 8
Derrida, Jacques, 3
desire, 31, *32*, *61–62*, *93–94*
devil, *18*, *108*, *112*, 174
diagrams: Arabic *tashjīr*, 24, 115; Byzantine, 25, 36, 194; conceptual diagrams, 11, 20–22, 36, 48, 95, 99, 194, 198; *diaereses*, 24–25; embedded diagrams, 75, 163; genealogical diagrams, 16–17, 22, 24, 179, 194; hierarchical diagrams, 21; non-Latin diagrams, 24–25, 36, 50, 115, 194; parasitic diagrams, 10, 57, 63, 75–77, 113, 165; Ramist diagram (*see* Ramus, Peter); "six contrarieties" diagram, 70; Square of Opposition, 7, 20, 51, 64; syllogistic diagrams (*see* syllogism); Syriac *pulaga*, 24, 50; Tree of Affinity, 20, 109, 147; Tree of Consanguinity, 20, 109, 147; vertical branching diagrams, 16, 137; vertical medallion divisions, 22–23
dialogue analysis, 177–78
disputation, 73, 89, 102, 176, 179–80
distinction, 10, 15, 18, 37, 42, 53, 56–57, 60, 62, 75, 79, 87, 89–119, 121, 138, *160*, 162–65, *166–68*, 195–96, 198; biblical distinctions (*see* Bible); marginal distinctions, 151, 160
distinctiones, 10, 15, 17, 25, 42, 79, 89, 91, 97, 99, 101, 103, 105–6, 109, 113–14, 117–18
divisio textus, 88, 156–57, 171–72, 182–83; diagrams, 54, 115, 145, 180
Dominicans, 38, 56, 106, 109, 163, 171
Donatus: *Ars grammatica*, 137, 141
doodles, 4, 51, 69, 74, 75
draft, 11, 38, *50*, 53, 60–62, 74–75, 150, 153, 155, 172
Durand of Huesca, 106

Ebbesen, Sten, 25
Eco, Umberto, 64, 100–101; *From the Tree to the Labyrinth*, 100
Eddy, Matthew Daniel, 198
England, 60, *131*, 163
Erasmus, 135
Etienne of Abbeville, 79
Eustaches d'Arras, 79
Eve, 125
Extended Mind Theory. *See* mind
externalization, 4–5, 37, 41, 62, 118, 156, 199
eye, diagram of, 21

Ferrara, 95
Finke Test, 4
Fleming, Ian: *Goldfinger*, 183
Florence, BML Plut. 20.18, 172, 175, 179
Florence, BML Plut. 25 sin. 05 24, 140
Florence, BML Plut 34.47, 139
Florence, BML Plut. 72.3, 25
Franciscans, 79, 171, 174
Francis of Assisi, 27
French HT diagrams, 79–80
full page, *50*, 113
fume, 17

Galen, 74, 115; *Tegni*, 115
Geoffrey of Vinsauf: *Poetria nova*, 155
Gerard of Abbeville, 62, 76
Gersonides, 81
Gilbert de la Porrée: *Liber de sex principiis*, 64, 72
Gilbert of Tournai: *Sermones ad status*, 51
God, 17, 43, 44, *58*, *61*, *62*, 99, 103, 104–5, *107*, 108, 114, 149, 150, 165, *167*–69, 175–78, 184, 187–90

Goldilocks, 178
Goodall, Grant, 28
Goody, Jack, 156
Gospel of John, commentary, 56, 106
Gospel of Matthew, commentary, 106
grammar, 7, 79, 134, 135–44, 157, 181, 184, 186; declination, 24, *140*, 142–43
Gratian: *Decretum*, 109–14
Greek manuscripts, diagrams in, 24, 25, 79
Gregory IX (pope): *Decretales*, 73, 112
Guerric of Saint-Quentin, 171

habits, 5–11, 49, 50–83, 87, 115; cognitive habits, 11, 28–29, 53, 92, 197; diagramming habits, 25, 70–71, 74–82, 121, 194; learning habits, 64, 73, 79; reading habits, 44, 52, 67, 69, 80, 195; visual habits, 7, 25, 64, 80, 128, 196; writing habits, 52, 54–55, 63, 67–68, 72, 75–76, 79, 82, 109, 137
habitus, 6, 161
Hacking, Ian, 64
Hagen, Karl, 181
Halifax, George, 51
Hamburger, Jeffrey, 196
Hebrew, HTs in, 80–81
Hegarty, M., 154
Heidelberg, 141
Helstrup, Tore, 4
Henry of Braxton: *Book on the Laws of England*, 127
Herrad of Hohenberg: *Hortus deliciarum*, 21
Hippocrates: *Aphorisms*, 115, 118; *De regimine*, 115; *Prognostica*, 115
Hobbes, Thomas: *Optics*, *19*, 128
Holy Spirit, 60, *107*, 149, 162, *166–69*
Hrabanus Maurus, 127
Hugh of Saint-Cher, 171
Hugh of Saint-Victor, 8, 57, *58*; *Didascalicon*, 42
Huisman, Rosemary, 120
human happiness, *18*

Ibn Buṭlān: *Taqwīm al-sihhah* (*Tacuinum sanitatis*), 114
ignorance, *103*, *104*, *111*, *112*, 161
ink, 15, 38, 57, 60–61, 74, 80, 127
Innocent III (pope). *See* Lothar de Segni
Isidore of Seville, 23
Israeli, Isaac: *De urinis*, 118

Italy, 81, 129, 137, 158

Jaffe, Martin, 172
James of Venice, 25
Jenkinson, A. J., 159
Jerome, 150
Jesus, 171; Christ, 56, 99, 103, 105, *107*, 108, *149*
Jews, 80, 101–2, 195
Joachim of Fiore, 22
Job, book, *107*, 159; opening diagram, *174*; temptations diagram, *176*; text structure, 171–80, 184, 187–91
Johannitius: *Isagoge*, 115–16
John of Garland, 140
John of La Rochelle, 172
Johnson, Mark, 104
Johnson, Nancy S., 184–86
Justinian codex, 112

Kilwardby, Robert: *Ad arborem*, 109
Kirsh, David, 29

Labov, William, 149
Lacombe, George, 65
Lakoff, George, 104
Lambert of Saint-Omer: *Liber floridus*, 21
law, 7, 10, 20, 42, 87, 89, 91, *107*, 115, 195; canon law, 12, 31, 109, 111, 114, 118; civil law, 64, 73, 109, 112–14; Jewish law, 195
Law, Vivian, 136–37
Lawrence of Aquilegia, 79, 129–30, 134; *Practica dictaminis*, 129, *131*; *Speculum dictaminis*, 134
legal manuscripts, 79, 109–14, 129
Leonello d'Este, 95
letter writing. See *ars dictaminis*
Levelt, Willem J. M., 26
liberal arts, 64, 74, 83, 87, 109, 118
linearization problem, 26
linguistic paradigms, 9–11, 16, 25–36, 42, 135–37, 142, 184–86
lists, 9, 15–18, 22–24, 28–37, 39, 69, 74, 80, 89, 93, 106, 112, 118, 134, 147–50, 156, 180, 199
literacy, 5–6, 156, 196. *See also* reading
logic, 20, 25, 28, 46, 52, 57, 63–66, 70, 74, 81, 87, 91, 115, 138, 185, 195, 198
London, BL Add. 10960, 165, *167*, 170
London, BL Add. 10961, 54–55, 165, 170
London, BL Add. 18277, 81

London, BL Add. 22090, 81
London, BL Egerton 633, 38, 57, *58*, *59*, 90, 147
London, BL Harley 3140, 116, *117*
London, Wellcome Library 49, 22. *See also* "Wellcome Apocalypse"
Longfellow, Henry: *A Psalm of Life*, 120
Lothar de Segni (Innocent III), 22
love, 3, 18, *59*, *61*, *62*, 149
Lull, Raymond, 7, 43–44, 46, 48, 79

Macrobe, 74
Madrid, BNE 1564, 74
Madrid, BNE 9726, 145
Mandler, Jean M., 184–86
Mann, William C., 185
Matthew of Aquasparta, 75, 171–74, 177–78, 186
McLuhan, Marshall, 7
memorial plaques, 48, *51*, 198
memory, 5, 8, 30, 37, 47–49, 52, 59, 109; mnemonics, 47–49, 70
medicine, 3, 10, 12, 25, 52, 57, 64, 87, 91, 114–18
medieval universities, 7, 52, 76, 82, 90, 95, 118, 148, 158, 170, 181, 195, 197
metaphor, 10, 37, 99–108, 195, 197
mind, 3–4, 8, 10–11, 20, 23, 27, 29, 32, 37–39, 42, 43, 46, 48, 57, 59, 62, 75, 92, 101, 103, 105, 109, 135, 155–56, 162, 164, 170–71, 182, 195–97, 199; Extended Mind Theory, 4–5; mind maps, 194; mind theory, 4; philosophy of the mind, 4
Minnis, Alastair J., 171, 183
Mordechai Nathan, Rabbi, 81
Moretti, Franco, 8
Moses, 181
MS BL Harley 658, 23
MS BL Harley 3255, 17–18
MS BL Sloane 981, 21
Munich, Bayerische Staatsbibliothek clm 4660, 34, 121, *122–23*
Murphy, James, 131, 134

narratology, 11, 44, 37, 43, 88, 106, 130, 141, 145, 157–58, 165, 170–85, 177, 180–81, 196
nature, 93, 95, 101, 103, 165
New Testament, 102
Nigel of Longchamps (alias Nigel Witeker), 18
notebook, 4, 52–53, 75, 150

notes, 22, 27, 39, 43, *50*, 52–53, 57, 67, 73–74, 76, 109, 112–13, 115, 137, 151, 158, 178, 193–94, 198–99

oath, *114*
O'Boyle, Cornelius, 115
Oliver of Anchin Abbey, 127
Ong, Walter J., 7, 83, 198
Oresme, Nicole, 15, 80
Organon manuscripts, 25, 57, 65–67, 74, 128, 145, 158
Oxford, Balliol College 62, 39, *41*
Oxford, Balliol College 195, 60, *61–62*, 124–25, *126*
Oxford, Balliol College 253, *66*, 74
Oxford, Bodl. 344, 127
Oxford, Bodl. Digby 55, 96–97, 138, *139*
Oxford, Bodl. Laud. Misc. 511, 34, 75, *76*

paleography, 5, 8–9
Panofsky, Erwin, 6, 83; *Gothic Architecture and Scholasticism*, 6
paper, 3–5, 29, 39, 50, 52, 65, 81, 83, 211n26
paradigmatic axis vs. syntagmatic axis, 9, 26, 30, 136, 144
paradigmatic writing, 15, 23–24, 30, 34, 36–38, 43–44, 48, 51, 62–64, 67, 69, 71–72, 79–80, 82, 87, 92, 95, 109, 112, 118, 119–20, 124, 128–29, 134–35, 137, 140–44, 145–46, 181, 194, 197; diagrams, *130*, *131*, *132–33*
parasitic diagrams, 75
parchment, 7, 29, 50, 52–53, 55, 65, 83, 211n26
Paris, BnF Fr. 542, 80
Paris, BnF Heb. 926, 81
Paris, BnF Lat. 1154, 120
Paris, BnF Lat. 3574, 75
Paris, BnF Lat. 4289, 113
Paris, BnF Lat. 6319, 145
Paris, BnF Lat. 6459, 32, 63, 93, *94*
Paris, BnF Lat. 6520, 95
Paris, BnF Lat. 8653, 33, *130*, *133*
Paris, BnF Lat. 14174, 131
Paris, BnF Lat. 14717, 98
Paris, BnF Lat. 14719, 98
Paris, BnF Lat. 15323, 162, 165, *168*, 170
Paris, BnF Lat. 15652, 53, *54*, 75
Paris, BnF Lat. 16084, 91, *92*
Paris, BnF Lat. 16096, 93
Paris, BnF Lat. 16153, 79, 97

Paris, BnF Lat. 16174, *41*, 115, *116*
Paris, BnF Lat. 16405, 76, *77*
Paris, BnF Lat. 17806, 74
Parkes, Malcolm Beckwith, 23, 121, 128
Parsons, Terence, 64
Paul (apostle): Epistles, 48
Peter Lombard, 156, 158; *Sentences*, 11, 15, 54, 57–58, 60, 89, 90, 99, 102, 124, 146, 151, 162–70
Peter of John Olivi, 171, 174
Peter of Poitiers, 108
Peter of Spain (Petrus Hispanus), 161; *Ha-higayon* (Hebrew translation), 81; *Posteriora*, 70, 71; *Summulae*, 70
Peter the Chanter, 108; *De tropis loquendi*, 102; *Distinctiones Abel*, 99
Petrus Comestor, 104; *Historia Scholastica*, 99
pharmakon, 3
philosophy, 4, 7, 80, 87, 91, 93, 96, 145, 158; natural philosophy, 74, 81, 91, 95–97, 116, 138, 145
Plato, 3–4, 74, 92, *166–69*, 170; Egyptian myth, 3, 37; *Phaedros*, 3
pleasure, 43, 47, 57, 93, 106, 134–35, 159
Poe, Edgar Allan: *Annabel Lee*, 120
poetry, 7, 104, 108, 119–23, 126–28, 140, 155
Pons of Provence: *Summa dictaminis*, 130
Porphyry, 193; *De interpretatione*, 64; *Isagoge*, 64; Square of Opposition, 7; Tree (*arbor*), 7, 20, 64, 72, 100
portkeys, distinctions as, 106, *108*, 109, 113
Praepositinus of Cremona, 108
prayer, *146*
preachers, 34, 49, 79, 108–9, 195, 198
preaching. *See* sermons
Priscian: *Institutiones grammaticae*, 137
Psalms, 120, 173
Pseudo-Aristotle: *Physiognomia*, 95
Pseudo–Peter of Poitiers, 102

quaestio, 11, 146–47, 172

Radulfus Ardens, 20
Rainaldus of Anchin Abbey, 127
Ramus, Peter, 7, 83, 198
reading, 16, 23–24, 52, 67, 80, 91, 118, 120, 122–3, 125, 159, 170, 186, 194, 199
rhetoric, 106, 119, 129, 131, 134, 138, 157, 161, 163, 170, 185
Rhetorical Structure Theory, 185

rhymes, 119–28, 135, 137, 195; circular rhymes, 124; Leonine rhymes, 120; mnemonic rhyme, 70; *pariles colligati*, 124; tailed rhymes, 124
Richard Barre: *Compendium veteris and noui testament*, 17
Richard de Mores (Ricardus Anglicus), 42, 48, 113
Richard of Fishacre, 15, 165, *166–69*; commentary of the *Sentences*, 38, 55, 62, 163; *divisions*, 48, 163
Richard of Mediavilla, 171, 174
Richard of Saint-Victor, 60
Roland of Cremona, 171
Rouse, Mary and Richard, 100
Rowling, J. K., 105; *Harry Potter*, 106

Sacrobosco: *On the Sphere*, 96
Saenger, Paul: *Space between Words*, 52
salutation and narration, 129–31; diagram, *130*
Saint-Omer, BM 260, 56
Saint-Omer, BM 620, *66*, 74
Satan, 175–78, 184, 186, 188, 190
Saussure, Ferdinand de, 26
Savile, George, 51
Schmitt, Jean-Claude, 16
scholastics, 63, 79, 81, 88, 100, 136, 145, 146–47, 156–57, 161, 171, 179, 180–82, 185, 196; Latin diagrams, 24; scholastic culture, 6–7, 10–11, 31, 80, 83, 180–81, 196; scholasticism, 6, 12; theology, 89
scholia, 25
self, 4, *94*, 199
Sentences. *See* Peter Lombard
sermons, 15, 59, 57, 75, 79, 99, 103, 106, 108–9; preaching, 89, 104
servus ordinatus, 31, 113
Sherman, Claire, 80
Sicard of Cremona, 113
sickness, *116*
Silano, Giulio, 165
sin, 34, 103–4, *114*, 153–54, 190; sin is called darkness, *103*
sketches, 22, 74–75, 150, 153
Socrates, 3, 46, *92*; dialogues, 3
soul, 3, 27, 43, 47, 59, 92, 104, 150, 170, 173; diagrams, 74, 97–99, *114*, 149, *166–69*
stars, 57, *58*, 105, 197
stone, 6, *50*, 51
Sutton, John, 5

syllogism, 25, 35, 36, 48, 70–71, 111, 145, 159–62
syntax, 26, 28, 35, 67, 129, 131, 135, 137, 141, 145, 181, 183

tables, 5–6, 20, 22–24, 47, 52, 96, 114, 129, 140–41, *142*, 199
tablets, 50, 53, 199
taille, 79, *80*
tapestry pages, 57, 75, 77–79, 83, 96–97, 99, 108, 113, 118, 129, 131, 141, 198
Teeuwen, Mariken, 8
Ten Commandments, 60
theology, 10, 11, 17, 22–25, 44, 53, 56, 62, 64, 76, 87, 89, 90, 99, 102, 109, 114, 116, 118, 124, 158, 173, 176, 193, 195–96; biblical theology, 87, *89*, 101, 118; theological *distinctiones*, 79, 97, 101, 113, 117–18; theological *questiones*, 11, 53, 145, 146–56
Theophilus: *Urines*, 115
Thomas Le Myésier, 15, 48; *Breviculum* (*Electorium parvum*), 43, 79, 96
Thompson, Sandra A., 185
Toulouse, BM 737, 146
Tours, BM 121, 106–8
Trinity, 22, 53, 58, *59*
Turin, National University Library A I 14, 81
Tversky, Barbara, 155, 181
Tyrol, 121

Uppsala, Bibl. Regal. Univ. C. 599, 31, 71
Uppsala, Bibl. Regal. Univ. C. 678, 143

Vienna, ÖNB 2370, 73
violence, 112
Virgin Mary, 121, 124–25
visualized analyses, 135, 156–70, 178

"Wellcome Apocalypse," 22, 116, *117*
Westminster Abbey, 51
William of Alton: commentary on the Gospel of John, 56, 103
William of Middleton, 171, 174
William of Morbeke, 100
Winehouse, Amy, 123